THE LIFE OF
P. T. BARNUM

Written by Himself

COLLINS
CLASSICS

William Collins
An imprint of HarperCollins*Publishers*
1 London Bridge Street
London SE1 9GF

WilliamCollinsBooks.com

This William Collins paperback edition published in Great Britain in 2017

2

A catalogue record for this book
is available from the British Library

ISBN 978-0-00-827701-7

Classic Literature: Words and Phrases adapted from
Collins English Dictionary

Typesetting in Kalix by Palimpsest Book Production Limited,
Falkirk, Stirlingshire

Printed and bound by CPI Group (UK) Ltd, Croydon CR0 4YY

MIX
Paper from
responsible sources

FSC™ C007454

www.fsc.org

This book is produced from independently certified FSC™ paper
to ensure responsible forest management.

For more information visit: www.harpercollins.co.uk/green

History of William Collins

In 1819, millworker William Collins from Glasgow, Scotland, set up a company for printing and publishing pamphlets, sermons, hymn books, and prayer books. That company was Collins and was to mark the birth of HarperCollins Publishers as we know it today. The long tradition of Collins dictionary publishing can be traced back to the first dictionary William co-published in 1825, *Greek and English Lexicon*. Indeed, from 1840 onwards, he began to produce illustrated dictionaries and even obtained a licence to print and publish the Bible.

Soon after, William published the first Collins novel; however, it was the time of the Long Depression, where harvests were poor, prices were high, potato crops had failed, and violence was erupting in Europe. As a result, many factories across the country were forced to close down and William chose to retire in 1846, partly due to the hardships he was facing.

Aged 30, William's son, William II, took over the business. A keen humanitarian with a warm heart and a generous spirit, William II was truly 'Victorian' in his outlook. He introduced new, up-to-date steam presses and published affordable editions of Shakespeare's works and *The Pilgrim's Progress*, making them available to the masses for the first time.

A new demand for educational books meant that success came with the publication of travel books, scientific books, encyclopedias, and dictionaries. This demand to be educated led to the later publication of atlases, and Collins also held the monopoly on scripture writing at the time.

In the 1860s Collins began to expand and diversify and the idea of 'books for the millions' was developed, although the phrase wasn't coined until 1907. Affordable editions of classical literature were published, and in 1903 Collins introduced 10 titles in their Collins Handy Illustrated Pocket Novels. These proved so popular that a few years later this had increased to an output of 50 volumes, selling nearly half a million in their year of publication. In the same year, The Everyman's Library was also instituted, with the idea of publishing an affordable library of the

most important classical works, biographies, religious and philosophical treatments, plays, poems, travel, and adventure. This series eclipsed all competition at the time, and the introduction of paperback books in the 1950s helped to open that market and marked a high point in the industry.

HarperCollins is and has always been a champion of the classics, and the current Collins Classics series follows in this tradition – publishing classical literature that is affordable and available to all. Beautifully packaged, highly collectible, and intended to be reread and enjoyed at every opportunity.

CONTENTS

THE LIFE OF
P. T. BARNUM

INTRODUCTORY

PHINEAS TAYLOR was my maternal grandfather. I was his first grand-child, and it was suggested that I should perpetuate his honored name. My delighted ancestor confirmed the choice, and handed to my mother a gift-deed, in my behalf, of five acres of land, be the same more or less, situated in that part of the parish of Bethel, town of Danbury, county of Fairfield, State of Connecticut, known as "Plum Trees;" said tract of land being designated "IVY ISLAND."

The village and parish of Bethel, honored by embracing within its limits that valuable inheritance of mine, (of which I shall here-after have something to say,) has been repeatedly mentioned to me, by persons who ought to know, as my birth-place, and I have always acknowledged and reverenced it accordingly.

As however my grandfather happened to be born before me, and as it is said by all who knew *him* and have knowledge of *me*, that I am "a chip of the old block," I must record some facts regarding him.

I think I can remember when I was not more than two years old, and the first person I recollect having seen, was my grandfather. As I was his pet, and spent probably the larger half of my waking hours in his arms, during the first six years of my life, my good mother estimates that the amount of lump sugar which I swallowed from his hands, during that period, could not have been less than two barrels.

My grandfather was decidedly a wag. He was a practical joker. He would go farther, wait longer, work harder and contrive deeper, to carry out a practical joke, than for anything else under heaven. In this one particular, as well as in many others, I am almost sorry to say I am his counterpart; for although nothing that I can conceive of delights me so much as playing off one of those dangerous things, and although I have enjoyed more hearty laughs in planning and executing them, than from any one source in the world, and have

generally tried to avoid giving offence, yet I have many times done so, and as often have I regretted this propensity, which was born in me, and will doubtless continue until "dust returns to dust."

My grandfather had four children: IRENA, my mother; LAURA, now the widow of Aaron Nichols; EDWARD, late Judge of the County Court. These three at present reside in Bethel, in which village ALANSON, the youngest of the four, died June 5, 1846, aged nearly 45.

The two sons exhibited a small degree of their father's propensity for a joke. My aunt Laura is considerably given that way – my mother somewhat less so; but what is lacking in all the children, is fully made up with compound interest in the eldest grandson.

My paternal grandfather was Captain Ephraim Barnum, of Bethel* – a captain in the militia in the Revolutionary War. His son Philo was my father.† He too was of a lively turn of mind, and relished a joke better than the average of mankind. These historical facts I state as some palliation for my own inclination that way. "What is bred in the bone," etc.

BORN – MARRIED – DIED. Most of my ancestors have passed the third state. I hope, through the grace of God, to meet them all in a better world, where "they neither marry nor are given in marriage," and where "Death is swallowed up in victory."

*He had fourteen children. By his first wife, KEZIA, LUCY, REBECCA, JOSEPH, RUTH, DORCAS, NOAH, HANNAH, CHLOE. By his second wife, NOAH STARR, PHILO, EDER, REBECCA, PETER. Only four are now living: RUTH, aged 91; NOAH STARR, 77; EDER, 73; PETER, 70. The father died in 1817, aged 84.

† His children by his first wife were, RANA, ALMON, MARY, MINERVA, and PHILO F. Only the last two survive. His children by his second wife were, PHINEAS T., MARY, EDER, CORDELIA, and ALMIRA. The last named died in 1832. The others are still living.

CHAPTER I

My Early History

MY first appearance upon this stage was on the 5th day of July,
Anno Domini 1810. Independence Day had gone by, the cannons
had ceased to thunder forth their remembrances of our National
Anniversary, the smoke had all cleared away, the drums had finished
their rattle, and when peace and quiet were restored, I made my
début.

This propensity of keeping out of harm's way has always stuck
by me. I have often thought that were I forced to go to war, the
first arms that I should examine would be my legs. I should scarcely
fulfil the plan of the Yankee soldier who fired a few stray shots at
the enemy on his own hook, and then departed, singing,

> "He that fights and runs away,
> May live to fight another day."

I am decidedly a man of peace, and the first three words of the first line would never correctly apply to me if it was possible for me to appropriate the three words which follow them.

I am not aware that my advent created any peculiar commotion in the village, though my good mother declares that I made a great deal of noise the first hour I saw the light, and that she has never been able to discover any cessation since.

I must pass by the first seven years of my life – during which my grandfather crammed me with sugar and loaded me with pennies, to buy raisins and candies, which he always instructed me to solicit from the store-keeper at the "lowest cash price" – and proceed to talk of later events.

I commenced going to school at the age of about six years. The first date which I recollect inscribing upon my writing-book, was 1818. A schoolhouse in those days was a thing to be dreaded – a schoolmaster, a kind of being to make the children tremble. My first school-teacher was a Mr. Camp, the second Mr. Zerah Judson, the third a Mr. Curtiss from Newtown, the fourth Dr. Orris T. Taylor, and afterwards my uncle Alanson Taylor, etc. In the summers Miss Hannah Starr, an excellent teacher, of whom I was an especial favorite, and for whom I have ever entertained the highest respect, was our school-mistress. The first three male teachers used the ferule prodigiously, and a dark dungeon which was built in the house, was tenanted nearly all the time during school hours, by some unlucky juvenile frequently under eight years of age, who had incurred the displeasure of the "one-man power."

I was generally accounted a pretty apt scholar, and as I increased in years, there were but two or three in school who were considered my superiors. In arithmetic I was unusually quick and I recollect, at the age of twelve years, being called out of bed one night by my teacher, who had laid a small wager with a neighbor that I could figure up and give the correct number of feet in a load of wood in five minutes. The neighbor stated the dimensions, and as I had no slate in the house I marked them on the stove pipe, and thereon also figured my calculations, and gave the result in less than two minutes, to the great delight of my teacher, my mother, and myself, and to the no small astonishment of our incredulous

neighbor. My father was a tailor, a farmer, and sometimes a tavern-keeper; so I was often kept out of school, and never had any "advantages" except at the common district school, and one summer at the "Academy" in Danbury, a distance of three miles, which I marched and countermarched six times per week.

Like most farmers' boys, I was obliged to drive and fetch the cows, carry in firewood, shell corn, weed beets and cabbages, and, as I grew larger, I rode horse for ploughing, turned and raked hay, and in due time handled "the shovel and the hoe," as well as the plough; but I never really liked to work.

One of my playmates, who also had occasion to drive cows the same road with myself, and who was two years my senior, I will in these pages call John Haight. He was the son of Dr. Ansel Haight, one of our village physicians. John was a pretty hard customer. He was profane, bullying, fond of visiting other people's peach and apple orchards, water-melon patches, etc. Many is the whipping that fell to my lot for disobeying my mother's injunction "not to play with that John Haight."

John was a regular raw-head and bloody-bones to all prudent mothers, and although he had a happy faculty of coaxing their sons into scrapes, he never helped them out. The boys generally both liked and feared him. They liked him for his impudent, daredevil sort of character, and they feared him because he was a terrible tyrant, ruling his mates with a rod of iron, and flogging all who presumed to disobey him.

On one occasion a dozen of the schoolboys – John among the rest – were skating upon a pond where the water was about twelve feet deep. John, prompted by his reckless spirit, dashed out on a portion of the pond where the ice was known to be thin, and, breaking through, nearly disappeared. He however caught by the ice, and struggled to get out, with nothing but his head and shoulders visible. John was then about fourteen years of age, the other boys ranging from ten to twelve. He called lustily for assistance, but we were all afraid to approach the dangerous locality. The ice kept giving way under the pressure of his arms, while he kept following it up, struggling and calling for help. We were shy and remained at a respectful distance. John, seeing our fears, became excited, and swore, in the most bitter tones, that if we did *not* help him he would give every one of us a "thundering licking" if he ever *did* get out.

Not relishing this threat, and with the spirit of thoughtlessness

which marks boys of that age, we all decamped, leaving poor John to his fate. We quite expected he would be drowned, and as he had flogged several of us since morning, we did not much care what became of him. The next day I met one of my comrades. His head was enveloped in a cotton flag handkerchief, from under which I could perceive peeping out the edge of a black eye.

"What is the matter?" I inquired.

"John Haight got out yesterday, and has licked me this morning for not helping him," was the reply.

The next day, as I was approaching the pond for another skating spree, I met John.

"Stop, or you'll catch your death-blow!" roared John.

I halted as suddenly as if I had received the same command from a captain of artillery.

He approached me so closely that I could feel his breath upon my face, and looking me square in the eye, he exclaimed:

"Mr. Taylor Barnum, it seems to me I owe you a licking." He then very deliberately divested himself of his coat, threw it upon the snow, and proceeded to cancel the debt in double quick time. In less than two minutes I was pretty well pummelled, and started for home, "drowned in tears." My mother inquired the cause of my troubles, and when I informed her, she replied that I was served right for keeping such company.

A week had not elapsed after John's accident before the round dozen of his schoolmates had received their promised "licking." The boys were generally careful not to complain at home when John had whipped them, lest their fathers should administer the rod for having been caught in such company.

My father met John a few days after his accident, and never having heard a word about it, among other remarks he said, "Well, John, do you skate any now-a-days?"

"Oh, yes, Uncle Phile; the other day I skated clear up to here," answered John, pointing to his neck with imperturbable gravity.

In spite of the tyranny of that boy, I preferred his companionship to that of any other of my mates; and though the family removed to Norwalk, so many of my early memories are linked with him that I feel impelled to relate additional incidents concerning him, although I was not immediately interested in them.

The Sunday after the family removed, (it was in midsummer,) John took his younger brother into the creek to bathe. Just as the various congregations were pouring out of the churches, John and

Tom were seen perfectly naked standing upon the railing of the bridge.

"Don't you stir till I give the word," said John to his almost helpless brother.

The crowds of ladies and gentlemen were fast approaching the bridge, but the brothers stood fixed as statues. As the first score of persons stepped upon the bridge, and hundreds were at their heels, John exclaimed, at the top of his voice, "Now, Tom, dive, you little vagabond – dive!" at the same time pushing poor little Tom off into the deep creek, which was running thirty feet below. John himself leaped at the same instant, and in a few moments afterwards was seen swimming like a duck to the shore, with little Tom on his back.

While living in Norwalk, a comb-maker, who looked more to interest than principle, one day said to him, "John, the country comb-makers are having a good many horns come up on board the sloops, and they are stored in the warehouse of Munson Hoyt & Co. on the dock. If you can manage to hook some of them occasionally, I'll buy them of you at a shilling apiece." This was less than half their value, but as John wanted spending money, he assented.

The next night he brought the comb-maker four fine-looking ox horns, and received half a dollar for the larceny. The following night he brought as many more. The comb-maker cautioned John to be very careful and not get caught. John thanked him for his kind warning, and promised to conduct his thefts with the most profound secrecy. Night after night, and week after week, did John bring horns and receive the rewards of his iniquity. Months rolled on, and John still escaped suspicion. At last he brought in a dozen horns at once, and insisted on receiving three dollars for them; "For," said he, "they are much larger than any I ever before 'hooked,' and are worth treble what I ask for them." The comb-maker looked at them, and exclaimed, in astonishment, "Why, these are the largest kind of Spanish horns. Where did you get them?"

"At the storehouse on the wharf, of course," replied John.

The comb-maker had some misgivings. "I'll pay you two dollars on account," he continued, "and in the morning I'll go down to the storehouse and examine the lot."

John received his two dollars, but it was the last money he ever earned in that way. The next morning the comb-maker discovered that there were no such horns in the warehouse, and he also learned the uncomfortable fact that John Haight had received over a hundred dollars for stealing horns from the comb-maker's own

pile in the back shop, and bringing them into the front door for sale!

The following Fourth of July was celebrated in Norwalk by horse-racing. I was present. The owner of one high-mettled steed desired to enter him for the purse, but no person of sufficiently light weight could be found who dared to ride him. He had thrown many a good rider, and the equestrians in those parts were shy about mounting him. John heard of the owner's dilemma, and as he never feared anything, he volunteered to ride, provided in case of winning he should have a portion of the stakes. The owner readily assented to this proposition, and John was soon astride the fractious animal. Preliminaries were settled, the judges took their stand, the horses were brought into line, and all started at the word "go." Before they had reached half a mile, every horse was at the top of his speed, under the incessant application of whip and spur; when, quick as thought, John's horse, frightened by some object at the road-side, came to a dead stand-still, and threw the rider headlong over a stone wall about seven feet high!

Hundreds of persons ran to the spot, and poor John was taken up for dead. A large contusion was found on his forehead from which the blood was running profusely, and several other frightful wounds marked his face and portions of his body. His father and other physicians were soon upon the ground. John was bled and restoratives applied, but in vain. He remained insensible, and was carried home on a litter. The sports of the day ceased, and the village was overspread with gloom. John was not what might be termed absolutely vicious, and his eccentricities furnished such a fund of amusement to the villagers that they felt "they could better spare a better person."

"Will he die, do you think?" was the oft-repeated question addressed to such persons as were seen to emerge from the house where John lay in a stupor.

"There seems no hope of his recovery," was the usual response.

John lay all night without manifesting any signs of life, except an almost imperceptible breathing, and occasionally a mournful and subdued groan.

In the morning he was still unconscious, and the monotony of his darkened chamber was only occasionally broken by some inarticulate mutterings which betrayed the absence of his reason.

A medical consultation was held, and inquirers were told that under the effects of remedies which had been applied, a crisis would

probably occur about noon, which would determine whether there was any chance for his recovery. The slow-moving minutes seemed hours as his anxious parents and relatives watched at the silent bedside, and occasionally glanced at the clock. Eleven; half-past eleven; twelve o'clock arrived – and yet no sign of returning consciousness appeared. Ten, fifteen minutes more elapsed, and yet no sign.

"Will he leave us without one word or look of recognition?" inquired his agonized mother.

"We hope and believe," responded one of the physicians in a whisper, "that even should his case prove fatal, he will return to consciousness in a few minutes, and be in full possession of his senses."

Ten minutes more passed, and John turned his face slowly towards his anxious watchers. His eyes gradually opened, his lips began to move – all was breathless silence, every ear was on the *qui vive* to catch the first audible sound.

"Curse that thundering horse – I believe he bolted!" drawled the now conscious John.

A suppressed laugh was heard among the bystanders; the faces of his anxious parents were lit up with smiles, and the physicians declared that with quiet and good nursing he would probably recover.

In a week afterwards John was seen about the streets with his head bandaged, and he himself as ready as ever to embark in the first reckless enterprise that might turn up.

When John attained the age of sixteen years he had become so headstrong that his parents found him quite unmanageable. His father therefore determined upon sending him to sea. John, nothing loth, accompanied him to New York, and an arrangement was soon made for him to go before the mast on board a stout brig bound for Rio Janeiro. He was somewhat fractious during the first few days at sea, but under the discipline of a resolute mate he soon was mellowed down, and behaved well. He returned to New York with the vessel, and of his own choice shipped for another voyage.

On his second arrival at Rio, his clothing was stolen by some of the sailors. He was vexed, quitted the brig, and secreted himself, being determined not to return in her. The captain vainly sought for him, and was obliged to return to New York without him. The day the brig's arrival in New York was announced, John's father (who had removed to that city) went down to the wharf to see his

son. His surprise and grief were great upon being told that John had left the ship, and remained in South America. His family were filled with sorrow, and the captain was urged to try, on the next trip, to induce him to return. Unfortunately the captain was obliged to make a trip to Liverpool and back, and another to New Orleans, before again visiting the Brazils.

At last, however, he was again ready to set sail. Dr. Haight placed a hundred dollars in his hands, and begged him to find his son, use the money for his benefit, and bring him back to his anxious parents. The captain promised to do all in his power.

When the brig arrived at Rio, the captain went on shore, and almost the first man he met was John Haight, with an epaulette upon each shoulder, and in the full dress of an officer in the Brazilian navy.

"Why, Haight, is it possible this is you?" exclaimed the astonished captain.

"Well, I guess it is a chap of about my size," returned John with some dignity.

"I am glad to see you, but astonished to behold you in that dress," responded the captain.

"I expect to astonish some other folks before I die," replied the young officer.

"But I want you to return with me without fail," rejoined the captain. "Your family are in great distress about you, and your father has sent a hundred dollars by me to relieve your wants."

"I ha'n't got any wants," replied John, "so you may take the money back to father with my compliments; and please say to him that I was robbed of all my clothes in this country, and I will never return home until I lose more, or get the worth of them back."

John never returned, and I believe was never heard of more. Probably death soon afterwards terminated the career of one, who, had he been carefully trained, might have shone brightly in a high sphere of society, and been an ornament to his family as well as a blessing to his race.

My organ of acquisitiveness must be large, or else my parents commenced its cultivation at an early period. Before I was five years of age I began to accumulate pennies and sixpennies. At the age of six years my grandfather informed me that all my little pieces of coin amounted to one dollar, and if I would go with him and take my money, he would show me something worth having. Placing all

my wealth in a pocket handkerchief which was closely wound up and firmly grasped, I started with my grandfather. He took me to the village tavern, then kept by Mr. Stiles Wakelee, and approaching the landlord, he said, "Here, Mr. Wakelee, is the richest boy in this part of the country. He has a dollar in cash. I wish you to take his change and give him a silver dollar for it."

The complaisant landlord took my deposits and presently handed me a silver dollar.

Never have I seen the time (nor shall I ever again) when I felt so rich, so absolutely independent of all the world, as I did when I looked at that monstrous big silver dollar, and felt that it was all my own. Talk of "cart wheels," there was never one half so large as that dollar looked to me. I believed, without the slightest reservation, that this entire earth and all its contents could be purchased by that wonderful piece of bullion, and that it would be a bad bargain at that.

But my dollar did not long remain alone. My mother taught me that I should still save my pennies, and I did so. As I grew larger, my grandfather paid me ten cents per day for riding the horse which preceded the ox-team in ploughing, and I hit upon various expedients for adding to my pile. On "training days," instead of spending money, I was earning it in the vocation of a peddler. My stock in trade consisted of a gallon of molasses, boiled down and worked into molasses candy, called in those times "cookania," and I usually found myself a dollar richer at the end of "training," than I was at the commencement. As I always had a remarkable taste for speculation, my holiday stock soon increased, and comprised "ginger-bread," cookies, sugar candies, and cherry rum. The latter article consisted of a demijohn of New England rum, in which was put a quantity of wild cherries, and I believe a little sugar. I soon learned that the soldiers were good cherry-rum customers, and no sooner did I hear the words "halt," "ground arms," than I approached the "trainers" with my decanter and wine-glass. In a few years I should have been a second Crœsus in wealth, had not my father considerately allowed me to purchase my own clothing. This arrangement kept my pile reduced to a moderate size. Always looking out for the main chance, however, I had sheep of my own, a calf of which I was the sole proprietor, and other individual property which made me feel, at twelve years of age, that I was quite a man of substance.

I felt at the same time that I had not reached my proper sphere.

The farm was no place for me. I always disliked work. Headwork I was excessively fond of. I was always ready to concoct fun, or lay plans for money-making, but hand-work was decidedly not in my line. My father insisted that I could hoe and plough and dig in the garden as well as anybody else, but I generally contrived to shirk the work altogether, or by slighting it, get through with the day's work.

I was not quite twelve years of age when I visited the commercial metropolis for the first time. It happened as follows: My father, as before stated, kept the village tavern. Late one afternoon in January, 1822, Mr. Daniel Brown, of Southbury, Ct., arrived at our house with a drove of fat cattle which he was taking to New York for sale. The stock were put into our large barnyard, the horses ridden by himself and assistant were stabled, and Mr. Brown having partaken of a warm supper, drew off his boots, put on his slippers, and sat down by the fire to spend the evening comfortably.

I looked upon him as a great man, for he had been to "York," and to "go to York" in those days was thought quite as much of as to go to Europe is now. I listened to the relation of his adventures in city and country, my interest in the man continually increasing. At last I heard him say to my father, that he expected to buy many more cattle in Ridgefield, and at other points on his way to the city, and he would be glad to hire a boy who was light of foot, to run along with him and assist in driving the cattle. I immediately besought my father (like a modern office-seeker) to intercede for me, and if possible procure me the coveted situation. He did so. Consultation with my mother resulted in her consent, and it was immediately arranged that I should visit New York. I was told to retire at once, so as to be ready to start with the drove of cattle at daylight in the morning. I went to bed, but not to sleep. Visions of all sorts haunted my imagination. A new world was about to be opened to me. I slept an hour or two towards morning, dreaming of the great city with streets paved with gold, and many castles – in the air.

At daylight I was aroused, took a few mouthfuls of breakfast, and started off on foot in the midst of a heavy snow-storm, to help drive the cattle. Before reaching Ridgefield, Mr. Brown put me on his horse to gallop after a wandering ox; the horse fell, rolled upon my foot, and sprained my ankle. I suffered intensely, but dared not complain lest my employer should contrive some way to send me

back, for I was not yet ten miles from home. He very considerately allowed me to ride behind him on the horse, and that night the landlady of the hotel where we stopped bathed my ankle, which was considerably swollen. The next day it was a trifle better, but as I continued to limp, Mr. Brown permitted me to ride most of the time.

In three or four days we reached the city of New York, and put up at the Bull's Head tavern, kept, I think, by Mr. Givens. The drover would be busy a week selling his cattle, and then I was to return home with him in a sleigh.

That was a great week for me. My mother gave me a dollar before I left home, and I never expected to see the end of it. I supposed it would supply my every wish, and yet leave unknown quantities of small change on hand. The first outlay I made was for oranges. I was very fond of this fruit, and had often wished I could have as many as I could eat. I entered a confectionery store and inquired the price of oranges. "Four pence apiece," was the reply.

Now, "four pence" in Connecticut is six cents, and I supposed it was the same the world over. Profiting by my experience in "beating down" the price, and not doubting Franklin's proverb that "a penny saved is two pence earned," I informed the lady that "I considered four pence apiece too dear, but I would give her ten cents for two."

The feminine shopkeeper hesitated for a moment, but finally said that seeing it was me, and as it was probably my first visit to New York, she would let me have the two oranges for ten cents, but she should expect me to trade with her whenever I wanted any thing in her line. I thanked her, and took the oranges. I thought it was very liberal in her to make such a generous deduction from the price of her fruit, little dreaming that, owing to the difference in currency, I had paid her two cents more than she asked.

Soon dispatching my two oranges, I purchased two more, and had eighty cents left. This seemed to me sufficient for all mortal wants. I then bought for thirty-one cents a little gun, which would "go off" and send a stick some distance across the room. I intended to astonish my schoolmates with the gun when I got home, for it astonished me considerably, as I had never seen any thing of the kind before. I went into the bar-room of our hotel, and began to amuse myself with the extraordinary implement. The bar-room was crowded with customers, and shooting at random, the arrow grazed one man's nose and passed on, hitting the barkeeper in the eye.

Smarting under the pain it occasioned, the latter came in front of his counter, caught me by the collar, shook me sternly, boxed my ears till my head rung, and told me to put that gun out of the way or he would throw it into the stove. I felt considerably injured in my feelings, and sneaking slyly up stairs placed the precious treasure under my pillow.

Visiting the toy shop again, the good woman instructed me in the mystery of torpedoes. She threw one with considerable force on the floor, and it exploded, greatly to my delight. Would not these astonish our school-boys? I bought six cents' worth for that purpose, but could not wait to use them at home. As the guests at the hotel were passing in to dinner, and supposing that they had never seen any thing in the torpedo line and would be delighted to do so, I could not refrain from giving them the opportunity. So taking two from my pocket and throwing them with all my strength against the side of the hall through which the crowd was passing, a loud double-report followed, much to the surprise and annoyance of the guests. The landlord came rushing out in a high state of excitement, and discovering the culprit he stretched me upon the floor at a single blow with his open hand.

"There, you little greenhorn," he exclaimed, "see if that will teach you better than to explode your infernal crackers in my house again!"

It did. I was perfectly taught in a single lesson; went up stairs and deposited the balance of the torpedoes with my gun. I ate no dinner that day. My dignity had been insulted and my appetite had vanished. I was humbled. I felt forlorn and forsaken. I however had one resource. It was the toy shop. I visited it again, bought a watch, a breast-pin, and a top. I was still a rich man. I had eleven cents left. I went to bed and dreamed of all my possessions.

The next morning, immediately after breakfast, I visited the toy shop again to "look around," and perceived many things which I had not noticed the day previously. Presently I saw a beautiful knife with two blades, besides a gimlet and cork-screw! This was a novelty. The most useful article in existence, beyond all doubt. I must possess it. My father would be delighted, for it was a carpenter shop in miniature, and was too valuable an article to leave behind me. Wouldn't old Bethel be astonished! But what was the price of this combination of all that was useful and ornamental? Only thirty-one cents. Alas, I had only eleven! I learned to my astonishment that my funds were exhausted. But have the knife I must, and so

I proposed to my kind friend, the shop woman, that she should receive back the top and breast-pin at a slight deduction from what I had paid for them, and then taking my eleven cents, should let me have the knife. The kind creature consented, and thus I made my first "swop." Presently I discovered some molasses candy. It was whiter and nicer than any I had ever seen before. I must have some. So I asked the lady to take back the watch at a slight discount, and give me the worth of it in molasses candy. She did so. It was delicious. I had never tasted any thing so nice – and before night I had resigned my gun into her possession and swallowed its value in molasses candy. The next morning I swallowed all my torpedoes in the same shape, and in the course of the day even my knife followed in the sweet footsteps of its illustrious predecessors. Molasses candy was the rock on which I split. My money was all gone – my notions all swopped for it – and yet, like Oliver Twist, I cried for "more."

The good woman had a son of about my size. I had no particular use for my two pocket handkerchiefs. Her boy could use them, and I gladly accepted her proposal to trade them for four sticks of molasses candy. I had an extra pair of stockings which I was sure I should never need, and they went for five more rolls of molasses candy!

When thus divested of all I possessed, I became resigned to my fate, and, turning my attention to some other source of excitement, I made the acquaintance of a young gentleman from Connecticut. He was about twenty years of age, had been in New York once before, "knew the ropes," and proposed to show me the city. I gladly accompanied him, and saw many sights that day which astonished me beyond measure. He took me to "Bear Market," as it was then called – "Washington Market," as it is now designated. I was greatly surprised at the immense quantities of meat there displayed.

"What under heaven do they expect to do with all this meat?" I asked my companion with much curiosity.

"They expect to sell it, of course," he said.

"They'll get sucked in then," I replied exultingly, for I felt assured that it would never be possible to consume all that beef before doomsday. It was probably all masticated within the next twenty-four hours, but to a raw boy from the country such a thing would seem incredible. It was equally incredible to "Uncle Sam Taylor," several years afterwards. Rising early one morning, the old gentleman roused his companions, saying, "Let us look in upon

Fulton Market. I rather guess there will be a grand show of beef. I have already seen three cart loads go by!"

I think I shall never forget an inscription which I saw painted on a small square piece of board and fastened to a post on the dock at the rear of the market. It was a corporation warning, and read as here presented.

FIVE DOLLARS FINE FOR
THROWING any kind of DAMD
aged meat or fish into
the Public Docks.

I was astonished at the profanity of the public authorities, and wondered why they could not have said simply, "aged meat or fish," without prefixing the offensive adjective. I called the attention of my friend to the deplorable state of public morals as exhibited on their public "sign," when he explained that some wicked wag, not having the fear of the city aldermen before his eyes, had interpolated the little "D," and thus made the word "damaged" express its own true meaning, though in an unnecessarily strong and objectionable manner.

My friend also took me out of town to see the State Prison, paid my way in, and witnessed my astonishment at seeing so many wicked convicts dressed in the striped prison suit, and especially to see about two hundred shoe-makers turn their faces to the door when we entered, with as much precision as if they had been automatons all moved by a single wire. I also saw a large windmill the same day, which was the first time I had ever seen the like.

My week was soon up. Mr. Brown took me into his one-horse sleigh immediately after dinner, drove as far as Sawpitts, now called Port Chester, stopped over night, started early the next morning, and arrived at Bethel the same evening.

I had a thousand questions to answer, and found my brothers and sisters much disappointed that I had brought them none of the fruits of my dollar. My mother examined my wardrobe, and finding it two pocket-handkerchiefs and one pair of stockings short, I was whipped and sent to bed. Thus terminated my first visit to New York.

I was however for a long time quite a lion among the school-boys, for I had "been to York," and seen with my own eyes many wonders "which they had only heard tell of."

CHAPTER II

Clerk in a Store – Anecdotes

My aversion to hand-work, on the farm or otherwise, continued to be manifested in various ways, all of which was generally set down to the score of laziness. I believe, indeed, I had the reputation of being the laziest boy in town, probably because I was always busy at head-work to evade the sentence of gaining bread by the sweat of the brow. In sheer despair of making any thing better of me, my father concluded to try me as a merchant. He had previously erected a suitable building in Bethel, and taking Mr. Hiram Weed as a partner, they purchased a stock of dry goods, groceries, hardware, and a thousand other "notions;" and I was duly installed as clerk in a country store.

Like many greenhorns before me, this was the height of my ambition. I felt that it was a great condescension on my part to enter into conversation with the common boys who had to work for a living. I strutted behind the counter with a pen back of my ear, was wonderfully polite to ladies, assumed a wise look when entering

charges upon the day-book, was astonishingly active in waiting upon customers, whether in weighing tenpenny nails, starch, indigo, or saleratus, or drawing New England rum or West India molasses.

Ours was a cash, credit and barter store; and I drove many a sharp trade with old women who paid for their purchases in butter, eggs, beeswax, feathers, and rags, and with men who exchanged for our commodities, hats, axe-helves, oats, corn, buck-wheat, hickory-nuts, and other commodities. It was something of a drawback upon my dignity that I was compelled to sweep the store, take down the window-shutters, and make the fire; nevertheless the thought of being a "merchant" fully compensated me for all such menial duties.

My propensities for money-making continued active as ever, and I asked and obtained the privilege of purchasing candies on my own account, to sell to the juvenile portion of our customers. I received a small salary for my services, (my father as usual stipulating that I should clothe myself,) and I intended to be faithful to my employers; but I have found, all through life, that wherever there are conflicting interests, men are very apt to think of self first, and so I fear it was with me, – for I well remember spending much time in urging indulgent mothers to buy candies for their darling children, when other customers were waiting to be served with more substantial articles of merchandise.

A country store in the evening, or upon a wet day, is a miserably dull place, so far as trade is concerned. Upon such occasions therefore I had little to do, and I will explain why the time did not hang unpleasantly upon my hands.

In nearly every New England village, at the time of which I write, there could be found from six to twenty social, jolly, story-telling, joke-playing wags and wits, regular originals, who would get together at the tavern or store, and spend their evenings and stormy afternoons in relating anecdotes, describing their various adventures, playing off practical jokes upon each other, and engaging in every project out of which a little fun could be extracted by village wits whose ideas were usually sharpened at brief intervals by a "treat," otherwise known as a glass of Santa Cruz rum, old Holland gin, or Jamaica spirits.

Bethel was not an exception to this state of things. In fact no place of its size could boast more original geniuses in the way of joking and story-telling than my native village. As before stated, my grandfather, Phineas Taylor, was one of the sort. His near

neighbor, Benjamin Hoyt, or "Esquire Hoyt," as he was called, on account of being a justice of the peace, was one of the most inveterate story-tellers I ever knew. He could relate an anecdote with better effect than any man I have ever seen. He would generally profess to know all the parties in the story which he related, and however comic it might be, he would preserve the most rigid seriousness of countenance until its *dénouement*, when he would break forth into a hearty haw! haw! which of itself would throw his hearers into convulsions of laughter.

Luckily or unluckily, our store was the resort of all these wits, and many is the day and evening that I have hung with delight upon their stories, and many the night that I have kept the store open until eleven o'clock, in order to listen to the last anecdotes of the two jokers who had remained long after their companions had gone to rest.

Inheriting a vital love of fun and an aptness for practical jokes, all that was said and done by these village wags was not only watched with the most intense pleasure by myself, but was also noted upon the tablets of a most retentive memory, whence I can now extract them without losing scarcely a word. Some of these specimens I will present to the reader hereafter. I will however here advert to a circumstance which will show how the whole neighborhood, as it were, would join in practising and perpetuating a joke.

It will be remembered that my grandfather, a few days after my birth, in consideration of my taking his name, presented me with a tract of land called "Ivy Island." I was not four years of age before my grandfather informed me, with much seriousness, that I was a landowner; that he had given me a valuable farm on account of my name, etc.; and I am certain that not a week elapsed, from that period till I was twelve years of age, that I did not hear of this precious patrimony. My grandfather never spoke of me in my presence, either to a neighbor or stranger, without saying that I was the richest child in town, because I owned all "Ivy Island," the most valuable farm in Connecticut. My mother often reminded me of my immense possessions, and my father occasionally asked me if I would not support the family when I came in possession of my property. I frequently assured my father, in the most perfect good faith, that he need give himself no uneasiness upon that score, for I would see that all the family wants were bountifully supplied when I attained my majority and received my estate. Our neighbors, too, reminded me a dozen times a day, that they feared I would refuse to play

with their children, because I had inherited such immense wealth, while they had nothing of the sort.

These continual allusions to "Ivy Island," for six or eight years, I fear excited my pride, and I know that the prospect made me wish that the slow-moving wheels of time would attain a rapidity which would hurry up that twenty-first birth-day, and thus enable me to become the nabob, which my grandfather's generous foresight had cut me out for. How often, too, did I promise my playmates, when they rendered me a kind action, that when I became of age they should have a slice of "Ivy Island" that would make them rich for life! I sincerely intended to fulfil these promises to the letter. But, alas for the mutability of human affairs! an issue was at hand which I little expected, and one which was destined to effect a serious change in my hopes and aspirations.

One summer (I think it was 1822, at which period I was twelve years old) I asked my father's permission to visit "Ivy Island." He promised I should do so in a few days, as we should be getting hay in that vicinity. I scarcely slept for three nights, so great was my joy to think that, like Moses of old, I should be permitted to look upon the promised land. The visions of wealth which had so long haunted me in relation to that valuable locality now became intensified, and I not only felt that it must be a land flowing with milk and honey, but caverns of emeralds, diamonds, and other precious stones, as well as mines of silver and gold, opened vividly to my mind's eye.

The wished-for morning at length arrived, and my father informed me that we were to mow in the meadow adjoining "Ivy Island," and that I might visit it with our hired man during "nooning." My grandfather kindly reminded me that when I came to look upon the precious spot, I was to remember that I was indebted to his bounty, and that if I had not been named "Phineas" I never could have been the proprietor of "Ivy Island." My mother, too, had to put in a word.

"Now, Taylor," said she, "don't become so excited when you see your property as to let your joy make you sick, for remember, rich as you are, that it will be nine years before you can come into possession of your fortune." I promised to be calm and reasonable.

"If you visit Ivy Island," she continued, "you will lose your rest at noon, and you will feel tired, after turning hay all the forenoon. Had you not better lie under the trees and rest at 'nooning,' and visit Ivy Island at some other time?"

"No, my dear mother," I replied, "I don't care for nooning, I shall not feel tired, and I am so anxious to step upon my property, that I cannot wait any longer."

"Well, go," said my mother; "but don't feel above speaking to your brothers and sisters when you return."

I felt that this injunction was not altogether superfluous, for I already began to feel that it was rather degrading for me to labor as hard as those who had no estate settled upon them.

We went to work in our meadow. It was situated in that part of "Plum-Trees" known as "East Swamp." When we arrived at the meadow I asked my father where "Ivy Island" was.

"Yonder, at the north end of this meadow, where you see those beautiful trees rising in the distance," he replied.

I looked towards the place indicated, and my bosom swelled with inexpressible pride and delight, as I beheld for the first time the munificent gift of my honored and generous grandsire.

The forenoon soon slipped away; I turned the grass as fast as two men could cut it, and after making a hasty repast with my father and the workmen under the shade trees, our favorite "hired man," a good-natured Irishman named Edmund, taking an axe upon his shoulders, told me he was ready to go with me to visit "Ivy Island."

I started upon my feet with delight, but could not restrain asking him why he took an axe. He replied that perhaps I would like to have him cut into some of the beautiful specimens of timber upon my property, in order that I could see how superior it was in quality to that found in any other part of the world. His answer was perfectly satisfactory, and we started. As we approached the north end of the meadow the ground became swampy and wet, and we found great difficulty in proceeding. We were obliged to leap from bog to bog, and frequently making a mis-step, I found myself up to my middle in water. At one time I stood upon a bog, and the next was so far off that I greatly feared I could not reach it. My companion, who was several rods in advance of me, saw my dilemma, and called out for me to leap stoutly and I should succeed.

"I am sure I cannot," I replied; "and if I could, I shall be worse off when I reach the next bog than I am now, for there is no place near it that is above water."

"You are a little off from the regular track," responded my Hibernian friend; "but never mind, you will have to wade a little."

"The water will be over my head, and I shall be drowned," I replied, in a most despairing tone.

"Divil a danger at all at all, for the water is not four feet deep in the deepest place," was the reply.

"If I go under, you must help me out," I replied tremblingly.

"To be sure I will; so never fear, but give a strong jump, and you are all safe," was the encouraging response.

I summoned all my strength, clenched both my hands, sprang with all my force, and just saved myself by striking upon the edge of the next bog. I straightened myself up, got upon the middle of the bog, and began to prepare for wading in the water, which I greatly feared would be too deep for me to ford, when I saw countless hornets rising from the spot on which I stood. Instantly they came buzzing about my face and ears. One vicious rascal stung me on the tip of my nose, and, shrieking with the smart, I leaped into the water regardless of consequences. I soon found myself up to my neck, and fearful that the next step would carry me under water altogether, I roared lustily for help.

The trusty Irishman, feeling that there was no real cause for alarm, broke into a peal of laughter, and bade me be of good cheer, "For," said he, "you'll not have to wade more than a quarter of a mile in that way before you reach the verge of your valuable property."

"If I go under, you must help me in a moment, for I can't swim," I replied despondingly.

"Niver fear me; if I see ye in danger I'll have ye out in a twinkling."

With this assurance I made an advance step and found my head still in the air. Half a dozen hornets now attacked me, and I involuntarily ducked my head under the water. When I popped out again my tormenters had disappeared, and I waded on as well as I could towards "Ivy Island." After about fifteen minutes, during which time I floundered through the morass, now stepping on a piece of submerged wood, and anon slipping into a hole, I rolled out upon dry land, covered with mud, out of breath, and looking considerably more like a drowned rat than a human being.

"Thank the Merciful Powers, ye are safe at last," said my Irish companion.

"Oh, what a dreadful time I have had, and how that hornet's sting smarts!" I groaned, in misery.

"Niver mind, my boy; we have only to cross this little creek, and ye'll be upon yer own valuable property," was the encouraging reply.

I looked, and behold we had arrived upon the margin of a stream ten or twelve feet wide, the banks of which were so thickly lined with alders that a person could scarcely squeeze between them.

"Good heavens!" I exclaimed, "is my property surrounded with water?"

"How the divil could it be 'Ivy *Island*' if it was not?" was the quick response.

"Oh! I had never thought about the meaning of the name," I replied; "but how in the world can we get across this brook?"

"Faith, and now you'll see the use of the axe, I am thinking," replied Edmund, as he cut his way through the alders, and proceeded to fell a small oak tree which stood upon the bank of the stream. This tree fell directly across the brook, and thus formed a temporary bridge, over which Edmund kindly assisted me.

I now found myself upon "Ivy Island," and began to look about me with curiosity.

"Why, there seems to be nothing here but stunted ivies and a few straggling trees!" I exclaimed.

"How else could it be 'Ivy *Island*'?" was the quiet answer.

I proceeded a few rods towards the centre of my domain, perfectly chop-fallen. The truth rushed upon me. I had been made a fool of by all our neighborhood for more than half a dozen years. My rich "Ivy Island" was an inaccessible piece of barren land, not worth a farthing, and all my visions of future wealth and greatness vanished into thin air. While I stood pondering upon my sudden downfall, I discovered a monstrous black snake approaching me, with upraised head and piercing black eyes. I gave one halloo and took to my heels. The Irishman helped me across the temporary bridge, and this was my first and *last* visit to "Ivy Island!" We got back to the meadow, and found my father and men mowing away lustily.

"Well, how do you like your property?" asked my father, with the most imperturbable gravity.

"I would sell it pretty cheap," I responded, holding down my head.

A tremendous roar of laughter bursting from all the workmen showed that they were in the secret. On returning home at night, my grandfather called to congratulate me, with as serious a countenance as if "Ivy Island" was indeed a valuable domain, instead of a barren waste, over which he and the whole neighborhood had

chuckled ever since I was born. My mother, too, with a grave physiognomy, hoped I had found it as rich as I anticipated. Several of our neighbors called to ask if I was not glad now, that I was named Phineas; and from that time during the next five years I was continually reminded of the valuable property known as "Ivy Island."

I can the more heartily laugh at this practical joke, because that inheritance was long afterwards of service to me. "Ivy Island" was a part of the weight that made the wheel of fortune begin to turn in my favor at a time when my head was downward.

"What is the price of razor strops?" inquired my grandfather of a peddler, whose wagon, loaded with Yankee notions, stood in front of our store.

"A dollar each for Pomeroy's strops," responded the itinerant merchant.

"A dollar apiece!" exclaimed my grandfather; "they'll be sold for half the money before the year is out."

"If one of Pomeroy's strops is sold for fifty cents within a year, I'll make you a present of one," replied the peddler.

"I'll purchase one on those conditions. Now, Ben, I call you to witness the contract," said my grandfather, addressing himself to Esquire Hoyt.

"All right," responded Ben.

"Yes," said the peddler, "I'll do as I say, and there's no back-out to me."

My grandfather took the strop, and put it in his side coat pocket. Presently drawing it out, and turning to Esquire Hoyt, he said, "Ben, I don't much like this strop now I have bought it. How much will you give for it?"

"Well, I guess, seeing it's you, I'll give fifty cents," drawled the 'Squire, with a wicked twinkle in his eye, which said that the strop and the peddler were both incontinently sold.

"You can take it. I guess I'll get along with my old one a spell longer," said my grandfather, giving the peddler a knowing look.

The strop changed hands, and the peddler exclaimed, "I acknowledge, gentlemen; what's to pay?"

"Treat the company, and confess you are taken in, or else give me a strop," replied my grandfather.

"I never will confess nor treat," said the peddler, "but I'll give you a strop for your wit;" and suiting the action to the word, he

handed a second strop to his customer. A hearty laugh ensued, in which the peddler joined.

"Some pretty sharp fellows here in Bethel," said a bystander, addressing the peddler.

"Tolerable, but nothing to brag of," replied the peddler; "I have made seventy-five cents by the operation."

"How is that?" was the inquiry.

"I have received a dollar for two strops which cost me only twelve and a half cents each," replied the peddler; "but having heard of the cute tricks of the Bethel chaps, I thought I would look out for them and fix my prices accordingly. I generally sell these strops at twenty-five cents each, but, gentlemen, if you want any more at fifty cents apiece, I shall be happy to supply your whole village."

Our neighbors laughed out of the other side of their mouths, but no more strops were purchased

There was a poor sot in Bethel, who had a family consisting of a wife and four children. Before he took to drink he was an industrious, thriving, intelligent, and respectable man – by trade a cooper; but for ten years he had been running down hill, and at last became a miserable toper. Once in a while he would "keg," as he called it; that is, he would abjure strong drink for a certain length of time – usually for a month. During these intervals he was industrious and sober. He visited the stores; the neighbors gladly conversed with him, and encouraged him to continue in well doing. The poor fellow would weep as he listened to friendly admonitions, and would sometimes reply:

"You are right, my friends; I know you are right, for now my brain is cool and clear, and I can see as well as *you* can that there is no happiness without sobriety. I am like the prodigal son, who, '*when he came to himself*,' saw that there was no hope for him unless he arose and returned to his father and to the walks of duty and reason. *I have come to myself.*"

"Yes," would be the reply; "but will you remain so?"

Drawing himself up, with a look of pride which always distinguished him before his fall, he would say, "Do you suppose that I would bemean myself and family by becoming a confirmed sot?"

His wife was respected and his children beloved by all the neighbors; they continued to interchange visits with our most worthy families; and, notwithstanding his long career of dissipation, his

neighbors did not cease to hope that, by appealing to his pride and self-respect, they could be able, during some of his sober intervals, to induce a promise of total and eternal abstinence from the cup. His sense of honor was so elevated, that they felt sure he would break the fatal spell for ever, if he would but once pledge his word to do so.

"No, surely you would not become a sot; your self-respect and love for your family would not permit it; and therefore I suppose you will never drink liquor again," remarked an anxious neighbor.

"Not till my '*keg*' is up, which is three weeks from yesterday," was the reply.

"Oh, give us your word now," chimed in several friends, "that you will not drink when your 'keg,' is up, but that you will abstain for ever. Only pledge your word, and we know you'll keep it."

"To be sure I would, so long as the world should stand. My word is sacred, and therefore I am cautious about pledging it. When once given, all the fiends of Pandemonium could not tempt or force me to break it. But I shall not pledge myself. I only say you are right, gentlemen; drinking liquor is a bad business, and when my 'keg' is up – I'll think about it. I break off once in a few months, merely to prove to myself and to you that I am not a drunkard and never shall be, for you see I can control myself."

With this delusive sophism the poor fellow would content himself, but he almost unconsciously looked forward with hope and joy for the time to arrive which had been fixed upon, for his pent-up appetite grew the stronger as the day approached, and therefore as soon as the moment arrived he would seize the bottle, and be drunk as speedily as possible. Then would be renewed his career of misery, and then again would his trembling wife and children feel overwhelmed by the dark picture opening before them.

At the termination of one of these "kegs," he got drunk as usual, and beat his wife as he had often done before. On awaking the next morning, he desired her to send a child to the store for rum. She replied that they had all gone to school. He then requested her to go and replenish the bottle. She made an excuse which put him off for an hour or two, when he arose from the bed and essayed to eat his breakfast. But his parched tongue and burning throat, the results of last night's debauch, destroyed all appetite except for rum, and although perfectly sober, this raging fire almost maddened him; and turning to his wife, he said:

"Mrs.—, I am sick; you must go and get me some liquor."

"I cannot do it," was the sad but firm reply.

"Cannot! Am I to be disobeyed by my lawful wedded wife? Have I sunk so low that my wishes may be thwarted and my directions disobeyed by the partner of my life?" replied he with all his native pride and dignity.

"I never refused to do any thing which would promote your happiness, but I cannot help you procure that which will make you unhappy and your family wretched," replied the desponding wife.

"We will soon see who is master here," replied the husband, "and you will find that I shall show my power in a manner that you will feel, for I will stop your credit at the store."

With this threat he buttoned up his coat, ran his fingers through his hair, and placing his bottle in his pocket, strode off to the village, with the dignity of a Brutus.

Arriving at our store, he marched up to the proprietor with the air of a wealthy patron, and exclaimed:

"Mr. Weed, my wife has disobeyed me this morning, and I forbid you to trust her on my account."

Mr. Weed, seeing by the rolling eye and pallid face of his customer, that the "keg" was broken, replied with considerable sharpness:

"Oh, Mr.—, you need not have taken the trouble to forbid me trusting your wife, for *I would not trust you!*"

This repulse, so sudden and unexpected, at once overwhelmed and saved him. He was astonished to find himself brought so low, and indignantly drawing the empty bottle from his pocket and dashing it into a thousand pieces upon the floor, he exclaimed:

"There! thou cursed *leveller* of humanity, and destroyer of man's respect! I pledge myself before God, I will never again taste a drop of any thing that can intoxicate;" and he kept his word. He is now a wealthy man, has frequently represented his town in the State Legislature, and his family, including several grand-children, is one of the first in the country in point of respectability and moral worth.

There is something to be learned even in a country store. We are apt to believe that sharp trades, especially dishonest tricks and unprincipled deceptions, are confined entirely to the city, and that the unsophisticated men and women of the country do every thing "on the square." I believe this to be measurably true, but know that there are many exceptions to this rule. Many is the time I cut open bundles of rags, brought to the store by country women in exchange

for goods, and declared to be all linen and cotton, that contained quantities of worthless woollen trash in the interior, and sometimes stones, gravel, ashes, etc. And sometimes, too, have I (contrary to our usual practice) measured the load of oats, corn or rye which our farmer-customer assured us contained a specified number of bushels, perhaps sixty, and found it four or five bushels short. Of course the astonished woman would impute the rag-swindle to a servant or neighbor who had made it up without her knowledge, and the man would charge carelessness upon his "help" who measured the grain, and by mistake "made a wrong count." These were exceptions to the general rule of honesty, but they occurred with sufficient frequency to make us watchful of our customers, and to teach me the truth of the adage, "There's cheating in all trades but ours."

While I was clerk in the store in Bethel, my father kept the village tavern. I usually slept with my younger brother Eder, but when our house was filled with travellers we were obliged to sleep "three in a bed," by taking in our honest Irish farmer, Edmund, as sleeping partner. After the store was closed at night, I would frequently join some of our village boys in a party at the house of their parents, and what with story-telling and various kinds of "child's play," a couple of hours would glide away, and at eleven o'clock at night (which was later than my parents permitted) I would slyly creep up stairs, and crawl into bed with the greatest caution lest I should awake my brother, who would be sure to report my late hours to my parents.

My brother contrived all sorts of plans to catch me on my return home, but sleep would overtake him, and thus I eluded his vigilance. Sometimes he would pile trunks and chairs against the door, so that I could hardly open it without upsetting the barricade, and awakening him by the noise. I generally managed, however, to open the door by degrees, and get to bed without disturbing his slumbers.

One night I found the door fastened on the inside by a nail firmly driven over the latch. Determined not to let him outwit me, I descended the stairs, found a short ladder which I ascended, and entered our bedroom window without being discovered. These continual contrivances of my brother made me always suspicious of some trap on my return home, and I generally approached my dormitory with the greatest caution. One night I returned as usual

about eleven o'clock, and opening the door a few inches with great care, I run in my arm in order to discover any obstructions which might lie in wait for me. My hand soon touched a small cord, which I found was attached to the door-latch by one end; where the other end was fastened I could not imagine, and the darkness would not enable me to discover. I drew a knife from my pocket, and cutting the cord very cautiously, opened the door and got into bed without discovery. On awaking the next morning, I found the other end of the cord attached to my brother's *big toe!* This ingenious contrivance he thought would wake him up, and it undoubtedly would have done so but for my timely discovery.

Another night he sat up in the middle of the bed and bolstered himself with pillows, determined to keep awake until I returned. But sleep at last overcame him, and when I arrived and found him in that position, I snugged myself in cosily across the foot of the bed and went to sleep. In the morning he found himself sitting bolt upright in bed, just as he went to sleep the night before. Giving me a kick, he woke me up, and exclaimed:

"You worked it pretty well last night, but I'll catch you yet."

"You are welcome to do it if you can," I replied; "but you will have to get up early in the morning to catch a weasel asleep."

The next night he fastened a spur upon his naked heel and went to sleep, thinking that when I got into bed I should hit the spur, and perhaps rake my shin, the pain of which would cause me to cry out and thus awake him. I retired with my usual caution that night, and discovering no contrivance, I concluded my brother had abandoned the chase, and turning my back to him I was soon wrapped in the arms of Morpheus.

It chanced that night that a number of tin peddlers and other travellers arrived at a late hour, and every bed being engaged, our Irish Edmund was obliged to sleep with us. Perceiving me stowed away on the farther side of the bed, and my brother lying as usual plump in the middle, he quietly laid himself down on the front and went to sleep. At about two o'clock I was awakened by a fearful noise. The full moon was streaming in at the window, making our bedroom as light as day.

"I'll tache ye to go to bed wid a spur on, ye little divil ye," exclaimed Edmund, as he held my brother high in the air, one hand gripping his neck and the other holding the offending leg with the spur on, just over my head.

"What is the matter, Edmund?" I exclaimed in surprise.

"Nothing is the matter, except this brother of yours has run his spur into me groin a matter of three inches," replied the indignant Irishman, who was suffering under the smart of his wound.

"I did not mean it for *you;* I meant it for Taylor," whined out my brother, only half awake.

"Divil a bit do I care who you meant it for, so that I have got it," replied Edmund, at the same time giving my brother several slaps, which made him yell like a young Indian.

Edmund then unbuckled the spur, and arranging us all in bed again, he turned to go to sleep, simply remarking to my brother: "The nixt time ye try to ride me for a horse, ye'll find I'm a kicking one, ye spalpeen!"

CHAPTER III

Sunday School – Old Meeting-House

The Sunday-School – Eccentric Clergyman – A zealous
Brother – Pumping a Witness – Awful Disclosures –
Suspicious Circumstances – The Trial – The Climax
– The Wedding Fee – Doctrinal Discussions – The
Old Meeting-House – The Stove Reform – Power of
Imagination – The Deacon's Appeal – The Bible-Class –
The One Thing Needful – An Explosion.

LIKE most persons in the New England States, I was brought up to
attend church regularly on the Sabbath. Indeed, before I was able
to read, I was one of the first scholars in Sunday-school. We had
but one church or "meeting-house" in Bethel, (Presbyterian,) and
here all attended. A difference in creeds and sects was scarcely
known in our little country village at that time. The old meeting-
house had neither steeple nor bell, but in summer time it was a
comfortable place for the inhabitants to congregate. My good mother
would teach me my lessons in the New Testament and the
Catechism, and my highest aspiration was to get every word so
perfectly as to obtain the reward of merit. This valuable pecuniary
consideration consisted of a ticket which stated that the bearer was
entitled to one mill "reward," so that ten tickets were worth one
cent; and as this reward was not payable in cash, but in Sunday-
school books at ten cents each, it follows that one hundred tickets
would be required to purchase one book, so that a scholar must be
successful every consecutive Sabbath (which was simply impossible)

for the space of two years before he could come in possession of a tangible prize! Infinitesimal as was this recompense, it was sufficient to spur me to intense diligence.

The first clergyman whom I remember preaching in Bethel was the Rev. Samuel Sturges. At the time I was a clerk, the Rev. Mr. Lowe was the preacher. He traded at our store, and although he was fond of his pipe, and most clergymen in those days who visited my father and grandfather loved their "glass," I was impressed with the belief that the clergy, individually and collectively, were considerably more than human. I still entertain sincere respect for that calling, and am certain that many of its members (as all ought to be) are devoted disciples of their blessed Master; yet it is sadly true, that as the "best fruit is most pecked by the birds," so also is the best cause most liable to be embraced by hypocrites; and we all have learned, with pain and sorrow, that the title "Rev." does not necessarily imply a saint, for nothing can prevent our sometimes being deceived by a "wolf in sheep's clothing."

The Rev. Richard Varick Dey, who resided at Greenfield, Ct, was in the habit of coming to Bethel to preach on Sabbath evenings. He was a very eloquent preacher, and an eccentric man. He possessed fine talents – his sermons were rich in pathos and wit, and he was exceedingly popular with the world's people. The more straight-laced, however, were afraid of him. His remarks both in and out of the pulpit would frequently rub hard against some popular dogma, or knock in the head some favorite religious tenet Mr. Dey was therefore frequently in hot water with the church – and was either "suspended," or about to be brought to trial for some alleged breach of ministerial duty, or some suspected heresy. While thus debarred from preaching, he felt that he must do something to support his family. With this view he visited Bethel, Danbury, and other towns, and delivered "Lectures," at the termination of which, contributions for his benefit were taken up. I remember his lecturing in Bethel on "Charity." This discourse overflowed with eloquence and pathos, and terminated in a contribution of more than fifty dollars.

It was said that on one occasion Mr. Dey was about to be tried before an ecclesiastical body at Middletown. There being no railroads in those days, many persons travelled on horseback. Two days before the trial was to take place, Mr. Dey started for Middletown alone, and on horseback. His valise was fastened behind the saddle, and putting on his large great-coat surmounted with half a dozen broad

"capes," as was the fashion of that period, and donning a broad-brimmed hat, he mounted his horse and started for the scene of trial.

On the second day of his journey, and some ten miles before reaching Middletown, he overtook a brother clergyman, also on horseback, who was wending his way to the Consociation.

He was a man perhaps sixty years of age, and his silvered locks stood out like porcupine quills. His iron visage, which seemed never to have worn a smile, his sinister expression, small keen selfish looking eyes, and compressed lips, convinced Mr. Dey that he had no hope of mercy from that man as one of his judges. The reverend gentlemen soon fell into conversation. The sanctimonious clergyman gave his name and residence, and inquired those of Mr. Dey.

"My name is Mr. *Richard*," replied Rev. *Richard* V. Dey, "and my residence is Fairfield." [Greenfield is a parish in the town of Fairfield.]

"Ah," exclaimed the other clergyman; "then you live near Mr. Dey: do you know him?"

"Perfectly well," responded the eccentric Richard.

"Well, what do you think of him?" inquired the anxious brother.

"He is a wide-awake cunning fellow, one whom I should be sorry to offend, for I would not like to fall into his clutches; but if compelled to do so, I could divulge some things which would astonish our Consociation."

"Is it possible? Well, of course your duty to the Church and the Redeemer's cause will prompt you to make a clean breast of it, and divulge every thing you know against the accused," responded the excited clergyman.

"It is hard to destroy a brother's reputation and break up the peace of his family," answered the meek Mr. Richard.

"It is the duty of the elect to expose and punish the reprobates," replied the sturdy Puritan.

"But had I not better first tell our brother his fault, and give him an opportunity to confess and be forgiven?"

"Our brother, as you call him, is undoubtedly a heretic, and the true faith is wounded by his presence amongst us. The Church must be purged from unbelief. We must beware of those who would introduce damnable heresies."

"Are you sure that Mr. Dey is an unbeliever?" inquired the modest Mr. Richard.

"I have heard that he throws doubt upon the Trinity – shrugs his shoulders at some portions of the Saybrook Platform, and has said that even reprobates may sincerely repent, pray for forgiveness, and be saved. Ay, that he even doubts the damnation of unregenerate infants!"

"Horrible!" ejaculated Mr. Richard.

"Yes! Horrible indeed, but I trust that our Consociation will excommunicate him at once and for ever. But what do you know concerning his belief?"

"I know nothing specially against his *belief*," responded Mr. Richard, "but I have witnessed some of his acts which I should be almost sorry to expose."

"A mistaken charity! It is your duty to tell the Consociation all you know regarding the culprit, and I shall insist upon your doing so."

"I certainly desire to do that which is right and just, and as I am but young in the ministry I shall defer to your judgment founded on age and experience. But I would prefer at first to state to you what I know, and then will be guided by your advice in regard to giving my testimony before the Consociation."

"A very proper course. You can state the facts to me, and I will give you my counsel. Now what do you know?"

"I know that on more than one occasion I have caught him in the act of kissing my wife," replied the injured Mr. Richard.

"I am not at all astonished," responded the clergyman; "such conduct coincides exactly with the opinion I had formed of the man. I commiserate you, sir, but I honor your sense of duty in divulging such important facts, even at the expense of exposing serious troubles in your domestic relations. But, sir, justice must have its course. These facts must be testified to before the Consociation. Do you know any thing else against the delinquent?"

"I know something more, but it is of a nature so delicate, and concerns me personally so seriously, that I must decline divulging it."

"Sir, you *cannot* do that. I will not permit it, but will insist on your telling the *whole* truth before our Consociation, though your heart-strings were to break in consequence. I repeat, sir, that I sympathize with you personally, but personal feelings must be swallowed up in the promotion of public good. No sympathy for an individual can be permitted to clash with the interests of the true Church. You had better tell me, sir, all you know."

"Since you say that duty requires it, I will do so. I have caught him, under very suspicious circumstances, in my wife's bedroom," said the unfortunate Mr. Richard.

"Was your wife in bed?" inquired the man with the iron face.

"She was," faintly lisped the almost swooning Mr. Richard.

"Enough, enough," was the response. "Our Consociation will soon dispose of the Rev. Richard V. Dey."

The two clergymen had now arrived at Middletown. The Rev. Mr. Vinegarface rode to the parsonage, while Mr. Dey, alias "Mr. Richard," went to a small and obscure inn.

The Consociation commenced the next day. This ecclesiastical body was soon organized, and after disposing of several minor questions, it was proposed to take up the charges of heresy against the Rev. Mr. Dey. The accused, with a most demure countenance, was conversing with his quondam travelling companion of the day previous, who upon hearing this proposition instantly sprang to his feet, and informed the Reverend Chairman that providentially he had been put in possession of facts which must necessarily result in the immediate expulsion of the culprit from the Church, and save the necessity of examining testimony on the question of heresy. "In fact," continued he, "I am prepared to prove that the Rev. Richard V. Dey has frequently kissed the wife of one of our brethren, and has also been caught in a situation which affords strong evidence of his being guilty of the crime of adultery!"

A thrill of horror and surprise ran through the assembly. Every eye was turned to Mr. Dey, who was seated so closely to the last speaker that he touched him as he resumed his seat. Mr. Dey's countenance was as placid as a May morning, and it required keen vision to detect the lurking smile of satisfaction that peeped from a corner of his eye. A few minutes of dead silence elapsed.

"Produce your witnesses," finally said the Chairman, in an almost sepulchral voice.

"I call on the Rev. Mr. Richard, of Fairfield, to corroborate under oath the charges which I have made," responded the hard-visaged Puritan.

Not a person moved. Mr. Dey looked as unconcerned as if he was an utter stranger to all present, and understood not the language which they were speaking.

"Where is the Rev. Mr. Richard?" inquired the venerable Chairman.

"Here he is," responded the accuser, familiarly tapping Mr. Dey on the shoulder.

The whole audience burst into such a roar of laughter as probably never was heard in a like Consociation before.

The accuser was almost petrified with astonishment at such inconceivable conduct on the part of that sedate religious assembly.

Mr. Dey alone maintained the utmost gravity.

"That, sir, is the Rev. *Richard V. Dey*," replied the Chairman when order was restored.

The look of utter dismay which instantly marked the countenance of the accuser threw the assembly into another convulsion of laughter, during which Mr. Dey's victim withdrew and was not seen again in Middletown. The charges of heresy were then brought forward. After a brief investigation they were dismissed for want of proof, and Mr. Dey returned to Greenfield triumphant.

I have often heard Mr. Dey relate the following anecdote. A young couple called on him one day at his house in Greenfield. They informed him that they were from the southern portion of the State, and desired to be married. They were well dressed, made considerable display of jewelry, and altogether wore an air of respectability. Mr. Dey felt confident that all was right, and calling in several witnesses, he proceeded to unite them in the holy bonds of wedlock.

After the ceremonies were concluded, Mr. Dey invited the happy pair (as was usual in those days) to partake of some cake and wine. They thus spent a social half-hour together, and on rising to depart the bridegroom handed Mr. Dey a twenty-dollar bank note, remarking that this was the smallest bill he had, but if he would be so good as to pay their hotel bill (they had merely dined and fed their horse at the hotel) he could retain the balance of the money for his services. Mr. Dey thanked him for his liberality, and proceeded at once to the hotel with the lady and gentleman and informed the landlord that he would settle their bill. They proceeded on their journey, and the next day it was discovered that the bank note was a counterfeit, and that Mr. Dey had to pay nearly three dollars for the privilege of marrying this loving couple!

The newspapers in various parts of the State subsequently published facts which showed that the affectionate pair got married in every town they passed through – thus paying their expenses and fleecing the clergymen by means of counterfeits.

One of the deacons of Mr. Dey's church asked him if he usually kissed the bride at weddings. "Always," was the reply.

"How do you manage when the happy pair are negroes?" was the deacon's next question. "In all such cases," replied Mr. Dey, "the duty of kissing is appointed to the deacons."

My grandfather was a Universalist, and for various reasons, fancied or real, he was bitterly opposed to the Presbyterians in doctrinal views, though personally some of them were his warmest and most intimate friends. Being much attached to Mr. Dey, he induced that gentleman to deliver a series of Sunday evening sermons in Bethel, and my grandfather was not only on all these occasions one of the most prominent and attentive hearers, but Mr. Dey was always his guest. He would generally stop over Monday and Tuesday with my grandfather, and as several of the most social neighbors were called in, they usually had a jolly time of it. Occasionally "mine host" would attack Mr. Dey good-naturedly on theological points, and would generally come off second best, but he delighted, although vanquished, to repeat the sharp answers with which Mr. Dey met his objections to the "confession of faith."

One day, when a dozen or more of the neighbors were present, and enjoying themselves in passing around the bottle, relating anecdotes, and cracking jokes, my grandfather called out in a loud tone of voice, which at once arrested the attention of all present:

"Friend Dey, I believe you pretend to believe in foreordination?"

"To be sure I do," replied Mr. Dey.

"Well now, suppose I should spit in your face, what would you do?" inquired my grandfather.

"I hope that is not a supposable case," responded Mr. Dey, "for I should probably knock you down."

"That would be very inconsistent," replied my grandfather exultingly; "for if I spat in your face it would be because it was foreordained I should do so; why then would you be so unreasonable as to knock me down?"

"Because it would be foreordained that I should knock you down," replied Mr. Dey with a smile.

The company burst into a laugh, in which my grandfather heartily joined, and he frequently related this incident with much gusto.

I have before said that our old meeting-house, without either steeple or bell, was a comfortable place in summer. But my teeth

chatter even now, as I think of the dreary, cold, and freezing times we had there in winter. Such a thing as a stove in a meeting-house had never been heard of in those days, and an innovation of that description would have been considered little less than sacrilege. The old-fashioned sermons were an hour and a half to two hours long, and there the congregation would sit and shiver, and their faces would look so blue, that it is no wonder "the world's people" sometimes called them "blue skins." They were literally so.

Our mothers and grandmothers were the only persons who were permitted to approach comfort. Such as could afford it had a "muff and tippet," and carried a "foot-stove," which consisted of a small square tin box, perforated, and inclosed in a wood frame, with a wire handle. There was a door in one side, in which was thrust a small square iron dish of live coals, sprinkled over with a few ashes. Those who lived some distance from the meeting-house took their foot-stove in the wagon or "cutter" – for there was generally good sleighing in winter – and, on arriving "to meeting," they would replenish the foot-stove with fresh coals at the nearest neighbor's before entering the sanctuary.

At last, and after many years, the spirit of reform reached the shivering congregation of the old Bethel meeting-house. A brother, who was evidently quite ahead of the age, and not, as some of the older brethren thought, "out of his head," had the temerity to propose that a stove should be introduced into the church for the purpose of heating it. Many brethren and sisters raised their hands and rolled their eyes in surprise and horror. "A pretty pass, indeed, when professing Christians needed a fire to warm their zeal." The proposition was impious, and it was voted down by an overwhelming majority.

The "reformer," however, persevered, and, by persuasion and argument, he gradually gained a few converts. He argued that one large stove for heating the whole house was as harmless as fifty small stoves to warm the fifty pairs of feet belonging to the owners of said portable stoves; and while some saw no analogy between the two cases, others declared that if he was mad there was "method in his madness."

Another year rolled by; cold November arrived, and the stove question was again mooted. Excitement ran high; night meetings and church caucuses were held to discuss the question; arguments were made pro and con in the village stores; the subject was introduced into conference meetings and prayed over; even the youngsters

had the question brought up in the debating club, and early in December a general "society's meeting" was called to decide by ballot whether there should or should not be a stove in the meeting-house.

The ayes carried it by a majority of one, and, to the consternation of the minority, the stove was introduced. On the first Sabbath afterwards two venerable maiden ladies fainted on account of the dry atmosphere and sickly sensation caused by the dreaded innovation. They were carried out into the cold air, and soon returned to consciousness, after being informed that in consequence of there not being pipe enough within two lengths, no fire had yet been placed in the stove!

The following Sunday was a bitter cold day, and the stove was crammed with well-seasoned hickory wood and brought nearly to a red heat. This made most parts of the house comfortable, pleased many, and horrified a few.

Immediately after the benediction had been pronounced, at the close of the afternoon service, one of the deacons, whose "pew" was near the door, arose and exclaimed, in a loud voice, "The congregation are requested to tarry."

Every person promptly sat down on hearing this common announcement. The old deacon approached the altar, and turning to the people, addressed them in a whining tone of voice as follows:

"Brethren and sisters, you will bear me witness that from the first I have raised my voice against introducing a stove into the house of the Lord. But a majority has pronounced against me. I trust they voted in the fear of God, and I submit, for I would not wittingly introduce schisms into our church; but if we must have a stove I do insist on having a larger one, for the one you have is not large enough to heat the whole house, and the consequence is, it drives all the cold back as far as the outside pews, making them three times as cold as they were before, and we who occupy those pews are obliged to sit in the entire cold of this whole house."

The countenance and manner of the speaker indicated, beyond all doubt, that he was sincere, and nothing would appease him until the "business committee" agreed to take the subject into consideration. In the course of the week they satisfied him that the stove was large enough, except on unusually severe days, but they found great difficulty in making him comprehend that if the stove did not heat the entire building, it did not intensify the cold by driving it all into a corner.

* * * * * * * * *

While Rev. Mr. Lowe preached in Bethel he formed quite a large Bible-class, which was composed mostly of boys and girls from twelve to fourteen years of age. I was one of the class. A portion of our duty was to take a verse selected by the minister, write out our explanation of it, and drop the composition into a hat passed round for the purpose. All the articles were then read aloud by the clergyman. As the verses selected and distributed to the scholars were also promiscuously drawn from a hat, no person, not even Mr. Lowe himself, knew what subject fell to any particular scholar.

The Bible-class was held immediately after the conclusion of the afternoon services, and it was customary for the entire congregation to remain and hear the compositions read. Sometimes the explanations given by the scholars were wretched, sometimes ludicrous, but generally very good. I think that my own usually fell under the second head. Mr. Lowe always made a few remarks at the reading of each composition, either by way of approval or dissent, and in the latter case he always gave his reasons.

I remember that on one occasion I drew from the hat, Luke x. 42: "But one thing is needful; and Mary hath chosen that good part which shall not be taken away from her." *Question*. "What is the one thing needful?"

I took home my verse and question, and at the first opportunity wrote out the explanation about as follows:

"This question, 'What is the one thing needful?' is capable of receiving various answers, depending much upon the persons to whom it is addressed.

"The merchant might answer that 'the one thing needful is plenty of customers, who buy liberally without "beating down," and pay cash for all their purchases.'

"The farmer might reply that 'the one thing needful is large harvests and high prices.'

"The physician might answer that 'it is plenty of patients.'

"The lawyer might be of opinion that 'it is an unruly community, always engaged in bickerings and litigations.'

"The clergyman might reply, 'It is a fat salary, with multitudes of sinners seeking salvation and paying large pew rents.'

"The bachelor might exclaim, 'It is a pretty wife who loves her husband, and who knows how to sew on buttons.'

"The maiden might answer, 'It is a good husband, who will love, cherish, and protect me while life shall last.'

"But the most proper answer, and doubtless that which applied

to the case of Mary, would be, 'The one thing needful is to believe on the Lord Jesus Christ, follow in his footsteps, love God and obey his commandments, love our fellow-man, and embrace every opportunity of administering to his necessities. In short, the one thing needful is to live a life that we can always look back upon with satisfaction, and be enabled ever to contemplate its termination with trust in Him who has so kindly vouchsafed it to us, surrounding us with innumerable blessings, if we have but the heart and wisdom to receive them in a proper manner.'"

Although the reading of most of the above caused a tittering among the audience, in which the clergyman himself could scarcely refrain from joining, and although the name of "Taylor Barnum" was frequently whispered among the congregation, I had the satisfaction of hearing the Rev. Mr. Lowe say, at the conclusion, that it was a well-written and correct answer to the question, "What is the one thing needful?"

Mr. Lowe was an Englishman. He purchased a small farm near Bethel and undertook to carry on farming, but having had little or no experience in that way, he made many awkward mistakes. One day he and his man were engaged in blasting rocks near his barn. They had drilled a large deep hole, charged the blast, and adjusted the slow match. Mr. Lowe requested his man to retire while he completed the process. His man went to the other side of the barn. Mr. Lowe then applied the fire to the match, and stepping to the barn, which was within two rods of the rock, he stuck his head into the stable window, leaving his entire body exposed. The explosion filled the air with large fragments of rock. One piece, supposed to weigh three hundred pounds, fell at the side of the parson, grazing his clothing as it passed, and was imbedded twenty inches in the ground, close to his feet. Mr. Lowe could but acknowledge his frightfully narrow escape, and took no more lessons from the ostrich when engaged in blasting rocks.

CHAPTER IV

Anecdotes with an Episode

My Grandfather's Voyage – A Stray Clergyman – The
Beard Question – A Quandary – The Whiskers Doomed
– Half-shaved – The Razor Overboard – Indian File
– Unique Procession – The Joke kept up – Christian's
Death-bed – The Irishman's Dog – Clinching the
Bargain – The Trick discovered – Mrs. O'Brien consoled
– Blue-Laws – The Stage Agent – Dodging the Deacons
– Stretching the Legs – Jehu's Consternation – A Dry
Season – The Miller's Trial – The Verdict – Old Bob
– Bob in the Bogs – The Rider afoot – A Slave for Life –
Marking the Value.

DANBURY and Bethel were and still are manufacturing villages. Hats
and combs were the principal articles of manufacture. The hatters
and comb-makers had occasion to go to New York every spring and
fall, and they generally managed to go in parties, frequently taking
in a few "outsiders" who merely wished to visit the city for the fun
of the thing. They usually took passage on board a sloop at Norwalk,
and the length of their passage depended entirely upon the state of
the wind. Sometimes the run would be made in eight hours, and
at other times nearly as many days were required. It however made
little difference with the passengers. They went in for "a spree,"
and were sure to have a jolly time whether on land or water. They
were all fond of practical jokes, and before starting they usually
entered into a solemn compact, that any man who got angry at a

practical joke should forfeit and pay the sum of twenty dollars. This agreement frequently saved much trouble, for occasionally an unexpected and rather severe trick would be played off, and sadly chafe the temper of the victim.

Upon one of these occasions a party of fourteen men started from Bethel on a Monday morning for New York. Among the number were my grandfather, Capt. Noah Ferry, Benjamin Hoyt, Esq., Uncle Samuel Taylor, (as he was called by everybody,) Eleazer Taylor, and Charles Dart. Most of these were proverbial jokers, and it was doubly necessary to adopt the stipulation in regard to the control of temper. It was therefore done in writing, duly signed.

They arrived at Norwalk Monday afternoon. The sloop set sail the same evening, with a fair prospect of reaching New York early the next morning. Several strangers took passage at Norwalk, among the rest a clergyman. He soon found himself in jolly company, and attempted to keep aloof. But they informed him it was no use, they expected to reach New York the next morning, and were determined to "make a night of it," so he might as well render himself agreeable, for sleep was out of the question. His "Reverence" remonstrated at first, and talked about "his rights," but he soon learned that he was in a company where the rights of "the majority" were in the ascendant; so he put a smooth face upon affairs, and making up his mind not to retire that night, he soon engaged in conversation with several of his fellow-passengers.

The clergyman was a slim spare man, standing over six feet high in his stockings, light complexion, sandy hair, and wearing a huge pair of reddish-brown whiskers. Some of the passengers joked him upon the superfluity of hair upon his face, but he replied that nature had placed it there, and although he thought proper, in accordance with modern custom, to shave off a portion of his beard, he considered it neither unmanly nor unclerical to wear whiskers. It seemed to be conceded that the clergyman had the best of the argument, and the subject was changed.

Expectation of a speedy run to New York was most sadly disappointed. The vessel appeared scarcely to move, and through long weary hours of day and night, there was not a ripple on the surface of the water. Nevertheless there was merriment on board the sloop, each voyager contributing good-humor to beguile the tediousness of time.

Friday morning came, but the calm continued. Five days from

home, and no prospect of reaching New York! We may judge the appearance of the beards of the passengers. There was but one razor in the company; it was owned by my grandfather – and he refused to use it, or to suffer it to be used. "We shall all be shaved in New York," said he.

On Saturday morning "all hands" appeared upon deck – and the sloop was becalmed opposite Sawpitts! (now Port Chester.)

This tried the patience of the passengers sadly.

"I expected to start for home to-day," said one.

"I supposed all my combs would have been sold at auction on Wednesday, and yet here they are on board," said another.

"I intended to have sold my hats surely this week, for I have a note to pay in New Haven on Monday," added a third.

"I have an appointment to preach in New York this evening and to-morrow," said the clergyman, whose huge sandy whiskers overshadowed a face now completely covered with a bright red beard a quarter of an inch long.

"Well, there is no use crying, gentlemen," replied the captain; "it is lucky for us that we have chickens and eggs on freight, or we might have to be put upon allowance."

After breakfast the passengers, who now began to look like barbarians, again solicited the loan of my grandfather's razor.

"No, gentlemen," he replied; "I insist that shaving is unhealthy and contrary to nature, and I am determined neither to shave myself nor loan my razor until we reach New York."

Night came, and yet no wind. Sunday morning found them in the same position. Their patience was well nigh exhausted, but after breakfast a slight ripple appeared. It gradually increased, and the passengers were soon delighted in seeing the anchor weighed and the sails again set. The sloop glided finely through the water, and smiles of satisfaction forced themselves through the swamps of bristles which covered the faces of the passengers.

"What time shall we reach New York if this breeze continues?" was the anxious inquiry of half a dozen passengers.

"About two o'clock this afternoon," replied the good-natured captain, who now felt assured that no calm would further blight his prospects.

"Alas! that will be too late to get shaved," exclaimed several voices – "the barber shops close at twelve."

"And I shall barely be in time to preach my afternoon sermon," responded the red-bearded clergyman. "Mr. Taylor, do be so kind

as to loan me your shaving utensils," he continued, addressing my grandfather.

The old gentleman then went to his trunk, and unlocking it, he drew forth his razor, lather-box and strop. The passengers pressed around him, as all were now doubly anxious for a chance to shave themselves.

"Now, gentlemen," said my grandfather, "I will be fair with you. I did not intend to lend my razor, but as we shall arrive too late for the barbers, you shall all use it. But it is evident we cannot all have time to be shaved with one razor before we reach New York, and as it would be hard for half of us to walk on shore with clean faces, and leave the rest on board waiting for their turn to shave themselves, I have hit upon a plan which I am sure you will all say is just and equitable."

"What is it?" was the anxious inquiry.

"It is that each man shall shave one half of his face, and pass the razor over to the next, and when we are all half shaved we shall go on in rotation and shave the other half."

They all agreed to this except the clergyman. He objected to appearing so ridiculous upon the Lord's day, whereupon several declared that any man with such enormous reddish whiskers must necessarily always look ridiculous, and they insisted that if the clergyman used the razor at all he should shave off his whiskers.

My grandfather assented to this proposal, and said: "Now, gentlemen, as I own the razor, I will begin, and as our reverend friend is in a hurry he shall be next – but off shall come one of his whiskers on the first turn, or he positively shall not use my razor at all."

The clergyman seeing there was no use in parleying, reluctantly agreed to the proposition.

In the course of ten minutes one side of my grandfather's face and chin, in a straight line from the middle of his nose, was shaved as close as the back of his hand, while the other looked like a thick brush fence in a country swamp. The passengers burst into a roar of laughter in which the clergyman irresistibly joined, and my grandfather handed the razor to the clerical gentleman.

The clergyman had already well lathered one half of his face and passed the brush to the next customer. In a short time the razor had performed its work, and the clergyman was denuded of one whisker. The left side of his face was as naked as that of an infant, while from the other cheek four inches of a huge red whisker stood

out in powerful contrast. Nothing more ludicrous could well be conceived. A deafening burst of laughter ensued, and the poor clergyman slunk quietly away to wait an hour until his turn should arrive to shave the other portion of his face.

The next man went through the same operation, and all the rest followed; a new laugh breaking forth as each customer handed over the razor to the next in turn. In the course of an hour and a quarter every passenger on board was half shaved. It was then proposed that all should go upon deck and take a drink before operations were commenced on the other side of their faces. When they all gathered upon the deck the scene was most ludicrous. The whole party burst again into loud merriment, each man being convulsed by the ridiculous appearance of the rest.

"Now, gentlemen," said my grandfather, "I will go into the cabin and shave off the other side. You can all remain on deck. As soon as I have finished I will come up and give the clergyman the next chance."

"You must hurry or you will not all be finished when we arrive," remarked the captain, "for we shall touch Peck Slip wharf in half an hour."

My grandfather entered the cabin, and in ten minutes he appeared upon deck razor in hand. He was smoothly shaved.

"Now," said the clergyman, "it is my turn."

"Certainly," said my grandfather. "You are next, but wait a moment, let me draw the razor across the strop once or twice."

Putting his foot upon the side rail of the deck and placing one end of the strop upon his leg, he drew the razor several times across it. Then as if by mistake the razor flew from his hand, and dropped into the water! My grandfather with well-feigned surprise exclaimed in a voice of terror, "Good heavens! the razor has fallen overboard!"

Such a picture of consternation as covered one half of all the passengers' faces was never before witnessed. At first they were perfectly silent as if petrified with astonishment. But in a few minutes murmurs began to be heard and soon swelled into exclamations. "An infernal hog!" said one. "The meanest thing I ever knew," remarked another. "He ought to be thrown overboard himself," cried several others; but all remembered that every man who got angry was to pay a fine of twenty dollars, and they did not repeat their remarks. Presently all eyes were turned upon the clergyman. He was the most forlorn picture of despair that could be imagined.

"Oh, this is dreadful!" he drawled in a tone which seemed as it every word broke a heart-string.

This was too much, and the whole crowd broke into another roar. Tranquillity was restored! The joke, though a hard one, was swallowed. The sloop soon touched the dock. The half-shaved passengers now agreed that my grandfather, who was the only person on board who appeared like a civilized being, should take the lead for the Walton House in Franklin Square, and all the rest should follow in "Indian file." He reminded them that they would excite much attention in the streets, and enjoined them not to smile. They agreed, and away they started. They attracted a crowd of persons before they reached the corner of Pearl street and Peck Slip, but they all marched with as much solemnity as if they were going to the grave. The door of the Walton House was open. Old Backus the landlord was quietly enjoying his cigar, while a dozen or two persons were engaged in reading the papers, etc. In marched the file of nondescripts with the rabble at their heels. Mr. Backus and his customers started to their feet in astonishment. My grandfather marched solemnly up to the bar – the passengers followed and formed double rows behind him. "Santa Cruz rum for nineteen," exclaimed my grandfather to the barkeeper. The astonished liquor-seller produced bottles and tumblers in double quick time, and when Backus discovered that the nondescripts were old friends and customers, he was excited to uncontrollable merriment.

"What in the name of decency has happened," he exclaimed, "that you should all appear here half shaved?"

"Nothing at all, Mr. Backus," said my grandfather, with apparent seriousness. "These gentlemen choose to wear their beards according to the prevailing fashion in the place they came from, and I think it is very hard that they should be stared at and insulted by you Yorkers because *your* fashion happens to differ a trifle from theirs."

Backus half believed my grandfather in earnest, and the by-standers were quite convinced such was the fact, for not a smile appeared upon one of the half-shaved countenances.

After sitting a few minutes the passengers were shown to their rooms, and at tea-time every man appeared at the table precisely as they came from the sloop. The ladies looked astonished, the waiters winked and laughed, but the subjects of this merriment were as grave as judges. In the evening they maintained the same gravity in the bar-room, and at ten o'clock they retired to bed with

all due solemnity. In the morning however, bright and early, they were in the barber's shop undergoing an operation that soon placed them upon a footing with the rest of mankind.

It is hardly necessary to explain that the clergyman did not appear in that singular procession of Sunday afternoon. He tied a handkerchief over his face, and taking his valise in his hand, started for Market street, where it is presumed he found a good brother and a good razor in season to fill his appointment.

In the month of August, 1825, my maternal grandmother met with an accident which, although considered trivial at the time, resulted in her death. While walking in the garden she stepped upon the point of a rusty nail, which ran perhaps half an inch into her foot. It was immediately extracted, but the foot became swollen, and in a few days the most alarming symptoms were manifest. She was soon sensible that she was upon her death-bed, but she was a good Christian, and her approaching end had no terrors for her. The day before her departure, and while in the full possession of her faculties, she sent for all her grandchildren to take their final leave of her. I never can forget the sensations which I experienced when my turn came to approach her bed-side, and when, taking my hand in hers, she spoke to me of her approaching dissolution, of the joys of religion, the consoling reflections that a death-bed afforded those who could feel that they had tried to live good lives and be of benefit to their fellow-men. She besought me to think seriously of religion, to read my Bible often, to pray to our Father in heaven, to be regular in my attendance at church; to use no profane nor idle language, and especially to remember that I could in no way so effectually prove my love to God, as in loving all my fellow-beings. I was affected to tears, and promised to remember her counsel. When I received from her a farewell kiss, knowing that I should never behold her again alive, I was completely overcome, and however much I may have since departed from her injunctions, the impressions received at that death-bed scene have ever been vivid among my recollections, and I trust they have proved in some degree salutary. A more sincere Christian or a more exemplary woman than my grandmother I have never seen.

But my serious moods did not long remain undisturbed. One of the customers at our store was an Irishman named Peter O'Brien, a small farmer in one of the districts several miles north of Bethel.

An Irishman in those days was a rarity in the interior of Connecticut, and the droll mother-wit, as well as the singular Irish bulls of Peter, gave him considerable celebrity in those parts.

On one occasion Peter visited the store to make some purchases, and one of our village wags perceiving a small dog in his wagon, and wishing to joke the Hibernian, asked O'Brien if the dog was for sale.

"As for the matter of that, I'll be afther selling almost any thing for money," responded the Irishman.

"Is he a good watch-dog?"

"Faith, and he'll defind with his last dhrop of blood any property that you'll show him."

"Is he good to drive cattle from a field?"

"He'll never give over chasing any thing he sees till it's fairly into the street, after you once acquaint him with your wishes."

"Will you warrant all that you say is true?"

"Sure I will, and I'll give back the money if it's a lie I'm telling you," earnestly replied Peter O'Brien.

"What will you take for the dog?"

"Only the trifling matter of two dollars."

"Well," replied our villager, "he don't look as if he was worth two cents, but as I want a watch-dog with all the good qualities which you recommend, I'll take him."

"I'm sure it's making fun of me you are," said Peter; "and I don't know what Mrs. O'Brien could do without her favorite dog."

"I confess I was joking at first, Peter, but I am now in earnest, and there is your money," said his customer, handing him the two dollars.

"A bargain is a bargain," replied Peter, as he stowed away his money in a bit of old bladder which he used as a purse, "but sure and there'll be the deuce to pay with Mrs. O'Brien."

"Oh, you must buy her a little snuff to pacify her," replied the wag.

"Faith, and this will hold something that will do it better than snuff," replied Peter, as he took a wooden gallon bottle from his wagon and walked into the store.

"Now, me boy," said O'Brien, approaching me, "be after giving me half a gallon of New England rum, and half a gallon of molasses."

"Where is your other bottle?" I inquired.

"That will hold a gallon," replied Peter, with a gravity which evidently was not assumed.

"But you don't want to mix the rum and molasses together, I suppose?" I replied.

"Sure, and what a jackass I am, for I never thought of that," exclaimed Peter, in a tone of surprise, "and divil another bottle did I bring at all at all!"

Peter was as witty a fellow as ever left the Emerald Isle, and yet at times he was as stupid as a horse-block, the foregoing instance being a veritable illustration of the fact.

When Peter next came to our village, he was accosted very roughly by his dog-customer, when the following conversation ensued:

"You lying Irishman! I want you to take that miserable puppy and give me back my two dollars."

"Fun is fun," replied Peter, "and you are always funning me, but I don't like ye to charge me with lying, for that's a thing I leave for my betters. I never tells lies, sir."

"You do; you lied and deceived me about that worthless dog."

"Divil a lie did I tell ye at all at all."

"Why, the dog is blind as a bat," replied the customer in great anger.

"Sure, and that's no fault of the poor dog's, but his serious misfortune," replied Peter solemnly, amid a shout of laughter from a dozen loungers in the store.

"But you said he would watch property, and drive cattle out of the field."

"Not at all. I said he would chase any thing that he'd *see*, and watch all that you would *show* him," replied O'Brien with imperturbable gravity.

Another scene of merriment ensued, and the wag, seeing that Peter had the advantage of him, quietly asked him if he was going to refund the money.

"Surely not, for many valuable reasons, one of which is, I spent it three days ago."

"But your your wife, who loved the dog so well, would be glad to see him home again, I suppose?" replied the victim, who was becoming reconciled to the joke.

"As for the matter of that," replied Peter, "I told her he was sold into good and benevolent hands, and she has at last become reconciled to her loss."

Another laugh followed, in which the dog-purchaser joined.

"Well, you may keep the money," he replied, "but you may take the dog."

"No, I thank ye, it would only be opening the wound of Mrs. O'Brien afresh, and that you know would be cruel," replied Peter.

In the days of which I am now writing, a much stricter outward regard was paid to the Sabbath in the State of Connecticut than at present. If a man was seen riding horseback or in a carriage on Sunday before sundown, a tithing-man, deacon of a church, or grand-jury man was sure to arrest him, and unless he could show that sickness or some other case of necessity induced him to come out, he was fined the next day.

The mail stage from New York to Boston was permitted to run on the Sabbath, but in no case to take passengers. Sometimes the cupidity of the New York agents would induce them to book travellers through Connecticut on the holy day, but nearly every meeting-house had its sentinel on the look-out, and it was very difficult for a driver to escape being arrested if he had one or more persons in his coach. In that case the driver, his horses, stage, mail and passengers were obliged to "lie to" until Monday morning, when driver and passengers must each pay a fine before being permitted to depart.

On one occasion, Oliver Taylor and Benjamin Hoyt, a brace of wags from Bethel, were in New York, and as the way-bill was filled for several week-days ahead, they went to the stage office, No. 21 Bowery, early one Sunday morning, and asked to be carried that day to Norwalk, Ct.

"It can't be done," peremptorily replied the stage agent.

"It is very important," responded Oliver; "my wife and children are dangerously sick at Bethel, and I must reach there before to-morrow morning."

"And my mother isn't expected to live the day out," meekly added 'Squire Ben, with a face considerably elongated.

"It won't do, gentlemen; these periodical sicknesses are excessively prevalent, and I am *wonderfully* sorry for you, but we have been stopped, fined, and our mail detained several times this year, in your State. We are decidedly sick of it, and will carry no more passengers in Connecticut on Sunday," was the prompt reply.

"They are not as strict now as they were formerly," urged Mr. Taylor.

"Not half," added Mr. Hoyt.

"Formerly!" exclaimed the agent; "why, it is only two weeks since we were arrested in Stamford."

"Yes, and it cost me eleven dollars besides the detention," added the proprietor, who had just stepped in.

"Now, sir," said Mr. Taylor, addressing the proprietor, "our business is urgent; we are Connecticut men, and know Connecticut laws and Connecticut deacons – yes, and how to dodge them, too. We will pay you ten dollars for our passages to Norwalk, and whenever we pass through a Connecticut village we will lie down on the bottom of the stage, and thus your vehicle, being apparently empty, will pass through unmolested."

"Will you do this promptly as you pass through each Connecticut village?" asked the melting proprietor.

"Positively," was the reply of Taylor and Hoyt.

"Well, I don't think it any sin to dodge your Yankee blue-laws, and I'll take you on those conditions," responded the stage man.

The passage money was paid, the two valises snugly packed under the inside seats, and their two owners were as snugly seated in the mail coach.

"Remember your promises, gentlemen, and dodge the Yankee deacons," said the stage proprietor, just as the driver flourished his long whip, and the horses started off in a gallop. The two passengers nodded a willing assent.

Messrs. Taylor and Hoyt knew every inch of the road. As the stage approached the Connecticut line, they prepared to stow themselves away. Just before reaching Greenwich, they both stretched themselves upon their backs on the bottom of the coach. The agents of the law – and gospel, were on the look-out, the driver's face assumed a most innocent look, the apparently empty stage "passed muster," and was permitted to move along unmolested, a straight-laced deacon merely remarking to the tithing-man, "I guess them 'ere Yorkers have concluded it won't pay to send their passengers up this way on the Lord's day." The tithing-man nodded his satisfaction.

At Stamford the game of "hide and seek" was successfully repeated. At Darien, which is within six miles of Norwalk, where our passengers were to leave the stage and take their chances for reaching Bethel, about twenty miles north, they once more laid themselves down upon their backs, and the driver, assuming a demure look, let his horses take a slow trot through the village.

"Now, Ben," said Taylor, "I'm a-going to give the deacons a chance, fine or no fine," and instantly he thrust his feet a tempting distance out of the side window of the coach.

"Oh, for heaven's sake draw in your feet," exclaimed Hoyt, in horror, as he saw a pair of boots sticking a couple of feet [no pun intended] out of the window.

"Couldn't think of such a thing," quietly responded Taylor, with a chuckle.

"But we agreed to hide, and now you are exposing the stage-driver as well as ourselves," urged the conscientious and greatly alarmed Hoyt.

"We agreed to lie on our backs, and we are doing it flat enough; but my legs want stretching, and they must have it," was the mischievous reply.

They were now opposite the village church, and the poor driver, unconscious of the grand display his passengers were making, carried his head high up, as much as to say, "You may look, gentlemen, but it's no use."

A watchful deacon, horror-struck at beholding a pair of boots with real legs in them emerging from the stage window, hallooed to the driver to stop.

"I'm empty, and shan't do it," responded coachee, with a tone of injured innocence.

"You have got a passenger, and *must* stop," earnestly replied the deacon.

The driver, turning his face towards the body of his coach, was alarmed at seeing a pair of legs dangling out of the window, and with a look of dismay instantly jerking his reins and giving his horses half a dozen smart cuts, they struck into a quick gallop just as the deacon's hand had reached within a foot of the leader's bridle. The coach slightly grazed the deacon, half knocking him over, and was soon beyond his reach. The frightened driver applied the lash with all his might, continually hallooing, "Draw in them infernal boots!"

A double haw-haw of laughter was all the satisfaction he received in reply to his commands, and, Jehu-like, the team dashed ahead until not a house was in sight. The driver then reined in his horses, and began remonstrating with his passengers. They laughed heartily, and handing him half a dollar, bade him be quiet.

"In ten minutes it will be sundown," they added, "you can therefore go into Norwalk in safety."

"But they will pull me up in Darien and fine me when I return," replied the driver.

"Don't be alarmed," was the response; "they can't fine you,

for no one can swear you had a passenger. Nothing was seen but a pair of legs, and for aught that can be proved they belonged to a wax figure."

"But they moved," replied the driver, still alarmed.

"So does an automaton," responded Mr. Taylor; "so give yourself no uneasiness, you are perfectly safe."

The driver felt somewhat relieved, but as he passed through Darien the next day, he had some misgivings. The deacon, however, had probably reached the same conclusion in regard to the rules and nature of evidence as had Mr. Taylor, for no complaint was made, and the driver was permitted to pass unheeded. His fright, however, caused him to notify his employers, that if they ever sent any more passengers to Connecticut on the Sabbath, they might send a driver with them, for he would see them – "blowed" before they would catch *him* in another such a scrape.

About the last prosecution which we had in Danbury for a violation of the Sabbath, was in the summer of 1825. There was a drought that season. The grass was withered, the ground was parched, all vegetation was seriously injured, and the streams far and near were partially or wholly dried up. As there were no steam mills in those days, at least in that vicinity, our people found it difficult to get sufficient grain ground for domestic purposes without sending great distances. Our local mills were crammed with the "grists" of all the neighborhood awaiting their turn to be converted into flour or meal. Finally it commenced raining on a Saturday night, and continued all day Sunday. Of course, everybody was delighted. Families who were almost placed upon an "allowance" of bread, were gratified in the belief that the mills would now be set a-going, and that the time of deliverance was at hand. One of our millers, an eccentric individual, and withal a worthy man, knowing the strait in which the community was placed, and remembering that our Saviour permitted his disciples to pluck ears of corn upon the Sabbath, concluded to risk the ire of bigoted sticklers who strained at a gnat and swallowed a camel, set his mill in motion on Sunday morning, and had finished many a grist for his neighbors before Monday's sun had arisen.

On Monday afternoon he was arrested on a grand juror's complaint for breaking the Sabbath. He declined employing counsel, and declared himself ready for trial. The court-room was crowded with sympathizing neighbors. The complaint was read, setting forth

the enormity of his crime in converting grain into flour on the holy Sabbath – but it did not state the fact, that said grinding saved the whole neighborhood from a state of semi-starvation. The defendant maintained a countenance of extreme gravity.

"Are you guilty or not guilty?" asked the man of judicial authority.

"Not guilty – but I ground," was the reply.

Loud laughter, which the court declared was quite unbecoming the halls of justice, was here indulged by the spectators.

As the act was confessed, no evidence was adduced on the part of the State. Numerous witnesses testified regarding the great drouth, the difficulty in procuring bread from the lack of water to propel the mills, and stated the great *necessity* of the case. The defendant said not a word, but a verdict of *not guilty* was soon returned. The community generally was delighted, and the ideas that had heretofore existed in that vicinity, that a cat should be punished for catching a mouse on Sunday, or that a barrel of cider should be whipped for "working" on the first day of the week, became obsolete; compelling men to go to "meeting" went out of fashion; in fact, a healthy reaction took place, and from that time the inhabitants of Connecticut became a *voluntary* Sabbath-observing people, abstaining from servile labor and vain recreation on that day, but not deeming it a sin to lift a suffering ox from the pit if he happened to be cast therein after sunset on Saturday, or before sundown on Sunday.

My father, besides being in the mercantile line, and keeping the village tavern, ran a freight wagon to. Norwalk, and kept a small livery stable. On one occasion, a young man named Nelson Beers applied to him for the use of a horse to ride to Danbury, a distance of three miles. Nelson was an apprentice to the shoe-making business, nearly out of his time, was not over-stocked with brains, and lived a mile and a half east of our village. My father thought that it would be better for Nelson to make his short journey on foot than to be at the expense of hiring a horse, but he did not tell him so.

We had an old horse named "Bob." Having reached an age beyond his teens, he was turned out in a bog lot near our house to die. He was literally a "living skeleton" – much in the same condition of the Yankee's nag, which was so weak his owner had to hire his neighbor's horse to help him draw his last breath. My father, in reply to Nelson's application, told him that the livery horses were

all out, and he had none at home except a famous "race-horse," which he was keeping in low flesh in order to have him in proper trim to win a great race soon to come off.

"Oh, do let me have him, Uncle Phile;* I will ride him very carefully, and not injure him in the least; besides, I will have him rubbed down and fed in Danbury," said Nelson Beers.

"He is too valuable an animal to risk in the hands of a young man like you," responded my father.

Nelson continued to importune, and my father to play off, until it was finally agreed that the horse could be had on the condition that he should in no case be ridden faster than a walk or slow trot, and that he should be fed four quarts of oats at Danbury.

Nelson started on his Rosinante, looking for all the world as if he was on a mission to the "carrion crows;" but he felt every inch a man, for he fancied himself astride of the greatest race-horse in the country, and realized that a heavy responsibility was resting on his shoulders, for the last words of my father to him were, "Now, Nelson, if any accident should happen to this animal while under your charge, you could not pay the damage in a lifetime of labor."

Old "Bob" was duly oated and watered at Danbury, and at the end of several hours Mr. Beers mounted him and started for Bethel. He concluded to take the "great pasture" road home, that being the name of a new road cut through swamps and meadows, as a shorter route to our village. Nelson, for the nonce forgetting his responsibility, probably tried the speed of his race-horse and soon broke him down. At all events *something* occurred to weaken old Bob's nerves, for he came to a stand-still, and Nelson was forced to dismount. The horse trembled with weakness, and Nelson Beers trembled with fright. A small brook was running through the bogs at the roadside, and Beers thinking that perhaps his "racehorse" needed a drink, led him into the stream. Poor old "Bob" stuck fast in the mud, and not having strength to withdraw his feet, quietly closed his eyes, and, like a patriarch as he was, he dropped into the soft bed that was awaiting him, and died without a single kick.

No language can describe the consternation of poor Beers. He could not believe his eyes, and vainly tried to open those of his

* My father's name was Philo, but as it was the custom to call everybody in those parts uncle or aunt, deacon, colonel, captain, or squire, my father's general title was as above.

horse. He placed his ear at the mouth of poor old Bob, but took it away again in utter dismay. The breath had ceased.

At last Nelson, groaning as he thought of meeting my father, and wondering whether eternity added to time would be long enough for him to earn the value of the horse, took the bridle from the "dead-head," and unbuckling the girth, drew off the saddle, placed it on his own back, and trudged gloomily towards our village.

It was about sundown when my father espied his victim coming up the street with the saddle and bridle thrown across his shoulders, his face wearing a look of the most complete despair. My father was certain that old Bob had departed this life, and he chuckled inwardly and quietly, but instantly assumed a most serious countenance. Poor Beers approached more slowly and mournfully than if he was following a dear friend to the grave.

When he came within hailing distance my father called out, "Why, Beers, is it possible you have been so careless as to let that race-horse run away from you?"

"Oh, worse than that – worse than that, Uncle Phile," groaned Nelson.

"Worse than that! then he has been stolen by some judge of valuable horses. Oh, what a fool I was to intrust him to anybody!" exclaimed my father with well-feigned sorrow.

"No, he ain't stolen, Uncle Phile," said Nelson.

"Not stolen! well, I am glad of that, for I shall recover him again; but where is he? I am afraid you have lamed him."

"Worse than that," drawled the unfortunate Nelson.

"Well, what is the matter? where is he? what ails him?" asked my father.

"Oh, I *can't* tell you – I can't tell you!" said Beers with a groan.

"But you *must* tell me," returned my father.

"It will break your heart," groaned Beers.

"To be sure it will if he is seriously injured," replied my father; "but where is he?"

"He is DEAD!" said Beers, as he nerved himself up for the announcement, and then closing his eyes, sank into a chair completely overcome with fright.

My father groaned in a way that started Nelson to his feet again. All the sensations of horror, intense agony, and despair were depicted to the life on my father's countenance.

"Oh, Uncle Phile, Uncle Phile, don't be too hard with me; I wouldn't have had it happen for all the world," said Beers.

"You can never recompense me for that horse," replied my father.

"I know it, I know it, Uncle Phile; I can only work for you as long as I live, but you shall have my services till you are satisfied after my apprenticeship is finished," returned Beers.

After a short time my father became more calm, and although apparently not reconciled to his loss, he asked Nelson how much he supposed he ought to owe him.

"Oh, I don't know – I am no judge of the value of blood horses, but I have been told they are worth fortunes sometimes," replied Beers.

"And mine was one of the best in the world," said my father, "and in such perfect condition for running – all bone and muscle."

"O yes, I saw that," said Beers, despondingly, but with a frankness that showed he did not wish to deny the great claims of the horse and his owner.

"Well," said my father with a sigh, "as I have no desire to go to law on the subject, we had better try to agree upon the value of the horse. You may mark on a slip of paper what sum you think you ought to owe me for him, and I will do the same; we can then compare notes and see how far we differ."

"I will mark," said Beers, "but, Uncle Phile, don't be too hard with me."

"I will be as easy as I can, and endeavor to make some allowance for your situation," said my father; "but, Nelson, when I think how valuable that horse was, of course I must mark something in the neighborhood of the amount of cash I could have received for him. I believe, however, Nelson, that you are an honest young man, and are willing to do what you think is about right. I therefore wish to caution you not to mark down one cent more than you really think, under the circumstances, you ought to pay me when you are able, and for which you are now willing to give me your note of hand. You will recollect that I told you when you applied for the horse that I did not wish to let him go."

Nelson gave my father a grateful look, and assented to all he said. At least a dozen of our joke-loving neighbors were witnessing the scene with great apparent solemnity. Two slips of paper were prepared; my father marked on one, and after much hesitation Beers wrote on the other.

"Well, let us see what you have marked," said my father.

"I suppose you will think it is too low," replied Beers, handing my father the slip of paper.

"Only three hundred and seventy-five dollars!" exclaimed my father, reading the paper; "well, there is a pretty specimen of gratitude for you."

Nelson was humbled, and could not muster sufficient courage to ask my father what *he* had marked. Finally one of our neighbors asked my father to show his paper – he did so. He had marked "*Six and a quarter cents.*" Our neighbor read it aloud, and a shock of mirth ensued which fairly lifted Beers to his feet. It was some time before he could comprehend the joke, and when he became fully aware that no harm was done, he was the happiest fellow I have ever seen.

"By thunder!" said he, "I've got a dollar and thirty-seven and a half cents, and darned if I don't treat that out as free as air. I was never scared so bad before in my life."

Nelson stood treat for the company, and yet having half his money left on hand, he trudged home a happier if not a wiser man.

CHAPTER V

A Batch of Incidents

AMONG the various ways which I had for making money on my own account, from the age of twelve to fifteen years, was that of lotteries. One of our neighbors, a pillar in the church, permitted his son to indulge in that line, the prizes consisting of cakes, oranges, molasses candy, etc.; and the morality of the thing being thus established, I became a lottery manager and proprietor. The highest prize was generally five dollars – sometimes less, and sometimes as high as

ten dollars. All the prizes in the lottery amounted to from twelve to twenty-five dollars. The cost of the entire tickets was twenty or twenty-five per cent. more than the prizes. I found no difficulty in disposing of my tickets to the workmen in the hat and comb manufactories, etc.

I had Gen. Hubbard as a predecessor in that business. He was a half-witted old fellow, who wandered about the town living upon the charities of its inhabitants. He was eccentric. One day he called in at Major Hickock's and asked to have his boots soled. When they were finished Hubbard said to the Major, "I thank you kindly." "Oh, that is more than I ask," said the good-hearted Major. "'Thank you kindly' is two and sixpence, and I ask only two shillings." "Well, I'll take the rest in cider," responded Hubbard.

On one occasion he got up a lottery – capital prize ten dollars, tickets twelve and a half cents each. He sold out all his tickets in a few days and pocketed the money. Coming around in those parts a fortnight afterwards, his customers inquired about their prizes. "Oh," replied Gen. Hubbard, "I am convinced this is a species of gambling, so I have concluded not to draw the lottery!" His customers laughed at the joke and lost their shillings.

Lotteries in those days were patronized by both Church and State. As a writer has said, "People would gamble in lotteries for the benefit of a church in which to preach *against* gambling."

In 1819 my grandfather, Phineas Taylor, and three other gentlemen, were appointed managers of a lottery for such a purpose, and they met to concoct a "scheme." My grandfather was anxious to adopt something new, so as, if possible, to make it peculiarly attractive and popular. He finally hit upon a plan which he said he was sure would carry every thing before it. It was adopted, and his anticipations were fully realized. The Scheme, as published in the "Republican Farmer," Bridgeport, July 7, 1819, set forth that the lottery was "By Authority of the State of Connecticut," for the benefit of the "Fairfield Episcopal Society," and the inducements held out for the purchase of tickets were as follows:

> "The Episcopal Society in Fairfield was at the commencement of the revolutionary war blessed with a handsome Church, completely finished, and painted inside and out, with an elegant set of plate for the communion service, and a handsome Library; also a large and elegant Parsonage-House, with out-houses, fences, &c., which were all destroyed by fire, or carried away at the time the town of Fairfield

was burnt, in the year 1779, by the British troops under Tryon, which so impoverished the Society that they never have been able to reinstate themselves; and, as all other Ecclesiastical Societies, and individuals, who suffered losses by the enemy at that time, have long since, in some measure, been remunerated by the Hon. Legislature; and at their Spring Session, 1818, on the petition of the Wardens and Vestry of the Episcopal Church in Fairfield, to the Hon. General Assembly, they granted a Lottery that might in some measure remunerate them also for their so long omitted claims."

The "Scheme" itself was considered a novelty, for it announced, "Not a Blank in the Lottery." It was certainly attractive, for while the price of a ticket was five dollars, 11,400 out of a total of 12,000 prizes were set down at $2.50 each!

This favorable state of things justified the managers in announcing, (as they did,) that

"A more favorable Scheme for the Adventurer, we presume to say, was never offered to the public. The one now offered contains more high Prizes than Schemes in general of this amount; and it will be observed that a person can obtain two Tickets for the same money that will buy but one in a Scheme of any other description. Consequently the Adventurer will have two chances for the high Prizes to one in any other Lottery."

Never was a lottery so popular, *before it was drawn*, as this. The fear of drawing a *blank* had hitherto been quite a drawback to investments in that line; but here there was "NOT A BLANK IN THE LOTTERY!" Besides, adventurers had "*two chances for the high prizes to one in any other lottery!*" Rather slim chances to be sure, when we observe that there were only *nine* prizes above one hundred dollars, in twelve thousand tickets! One chance in thirteen hundred and thirty-three! But customers did not stop to think of that. Then again, according to the Scheme, "a person can obtain two Tickets for the same money that will buy but one in a Scheme of any other description."

The tickets sold with unparalleled rapidity. Scarcely a person thought of purchasing less than two. He was sure to draw two prizes of $2.50 each, and at the worst he could lose no more than $5, the ordinary price of a ticket! All the chances were sold some time previous to the day announced for the commencement of the

drawing – a fact unprecedented in the history of lotteries. My grandfather was looked upon as a public benefactor. He sold personally more than half the entire number of tickets, and as each manager received a per centage on sales made by himself, there was profit in the operation.

The day of drawing arrived. My grandfather announced each prize as it came from the wheel, and during the twenty-four days required for drawing the twelve thousand numbers at five hundred each day, he called out "two dollars and fifty cents" eleven thousand four hundred times, and various other prizes, all told, only six hundred times!

Persons who had bought two tickets, being sure of losing not more than $5 at the worst, found themselves losers $5.75, for as the Scheme announced "all prizes subject to the usual deduction of 15 per cent.," each $2.50 prize realized to the holder $2.12, "payable in 60 days."

The whole country was in an uproar. "Uncle Phin Taylor" was unanimously voted a regular old cheat – the scheme, with "not a blank in the lottery," was denounced as "the meanest scheme ever invented, and nobody but Phin Taylor would have ever thought of such a plan for deceiving the people!" In fact, from that date till the day of his death, he was called "old two dollars and fifty cents," and many was the hearty laugh which he enjoyed at the thought thereof. As time wore away, he was declared to be the 'cutest man in those parts, and the public generally became reconciled to consider his famous "Scheme" as a capital practical joke.

The drawing of a State-Church Lottery (under other managers) was advertised in February, 1823, and "adventurers" were assured of this "farther opportunity of obtaining an easy independence for the small sum of $5." The quiet unction of this announcement is peculiarly refreshing. One chance in *only* twelve thousand! Such bipeds as "humbugs" certainly existed long before I attained my majority.

My grandfather was for many years a "Justice of the Peace," and became somewhat learned in the law. As lawyers were not then so plenty in Connecticut as at present, he was sometimes engaged in pettifogging small cases before a Justice. On one occasion he went to Woodbury, Ct., in that capacity. His opponent was lawyer Bacon, an attorney of some celebrity. Bacon despised the idea of contending against a pettifogger, and seized every opportunity during the trial to annoy my grandfather. If the latter objected to evidence introduced by the former as irrelevant or illegal, Mr. Bacon would remind

the court that his adversary was a mere pettifogger, and of course knew nothing about law or the rules of evidence. My grandfather took this all very coolly; indeed it gratified him to annoy the learned counsel on the other side. At last Mr. Bacon became considerably excited, and looking my grandfather directly in the face, he said:

"Your name is Taylor, I believe, sir?"

"It is," was the reply.

"It takes nine tailors to make a man," responded the lawyer triumphantly.

"And your name is Bacon, I think," said my grandfather.

"Yes, sir."

"Bacon is the meanest part of the hog," rejoined the pettifogger.

Even the court joined in the laughter which followed, and at the same time advised Mr. Bacon to refrain in future from remarks which were unnecessary and unbecoming. The learned attorney exhibited a ready willingness in acceding to the request of the Judge.

My grandfather was troubled with the asthma. One day while walking up a steep hill in company with Mr. Jabez Taylor, (father to Oliver,) an old wag of about his own age, my grandfather, puffing and breathing like a porpoise, exclaimed:

"I wish I could stop this plaguy breathing."

"So do all your neighbors," was the facetious reply.

One of our neighbors, "Uncle Sam Taylor," as he was called, was an eccentric man. He always gloried in being on the contrary side. If a proposition was as plain as the sun at noon-day, Uncle Sam would never admit it. If a question had two sides to it, he would be sure to find the wrong one, just for the sake of the argument. Withal, he was a good-hearted man, and an excellent neighbor. Ask him to loan you his axe or hoe, and he would abruptly reply: "You can't have it, I don't lend my tools," and presently he would bring the article you desired.

I once called to borrow his horse to ride to Danbury. "You shan't have it," he replied in a tone that frightened me. I started towards the door quite chop-fallen.

"You will find the saddle and bridle on the stairs," called out Uncle Sam. The hint was sufficient, and I rode his horse to "town."

On one occasion Uncle Sam and my uncle Edward Taylor were mowing for Phineas Judd. Mr. Judd visited the meadow several times in the course of the day, and seemed dissatisfied with the

labor. In the afternoon he complained that they had not cut as much grass as he expected they would in the same space of time.

"I don't care any thing about you, Phin," said Uncle Sam. "I have worked as fast as I am going to do, and faster than you should expect men to work on New England rum."

"New England rum!" exclaimed Mr. Judd, with surprise. "It is good Santa Cruz."

"It is the meanest kind of New England rum, Phin, and you know it – real white-face," said Uncle Sam.

"You are certainly mistaken, Mr. Taylor," said Mr. Judd, in a tone which showed his feelings were injured. "I told the boy to get the best kind of Santa Cruz rum."

"No, you didn't. You told him to get New England rum, and you know it," said Uncle Sam.

Mr. Judd called up the boy. "What kind of rum did you tell Mr. Weed you wanted?" said Mr. Judd, addressing the boy.

"The best Santa Cruz," was the reply.

"There," said Mr. Judd triumphantly, "now you see it is just as I told you, Mr. Taylor."

"It's New England rum, and you know it," replied Uncle Sam, and then addressing my uncle Edward, he said: "Come, Ed, let us take another drink of 'white-face' and go on with our mowing."

They did so, and Mr. Judd left the field with downcast countenance. When he had got out of hearing, my uncle Edward said:

"Uncle Sam, is that really New England rum?"

"No, it is as good Santa Cruz as ever was tasted, but I thought I'd pay Phin for his grumbling," said the ever contrary Uncle Sam.

"You do like to be contrary," responded uncle Ed.

"I always was on the contrary side, and I always mean to be," replied the eccentric old man.

A religious revival took place in Bethel. As is generally the case on these exciting occasions, many persons were awakened, became converted, and joined the church. One man was taken into the church who was not overstocked with brains. When he joined the church one of the deacons, addressing him, said:

"Brother P–, from this time we shall all look to you as one of the pillars of the church."

Poor P–, looking around and noticing the columns which supported the gallery, not doubting that he was to be placed in a

similar position as a "pillar," burst into tears, exclaiming, "That burthen will be greater than I can bear."

Another half-witted man was determined to join the church, but not being wanted, he was told that "the church was full." He then applied for the first vacancy, and waited a long time in patience for death to make a removal, so that he could be admitted.

One old man, who was quite stubborn in his religious notions, attended all the meetings, but was not converted. The village clergyman took that opportunity to urge him to come to the anxious seat – but the old man replied:

"You know my sentiments on this subject, for I have frequently argued points of theology with you. You are welcome to your opinion, I have mine. We don't agree."

The next day the clergyman mentioned the old man's case to one of the Revivalist ministers.

"Oh," he replied, "that man evidently needs some sound arguments. Introduce me to him, and if his heart don't become softened I am mistaken."

The introduction was made, and the clerical stranger said to the old man:

"Have you any objections to listening to some arguments which I desire to offer in favor of your being converted and joining the church?"

"Not at all," was the reply.

The clergyman then commenced his argument, which lasted three-quarters of an hour. The old man listened attentively.

"Now," says the clergyman, "what do you think about joining the church?"

"Oh, I suppose it's well enough for some folks, but I have got so old, it is hardly worth pottering about," was the curious reply.

As Danbury lies twenty miles from the sea-board, we had no fish market there, but a good substitute was found in numerous fish peddlers, who brought clams, oysters, scallops, and all kinds of fish and samphire in its season from Bridgeport, Norwalk, etc., and sold the same from house to house in such quantities as might be wanted. These peddlers usually each made several trips per week, so that although we were situated inland, we could usually obtain a daily supply of fresh fish. My grandfather, who took great pride in excelling his neighbors in any thing he undertook, made a standing offer of one dollar for the first fresh shad that was brought to our village each season. As customers usually were willing to buy shad only

when they were sufficiently plenty to retail at twenty-five cents each, my grandfather was sure to receive his "first shad" annually a week or two before any others were seen in that market. One season, as usual, the itinerant fish merchant coming into Bethel with a load of "porgies," clams and fresh cod, brought the prize shad and received his dollar. My grandfather invited several of the neighbors to breakfast with him the next morning, and placed his shad in cold water upon his back piazza. Captain Noah Ferry, a precious wag, managed to steal it just in the dusk of the evening and conveyed it to his own house. The neighbors were as usual gathered at the store in the evening. My grandfather countermanded his invitations, and complained bitterly that the shad had been stolen. He could not help thinking that a dog had done it, and concluded that it was destroyed. The neighbors, most of whom were in the secret, pretended to sympathize with the loser.

"Never mind, Phin," said Captain Noah, "you must be more careful next time and put your fish out of the reach of dogs. As it is, you probably have made no provision for breakfast, so I invite you and Ben and Dr. Haight to come over and breakfast with me. I shall have a nice loin of veal cooked in a new style, which I am sure will please you."

The invitation was accepted, and Noah purchased a quart of Santa Cruz rum, at the same time enjoining 'Squire Hoyt to be sure and bring over some fresh tanzy in the morning for bitters.

The guests arrived at an early hour, and after a brief social chat, breakfast was announced. Instead of veal, a splendid shad, hot, well buttered, and bearing the marks of the gridiron, appeared upon the table. My grandfather perceiving the joke, and waiting for the hearty "haw-haw" of his neighbors to cease, merely remarked, "Well, Noah, I always suspected you were a thief, and now I am sure of it." Another laugh from the company gave an additional zest to their appetite, and the "first shad of the season" was soon numbered among the things that were.

The following spring, my grandfather's prize shad was stolen by a dog. Somewhat more than half of the tit-bit was, however, redeemed from the thief, and put into a pan of clean water on the back piazza. By 'cute management of its owner, Ferry stole the precious morsel, and invited a company to breakfast, as before, without specifying the viands. My grandfather purposely arrived at too late an hour to participate in the luxury. Ferry expressed regret, "for," said he, "we had the first shad of the season." When the facts

came out, he was thoroughly chop-fallen, and it was long before he forgave the practical joke.

As before stated, my grandfather had a great desire to *excel*. On his farm he had a particular meadow of ten acres which every season he would have cut, dried, and put into the barn in a single day, merely that he could brag of doing what no one else did. Of course he hired extra help for that purpose. In the year 1820 he was appointed deputy marshal for taking the census in that part of the county. True to his natural characteristics, he was determined it should be done *quicker* than any predecessor had ever accomplished the same thing. Consequently he arose every morning at daylight, spent little time at breakfast, and mounting his horse started off on his mission, not returning home till dark. He would ride up to a house, give a "halloo," and immediately address his interrogations to the lady or whoever else happened to come to the door.

"What is the name of this family?" "How many children?" "What sexes?" "What ages?" "How many can read and write?" "Any deaf and dumb," etc., etc. Then placing his memorandum book in his side coat pocket, he would say "All right," and gallop off to the next neighbor. My grandfather's chirography was horrid. It usually looked as if a spider that had dropped into a bottle of ink was permitted to crawl over the paper. He himself could not read it half the time when he had forgotten the purport of the subject he had written about.

He hurried up the census of the territory placed under his charge in twenty-one days. Ten years previously it had taken thirty-nine days. Here was a feat for him to boast of, and he improved the opportunity.

But having once taken the census, it was now necessary to get competent persons to transcribe, or perhaps I might more properly say, *translate* it. For this purpose he employed Moses Hatch, Esq., a talented and witty lawyer in Danbury, 'Squire Ben Hoyt, who wrote a plain round hand, and his own son, Edward Taylor.

It was a rare treat to see these individuals seated at the table trying to decipher the wretched manuscript that lay before them. My grandfather walked up and down the room, being called every few minutes to explain some name or other word that was as unintelligible as if it had been written in Arabic. He would put on his spectacles, look at it, turn it over, scratch his head, and try to recollect some circumstance which would enlighten him and aid in

threading the labyrinth. He had an excellent memory, and would generally manage, after long studying, to make out what he had intended to write. The delay, however, occupied many more days than he had gained in taking the census. At times the old gentleman would lose his patience, and protest that his writing was not half as bad as his transcribers pretended, but that their own obtuseness caused the delay; he would then say, "It is unreasonable to expect me to write, and then furnish brains to enable you to copy it."

On one occasion Moses Hatch, after puzzling in vain for twenty minutes over something that was intended for a man's name, called out, "Come, Uncle Pnin, here is a man named Whitlock, but what in all conscience do you call this which you have marked down for his Christian name?"

My grandfather glanced at it for a moment, and said it was "Jiabod," adding, "Any fool could see that, without calling on me to read it for him."

"Jiabod!" said Hatch. "Now, what mother would ever think of giving her son such an outlandish name as 'Jiabod?'"

"I don't know nor care any thing about that," replied my grandfather, "but I know it is Jiabod. I recollect the name perfectly well."

"Jiabod Whitlock," repeated Hatch; "you are certainly mistaken; you *must* be mistaken; no man ever could have been named Jiabod."

My grandfather insisted he was right, and intimated to Mr. Hatch that he desired him to write away and not dispute him when he knew he could not be mistaken.

'Squire Hoyt looked at the word some time, and then said, "Phin, was not his name Ichabod?"

"I declare I believe it was," said my grandfather, mellowing down considerably.

The transcribers' laugh nettled him.

"You can laugh, gentlemen," said he, "but remember under what circumstances that was written. It was done on horseback, in warm weather, and the horse was continually kicking off the flies; the devil could not write legibly under such circumstances."

"Oh no," said Hatch soothingly; "as you say, nobody could write plainly on horseback while the horse was kicking off the flies; but only give you a good pen, 'Squire Taylor, and let you sit down to a table, and *you do write a beautiful hand!*"

My grandfather could not help joining in the merriment that

followed this happy hit. It was many years before he heard the last of "Jiabod."

Doctor Haight, the father of John, was a good-natured joker. He took the world very easily – could tell a good story, and laugh as heartily as any body. His language was not always chosen with the degree of discretion that could be wished, and he consequently frequently slipped out expressions which sounded harshly, especially to those who did not know him.

On one occasion he and Mr. Jonathan Couch, a very worthy and sedate Methodist in Bethel, were appointed administrators on an estate. They visited the Probate Judge at Danbury for the purpose of taking out letters of administration. Judge Cook, who was a gentleman of the old school, received his visitors with considerable dignity.

"Will you please take the necessary oath, gentlemen?" said Judge Cook, with official solemnity.

"I prefer to affirm," said the conscientious Mr. Couch. The affirmation was solemnly administered by Judge Cook, who then turned to Dr. Haight and said, "Which do you prefer, sir, the affirmation or the oath?"

"Oh, I don't care a d—n which I take," said the doctor abruptly. The moral sense of his auditors was of course shocked beyond expression.

Dr. Carrington, Esquire James Clarke, and other well-known jokers of Danbury, were the authors of many anecdotes which I heard in my younger days. The doctor kept a country store. A small farmer coming to trade with him one day, asked him if he took cheese in exchange for goods. "Certainly," was the reply. The farmer brought in a large bag and emptied out eleven very small cheeses. "Only eleven!" said the doctor counting them; "I can't do any thing with them."

"Why not?" asked the farmer.

"There is not a full set – there should be twelve," responded the doctor.

"A full set of what?" inquired the farmer.

"Button moulds, of course," was the reply.

Fortunately the farmer was of a humorous turn and took the joke in good part.

"Tin peddlers," as they were called, were abundant in those days. They travelled through the country in covered wagons, filled with tin ware and small Yankee notions of almost every description,

including jewelry, dry goods, pins, needles, etc., etc. They were a sharp set of men, always ready for a trade whether cash or barter, and as they generally were destitute of moral principle, whoever dealt with them was pretty sure to be cheated. Dr. Carrington had frequently traded with them, and had just as frequently been shaved. He at last declared he would never again have any business transaction with that kind of people.

One day a peddler drove up to the doctor's store, and jumping from his wagon went in and told him he wished to barter some goods with him.

The doctor declined trading, quietly remarking that he had been shaved enough by tin peddlers, and would have nothing more to do with them.

"It is very hard to proscribe an entire class because some of its members happen to be dishonest," said the wary peddler, "and I insist on your giving me a trial. I am travelling all through the country, and can get rid of any of your unsaleable goods. So, to give you a fair chance, I will sell you any thing I have in my wagon at my lowest wholesale price, and will take in exchange any thing you please to pay me from your store at the retail price."

"Your offer seems a fair one," said the doctor, "and I will look over your goods."

He proceeded to the wagon, and seeing nothing that he wanted except a lot of whetstones, of which the peddler had a large quantity, he inquired the price.

"My wholesale price of whetstones is $3 per dozen," replied the peddler.

"Well, I will take a gross of them," said the doctor.

The twelve dozen whetstones were brought in, counted out, and carefully placed upon a shelf behind the counter.

"Now," said the peddler, "you owe me $36, for which I am to take such goods as you please at the retail price. Come, doctor, what are you going to pay me in?"

"In whetstones at fifty cents each, which will take just six dozen," replied the doctor gravely, at the same time commencing to count back one half of his purchase.

The peddler looked astonished for a moment, and then bursting into what is termed "a horse laugh," he exclaimed, "Took in, by hokey! Here, doctor, take this dollar for your trouble (handing him the money); give me back my truck, and I'll acknowledge for ever that you are too sharp for a tin peddler!"

The doctor accepted the proposed compromise, and was never troubled by that peddler again.

In those days politics ran high. There were but two parties, Democrats and Federalists. On one election day it was known that in Danbury the vote would be a very close one. Every voter was brought out. Wagons were sent into all parts of the town to bring in the "lame, halt, and blind" to cast their votes. The excitement was at its height, when a slovenly fellow who had just voted was heard to whisper to a friend, "I have voted once, and I would go and vote again if I thought the moderator would not know me."

"Go and wash your face, and nobody would know you again," said uncle Jabez Taylor, who happened to overhear the remark, and who was on the opposite political side.

My uncle, Colonel Starr Barnum, who is still living, was always famous for a dry joke. On one occasion he and my grandfather engaged in a dispute about the church. My grandfather had contributed largely towards building the Bethel "meeting-house," and twenty years afterwards, when he invited a clergyman of his own particular belief to preach there, the use of the house was refused him. He was indignant, and in this conversation with my uncle he became much excited, and said "the church might go to the devil."

"Come, come, my dear fellow; you are going a little too fast, my dear fellow," said the Colonel; "it don't happen to be your business to be sending folks to the devil in that way. You are a little too fast, my dear fellow."

The expression, "my dear fellow," was a favorite one with my uncle, and was used on all occasions.

In the course of their conversation the belligerents disputed about an ox-chain. Each claimed it as his own. Finally my grandfather seized it, and declaring that it was his, said that no person should have it without a law-suit.

"Take it and go to the devil with it," said the Colonel in a rage.

"Come, come, my dear fellow," said a neighbor who had heard all their conversation; "you are a little too fast, my dear fellow. You must not send Uncle Phin to the devil in that way, my dear fellow."

My uncle saw the force of the remark, and merely replied with a smile, "You must remember, my dear fellow, that he was sending a whole church to the devil, when I was sending only one man there. That, I take it, is a very different thing, my dear fellow."

The old Colonel, now over seventy years of age, still resides in Bethel. I called on him a few days since. He is quite infirm, but retains his vivacity in a great degree. I spent half an hour with him in talking over old times, and when about to leave, I said, "Uncle Starr, I want to come up and spend several days with you. I am collating facts for my autobiography, and I have no doubt you could remind me of many things that I would like to put into my book."

"I guess I could remind you of many things that you would *not* like to put in your book," grunted the old Colonel with a chuckle, which showed his love of the humorous to be as strong as ever.

My grandfather one day had a cord of hickory wood lying in front of his door. As he and 'Squire Ben Hoyt stood near it, a wood-chopper came along with an axe in his hand. Always ready for a joke, my grandfather said, "Ben, how long do you think it would take me to cut up that load of wood in suitable lengths for my fireplace?"

"I should think about five hours," said Ben.

"I think I could do it in four hours and a half," said my grandfather.

"Doubtful," said Ben; "hickory is very hard wood."

"I could do it in four hours," said the wood-chopper.

"I don't believe it," said Ben Hoyt.

"I do," replied my grandfather.

"I don't think any man could cut that wood in four hours," said 'Squire Ben, confidently.

"Well, I'll bet you a quart of rum this man can do it," said my grandfather.

"I will bet he can't," replied Ben, who now saw the joke.

The wood-chopper took off his coat and inquired the time of day

"Just nine o'clock," said my grandfather, looking through the window at his clock.

"Ten, eleven, twelve, one; if I get it chopped by one o'clock, you win your bet," said the wood-chopper, addressing my grandfather.

"Yes," was the response from both the bettors.

At it he went, and the chips flew thick and fast.

"I shall surely win the bet," said my grandfather.

"I don't believe it yet," said Esquire Hoyt.

Several of the neighbors came around, and learning the state of the case, made various remarks regarding the probable result.

Streams of perspiration ran down the wood-chopper's face, as he kept his axe moving with the regularity of a trip-hammer. My grandfather, to stimulate the zealous wood-cutter, gave him a glass of Santa Cruz and water. At eleven o'clock evidently more than half the wood-pile was cut. My grandfather expressed himself satisfied that he would win the bet.

Esquire Hoyt, on the contrary, insisted that the wood-chopper would soon begin to lag, and that he would give out before the wood was finished. These remarks, which of course were intended for the wood-cutter's ear, had the desired effect. The perspiration continued to flow, but the strength and vigor of the wood-cutter's arms exhibited no relaxation. The neighbors cheered him. His pile of wood was fast diminishing. It was half-past twelve, and only a few sticks were left. All at once a thought struck the wood-chopper. He stopped for a moment, and resting on his axe addressed my grandfather.

"Look here, who is going to pay me for cutting this wood?" said he.

"Oh, I don't know any thing about that," said my grandfather, with great gravity.

"Thunder! You don't expect I'm going to cut a cord of wood for nothing, do you?" exclaimed the wood-chopper indignantly.

"That's no business of mine," said my grandfather; "but really I hope you won't waste your time now, or I shall lose my bet."

"Go to blazes with your bet!" was the savage reply, and the wood-cutter threw his axe upon the ground.

The by-standers all joined in a hearty laugh, which increased the anger of the victim. They went to dinner, and when they returned he was sitting on the pile of wood, muttering vengeance against the whole village. After teasing him for an hour or two, my grandfather paid his demands.

The wood-chopper taking the money said: "That's all right, but I guess I shall know who employs me before I chop the next cord of wood."

An old gentleman lived in Bethel whom I will call "Uncle Reese." He was an habitual snuff-taker. He always carried a "bean" in his box, which, he insisted, imparted a much improved flavor to the snuff. "Uncle Reese" peddled clams, fish, etc., on the road from Norwalk to Danbury. On one occasion my grandfather, who was also a snuff-taker, borrowed the bean from him for a few days. In

the mean time the borrower whittled a piece of pine into the exact shape of the bean, and then taking it to a neighboring hat shop dropped it into the dye kettle, and thus colored it so that it was almost a fac-simile of the original bean. When Uncle Reese called for his treasure, my grandfather took from his snuff-box its wooden representative, and handed it over with many thanks.

Uncle Reese placed the imposition unsuspectingly into his snuff-box, and went on his way. He was just starting for Norwalk for a load of clams. Before he returned the next day, my grandfather had acquainted nearly all the town with the joke, in every case enjoining secresy. That caution was hardly necessary, for if there was ever a town where the inhabitants universally enjoyed a practical joke, that town was Danbury.

As Uncle Reese passed through Bethel and Danbury the next day, nearly every man, woman and child begged a pinch of snuff, and they all asked, as a particular favor, that it might be taken immediately under the bean, so as to secure some of the extra fragrance. The snuff-box was replenished several times that day. Many persons inquired of him what the properties of the bean were, where it came from, etc. He informed them that it grew on a tree in the East Indies, that it always imparted a peculiar and delightful flavor, and in fact that no snuff was fit for the human nose until it had been properly scented by the bean.

After the illusion had been kept up several days, my grandfather invited some twenty friends to dine with him the following week. "Uncle Reese" was one of the number, for the grand *dénouement* was appointed for that occasion. The fates were however against him. The victim came into our store to replenish his snuff-box. Dr. Orris Tyler Taylor, a most eccentric individual, (son of Uncle Samuel Taylor,) was present. He asked permission to examine the bean. Uncle Reese assured him it grew on a tree in the East Indies. The doctor run his knife through it, and the piece of pine wood, white as snow, was laid open to view.

"Uncle Reese" was astonished beyond measure. A roar of laughter which followed from all present, convinced him that there was a trick, and that all were in the secret. After a moment's reflection, he exclaimed, "That old sinner, Phin Taylor, did that!"

My grandfather was never forgiven to the day of his death. He also was sorely chagrined that he could not have been present when the joke was disclosed. He blamed the doctor very much for the premature exposure, and declared he would rather have lost

the best cow he owned, than to have had the secret divulged before the day of his dinner-party. I have no doubt he spoke the truth.

My father was brought to his bed with a severe attack of fever in March, and departed this life, I trust for a better world, on the 7th of September, 1825, aged 48 years.

I was then fifteen years of age. I stood by his bedside. The world looked dark indeed, when I realized that I was for ever deprived of my paternal protector! I felt that I was a poor inexperienced boy, thrown out on the wide world to shift for myself, and a sense of forlornness completely overcame me. My mother was left with five children. I was the oldest, and the youngest was only seven years of age. We followed the remains of husband and parent to their resting-place, and returned to our desolate home, feeling that we were forsaken by the world, and that but little hope existed for us this side the grave.

Administrators to the estate were appointed, and the fact was soon apparent that my father had not succeeded in providing any of this world's goods for the support of his family. The estate was declared *insolvent*, and it did not pay fifty cents upon a dollar. My mother, like many widows before her, was driven to many straits to support her little family, but being industrious, economical and persevering, she succeeded in a few years in redeeming the homestead and becoming its sole possessor. The few dollars which I had accumulated, I had loaned to my father, and held his note therefor, but it was decided that the property of a minor belonged to the father, and my claim was ruled out. I was subsequently compelled to earn as clerk in a store the money to pay for the pair of shoes that were purchased for me to wear at my father's funeral. I can truly say, therefore, that I began the world with nothing, and was barefooted at that.

I remained with Mr. Weed as clerk but a little longer, and then removed to "Grassy Plain," a mile north-west of the village of Bethel, where I engaged with James S. Keeler and Lewis Whitlock, as clerk in their store, at six dollars per month and my board – my mother doing my washing. I soon entered into speculations on my own account, and by dint of economy succeeded in getting a little sum of money ahead. I boarded with Mrs. Jerusha Wheeler and her daughters, Jerusha and Mary. As nearly everybody had a nick-name, the two former ladies were called "Rushia" – the old lady being designated "Aunt Rushia." They were an exceedingly nice and

worthy family, and made me an excellent home. I chose my uncle Alanson Taylor as my "guardian," and was guided by his counsel. I was extremely active as a clerk, was considered a 'cute trader, and soon gained the confidence and esteem of my employers. I remember with gratitude that they allowed me many facilities for earning money.

On one occasion a peddler called at our store with a large wagon filled with common green glass bottles of various sizes, holding from half a pint to a gallon. My employers were both absent, and I bantered him to trade his whole load of bottles in exchange for goods. Thinking me a greenhorn, he accepted my proposition, and I managed to pay him off in unsaleable goods at exorbitant prices. Soon after he departed, Mr. Keeler returned and found his little store half filled with bottles!

"What under heavens have you been doing?" said he in surprise.

"I have been trading goods for bottles;" said I.

"You have made a fool of yourself," he exclaimed, "for you have bottles enough to supply the whole town for twenty years."

I begged him not to be alarmed, and promised to get rid of the entire lot within three months.

"If you can do that," said he, "you can perform a miracle."

I then showed him the list of goods which I had exchanged for the bottles, with the extra prices annexed, and he found upon figuring that I had bartered a lot of worthless trash at a rate which brought the new merchandise to considerably less than one-half the wholesale price. He was pleased with the result, but wondered what could be done with the bottles. We stowed away the largest portion of them in the loft of our store.

My employers kept what was called a *barter* store. Many of the hat manufacturers traded there and paid us in hats, giving "store orders" to their numerous employees, including journeymen, apprentices, female hat trimmers, etc., etc. Of course we had a large number of customers, and I knew them all intimately.

I may say that when I made the bottle trade I had a project in my head for selling them all, as well as getting rid of a large quantity of tinware which had been in the store for some years, and had become begrimed with dirt and fly-specks. That project was a *lottery*. On the first wet day, therefore, when there were but few customers, I spent several hours in making up my scheme. The highest prize was $25, payable in any kind of goods the customer desired. Then

I had fifty prizes of $5 each, designating in my scheme what goods each prize should consist of. For instance, one $5 prize consisted of one pair cotton hose, one cotton handkerchief, two tin cups, four pint glass bottles, three tin skimmers, one quart glass bottle, six tin nutmeg graters, eleven half-pint glass bottles, etc., etc. – the glass and tinware always forming the greater portion of each prize. I had one hundred prizes of one dollar each, one hundred prizes of fifty cents each, and three hundred prizes of twenty-five cents each. There were one thousand tickets at fifty cents each. The prizes amounted to the same as the tickets – $500. I had taken an idea from the church lottery, in which my grandfather was manager, and had many prizes of only half the cost of the tickets. I headed the scheme with glaring capitals, written in my best hand, setting forth that it was a "MAGNIFICENT LOTTERY!" "$25 FOR ONLY 50 CTS.!!" "OVER 550 PRIZES!!!" "ONLY 1000 TICKETS!!!!" "GOODS PUT IN AT THE LOWEST CASH PRICES!!!!!" etc., etc., etc.

The tickets went like wildfire. Customers did not stop to consider the nature of the prizes. Journeymen hatters, boss hatters, apprentice boys, and hat trimming girls bought tickets. In ten days they were all sold. A day was fixed for the drawing of the lottery, and it came off punctually, as announced.

The next day, and for several days thereafter, adventurers came for their prizes. A young lady who had drawn five dollars would find herself entitled to a piece of tape, a spool of cotton, a paper of pins, sixteen tin skimmers, cups, and nutmeg graters, and a few dozen glass bottles of various sizes! She would beg me to retain the glass and tinware and pay her in some other goods, but was informed that such a proceeding would be contrary to the rules of the establishment and could not be entertained for a moment.

One man would find all his prizes to consist of tinware. Another would discover that out of twenty tickets, he had drawn perhaps ten prizes, and that they consisted entirely of glass bottles. Some of the customers were vexed, but most of them laughed at the joke. The basket loads, the arms full, and the bags full of soiled tin and glass bottles which were carried out of our store during the first few days after the lottery drawing, constituted a series of most ludicrous scenes. Scarcely a customer was permitted to depart without one or more specimens of tin or green glass. Within ten days every glass bottle had disappeared, and the old tinware was replaced by a smaller quantity as bright as silver.

My uncle Aaron Nichols, husband of my aunt Laura, was a

hat manufacturer on a large scale in Grassy Plains. His employees purchased quantities of tickets. He bought twelve, and was very lucky. He drew seven prizes. Unfortunately they were all to be paid in *tin!* He took them home one day in his wagon – looking like a tin peddler as he went through the street. Two days afterwards aunt Laura brought them all back.

"I have spent six hours," said she, "in trying to rub some of this tin bright, but it is impossible. I want you to give me some other goods for it." I told her it was quite out of the question.

"What on earth do you suppose I can do with all this black tin?" said she.

I replied that if my uncle Nichols had the good fortune to draw so many prizes, it would be presumption in me to dictate what use he should make of them.

"Your uncle is a fool, or he would never have bought any tickets in such a worthless lottery," said she.

I laughed outright, and that only added to her vexation. She called me many hard names, but I only laughed in return.

Finally, says I, "Aunt Laura, why don't you take some of your tin over to 'Aunt Rushia?' I heard her inquiring this morning at the breakfast table where she could buy some tin skimmers."

"Well, I can supply her," said my aunt Laura, taking half-a-dozen skimmers and an assortment of other articles in her apron and proceeding at once to my boarding-house across the street.

"Aunt Rushia," said she, as she entered the door, "I have come to sell you some tin skimmers."

"Mercy on us!" exclaimed "Aunt Rushia," "I have got skimmers enough."

"Why, Taylor Barnum told me you wanted to buy some," said aunt Laura in surprise.

"I am afraid that boy is a mischievous young joker," said aunt Rushia, laughing; "he did that to plague me, for I drew seven skimmers in the lottery."

Aunt Laura returned more vexed than ever. She emptied the whole lot of tin upon the floor of the store, and declared she would never have it in her house again. She returned home.

I immediately dispatched the lot of tin to her house in a wagon. It reached there before she did, and when she entered her kitchen she found the tinware piled up in the middle of the room, with the following specimen of my poetry dangling from the handle of a tin coffee-pot:

"There was a man whose name was Nick,
He drew seven prizes very slick;
For the avails he took tinware,
Which caused his wife to fret and swear."

It was several weeks before my aunt Laura forgave me the joke. At about that period, however, she sent me a mince pie nicely covered over in clean white paper, marked on the outside, "A mince pie for Taylor Barnum."

I was delighted. I cut the string which surrounded it and took off the paper. The pie was baked in one of the unwashed tin platters! Of course I could not eat it, but it was an evidence to me of reconciliation, and that afternoon I took tea with my aunt, where I had enjoyed many an excellent meal before, and have done the same thing scores of times since.

My grandfather enjoyed my lottery speculation very much, and seemed to agree with many others, who declared that I was indeed "a chip of the old block."

Occasionally some one of my school-mates in Bethel would visit me in the evening, and sleep with me at my boarding-house. James Beebe, a boy of my own age, once came for that purpose. One of our nearest neighbors was Mr. Amos Wheeler, son of the widow, "Aunt Jerusha." As he and his wife were absent that night, they had arranged that I should sleep in their house, so as not to have their children left alone. I took my chum Jim Beebe with me, as a fellow-lodger. Several days afterwards Jim called on me and said that in dressing himself in the morning, at Mr. Wheeler's, he had put on the wrong stockings. Instead of getting his own, which were a new pair, he had got an old pair belonging to Mr. Wheeler. They were distinctly marked "A. W." I told him the only way was for him to return to Mrs. Wheeler her husband's stockings, and explain to her how the mistake had been made. He did so, and soon returned in a high state of anger. He called Mrs. Wheeler all sorts of hard names. It seems that she examined the old stockings, and notwithstanding the initials of her husband's name, "A. W.," were worked into the top of them, she denied that they were his, and of course denied having any stockings in her possession belonging to Jim Beebe.

I confess I thought her conduct was unaccountable. It was difficult to believe that for the sake of a pair of stockings she would

state an untruth, and yet it was evident that "A.W." were not the initials of James Beebe's name, and that they were the initials of Amos Wheeler. Jim declared that he discovered his mistake on the very day that he dressed himself at Amos Wheeler's house, and of course Mrs. Wheeler must be mistaken. I showed the stockings to Mr. Wheeler. He did not know so much about his wardrobe as his wife did, but he said he was sure his wife could not be mistaken. Of course we were just as confident that she was mistaken. There could be no doubt about it, but Jim was compelled to take home the old stockings. I was considerably vexed by the circumstance. Jim was downright mad, and declared he would not sleep in Grassy Plains again under any consideration, lest the women might steal all his clothes, and claim them as their own.

I met him a week afterwards, and commenced laughing at him about his old stockings.

"Oh, that is all right," said he. "You see I happened to sleep with John Williams a night or two before I slept with you, and as all the Williams boys slept in the same room, I got the wrong pair of stockings. John Williams met me a few days ago and told me his brother Adam had a pair of stockings with my initials marked on them, and he concluded therefore that I had worn *his* and left mine by mistake. I called on Adam, and found that it was as he suspected."

So it seemed that the A. W. stood for Adam Williams, instead of Amos Wheeler, and that Mrs. Wheeler was right after all. It certainly was a singular coincidence, and made a strong impression on my mind. I have many a time since that simple event reflected that scores, probably hundreds of innocent men have been executed on circumstantial evidence less probable than that which went to prove Amos Wheeler to be the owner of the old stockings bearing his initials.

On Saturday nights I usually went to Bethel to remain with my mother and attend church on the Sabbath. My mother continued for some years to keep the village tavern. One Saturday evening a violent thunder shower came up; it was very dark, and rained in torrents, with occasional intervals of a few minutes. Miss Mary Wheeler (who was a milliner) sent word across to the store that there was a girl at her house from Bethel, who had come up on horseback to obtain her new bonnet, that she was afraid to return home alone, and if I was going to Bethel on horseback that night, she wished me to escort her customer. I assented, and in a few

minutes my horse was at "Aunt Rushia's" door. I went in, and was introduced to a fair, rosy-cheeked, buxom-looking girl, with beautiful white teeth, named "Chairy Hallett." Of course "Chairy" was a nickname, which I subsequently learned meant "Charity."

I assisted the young lady into her saddle, was soon mounted on my own horse, and we trotted slowly towards Bethel.

The brief view that I had of this girl by candle-light, had sent all sorts of agreeable sensations through my bosom. I was in a state of feeling quite new to me, and as unaccountable as it was novel. I opened a conversation with her, and finding her affable and in no degree prim or "stuck-up," (although she was on horseback,) I regretted that the distance to Bethel was not five miles instead of one. A vivid flash of lightning at that moment lighted up the horizon, and gave me a fair view of the face of my interesting companion. I then wished the distance was twenty miles at the least. I was not long in learning that she was a tailoress, working with Mr. Zerah Benedict, of Bethel. The tailoring trade stood much higher in my estimation from that moment than it ever did before. We soon arrived at Bethel, and bidding my fair companion good night, I went to my mother's. That girl's face haunted me in my dreams that night. I saw her the next day at church, and on every subsequent Sunday for some time, but no opportunity offered that season for me to renew the acquaintance.

Messrs. Keeler and Whitlock sold out their store of goods to Mr. Lewis Taylor in the summer of 1827. I remained a short time as clerk for Mr. Taylor. They have a proverb in Connecticut, that "the best school in which to have a boy learn human nature, is to permit him to be a tin peddler for a few years." I think his chances for getting "his eye-teeth cut" would be equally great, in a country barter store like that in which I was clerk. As before stated, many of our customers were hatters, and we took hats in payment for goods. The large manufacturers generally dealt preety fairly by us, but some of the smaller fry occasionally shaved us prodigiously. There probably is no trade in which there can be more cheating than in hats. If a hat was damaged "in coloring" or otherwise, perhaps by a cut of half a foot in length, it was sure to be patched up, smoothed over, and slipped in with others to send to the store. Among the furs used for the nap of hats in those days, were beaver, Russia, nutria, otter, coney, muskrat, etc., etc. The best fur was otter, the poorest was coney.

The hatters mixed their inferior furs with a little of their best, and sold us the hats for "otter." We in return mixed our sugars, teas, and liquors, and gave them the most valuable names. It was "dog eat dog" – "tit for tat." Our cottons were sold for wool, our wool and cotton for silk and linen; in fact nearly every thing was different from what it was represented. The customers cheated us in their fabrics: we cheated the customers with our goods. Each party expected to be cheated, if it was possible. Our eyes, and not our ears, had to be our masters. We must believe little that we saw, and less that we heard. Our calicoes were all "fast colors," according to our representations, and the colors would generally run "fast" enough and show them a tub of soap-suds. Our ground coffee was as good as burned peas, beans, and corn could make, and our ginger was tolerable, considering the price of corn meal. The "tricks of trade" were numerous. If a "peddler" wanted to trade with us for a box of beaver hats worth sixty dollars per dozen, he was sure to obtain a box of "coneys" which were dear at fifteen dollars per dozen. If we took our pay in clocks, warranted to keep good time, the chances were that they were no better than a chest of drawers for that purpose – that they were like Pindar's razors, "made to sell," and if half the number of wheels necessary to form a clock could be found within the case, it was as lucky as extraordinary.

Such a school would "cut eye-teeth," but if it did not cut conscience, morals, and integrity all up by the roots, it would be because the scholars quit before their education was completed!

On one occasion, a hatter named Walter Dibble called to buy some furs from us. For certain reasons I was anxious to play a joke upon him. I sold him several kinds of fur, including "beaver" and "coney." He wanted some "Russia." I told him we had none, but Mrs. Wheeler, where I boarded, had several hundred pounds.

"What on earth is a woman doing with 'Russia?'" said he.

I could not answer, but I assured him that there were 130 pounds of old Rushia, and 150 pounds of young Rushia in Mrs. Wheeler's house, and under her charge, but whether it was for sale I could not say.

Off he started with a view to make the purchase. He knocked at the door. Mrs. Wheeler, the elder, made her appearance.

"I want to get your Russia," said the hatter.

Mrs. Wheeler asked him to walk in and be seated. She of course supposed that he had come for her daughter "Rushia."

"What do you want of Rushia?" asked the old lady.

"To make hats," was the reply.

"To trim hats, I suppose you mean?" responded Mrs. Wheeler.

"No, for the outside of hats," replied the hatter.

"Well, I don't know much about hats," said the old lady, "but I will call my daughter."

Passing into another room where "Rushia" the younger was at work, she informed her that a man wanted her to make hats.

"Oh, he means sister Mary, probably. I suppose he wants some ladies' hats," replied Rushia, as she passed into the parlor.

"This is my daughter," said the old lady.

"I want to get your Russia," said he, addressing the young lady.

"I suppose you wish to see my sister Mary; she is our milliner," said the young Rushia.

"I wish to see whoever owns the property," said the hatter.

Sister Mary was sent for, and soon made her appearance. As soon as she was introduced, the hatter informed her that he wished to buy her "Russia."

"Buy Rushia!" exclaimed Mary in surprise; "I don't understand you."

"Your name is Miss Wheeler, I believe," said the hatter, who was annoyed by the difficulty he met in being understood.

"It is, sir."

"Ah! very well. Is there old and young Russia in the house?"

"I believe there is," said Mary, surprised at the familiar manner in which he spoke of her mother and sister, both of whom were present.

"What is the price of old Russia per pound?" asked the hatter.

"I believe, sir, that old Rushia is not for sale," replied Mary indignantly.

"Well, what do you ask for young Russia?" pursued the hatter.

"Sir," said Miss Rushia the younger, springing to her feet, "do you come here to insult defenceless females? If you do, sir, we will soon call our brother, who is in the garden, and he will punish you as you deserve."

"Ladies!" exclaimed the hatter, in astonishment, "what on earth have I done to offend you? I came here on a business matter. I want to buy some Russia. I was told you had old and young Russia in the house. Indeed, this young lady just stated such to be the fact, but she says the old Rushia is not for sale. Now, if I can buy the young Russia I want to do so – but if that can't be done, please to say so and I will trouble you no farther."

"Mother, open the door and let the gentleman pass out; he is undoubtedly crazy," said Miss Mary.

"By thunder! I believe I shall be if I remain here long," exclaimed the hatter, considerably excited. "I wonder if folks never do *business* in these parts, that you think a man is crazy if he attempts such a thing?"

"Business! poor man," said Mary soothingly, approaching the door.

"I am not a poor man, madam," replied the hatter. "My name is Walter Dibble; I carry on hatting extensively in Danbury; I came to Grassy Plains to buy fur, and have purchased some 'beaver' and 'coney,' and now it seems I am to be called 'crazy' and a 'poor man,' because I want to buy a little 'Russia' to make up my assortment."

The ladies began to open their eyes a little. They saw that Mr. Dibble was quite in earnest, and his explanation threw considerable light upon the subject.

"Who sent you here?" asked sister Mary.

"The clerk at the store opposite," was the reply.

"He is a wicked young fellow for making all this trouble," said the old lady. "He has been doing this for a joke," she continued.

"A joke!" exclaimed Dibble, in surprise. "Have you not got any Russia, then?" he asked.

"My name is Jerusha, and so is my daughter's," said Mrs. Wheeler, "and that, I suppose, is what he meant by telling you about old and young Rushia."

Mr. Dibble bolted through the door without a word of explanation, and made directly for our store. "You young scamp!" said he, as he entered; "what did you mean by sending me over there to buy Russia?"

"I did not send you to *buy* Rushia. I supposed you were either a bachelor or widower, and wanted to *marry* Rushia," I replied, with a serious countenance.

"You lie, you young dog, and you know it," he replied; "but never mind, I'll pay you off for that, some day;" and taking his furs, he departed with less ill-humor than could have been expected under the circumstances.

"As drunk as a hatter" has long since passed into a proverb. There were some sober hatters in the times of which I write, but there were also many drinking ones. The hatters from out of town bought their rum by the keg or barrel, while those on Grassy Plains kept a

man whose almost sole duty it was to go to and from the store and shops with half a dozen rum-bottles of various sizes. Some of these bottles were replenished several times in a day. My business, of course, included the filling of rum-bottles. I suppose I have drawn and bottled more rum than would be necessary to float a ship.

As it required a man of no superior intelligence to be a liquor carrier, the personage filling that office was usually a half-witted sort of fellow, or sometimes a broken-down toper, whose honor could be relied on not to drink until he had arrived at the hat shops with his precious burdens. The man who carried the bottles from the local hat shops the season I lived there was nicknamed "Soft Case." He did not resent this title, when used by the journeymen and other men, but would not permit the boys to make use of the epithet. He was a harmless sort of chap, usually about half drunk, with just about brains enough to fill the station to which he was appointed. His name was Jacob, and by this name I usually addressed him; but coming in one day while I was in a hurry, I called out, "Well, Soft Case, what kind of liquor do you want today?"

"Don't call me Soft Case," said he, indignantly; "I'll not allow it. I want you to understand, sir, that I am as hard a case as you or anybody else."

Among our customers were several old Revolutionary pensioners, who usually traded out the amounts of their pensions before they were due, leaving their pension papers with us as security. It was necessary for us, however, in order to obtain the pension money, that the pensioner should appear before the pension agent when his money was due, and sign a receipt therefor. As some of these old men were pretty hard drinkers, it behooved us not to suffer them to trade out all their pension long before it was due, as instances had been known where they had refused to appear and sign their names unless their creditor would present them with a handsome bonus.

The name of one of our pensioners was Bevans. His nickname was "Uncle Bibbins." He loved his glass, and was excessively fond of relating apocryphal Revolutionary adventures. We could hardly name a battle which he had not been in, a fortress which he had not helped to storm, nor any remarkable sight which he had not seen.

"Uncle Bibbins" had nearly used up his pension in trade at our store. We held his papers, but three months were to elapse before he could draw his money. We desired to devise some plan

to get him away for that length of time. He had relations in Guilford, and we hinted to him that it would be pleasant for him to spend a few months with his Guilford friends, but he did not seem inclined to go. I finally hit upon an expedient that I thought would effect our design.

A journeyman hatter, named Benton, worked for my uncle Nichols. He was fond of a joke. I induced him to call "Uncle Bibbins" a coward, tell him he had been wounded in the back, etc., and thus provoke a duel. He did so, and at my suggestion "Uncle Bibbins" challenged Benton to fight him with musket and ball at a distance of twenty yards.

The challenge was accepted, I was chosen second by "Uncle Bibbins," and the duel was to come off immediately. My principal, taking me aside, begged me to put nothing in the guns but blank cartridges. I assured him it should be so, and therefore that he might feel perfectly safe. This gave the old man extra courage, and caused him to brag tremendously. He declared that he had not been so long in bloody battles for nothing, and that he would put a bullet through Benton's heart at the first shot.

The ground was measured in the lot at the rear of our store, and the principals and seconds took their places. At the word given both parties fired. "Uncle Bibbins," of course, escaped unhurt, but Benton leaped several feet into the air, and fell upon the ground with a dreadful yell, as if he had been really shot. "Uncle Bibbins" was frightened. As his second I ran to him, told him that in my hurry to take the ball from Benton's gun, I had by some mistake neglected to extract the bullet from *his*, and that he had undoubtedly killed his adversary. I then whispered to him to go immediately to Guilford, to keep quiet, and he should hear from me as soon as it would be safe to do so. He started up the street on a run, and immediately quit the town for Guilford, where he kept himself quiet until it was time for him to return and sign his papers. I then wrote him that "he could return in safety, that almost miraculously his adversary had recovered from his wound, and now forgave him all, as he felt himself much to blame for having in the first place insulted a man of his known courage."

"Uncle Bibbins" returned, signed the papers, and we obtained the pension money. A few days thereafter he met Benton.

"My brave old friend," said Benton, "I forgive you my terrible wound and long confinement on the very brink of the grave, and I beg of you to forgive me also. I insulted you without a cause."

"I forgive you freely," said "Uncle Bibbins;" "but," he continued, "you must be careful next time how you insult a dead shot."

Benton promised to be more circumspect in future, and "Uncle Bibbins" supposed to the day of his death that the duel, wound, blood and all, was a plain matter of fact.

Perhaps I should apologize for devoting so much space, as I have done in the foregoing pages, to practical jokes and other incidents not immediately relating to myself. I was born and reared in an atmosphere of merriment; my natural bias was developed and strengthened by the associations of my youth; and I feel myself entitled to record the sayings and doings of the wags and eccentricities of Bethel, because they partly explain the causes which have made me what I am.

CHAPTER VI

Incidents and Various Schemes

In the autumn of 1826 Mr. Oliver Taylor, who had removed from Danbury to Brooklyn, Long Island, a few years previously, offered me the position of clerk in his grocery store. He had also a large comb factory in Brooklyn and a comb store in New York. I accepted Mr. Taylor's offer. The store was at the corner of Sands and Pearl streets.

Many of our customers were early ones, to buy articles for their breakfasts, and I was obliged to rise before daylight. This was

so different from my previous habits, that I had much difficulty in waking in the morning. To aid me in my endeavors at diligence, I arranged with a watchman, at two shillings per week, to pull a string which hung out of my chamber-window in the third story, one end being fastened to my big toe.

The arrangement fully answered the purpose, but Mr. Taylor became acquainted with it, through the watchman I believe; and on one occasion there was a more violent pulling than I had bargained for. I howled with pain, ran to the window, and bade the watchman desist, else he would pull my toe off. Not suspecting a trick, I dressed myself, went down stairs, and discovered that it was only half-past twelve o'clock! It was a long time before I ascertained who my tormentor was, though I might reasonably have suspected Oliver; but after that adventure I managed to wake without assistance, and discharged the watchman *in toto*.

I had not been long in Mr. Taylor's employment before I became conversant with the routine of the business, and the purchasing of all the goods for the store was soon intrusted to me. I bought for cash entirely, and thus was enabled to exercise my judgment in making purchases – sometimes going into all sections of the lower part of the city in search of the cheapest markets for groceries. I also frequently attended the wholesale auctions of teas, sugars, molasses, etc., so that by watching the sales, noting the prices, and recording the names of buyers, I knew what profits they were realizing, and how far I could probably beat them down for cash. At these auctions I occasionally made the acquaintance of several grocers who wanted small lots of the goods offered for sale, and we frequently clubbed together and bid off a lot which, being divided between us, gave each about the quantity he desired, and at a reduced price from what we should have been compelled to pay if the goods had passed into other hands and thus been taxed with another profit.

My employer manifested great interest in me, and treated me with the utmost kindness, but the situation did not suit me. The fact is, there are some persons so constituted that they can never be satisfied to labor for a fixed salary, let it be never so great. I am one of that sort. My disposition is, and ever was, of a speculative character, and I am never content to engage in any business unless it is of such a nature that my profits may be greatly enhanced by an increase of energy, perseverance, attention to business, tact, etc. As therefore I had no opportunity to speculate on my own

account in this Brooklyn store, I soon became uneasy. Young as I was, (and probably because I was so young,) I began to think seriously of going into business for myself, and although I had no capital to start on, several men of means had offered to furnish the money and join me in business. I was just then at an uneasy age – in a transition state – neither boy nor man – an age when it is of the highest importance that a youth should have some discreet friend and instructor on whose good counsel he can rely. How self-conceited, generally, are boys from sixteen to eighteen years old. They feel that they are fully competent to transact business which persons much older than they, know requires many years' experience. This is the age, too, when the "eighteen-year-old fever" is apt to make fools of young men in other than a business point of view. Boys of this age, and girls of twelve to sixteen, are undoubtedly the most disagreeable persons in the world. They are so wild, so stubborn and self-sufficient, that reflecting parents have great reason for deep anxiety as to the "turn" which they may take.

In the summer of 1827 I caught the small-pox, which, although I had been vaccinated successfully some eight years previously, assumed a very severe type of varioloid. This confined me to the house for several months. The expense attending my sickness made a sad inroad upon my funds. As soon as I was sufficiently recovered, I started for home to spend a few weeks in recruiting my health, taking passage on board a sloop for Norwalk. When the passengers, numbering twenty ladies and gentlemen, came on board, they were frightened at the appearance of my face, which still bore strong marks of the disease from which I had just recovered. By an unanimous vote I was requested to go on shore, and Captain Munson Hoyt, whom I well knew, having been in the habit of visiting his sloop weekly for the purchase of butter, eggs, etc., informed me that he was pained in conveying to me the wishes of the affrighted passengers. Of course I felt compelled to comply, and left the sloop with a heavy heart. I lodged that night at Holt's old hotel in Fulton street, and the next morning went to Norwalk by steamboat, reaching Bethel the same afternoon.

I spent several weeks with my mother, who was unremitting in her exertions to make me comfortable. During my convalescence I visited my old schoolmates and neighbors generally, and had several opportunities of slightly renewing the short acquaintance

which I had formed with the attractive tailoress "Chairy Hallett," while escorting her on horseback, from Grassy Plains to Bethel, in the thunder shower. These opportunities did not lessen the regard which I felt for the young lady, nor did they serve to render my sleep any sounder. However, "I did not tell my love," and the "worm in the bud" did not feed on my "pock-marked cheek."

At the end of four weeks I again left the maternal roof and departed for Brooklyn. In a short time I made arrangements for opening a porter-house on "my own hook," in the neighborhood of the grocery store; and, giving Mr. Taylor the requisite notice of my desire to leave his employment, he engaged a practised hand as my successor, and I opened the porter-house. Within a few months I found an opportunity of selling out to advantage, and as I had a good offer to engage as clerk in a similar establishment kept by Mr. David Thorp, 29 Peck Slip, New York, I sold out and removed thither. Mr. Thorp's place was a great resort of the Danbury and Bethel comb-makers, hatters, etc., and this giving me a constant opportunity of seeing my townsmen, made it very agreeable. I boarded in Mr. Thorp's family, who used me very kindly. He allowed me frequent opportunities of visiting the theatre with such of my companions as came to New York. I had much taste for the drama – soon became, in my own opinion, a close critic, and did not fail to exhibit my powers in this respect to all the juveniles from Connecticut who accompanied me to the theatre.

My habits generally were not bad. Although constantly engaged in selling liquor to others, I probably never drank a pint of liquor, wine, or cordials, before I was twenty-two years of age. I always attended church regularly, and was never without a Bible in my trunk, which I took frequent occasion to read.

In February, 1828, my grandfather wrote me that if I would come to Bethel and establish some kind of business for myself, he would allow me to occupy, rent free, one half of his carriage-house. I had a strong desire to return to my native village, and after several weeks' reflection I accepted his offer.

The carriage-house referred to was situated on the public street in Bethel, and I concluded to finish off one part of it, and open a retail fruit and confectionery store. Before leaving New York, I consulted several fruit dealers with whom I was acquainted, and made arrangements for sending them my orders. I then went

to Bethel, arranged the building, put in a small stock of goods, including a barrel of ale, and opened my establishment on the first Monday morning in May, 1828, that being our military training day.

The hopes and fears which agitated me for weeks previously to this my first grand opening, have probably never had a parallel in all my subsequent adventures. I was worth about one hundred and twenty dollars, and I invested all I possessed in this enterprise. It cost me fifty dollars to fit up my little store, and seventy dollars more purchased my stock in trade. I am suspicious that I received little good from attending church the day previously to opening my store, for I distinctly remember being greatly exercised in mind for fear it would rain the next day, and thus diminish the number of customers for my cakes, candies, nuts, raisins, etc.

I was up betimes on Monday morning, and was delighted to find the weather propitious. The country people began to flock into the village at an early hour, and the novelty of my little shop, which was set out in as good style as I was capable of, attracted their attention. I soon had plenty to do, and before noon was obliged to call in one of my old school-mates to assist me in waiting upon my numerous customers. Business continued brisk during the whole day and evening, and when I closed I had the satisfaction of counting out sixty-three dollars as my day's receipts! My entire barrel of ale was sold, but the assortment of other goods was not broken up, nor apparently very seriously diminished, so that although I had received the entire cost of my goods, less seven dollars, the stock on hand showed that my profits had been excellent.

I need not attempt to relate how gratified I was by the result of my first day's experiment. I considered my little store as a "fixed fact," and such it proved to be. I put in another barrel of ale, and proceeding to New York, expended all of my money for a small stock of fancy goods, and such articles as I thought would find a ready sale. My assortment included pocket-books, combs, beads, cheap finger-rings, pocket-knives, and a few toys. My business continued good during the summer, and in the fall I added stewed oysters to my assortment.

My grandfather had great pleasure in my success, and advised me to take the agency of some lottery dealer for the sale of lottery tickets on commission. Lotteries were at that time legal in Connecticut, and were generally considered as legitimate a branch of business as any other. I therefore adopted my grandfather's advice,

and obtained an agency for selling lottery tickets on a commission of ten per cent. This business, connected with the fruit, confectionery, oyster, and toy establishment, rendered my profits quite satisfactory.

On one occasion a young man of my acquaintance called to examine some pocket-books. He inquired the prices, and finally selected one that pleased him. He said he would take it, but he desired me to give him a credit on it for a few weeks. I told him that had he wanted any article of necessity which I had for sale, I would not object to trusting him a short time, but it struck me that a pocket-book was something of a superfluity for a person who had no money. He replied that it did not strike him in that light, and that he did not see why it was not as proper to seek credit for a pocket-book as for any thing else. He however failed to convince me of the necessity of his possessing such an article until he had something to put into it, and I therefore declined his proposition.

My little store became a favorite resort for the men in our village, and many is the good practical joke that was enacted there.

Danbury is situated about eight miles east of the line which separates the State of Connecticut from that of New York. Several eccentric individuals from "York State" were in the habit of visiting Bethel. Among these was a gray-headed old miller whom I will call Crofut. Another was Mr. Hackariah Bailey, always for short called "Hack Bailey." Crofut was a very profane man. Almost every other word was an oath. He had become so confirmed in a habit of swearing, that he was quite unaware of the extent of his profanity. He was a man of wealth. He generally visited Bethel to dispose of wheat-flour, bringing it in bags piled up to the very top of a large wagon, drawn by a pair of splendid horses. Crofut and Bailey were both self-willed men. When their minds were made up, there was no turning them. Hack Bailey was a showman. He imported the first elephant that was ever brought to this country, and made a fortune by exhibiting it. He was afterwards extensively engaged in travelling menageries, and subsequently was very successful in running opposition steamboats upon the North River. He built a fine hotel in Somers, N. Y., the place of his residence, called it the Elephant Hotel, and erected a large stone pillar in front of it, on which he placed a golden elephant.

One day, Crofut was in my little store, engaged in conversation with many of our neighbors, who were always sure to

congregate about him whenever he came to the village. His language as usual partook largely of the profane. Nathan Seelye, Esq., one of our village justices of the peace, who was a strict man in his religious principles, came in, and hearing the conversation told Mr. Crofut that he considered it his duty to fine him one dollar for swearing.

Crofut responded immediately with an oath, that he did not care a d – n for the Connecticut blue-laws.

"That will make two dollars," said Mr. Seelye.

This brought forth another oath.

"Three dollars," said the sturdy justice.

Nothing but oaths were given in reply, until Esquire Seelye declared the damage to the Connecticut laws to amount to fifteen dollars.

Crofut took out a twenty-dollar bill, and handed it to the justice of the peace, with an oath.

"Sixteen dollars," said Mr. Seelye, counting out four dollars to hand to Mr. Crofut, as his change.

"Oh, keep it, keep it," said Crofut, "I don't want any change, I'll d—n soon swear out the balance" – and he did so, after which he was more circumspect in his conversation, remarking that twenty dollars a day for swearing was about as much as he could stand.

"Hack Bailey," after making many thousand dollars by the exhibition of his elephant, concluded to take the world a little easier, and in order to avoid the necessity of travelling any more through the country, he sold one half of his interest in the animal to a showman, who agreed to exhibit the elephant and account to Hack for one half the receipts.

After the partner had been absent some weeks, Hack began to look with some anxiety for a remittance. Nothing came, however, and he wrote to his partner to inquire the cause. He received no reply. At last, becoming impatient, he took the stage to Boston, and in the course of a few days overtook his partner at New Bedford, Mass. Hack asked him why he had not remitted his portion of the profits. He was assured, in reply, that there were no profits, that the expenses swallowed them all, etc.

Hack knew better than this, for he had heard that the elephant had drawn large crowds wherever he went, and he saw that many hundreds of persons visited the exhibition in New Bedford. He therefore insisted on a settlement.

"I will settle with you when I return next fall; I have no time now," replied the stubborn partner.

This reply strengthened Hack's conviction that his chance for the profits under the present management was a very slim one. He then offered to sell his interest in the elephant to his partner.

"I have elephant stock enough now," was the reply.

"Well, I will buy out your interest," said Hack.

"No, I thank you, I don't care about selling; I am very well satisfied as it is."

"But I am not," replied Hack, "and I won't stand it. You shall not travel any longer in charge of this elephant as long as I own any interest in him."

"I would like to see you prevent it. Our written contract stipulates that I am to have charge of the elephant, and next fall we are to settle up," replied the partner.

"But it also stipulates that you are to remit me one half of the profits as fast as they accrue," replied Hack.

"Yes, and no faster. I tell you there are no profits," responded the partner.

Hack grew more indignant. "Will you sell your half of the elephant?" he asked.

"No," was the reply.

"Will you buy my half?"

"No."

"Then you go no farther with the animal," replied Hack.

"I know the law, and defy you to try it," responded the partner.

"I'll try something that will be effectual, as I am a living man," said Hack, who now felt the lion fairly aroused within him.

"Try what you please," was the reply.

The next morning at daylight the partner went to the barn to take the elephant, which was to be led to the next town. He found Hack Bailey standing at the elephant's side with a loaded rifle.

"Don't you touch that animal quite yet," said Hack, raising his rifle.

"Mr. Bailey, do you mean to kill me?" cried the affrighted partner.

"No, sir," replied Mr. Bailey, "I mean to do nothing but what is lawful. I came here to get my rights. You refuse them to me. You ought to know me better than to suppose you can impose upon me any longer. You have refused to buy or sell – now you may do what

you please with your half of that elephant, but I am fully determined *to shoot my half!*"

The man knew that there was no back-out in the character of Hack Bailey, and he saw also that he was never more in earnest in his life. Hack raised the rifle to his shoulder and pointed it towards the elephant.

"Stop, stop, and I'll settle," exclaimed the partner with a look of horror.

"Oh, no, you won't," said Hack, proceeding to take aim.

"I will, upon honor," was the earnest reply.

Hack lowered his rifle, and within half an hour afterwards he had sold his half of the elephant to his partner for a good round price, and the animal thus escaped having the life taken out of at least one half of him.

My grandfather, being a Justice of the Peace, frequently had to sit in judgment upon civil and criminal suits. On one occasion a man was arrested on a grand jury complaint for assault and battery. The case was to be tried before my grandfather. A young medical student named Newton was boarding at my mother's, and he volunteered to defend the prisoner. Of course pettifogging was new business to Newton, but he thought it would be a good chance to show off his talents to our villagers. Mr. Couch, the grand-jury man, came to me and said that inasmuch as a pettifogger was engaged by the prisoner, he thought the State ought to have some person to defend its interest, and he would give me a dollar if I would go in and argue the case of the State before the Justice. Nothing loth, I accepted the proposition and received my fee in advance.

The fact of two such "eminent counsel" being engaged, drew in crowds from the hat shops and other portions of the village. The guilt of the prisoner was established by the direct evidence of half a dozen witnesses, and as no testimony was offered on his part, there was no more need of arguing the case, than there would be to attempt to enlighten the court regarding the fact that noonday is lighter than midnight.

However, young Newton was in for the fight, and he arose with no small degree of dignity and addressed the court with "May it please the honorable court," etc. On he went with a string of rigmarole, quoting largely from Shakspeare, and repeating unknown quantities of poetry, occasionally alluding to the situation of "the persecuted defendant, the prisoner at the bar, and the cruel

vindictiveness of the plaintiff," pointing his finger disdainfully at the grand-jury man. My grandfather maintained the utmost gravity for about half an hour, at which time Newton, in the middle of what he intended to be a splendid peroration, having for probably the twentieth time pointed to Mr. Couch (the grand-jury man) as the plaintiff, was interrupted by the court. Newton felt excessively annoyed that he should be stopped at the precise moment that he was about to give the master-stroke to his grand conclusion.

"What is the pleasure of the honorable court?" asked Newton, in a tone of vexation.

"You should understand, as the pleasure of the court, that that gentleman is not the plaintiff in the case," answered the judge.

"Not the plaintiff! Then may it please your honor, I should like to know who *is* the plaintiff?" said Newton, sarcastically.

"If I had followed your argument it would have been rather a difficult matter to determine, and I was afraid if I allowed you to continue your high-flown poetical language much farther, none of us would have been able to make out who the plaintiff is; but I believe I heard from the grand-jury man that it was the State of Connecticut!" replied my grandfather, with a bland smile.

Poor Newton dropped into his chair as suddenly as if he had been struck by a twenty-four pounder.

A titter ran through the crowd at Newton's discomfiture, and I, who had been busy taking notes during the speech, now arose with great confidence, and after hitting Newton a rap over the knuckles, proceeded to examine the evidence and urge its demonstrative proof of the guilt of the prisoner. I bore upon the fact that every witness had seen the transaction, and all agreed in their statements. I further urged, that nothing in the cross-examination had been discovered to clash with that of the direct testimony – that no attempt had been made to impeach either of the witnesses – that no testimony whatever had been offered on the part of the defence – that not the slightest shadow of a doubt of the guilt of the prisoner could possibly exist – that I was astonished at the indiscretion and audacity of both prisoner and counsel in not pleading guilty in the first place. Warming with my subject, I soared aloft into space, where, after indulging in numerous grandiloquent manœuvres, I began to look down from my giddy height with some trepidation, lest I should not make a safe descent, when all at once my grandfather interrupted me.

"Young man," said he, "will you have the kindness to inform

the court which side you are pleading for – the plaintiff or the defendant?"

I dropped in an instant, amid a tremendous shout of laughter from every portion of the court-room. Newton had been sitting with a downcast look ever since his discomfiture, but on the principle that "misery loves company," he now looked up with a broad grin upon his features. I did not exactly relish the joke, and informed my grandfather that I thought he might have had some little regard for the sanctity of a court of justice, but he gave me no satisfactory reply. After order was restored, the prisoner was bound over to the next County Court for trial, and the new members of the bar were both glad to sneak out of the room with all reasonable celerity.

There was a journeyman hatter in Bethel, whom I will call Kane. He was a very penurious man. He was industrious, dressed pretty well, and was always excessively polite. He was never known to spend a farthing when he could by any decent possibility avoid it.

I do not know how it came to pass, but a young lady who resided a few miles east of our village, at a place called Wolfpits, accepted his addresses, and the wedding day was fixed upon. With his usual regard to economy, he concluded that the connubial knot could be tied as strongly by a justice of the peace as by a clergyman, and that the fee for performing the ceremony might be less in the former case than in the latter. He therefore engaged Abraham Stowe, Esq., to officiate. The ceremony was to be performed in the evening. Esquire Stowe resided in Wildcat, a distance of more than a mile from the house of the bride, reckoning by a short cut "across the lots." It was in the month of February. About sundown the justice started, making the best of his way through snow-drifts and muddy places, clambering over fences and leaping fearful ditches, until at last he reached his destination, pretty well tired out, with wet feet, and his pantaloons considerably bespattered with mud. A small circle of friends were in waiting, and the ceremony came off at once. The bachelor justice "saluted the bride" according to the custom of the country, although, from his excessive bashfulness, the act of doing so caused his face to assume the color of his hair, which was a bright red.

The bridegroom soon called the justice aside, and said to him, in his politest style, at the same time drawing out his wallet:

"Well, Esquire Stowe, what is the damage?"

"Oh, I hope there is no *damage* done," said the good-hearted justice, his palm already itching for the fee.

"Well, what do you charge for marrying?" pursued the penurious Mr. Kane.

"I don't *charge* any thing," was the modest reply.

"Well, really, I am very much obliged to you, Esquire Stowe," remarked the delighted bridegroom, as he returned the wallet unopened to his pocket. "But really," he continued, "I hope you will walk in and take a glass of cider with us before you go."

The disappointed justice took half a glass of cider, and started for home, promising himself that the next time he had occasion to marry a man of Kane's calibre, he would make it a matter of business and agree upon the price beforehand.

My business in Bethel continued to increase beyond my anticipations, and I was very happy in believing that my suit was prospering with Charity Hallett, the fair tailoress. Although I associated with all the young people, and attended their parties, pic-nics, sleigh-rides, etc., Chairy continued to stand highest in my estimation, and to improve upon acquaintance.

The manner in which I made arrangements for one of our sleighing parties, may be worth narrating. My grandfather, who kept a number of horses and vehicles, always had one at my disposal. He had one favorite horse, however, which he called the "Arabian," that he never permitted anybody to use except himself. He also had a new sleigh – the finest in the village, but unfortunately for me an embargo was likewise laid upon that. His other sleigh was a very good one, but I coveted the new one, as well as the Arabian horse. I knew that with such a turn-out I could eclipse all our village beaux; but indulgent as my grandfather usually was to me, I had no reasonable hopes of inducing him to break through his fixed rules for my accommodation. I thought, however, there would be no harm in trying. I therefore called on him.

"Grandfather," said I, "I want to procure a horse and sleigh to go on a sleighing party next Tuesday."

"Very well, you can have them," was the reply.

"Can I have Arabian and the new sleigh?" I asked with some hesitation.

"Yes, if you have twenty dollars in your pocket!" he replied with much surprise.

I pulled out my wallet, showed him that I had the amount of money which he named, and placing it again in the wallet, returned it to my pocket, exclaiming with a laugh, "There, you see I have

the twenty dollars. I am much obliged to you. I suppose I can have Arab and the new sleigh?"

The old gentleman had of course intended to intimate that I should pay him twenty dollars if I took his favorite team, considering that to be equivalent to a denial, but I had turned so suddenly upon him, he was taken by surprise, and relishing a good joke even at his own expense, he replied with a chuckle, "Yes, you may have them, but use them carefully."

I promised a ready compliance and on Tuesday, "Chairy" and I had the crack team of the day.

A man in our village who was somewhat of a genius, and could do almost any thing he undertook, purchased a set of "turnkeys," and added the business of extracting teeth to his numerous other avocations. He advertised his new branch of business, announced 12½ cents each as being his usual charge, and added to his advertisement that he would extract teeth for relatives gratis. A cousin of his, who was a wag, sent him a horse's head, and wrote a letter asking him to extract twenty teeth for him.

The pseudo dentist went to work, and by dint of hammer, pincers and "turnkeys" he extracted the twenty teeth, and sent them with the horse's head to his cousin, accompanied by the bill, amounting to two dollars and fifty cents.

The cousin refused to pay, claiming exemption on the ground of relationship. To this the tooth-puller replied, "I am cousin to *you*, but not to your horse, so you must pay up."

A joke was never given up in Bethel until the very end of it was unravelled; so the cousin, still refusing to pay, was sued before a village justice and condemned in debt and costs to the amount of seven dollars and a half, which he was compelled to pay for his joke.

One afternoon, the usual number of customers being gathered together in my little store, one of our joke-loving neighbors asked a farmer if he had geese feathers for sale.

"I shall pick my geese in about a month, and then I shall have a lot of feathers for sale," was the reply.

"What is your price?"

"Fifty cents per pound."

"Oh, that is too cheap. I will give you twenty-five dollars for as many pounds of pure geese feathers, if delivered to me in this store a month from to-day," was the reply.

The old farmer, who was pretty 'cute, was sure that there was some "catch" in this offer, but concluding to risk it, he assented to the proposition.

"Let us put it in writing," said our neighbor. He then drew up an agreement, stipulating that under a mutual forfeiture of twenty dollars, the farmer should deliver, on such a day, at my store, twenty-five pounds of pure geese feathers, for which the said neighbor should pay $25. The agreement was left with me.

On the day designated, the farmer, punctual to his agreement, was on hand with his feathers. The feather purchaser, being sure of a good joke upon the farmer, had invited a number of neighbors to witness the *dénouement*.

"Well, I have brought the feathers," said the farmer.

"Let me examine them," replied the neighbor.

One of the sacks was opened, the neighbor thrust in his hand, and drawing it out, exclaimed, "Oh, these feathers will never do for me; you were to deliver me pure geese feathers, and now I perceive they are half *ganders'* feathers. You must pay the forfeit."

"Not exactly," replied the farmer, with a grin; "that is just where I thought the catch lay, so I picked my geese by themselves, and here is a certificate signed by three respectable neighbors that there is not a gander's feather in the whole lot."

Our neighbor, a pretty substantial comb manufacturer, was completely caught in his own trap; so he had nothing to do but hand over the money and take the feathers, having the satisfaction of knowing that he had purchased twenty-five dollars' worth of pure geese feathers at a dollar per pound!

One Saturday evening, a young man, an apprentice to the tailoring trade in Bethel, whose education had been somewhat neglected, and whom I will call John Mallett, told me that he wished me to write a love-letter for him after I had closed the store. As I was somewhat of a novice in that line of business, I asked "Bill Shepard," a worthy young man of about my own age, to remain and assist in the great production.

At nine o'clock I closed the store, and after all had departed except Shepard, Mallett, and myself, we arranged the lights, pens, ink and paper, and asked Mallett to state his case.

It seemed that he had been very successful hitherto in paying his attentions to a young lady whom I shall call Lucretia. He had at times "cut out" nearly all the boys of the village, with Miss

Lucretia; in fact, I was one of the number thus made to stand behind, when Mallett was about. But now, after exhibiting a constancy of about six months' duration, she had shown strong symptoms of jilting the favorite, Mallett. On the Sunday evening previously, she had, very much to his astonishment, declined to "take his arm" when coming out of church, and immediately thereafter took the first young man's arm that was offered her. Mallett was now bent upon receiving from Lucretia an explanation of her unaccountable conduct, and he was determined, at the same time, to give her a piece of his mind. He desired us therefore to begin the letter in strong terms.

We commenced as follows – Shepard acting as scribe:

BETHEL, —, 18—.

Miss Lucretia: – I write this to ask an explanation of your conduct in giving me the mitten on Sunday night last. If you think, madam, that you can trifle with my affections, and turn me off for every little whipper-snapper that you can pick up, you will find yourself considerably mistaken. [We read thus far to Mallett, and it met his approval. He said he liked the idea of calling her "madam," for he thought it sounded so "distant," it would hurt her feelings very much. The terms "little whipper-snapper" also delighted him. He said he guessed that would make her feel cheap. Shepard and myself were not quite so sure of its aptitude, since the chap who succeeded in capturing Lucretia, on the occasion alluded to, was a head and shoulders taller than Mallett. However, we did not intimate our thoughts to Mallett, and he desired us to "go ahead and give her another dose."] You don't know me, madam, if you think you can snap me up in this way. I wish you to understand that I can have the company of girls as much above you as the sun is above the earth, and I won't stand any of your impudent nonsense no how. [This was duly read and approved. "Now," said Mallett, "try to touch her feelings. Remind her of the pleasant hours we have spent together;" and we continued as follows:] My dear Lucretia, when I think of the many pleasant hours we have spent together – of the delightful walks which we have had on moonlight evenings to Fenner's Rocks, Chestnut Ridge, Grassy Plains, Wildcat, and Puppy-town – of the strolls which we have taken upon Shelter Rocks, Cedar Hill – the visits we have made to Old Lane, Wolfpits, Toad-hole, and Plum-Trees* – when all these things come rushing on my mind, and when, my dear girl, I remember how often you have told me that you loved me better

*These were the euphonious names of localities in the vicinity of Bethel.

than anybody else, and I assured you my feelings were the same as yours, it almost breaks my heart to think of last Sunday night. ["Can't you stick in some affecting poetry here?" said Mallett. Shepard could not recollect any to the point, nor could I, but as the exigency of the case seemed to require it, we concluded to manufacture a verse or two, which we did as follows:]

> Lucretia, dear, what have I done,
> That you should use me thus and so,
> To take the arm of Tom Beers' son,
> And let your dearest true-love go!

> Miserable fate, to lose you now,
> And tear this bleeding heart asunder!
> Will you forget your tender vow!
> I can't believe it – no, by thunder!

[Mallett did not like the word "thunder," but being informed that no other word could be substituted without destroying both rhyme and reason, he consented that it should remain, provided we added two more stanzas of a *softer* nature; something, he said, that would make the tears come, if possible. We then ground out the following:]

> Lucretia, dear, do write to Jack,
> And say with Beers you are not smitten,
> And thus to me in love come back,
> And give all other boys the mitten.

> Do this, Lucretia, and till death
> I'll love you to intense distraction;
> I'll spend for you my every breath,
> And we will live in satisfaction.

["That will do very well," said Mallett. "Now I guess you had better blow her up a little more." We obeyed orders as follows:] It makes me mad to think what a fool I was to give you that finger-ring and bosom-pin, and spend so much time in your company, just to be flirted and bamboozled as I was on Sunday night last. If you continue this course of conduct, we part for ever, and I will thank you to send back that jewelry. I would sooner see it crushed under my feet than worn by a person who abused me as you have done. I shall despise you for ever

if you don't change your conduct towards me, and send me a letter of apology on Monday next. I shall not go to meeting to-morrow, for I would scorn to sit in the same meeting-house with you until I have an explanation of your conduct. If you allow any young man to go home with you to-morrow night, I shall know it, for you will be watched. ["There," said Mallett, "that is pretty strong. Now I guess you had better touch her feelings once more, and wind up the letter." We proceeded as follows:] My sweet girl, if you only knew the sleepless nights which I have spent during the present week, the torments and sufferings which I endure on your account; if you could but realize that I regard the world as less than nothing without you, I am certain you would pity me. A homely cot and a crust of bread with my adorable Lucretia would be a paradise, where a palace without you would be a hades. ["What in thunder is hades?" inquired Jack. We explained. He considered the figure rather bold, and requested us to close as soon as possible.] Now, dearest, in bidding you adieu, I implore you to reflect on our past enjoyments, look forward with pleasure to our future happy meetings, and rely upon your affectionate Jack in storm or calm, in sickness, distress, or want, for all these will be powerless to change my love. I hope to hear from you on Monday next, and, if favorable, I shall be happy to call on you the same evening, when in ecstatic joy we will laugh at the past, hope for the future, and draw consolation from the fact that "the course of true love never did run smooth." This from your disconsolate but still hoping lover and admirer, JACK MALLETT.

P. S. On reflection I have concluded to go to meeting tomorrow. If all is well, hold your pocket handkerchief in your left hand as you stand up to sing with the choir – in which case I shall expect the pleasure of giving you my arm to-morrow night. J. M.

I am sorry to say that Lucretia was not overpowered by this letter, which was handed to her early on Sunday morning. She held her handkerchief firmly in her right hand during all the church services, and on Monday morning returned the "ring and bosom-pin" to her disconsolate admirer. Beers' son carried off the palm, and the following year led Lucretia to the altar.

Mallett had agreed to give me five pounds of carpet rags for my mother, and to deliver twelve yards of broadcloth "lists" to Shepard, as a remuneration for our services; but owing to his ill success with Lucretia, he "begged off," and we compromised by accepting one-half the amount promised.

* * * * * * * *

About this time I made arrangements to go to Pittsburgh, Pa., with Mr. Samuel Sherwood, of Bridgeport, on an exploring expedition. I had heard that there was a fine opening in that city for a lottery office, and Sherwood and myself concluded to try our fortunes there, provided we found the prospects equal to our anticipations. We called at the office of the New York managers, Yates & McIntyre, and had an interview with their chief business man, Mr. Dudley S. Gregory — at present ex-mayor and a large proprietor in Jersey City. Mr. Gregory did not think favorably of Pittsburgh, but, after an hour's conversation with me, he offered me the entire lottery agency for the State of Tennessee, if I would go to Nashville and open an office there. The proposition was tempting, but I feared the distance was too great to meet the approbation of a certain tailoress in Bethel whose wishes I felt bound to consult, for special reasons. I therefore declined giving an answer for two weeks. In the mean time, Sherwood and myself having given up the Pittsburgh trip, concluded to go to Philadelphia for a pleasure excursion. We went in a morning boat to New Brunswick, where the passengers all took stages to Bordentown, a distance of perhaps thirty miles through the sand, where we again took steamboat to Philadelphia, arriving there about dusk. We put up at Congress Hall in Chestnut street, where we experienced rather taller living than we had ever before met with. The array of waiters, napkins, and other et-ceteras, as well as a frequent change of plates, was something entirely ahead of all our former experience; but we lay off like old stagers, and lived in clover for a week, going to the theatre every night, and riding in our coach every day. On Sunday, we listened to the chiming bells of Christ Church with great satisfaction, it being the first we had ever heard. At last we concluded to start for home. Our hotel bill astonished us beyond measure, and awakened serious apprehensions in regard to our ability to raise sufficient funds to reach home. Counting up both our piles, we found that our fears were not without foundation. We had been foolishly extravagant in our outlays, and after paying our hotel bills and securing our tickets for New York, we had only twenty-seven cents left!

This was decidedly a close shave. Fortunately we discovered our dilemma before breakfast, and as that meal had been included in our bill, each of us embraced the opportunity, while sipping our coffee, to pocket a few biscuits, which sufficed us for a dinner we could not buy.

As we were about leaving the hotel, the boot-black asked us to remember him, to which Sherwood replied that it was an imposition: he had always while travelling been accustomed to have his boot-blacking included in the bill, and he would not stand it. I tried to look indignant also, but was overcome, and putting my hand in my pocket, drew forth a quarter dollar, and handed to the polisher of our "understandings." This reduced our capital to two cents, and with this we started, saying to the porter that, merely for the sake of the exercise, we preferred to carry our own trunks.

Living all day upon our biscuits and cold water, we reached New York, and carried our baggage to Holt's Hotel in Fulton street, a distance of about a mile. In the morning, Sherwood borrowed a couple of dollars from a Bridgeport friend, and proceeding to Newark, obtained the loan of fifty dollars from his friend and cousin, Dr. Sherwood. He loaned me one-half the amount, and after sojourning a few days in New York, we returned home. I do not know what Sherwood's feelings were, but I was forcibly reminded, as I have often been since, of the old adage, that "a fool and his money are soon parted."

Our visit to the New York lottery managers greatly enlightened me in regard to the profits of that line of business. I had been in the habit of selling tickets for Washington Yale, the editor and printer in Danbury, also for O. W. Sherwood and his cousin Samuel of Bridgeport, for a commission of 10 to 15 per cent.; but in my interviews with Mr. Gregory, I learned that the managers, taking to themselves the fifteen per cent. deducted on all prizes, furnished tickets to their agents at what was called "scheme price," which allowed the agents from 25 to 30 per cent. profit. The lotteries being drawn by combination numbers, the public generally had no knowledge whatever of the number of tickets in a lottery; the managers, therefore, made the prizes amount to less than the retail price of tickets by 25 or 30 per cent. This extra per centage was a shave additional to the 15 per cent. allowed in old-fashioned lotteries. I also learned that the process of arriving at the number of tickets in a lottery is this: Multiply the three highest combination numbers and divide by six; the quotient is the number of tickets.

I am continually annoyed, even at this late date, by Lottery Schemes sent by various agents at the South, where lotteries are still legal. I received one yesterday from a lottery firm in Baltimore.

One of their schemes is as follows. My object in inserting it will, I trust, be appreciated.

It will be observed that there are 78 combination numbers in this lottery. The number of tickets, as I have remarked, is determined by multiplying together the three highest combination numbers, 76, 77, and 78, and dividing by 6, as follows:

$$\begin{array}{r} 78 \\ \underline{77} \\ 546 \\ \underline{546} \\ 6006 \\ \underline{76} \\ 36036 \\ \underline{42042} \\ 6)456456 \\ \hline 76076 \text{ tickets.} \end{array}$$

$30,000.
MARYLAND
CONSOLIDATED LOTTERY,
For the Benefit of the Susquehanna Canal, and other purposes.
CLASS 25.
To be drawn in Baltimore, Md., on *WEDNESDAY, Sept. 27th*, 1854.

SCHEME.

1 of	$30,000	is...........	$30,000
1 of	20,000	is...........	20,000
1 of	10,000	is...........	10,000
1 of	5,000	is...........	5,000
1 of	3,000	is...........	8,000
1 of	2,870	is...........	2,870
50 of	1,000	are...........	50,000
50 of	500	are...........	25,000
180 of	200	are...........	36,000
☞ 65 Prizes of	100	are...........	6,500
65	do.	80 are...........	5,200
130	do.	60 are...........	7,800
130	do.	40 are...........	5,200
4,680	do.	20 are...........	93,600
27,040	do.	10 are...........	270,400

32,396 prizes, amounting to$570,570

Tickets, $10; Half, $5; Qr., $2 50.

Certificate of Package of 26 Wholes,	$148 00
do. do. 26 Halves,	74 00
do. do. 26 Quarters,	37 00

78 Numbers and 13 Drawn Ballots.

This number of tickets, at $10 each, amounts to	$760,760 00
Whereas the prizes amount to no more than	570,570 00
Leaving a profit of	$190,190 00
Add 15 per cent., deducted from $570,570, the aggregate of prizes	85,585 50
Making the entire profits on a single lottery	$275,775 50

The "scheme" I have here presented is "Class 25." If the preceding classes were the same, the aggregate profit on the series is nearly *seven millions of dollars!*

In the above lottery the agent procures his tickets at $7.50 each. The whole number of tickets, multiplied by this price, amounts

exactly to the sum set apart for prizes, $570,570; and the managers get 15 per cent. drawback, or $85,585.50.

Another scheme, in the same circular, announces tickets at $2 each, 78 numbers, the prizes amounting to $106,506½. The tickets in this lottery are, at the scheme price, $1.40 each, thus giving the agent 60 cents profit on each $1.40 which he expends – or a trifle over 42 per cent.! This, with the 15 per cent, of the managers, makes more than 57 per cent., thus giving a lottery-ticket buyer a chance of realizing 42½ cents for every dollar that he expends! provided he is as lucky as the other adventurers.

Thousands of persons are at this day squandering in lottery tickets and lottery policies the money which their families need. If this *exposé* shall have the effect of curing their ruinous infatuation, I, for one, shall not be sorry.

After learning the *profitable* basis of the foregoing facts, I went to our Connecticut lottery managers, and from that time obtained my tickets directly from them at "the scheme price." In my turn I established agents all through the country, and my profits were immense. I sold from five hundred to two thousand dollars' worth of tickets per day. About this time my uncle Alanson Taylor joined me as a partner in the lottery business, and proved a very efficient salesman.

On one occasion I sold a package of quarter tickets to my aunt Laura Nichols and a neighbor of hers for $25. Before the lottery was drawn the neighbor sickened of her bargain and begged me to take the tickets back, and my aunt consented. When the mail brought the drawn numbers from Hartford, I had the package of tickets on hand. Not desiring to risk that amount of money, I induced eight of my customers to join me in the purchase of the package. We then opened the letter containing the drawn numbers, and found that we had drawn a quarter of the highest prize, $15,000. This result gave myself and eight others a profit of $350 each.

The fact was duly announced, and my aunt never ceased to blame her timid neighbor nor to lament her own ill fortune. The great luck of drawing the highest prize spread like wild-fire, as usual in such cases, and the country, for miles around, was lottery-crazy. Our sales increased immensely. My clerk was a boy named HIRAM M. FORRESTER, at present a successful New York merchant. At another time, I employed a boy named PHILO K. WILDMAN, who became an eminent surgeon, and recently died in Savannah, Ga.

Fully appreciating the powers of the press, (to which more

than to any other one cause I am indebted for my success in life,) I did not fail to invoke the aid of "printer's ink." I issued handbills, circulars, etc., by tens of thousands, with striking prefixes, affixes, staring capitals, marks of wonder, pictures, etc. The newspapers throughout the region teemed with unique advertisements. Immense gold signs, and placards in inks and papers of all colors, covered my lottery office. As the curious letters of "Joe Strickland" were highly popular at that time, I advertised my office as being under the special favor and protection of "Dr. Peter Strickland," own blood cousin to the renowned Joe Strickland, etc. In my bills and advertisements, I rung all possible changes upon the renowned name. "The ever lucky Dr. Strickland," "Five more capital prizes sold by Dr. Strickland!" "A fortune for a dollar – apply to Fortune's favorite, Dr. Strickland," "Another mammoth prize! – huzza for Dr. Strickland," etc., etc. Home-made poetry was also frequently brought into requisition to set forth the inducements for patronizing my office. Customers who brought their tickets and found them blanks, were told that their only wise plan was to "look for their money where they lost it," – "it was a long lane that never turned," – "such bad luck could not continue long," etc., etc.

The lucky drawers of the high prize before mentioned gave an oyster supper at my mother's tavern to about sixty persons, (whom I invited, knowing them to be good ticket customers;) and after the supper was finished, I counted out the prize-money to the elated holders of the fortunate ticket. This so excited our guests, that a package of tickets, amounting to one thousand dollars, was forth-with sealed up and bought by fifty subscribers on the spot, at $20 each.

Selling so many tickets as I did, a prize of one or two thousand dollars, and numerous smaller ones, must occasionally turn up. These, being duly trumpeted, rendered mine the "lucky office" in the estimation of many. I received orders from distant parts of the country by mail, and sent out tickets on commission by post-riders and others. Among my "private customers" were a number of clergymen and deacons; and occasionally some of the weak brothers of the "Shakers," who came to Bethel to sell garden seeds, bought a few lottery tickets "on the sly."

Whenever I visited Brookfield I called on one man who was of a serious turn. He and his wife were professors of religion, and he was a frequent exhorter at prayer meetings. He always managed to buy a ticket or two from me, under the strictest injunction never

to divulge the fact to his wife. I usually dined with him; and when he was busy looking after my horse, or otherwise engaged out of doors, I never failed to sell a ticket to his wife, who begged me to be very careful not to let her husband have any suspicion of it, for he was opposed to such things, and would never forgive her if he should know there was a lottery ticket in the house.

I still kept a close eye upon the attractive tailoress, Charity Hallett; and although my good mother and some other relatives feared that I was not looking high enough in the world, those who knew the girl best declared that she was an industrious, excellent, sensible, and well-behaved girl, and some of them added that "she was altogether too good for Taylor Barnum." I perfectly agreed with them in their conclusions, and in the summer of 1829 I proved it by asking her hand in marriage. My suit was accepted, and the wedding day appointed. In the mean time I applied myself closely to business, no person suspecting that the "event" was near at hand. In October my "sweetheart" went to New York, ostensibly to visit her uncle, Nathan Beers, who resided at No. 3 Allen street. I left home on Saturday, November 7, for New York, having particular occasion to purchase goods for our little store. On the next evening, by the aid of the Rev. Dr. McAuley, and in the presence of sundry relatives and friends of hers, the tailoress changed her name to Mrs. CHARITY BARNUM, and I became the husband of one of the best women that was ever created.

I was at that time little more than nineteen years of age. I have long felt assured, that had I waited twenty years longer, I could not have found another woman so well suited to my disposition, and so valuable as a wife, a mother, and a friend; yet I do not approve of nor recommend too early marriages. Young persons' minds should become more matured before they venture to decide upon the most important event which can occur to them in a lifetime. Marriage has been called "a lottery," "taking a leap in the dark," etc. It is, to say the least, a serious ordinance, deserving serious thought. Hasty marriage, and especially the marriage of boys and girls, has, in my opinion, been the cause of untold misery in thousands of instances, the advice of that worthy old philosopher, Ben Franklin, to the contrary notwithstanding.

The bride and bridegroom returned to Bethel the same week, and took board in the family where she had previously resided. My mother received me as if nothing had happened, and made no allusion to the wedding. She evidently felt chagrined at the clandestine

manner of my marriage; but I called on her every day with the same freedom that I had ever done, and within a month she invited me to bring "my wife" and spend the following Sabbath with her. I did so; and from that day to this, I am sure that neither she nor any other person ever said or believed that I had not been extremely fortunate in the selection of my companion.

Notwithstanding my pressing business engagements, I occasionally indulged in what always gave me so much pleasure – a practical joke. On one occasion, an Irish peddler called upon my uncle Edward Taylor for a writ against one of our neighbors, who, he said, had turned him out of his house and otherwise abused him. My uncle told him that he knew our neighbor to be a peaceable, well-disposed man, and that he was sure he had never turned any person out of his house without good reason; he should therefore decline being engaged in the case. The peddler came into my store, and after hearing his story, I was convinced that he was himself to blame. I told him I practised at the bar, and would issue a writ against the culprit if he desired it. He handed me a fee of a couple of dollars, and I proceeded to issue a writ, naming the hour for trial at eleven o'clock the same day. The writ was put into the hands of a mock constable, with orders to serve it instantly upon the defendant. Owing to the importance of the case, I brought it before three judges, consisting of my grandfather, Mr. Parsons, (a mason who happened at that time to be building a chimney in the village,) and Zachariah Porter, our village butcher. The anticipated trial was immediately noised all over the place, and at eleven o'clock my mother's bar-room was crowded with spectators. The three venerable judges were upon the bench, bearing themselves with as much dignity as if they constituted the Court of Errors. It was decidedly a democratic court in appearance; for "Judge Taylor" had been working in his garden, and appeared in his shirt sleeves; "Judge Parsons," coming directly from his unfinished chimney, wore an old pair of overhauls and a leather apron, besides being pretty well sprinkled with mortar; and their learned associate, "Judge Porter," appeared without a coat, his other clothing considerably stained with the blood of a calf which he had just butchered.

The prisoner had not yet arrived, and of course would not, inasmuch as I had really not sent for him. My client took his seat by my side, and I pretended to be intensely occupied in writing out the heads of my argument, notes of the evidence required, etc Every

few minutes I apologized to the "honorable court" for the non-appearance of the prisoner, who, I hoped, had not escaped the vigilance of the sheriff, and would therefore soon be forthcoming. My Hibernian client was considerably excited, and had frequent occasion to whisper in my ear, asking questions and making observations that were about as relevant to the case as a question in algebra would be to settle the qualities of a specimen of soap. Finally, I asked my client, in a low tone, how long it would require him to bring testimonials of his good character into court. He replied that several days would be needed, inasmuch as he resided in Fairfield, Ct. I suggested to him that we had better adjourn the court a week for that purpose. That idea pleased him. He could by that time, he said, procure a score of affidavits, setting forth that he was a peaceable, honest, and well-disposed citizen.

I then rose with much dignity and made the motion to adjourn the court for a week, stating my reasons therefor. The court considered the question, and my grandfather delivered its decision. The honorable Chief Justice stated that it was customary, upon motions being made for adjournment, to do so when good cause was shown, but never except upon payment of costs by the party making the motion; that the costs would in this case be about seven dollars, but inasmuch as my client was a stranger, the court had concluded to waive the costs, and subject the plaintiff only to the expenses of refreshments for the court and bar. This, in the simple vernacular, meant that my motion should prevail, provided my client "stood treat all round." We willingly accepted the decision of the court; my client arose and thanked them for their favor, on the ground of his being a stranger in Bethel, and proceeded at once to treat all the legal gentlemen as well as all the spectators. The prisoner did not arrive, but I assured my client he need give himself no uneasiness upon that point. I would be sure to have him in the hands of the sheriff and placed under heavy bonds for his appearance on Thursday of the following week, that being the period to which the court stood adjourned.

My client then started for Fairfield to procure affidavits of character. This was all we expected to hear about the case, as we were quite sure that the first persons to whom he related his adventure would undeceive him in regard to the facts, and of course that he would be too much ashamed to re-appear.

On the following Thursday, at about one o'clock, a lawyer from Newtown rode into Bethel, dismounted, and walked into the

law office of my uncle Edward Taylor. After passing the compliments of the day, he said, "Well, brother Taylor, we have a case to try to-day, I believe?"

"Not that I am aware of," said my uncle.

"Oh yes," returned the Newtown counsel; "I have been engaged to assist you in the prosecution of a man for abusing our client."

"Who is our client?" asked my uncle.

"An Irishman, a peddler," was the response.

My uncle saw what was in the wind, and merely replying, "Oh yes, I had forgotten it," excused himself for a few minutes. He then came and informed me of the state of the case. I was somewhat alarmed, and ran with the information to my grandfather. He feared it would prove a serious matter, and locking himself in his bedroom gave notice to his household that he was "not at home" that afternoon.

The chimney on which Judge Parsons was engaged was just peering through the roof of the building, and the venerable dispenser of law, sitting astride the ridge of the house, was calling, "More mort!" (more mortar,) just as my head and shoulders became visible on the top of the ladder. I hastened to acquaint Judge Parsons with the serious turn our law joke was taking, upon which, in much fright, he begged me to go down as soon as possible, so that he could place himself beyond the reach of the Newtown lawyer or any other adversary. I descended; the Judge immediately drew up the ladder, and thus cut off all communication with *terra firma.* I jumped on to a horse and started for Danbury, giving notice to the butcher, whose house I passed upon the way, that it would be dangerous for him to approach the village at that time.

The Irishman soon made his appearance. My uncle Edward had in the mean time explained the affair to the Newtown lawyer, who was exceedingly chagrined at the "take-in." Calling his client aside, he demanded a fee of $3. The Irishman handed over the money, whereupon his counsel said, "Now I advise you to get out of this place as soon as possible, for they are all making a fool of you!"

The astonished Hibernian asked for an explanation, but none was vouchsafed him. The lawyer mounted his horse and started for Newtown, leaving his amazed client in a sad quandary. Entering my store, he inquired for me. My clerk informed him I was out of town, and might not be back for a month. Several of the neighbors

came in and began joking the Irishman about trying his cause before a farmer, mason, and butcher, with a lottery-ticket seller as his counsel, who managed to mulct him in "a treat" for the company for the privilege of having been turned out of doors.

The Irishman started off, swearing he would prosecute the whole of us for swindling and obtaining money under false pretences, and for a long time we were much afraid that he would be as good as his word. He might undoubtedly have done so successfully; but, fortunately for us, he concluded that such a prosecution would cause him more trouble than profit, which timely reflection was all that saved us. The mason, who is still living in Danbury, will carry the title, "Judge Parsons," to his grave.

Towards the latter portion of my grandfather's life, he became somewhat deaf; he could however hear by a little extra attention. His neighbors remarked that it was the most "convenient deafness" they had ever heard of, for he could always hear when they asked him to "take a drink," but never when they invited him to "stand treat." Whenever, too, while joking with his neighbors, he received a sharp and unexpected repartee, he would say, "I don't know what the fool says, but I am sure there is no sense in it."

In the winter of 1829–30, I opened a lottery office in the village of Danbury, still keeping up the Bethel office, as well as branches in Norwalk, Stamford, Middletown, etc., and a host of small agencies all through the country, for thirty miles around. In June, 1830, I purchased from my grandfather three acres of land in Bethel, a few rods south of the village, for the purpose of erecting a dwelling thereon. Lewis Osborne, the builder, put me up a two-and-a-half story house, 26 by 30 feet, for ten hundred and fifty dollars, and my wife and myself moved into it and commenced housekeeping the ensuing spring.

My ticket sales were now confined in a great measure to a few large customers, who bought liberally, and to whom I gave a credit. Leaving these "large customers" in the hands of a trusty clerk, I went into a book speculation for a couple of months. I purchased books at auction and otherwise in New York, and taking them around the country, advertised and sold them at auction, I acting as auctioneer. I did tolerably well, with two exceptions. I held my auction one night at Litchfield, Ct. The law school was located there at that time. The students were among my customers, and they

managed to steal a large number of the most costly books. The same thing was done in Newburgh, N. Y., and I quit the auction business in disgust.

In the same spring of 1831, I put up a building in Bethel, known as "the yellow store," making it sufficiently capacious to accommodate a family in the second and third stories. In July, 1831, my uncle Alanson and myself opened the establishment with an assortment of goods, such as are usually found in a country store, consisting of dry goods, groceries, hardware, crockery, etc., etc. Like most persons who engage in a business which they do not understand, we were unsuccessful in the enterprise, and on the 17th of October, I bought out my uncle's interest, as will be seen by the following advertisement, which I cut from a newspaper dated the 20th of that month:

> "DISSOLUTION. – The firm of TAYLOR & BARNUM is this day dissolved by mutual consent. ALANSON TAYLOR,
> PHINEAS T. BARNUM.
> "☞ The business will be conducted in future by P. T. BARNUM, who will sell all kinds of dry goods, groceries, crockery, etc., etc., 25 per cent, cheaper than any of his neighbors.
> "Bethel, Oct. 17, 1831."

At about this period there was much excitement in the religious world – I mean in that portion of the country where I was residing, and indeed generally throughout New England. Protracted religious meetings were held in many of the churches, and by means of systematized effort, large numbers of people of all ages, but especially the young, were converted and received as members into the various churches where these meetings were held. So great was the alarm awakened in the minds of some of these converts, that they became victims of religious frenzy, and frequent cases of suicide and murder committed while in this state were chronicled throughout the country. I could mention many melancholy instances of the sort, including the murder of two children in New Canaan by their own father, but I forbear. I merely refer to the facts as one of the considerations moving me to the publication of a newspaper.

There was the additional consideration that certain overzealous sectarian partisans had recently, and most injudiciously, recommended the formation of a "Christian party in politics." They advised that none except professors of religion should receive the

benefit of the elective franchise, for any office of honor or profit in the civil government. One venerable clergyman stated that through the influence of Sabbath schools alone, a complete triumph could be achieved over "the world's people" within ten, or at the farthest, twenty years.

I had never yet voted, having attained my majority on the 5th of July, 1831, but all my predilections were strongly in favor of the Democratic party. My grandfather and his two sons were staunch Democrats, and I felt extremely anxious thus far to tread in their footsteps. Many persons (myself among the number) were honestly alarmed lest a great religious coalition should be formed in this country, which would carry out the desires of certain fanatics, as above shadowed forth.

I have long seen, and here confess, that our fears were exaggerated, though it is possible those fears had a part to perform in preventing the result referred to. It is true, many thousands of our citizens were influenced by the religious enthusiasm which was sweeping like a tornado through our land, and with the pages of history opened before us, setting forth what atrocities had been committed in the name of religion, when sectarism was in power, persons were perhaps excusable for fearing that such scenes might possibly be re-enacted in this country. And yet I repeat, that after all, there was little reason to fear such a result. There were multitudes of sincere professors of religion, who cherished a deep reverence and love for those old Puritans, and others, who fled from persecution across the ocean, and it was an unreasonable apprehension that these would consent or be a party to any measure tending, in the remotest degree, to a union of Church and State. Our entire system of school education, too, had been, and still is, so strongly in favor of liberty, including of course political and religious equality, as to debar the success of any party that should attempt to ostracize such citizens as should happen to differ with them in their religious tenets.

However, being, as I confess, one of the number who had serious apprehensions on that subject, and being also a devoted democrat at heart, I openly expressed my opinions, and doubtless thereby excited feelings of animosity with some individuals which otherwise would never have existed. I also wrote several communications for the Danbury weekly paper, setting forth my fears upon the subject, and animadverting in strong terms upon the evils resulting from undue religious excitement, and especially from countenancing the publicly announced policy of certain fanatical clergymen in

relation to public affairs. The publication of those communications was refused me by the proprietors of the Danbury paper. I became exceedingly indignant, and declared, as I honestly believed, that already had this sectarian influence become so powerful as to muzzle the press, and hence I felt it a double duty to arouse the public to a full apprehension of the true state of affairs.

I accordingly announced that I should purchase a press and types, and would within a few weeks commence the publication of a weekly paper which should oppose all combinations against the liberties of our country. On the 19th of October, 1831, I issued the first number of "THE HERALD OF FREEDOM."

The boldness and vigor with which this paper was conducted, soon commanded a liberal circulation, not only in the vicinity of its publication, but large numbers of copies were sent into nearly every State in the Union.

Impelled by the vehemence of youth, and without the caution of experience or the dread of consequences, I repeatedly laid myself open to legal difficulty under the law of libel, and three times, during my three years as editor, I was prosecuted. One of these was a civil prosecution brought by a butcher in Danbury, a zealous politician, whom I accused as being a spy in the caucus of the Democratic party. On the first trial the jury could not agree; on the second, I was fined several hundred dollars. Both the other prosecutions were brought in the name of the State. One of these was withdrawn without coming to trial. In the issue of the other, I was sentenced to pay a fine of one hundred dollars, and to be imprisoned for sixty days in the common jail.

The libel of the butcher will scarcely be thought a heinous offence, as judged by the general standard of political warfare; the suit entered but not tried need not be more particularly mentioned; but the most serious of the libels will justify a few lines in detail.

I was indicted for informing the readers of my paper, that a certain lay dignitary of a church in Bethel had "been guilty of taking usury of an orphan boy." The general fact was accompanied by severe editorial commentary, and criminal prosecution was instituted against me.

The case came to trial, and several witnesses, including the party accused, proved substantially the truth of my statement. But, alas! "the greater the truth the greater the libel;" and besides, I had employed the term *usury*. Had I termed the deed an extortion, or note-shaving, or grinding the face of the poor orphan boy,

the verdict might have been different – but I had called the act "usury." The judge charged the jury as though he were the attorney for the prosecution, and was believed to experience personal satisfaction in pronouncing the sentence which I have already mentioned.

I here withhold the names of the parties, because the insertion of them could accomplish no good purpose. The party whom I charged with a serious offence, naturally felt deeply aggrieved, though he has recently declared that the prosecution was instituted without his suggestion or concurrence. At the time, I spoke in no gentle terms in relation to him, and since that date have frequently repeated those hard words. Nevertheless the whole affair was, and has always been, a source of merriment to me. The annoyance I experienced was measurably merited by the severity of my strictures on a deed which aroused my indignation, but which might possibly have been palliated by the circumstances; and now that I am fastening the general facts in these pages, I desire to wipe out all unpleasant recollections on the subject. The judge exemplified only human weakness in permitting my course as an editor to embitter his feelings as an earnest sectarian; but he has gone to that "better country" in which animosities are not cherished, and I am sure they exist not in my own breast in connection with his memory.

I was very comfortably provided for in the common jail of Danbury. I had my room papered and carpeted previously to taking possession as a tenant for sixty days; I lived well; was even oppressed by the almost constant visits of cordial friends; edited my paper as usual, and received several hundred additional subscribers to my list, during the term of my imprisonment.

When that term was ended, the event was celebrated by a large concourse of people, from all the country round. It was celebrated in the court-room in which I had been convicted for libel. An admirable ode, written for the occasion, was sung, and an eloquent oration on the Freedom of the Press was delivered by the Rev. T. Fiske. Several hundred gentlemen afterwards partook of a sumptuous dinner, and the toasts and speeches, while not neglecting the subjects usual in political and social festivals, related prominently to the circumstances which had called the people together.

Then came the most imposing part of the ceremonial. It was reported and described as follows in my paper of December 12, 1832:

"P. T. BARNUM and the band of music took their seats in a coach drawn by six horses, which had been prepared for the occasion. The coach was preceded by forty horsemen, and a marshal, bearing the national standard. Immediately in the rear of the coach was the carriage of the Orator and the President of the day, followed by the Committee of Arrangements and sixty carriages of citizens, which joined in escorting the editor to his home in Bethel.

"When the procession commenced its march amidst the roar of cannon, three cheers were given by several hundred citizens who did not join in the procession. The band of music continued to play a variety of national airs until their arrival in Bethel, (a distance of three miles,) when they struck up the beautiful and appropriate tune of 'Home, Sweet Home!' After giving three hearty cheers, the procession returned to Danbury. The utmost harmony and unanimity of feeling prevailed throughout the day, and we are happy to add that no accident occurred to mar the festivities of the occasion."

No one will be surprised that I should have regarded such a return to my home and family as a triumphal march. It was in effect a vindication, because an approval of my course, and a condemnation both of the "common law of libel," and of all who had been engaged in my prosecution.

My editorial career was one of constant contest, and might furnish many interesting incidents for these pages, but I pass to another section of my history.

The mercantile business, which I continued while publishing the Herald, did not thrive, for various reasons. I was not in my natural sphere. I wanted to do business faster than ordinary mercantile transactions would admit; hence I bought largely, and in order to sell largely, was compelled to give extensive credits – and soon had an accumulation of bad debts. My old ledger at this day has hundreds of accounts upon it which are balanced thus: "By death, to balance," – "By running away, in full," – "By cheating me out of my dues, to balance," – "By failing, in full," – "By swearing he would not pay me, in full;" and one small account of a few dollars against a rich man of Danbury, having stood so long that I supposed the wealthy debtor had forgotten it, and I felt loth to remind him of his indebtedness, stands balanced by being "Too rich to be dunned."

I should have said that in the summer of 1831, I took Horace

Fairchild into co-partnership, but in January, 1833, I sold out all my interest in the store to a Mr. Toucey, brother of Senator Toucey, who, with Horace Fairchild, continued the business under the name of "Fairchild & Co."

No. 160 of the "Herald of Freedom" was published in Danbury, Nov. 5, 1834, after which it was removed to Norwalk, Ct., and there published for me by my brother-in-law, John W. Amerman, until, in the course of the year ensuing, it was sold to Mr. George Taylor.

CHAPTER VII

Struggling – Joice Heth – Vivalla

In the winter of 1834–35, I removed my family to New York, having hired a house in Hudson street. Strictly speaking, I entered that great city to "seek my fortune." Lotteries in the State of Connecticut had been prohibited by law; I had lost large amounts of money by my private customers, some of whom had gone beyond their means in purchasing tickets, while others had put their property out of their hands, and thus defrauded me of considerable sums. I was also a large loser by the mercantile business, and must confess, in addition, that the old proverb, "Easy come easy go," was too true

in my case. I had learned that I could make money rapidly and in large sums, whenever I set about it with a will, and I did not hesitate to expend it in various extravagances as freely as I gained it. I acquired it so readily, that I did not realize the worth of it, and I entertained no anxiety whatever about laying it up. To be sure, I thought that at *some future time* I should begin to accumulate by saving, but I cared not for the present, and hence I scattered my means with an open and unsparing hand.

When I removed to New York, I had no pecuniary resources except such as were derived from old debts left in the hands of an agent in Bethel for collection.

I had hoped to find an opening with some mercantile firm in New York, where for my services I could receive a portion of the profits, for I had a disposition which ever revolted at laboring for a fixed salary. I wanted an opportunity where my faculties and energies could have full play, and where the amount of profits should depend entirely upon the amount of tact, perseverance and energy, which I contributed to the business. But I could not find the situation I coveted. My resources began to fail me, and, my family being in ill-health, I found it difficult to maintain them. In order to do so, I secured the situation of "drummer" to several stores, including the cap and stock store of Mr. Chapman in Chatham street, the proprietors of which allowed me a small commission on all sales which they made to customers whom I introduced.

This of course was only a temporary arrangement, and, like "Micawber," I was continually on the look-out for something better to "turn up." Every morning at sunrise my eyes were running over the columns of "Wants" in the New York "Sun," hoping to hit upon something that would suit me. Many is the wild-goose chase which I had in pursuit of a situation so beautifully and temptingly set forth among those "wants." Fortunes equalling that of Crœsus, and as plenty as blackberries, were dangling from many an advertisement which mysteriously invited the reader to apply at Room No. 16, in the fifth story of a house in some retired and uninviting locality; but when I had wended my way up flights of dark, rickety, greasy stairs, and through sombre, narrow passages, I would find that my fortune depended firstly upon my advancing a certain sum of money, from three dollars to five hundred as the case might be; and secondly, upon my success in peddling a newly discovered patent life-pill, an ingenious mouse-trap, or something of the sort.

I remember that, on one occasion, an advertisement was

headed, "IMMENSE SPECULATION on a small capital! – $10,000 easily made in one year! Apply to Professor–, at Scudder's American Museum."

I had long fancied that I could succeed if I could only get hold of a public exhibition, and I hastened with all dispatch to call on the kind Professor who held forth such flattering promises at the Museum. Being ushered upon the stage of the lecture-room in the third story, I was grieved to find a dozen applicants already ahead of me. I instantly sought out the Professor, and calling him aside, took a few moments to recover myself, for I was nearly out of breath from running so fast up stairs, and then I asked him whether he had yet disposed of his speculation.

"Not positively, but several customers are ready to close with me immediately," was the Professor's reply.

"I beg of you to give me a chance; you will find me just the man you want," I replied with great earnestness.

"Well, as you are so anxious, and seem to be a young man of energy, I will give you the first chance," replied the kind Professor.

I felt exceedingly grateful, and asked him the nature of his enterprise.

"I am the proprietor of the great Hydro-oxygen Microscope," said he. "It is the most extraordinary instrument now extant. Its public exhibition through the country would in a very short period secure to its owner an independence. My health is feeble, and I will sell for only two thousand dollars; one thousand cash – the balance in sixty and ninety days, on good security."

My golden visions vanished, and I abruptly informed the Professor that I declined becoming a purchaser of his instrument.

On another occasion an advertisement announced that "twenty dollars per day could be earned without any capital." This struck me as a capital chance, and I started forthwith for the place indicated for applicants.

I found a little dark-looking old woman, surrounded by at least twenty anxious listeners. Her tongue was running at a most rapid rate. She informed her auditors that she was about to publish a pamphlet, called the Tenant's Guide, setting forth a full description of all the houses that were to let in the city of New York. "Now," said she, "here is a quantity of small blank books and lead pencils. Each of you is to take one of these books and pencils; leave me a shilling as a guaranty that you will return them; then tell me what streets you will take, so as not to cross each other's track. You are

to watch every house closely. The moment you see a bill up, indicating that the house is 'To Let,' ring the bell, pull out your book and pencil, and when a person comes to the door, inquire the price of rent, the number of rooms, and all the various accommodations – mark them all down, and hasten on to the next house which has a bill up, where you must repeat the operation. I hope, by having a large and effective corps of agents, to have the city finished in ten days, and to print my book in ten days more. The proceeds of my pamphlet, after paying the expenses of printing, publishing, advertising, etc., shall be divided in this manner: One half to me, the inventor of this great desideratum, and the other half to be fairly divided among you, my agents, according to the number of 'houses to let' which you return to me. I have no doubt that thousands of dollars will be realized by this speculation, and you will perceive that he who works the hardest will be the best paid. I always like to reward persons according to their labors. In other words, I delight in helping people who will try to help themselves. I would mention, however, that the number of houses obtained will not be the only criterion of reward, as I shall make favorable allowance to such as write plainly and who give me the best detail of particulars in regard to each house."

Before the old lady had finished her speech the larger portion of her audience had departed, but new applicants continued to arrive, and she recommenced her address so soon as she had finished it.

It will be believed that I was not tempted by the grand speculation, but being always a student of human nature, I could not help remaining until she had repeated her speech several times, merely to witness the effect which it had upon her hearers. None ventured to take a book while I was there, and the supply of customers being about equal to its falling off, there were constantly two moving rows of applicants, one row passing down stairs and the other passing up.

One morning I found in the "Sun" an advertisement for a barkeeper, application to be made to Wm. Niblo. I proceeded at once to Niblo's Garden, and there, for the first time in my life, saw its gentlemanly and justly-popular proprietor. Upon stating my business, Mr. Niblo informed me that he wished to employ a well-behaved and reliable man, who was competent to fill the vacant situation, who could produce the highest testimonials of his integrity, and who would bind himself to remain in the situation for three years. This last

condition, of course, clashed with my arrangements, as I sought the situation only as a means of temporary relief, being determined at an early day, if possible, to secure a place such as I have before described.

All my running at the beck of advertisers finally benefited me nothing. I obtained no situation during the entire winter.

Early in the spring I received several hundred dollars from my agent in Bethel, and finding no other business to suit me, I opened a small private boarding-house at No. 52 Frankfort street, on the 1st May, 1835. I intended this mostly for transient boarders, consisting of my acquaintances in Connecticut who had occasion to visit New York. We soon had a good share of custom, but not having sufficient employment for my time I purchased an interest in a grocery store, No. 156 South street, in company with Mr. John Moody.

During this year, I occasionally visited Bridgeport, and seldom failed to see a noted joker, named Darrow, at the hotel, in the evening. He spared neither friend nor foe in his tricks. He was generally the life of the bar-room, and if a stranger made his appearance Darrow would try to win a treat for the company, by some bet which he would induce him to make. On one occasion he made several ineffectual efforts to catch me with some of his tricks. At last Darrow, who always stuttered, made another trial. Coming up in front of me, and looking me square in the eyes, he said, "Come, Barnum, I'll make you another p-p-pr-proposition. I'll bet you hain't got a whole shirt on your back." The catch in this proposition consists in the fact that under ordinary circumstances only *one half* of that useful garment is upon the back. Anticipating this proposition, however – in fact having induced a Mr. Hough to put Darrow up to the trick – I had taken a shirt from my valise, and nicely folding it, placed it exactly on my back, fastening it there by passing my suspenders over it.

The bar-room was crowded with customers, who, with the exception of Hough, were not in the secret. They supposed that if I made the bet I should be caught. Wishing to play off a little, in order to make Darrow the more sharp for betting, I replied:

"That is a foolish bet to make. I am sure my shirt is whole because it is nearly new, but I don't like to bet on such a subject."

"A good reason why," said Darrow, in high glee; "it's ragged. Come, I'll bet you a treat for the whole company you hain't got a whole shirt on your b-b-b-back!"

"I'll bet my shirt is cleaner than yours," I replied.

"That's nothing to do w-w-with the case; it's ragged, and y-y-you know it."

"I know it is not," I replied with pretended anger, which caused the crowd to laugh heartily.

"You poor ragged f-f-fellow, come down here from D-D-Danbury, I'm sorry for you," said Darrow tantalizingly.

"You would not pay if you lost," I remarked.

"Here's f-f-five dollars I'll put in Captain Hinman's (the landlord's) hands. Now b-b-bet if you dare, you ragged c-c-creature you!"

I put up five dollars in Captain Hinman's hands, and told him to treat the company from it if I lost the bet.

"Remember," said Darrow, "I b-b-bet you hain't got a whole shirt on your b-b-back!"

"All right," said I, taking off my coat and commencing to unbutton my vest. The whole company, feeling sure that I was caught, began to laugh heartily. Old Darrow fairly danced with delight, and as I laid my coat on a chair he came running up in front of me, and slapping his hands together exclaimed:

"You needn't t-t-take off any more c-c-c-clothes, for if it ain't all on your b-b-back, you've lost it."

"If it is, I suppose you have!" I replied, pulling the whole shirt from off my back!

Such a shriek of laughter as burst forth from the crowd I scarcely ever heard, and certainly such a blank countenance as old Darrow exhibited it would be hard to conceive. Seeing that he was most incontinently "done for," and perceiving that his neighbor Hough had helped to do it, he ran up to him in great anger, and shaking his fist in his face exclaimed:

"H-H-Hough, you infernal r-r-rascal, to go against your own n-n-neighhor in favor of a D-D-Danbury man. I'll pay you for that some time, you see if I d-d-don't."

All hands went up to the bar and drank with a hearty goodwill, for it was seldom that Darrow got taken in, and he was such an inveterate joker they liked to see him paid in his own coin. Never till the day of his death did he hear the last of the "whole shirt."

In the latter part of July, 1835, Mr. Coley Bartram, of Reading, Ct., and at present a resident of the same State, called at our store. He was acquainted with Mr. Moody and myself. He informed us that he had owned an interest in an extraordinary negro woman,

named JOICE HETH, whom he believed to be one hundred and sixty-one years of age, and whom he also believed to have been the nurse of General Washington. He had sold out his interest to his partner R. W. Lindsay, of Jefferson County, Kentucky, who was now exhibiting her in Philadelphia, but not having much tact as a showman, he was anxious to sell out and return home.

Mr. Bartram also handed me a copy of "The Pennsylvania Inquirer," of July 15, 1835, and directed my attention to the following advertisement, which I here transcribe *verbatim*:

> CURIOSITY. – The citizens of Philadelphia and its vicinity have an opportunity of witnessing at the MASONIC HALL, one of the greatest natural curiosities ever witnessed, viz., JOICE HETH, a negress aged 161 years, who formerly belonged to the father of Gen. Washington. She has been a member of the Baptist Church one hundred and sixteen years, and can rehearse many hymns, and sing them according to former custom. She was born near the old Potomac River in Virginia, and has for ninety or one hundred years lived in Paris, Kentucky, with the Bowling family.
>
> All who have seen this extraordinary woman are satisfied of the truth of the account of her age. The evidence of the Bowling family, which is respectable, is strong, but the original bill of sale of Augustine Washington, in his own handwriting, and other evidence which the proprietor has in his possession, will satisfy even the most incredulous.
>
> A lady will attend at the hall during the afternoon and evening for the accommodation of those ladies who may call.

The New York newspapers had already furnished descriptions of this wonderful personage, and becoming considerably excited upon the subject, I proceeded at once to Philadelphia and had an interview with Lindsay at the Masonic Hall.

I was favorably struck with the appearance of the old woman. So far as outward indications were concerned, she might almost as well have been called a thousand years old as any other age. She was lying upon a high lounge in the middle of the room; her lower extremities were drawn up, with her knees elevated some two feet above the top of the lounge. She was apparently in good health and spirits, but former disease or old age, or perhaps both combined, had rendered her unable to change her position; in fact, although she could move one of her arms at will, her lower limbs were fixed

in their position, and could not be straightened. She was totally blind, and her eyes were so deeply sunken in their sockets that the eyeballs seemed to have disappeared altogether. She had no teeth, but possessed a head of thick bushy gray hair. Her left arm lay across her breast, and she had no power to remove it. The fingers of her left hand were drawn down so as nearly to close it, and remained fixed and immovable. The nails upon that hand were about four inches in length, and extended above her wrist. The nails upon her large toes also had grown to the thickness of nearly a quarter of an inch.

She was very sociable, and would talk almost incessantly so long as visitors would converse with her. She sang a variety of ancient hymns, and was very garrulous when speaking of her protégé "dear little George," as she termed the great father of our country. She declared that she was present at his birth, that she was formerly the slave of Augustine Washington, the father of George, and that she was the first person who put clothes upon him. "In fact," said Joice, and it was a favorite expression of hers, "I raised him." She related many interesting anecdotes of "her dear little George," and this, mixed with her conversations upon religious subjects, for she claimed to be a member of the Baptist Church, rendered her exhibition an extremely interesting one.

I asked Mr. Lindsay for the proofs of her extraordinary age, and he exhibited what purported to be a bill of sale from Augustine Washington, of the county of Westmoreland, Virginia, to "Elizabeth Atwood," of "one negro woman, named Joice Heth, aged fifty-four years, for and in consideration of the sum of thirty-three pounds lawful money of Virginia." The document bore the date "fifth day of February, one thousand seven hundred and twenty-seven," and was "sealed and delivered in presence of Richard Buckner and William Washington."

The story told by Lindsay and "Aunt Joice" was, that Mrs. Elizabeth Atwood was a sister-in-law of Augustine Washington, that the husband of Joice was a slave of Mrs. Atwood, and for that reason the above sale was made. As Mrs. Atwood was a near neighbor of Mr. Washington, Aunt Joice was present at the birth of "little George," and she having long been the old family nurse, was the first person called upon to clothe the new-born infant.

The story seemed plausible, and the "bill of sale" had every appearance of antiquity. It was exhibited in a glass frame, was very sallow in appearance, and seemed to have been folded for such a

great length of time that the folds were worn nearly through, and in some parts entirely so.

I inquired why the existence of such an extraordinary old woman had not been discovered and made known long ago. The reply was that she had been lying in an out-house of John S. Bowling of Kentucky for many years, that no one knew or seemed to care how old she was, that she had been brought thither from Virginia a long time ago, and that the fact of her extreme age had been but recently brought to light by the discovery of this old bill of sale in the Record office in Virginia, by the son of Mr. Bowling, who, while looking over the ancient papers in that office, happened to notice the paper endorsed Joice Heth, that his curiosity was excited, and from inquiries made in that neighborhood he was convinced that the document applied to his father's old slave then living, and who was therefore really one hundred and sixty-one years of age; that he thereupon took the paper home, and became confirmed in regard to the identity of Joice with the slave described in that paper.

This whole account appeared to me satisfactory, and I inquired the price of the negress. Three thousand dollars was the sum named, but before leaving Philadelphia I received from Mr. Lindsay a writing, stipulating that I should have the right at any time within ten days to become her owner upon paying to him the sum of one thousand dollars.

With this paper I started for New York, determined if possible to purchase Joice Heth. I did not possess more than five hundred dollars in cash, but my glowing representations to a friend, of the golden harvest which I was sure the exhibition must produce, induced him to loan me the other five hundred dollars, and after a few days, during which time I sold my interest in the grocery store to my partner, Moody, I returned to Philadelphia with the money, and became the proprietor of the negress, as appears by the following document:

WHEREAS, by articles of agreement dated June 10th, A. D. 1835, John S. Bowling, the owner of an African woman called JOICE HETH, and R. W. Lindsay, of Jefferson County, Commonwealth of Kentucky, covenanted and agreed for the term of twelve months to participate equally in the gains and losses in exhibiting the African woman, Joice Heth, in and amongst the cities of the United States: And whereas, R. W. Lindsay says, that John S. Bowling transferred all his right, title, interest, and claim arising out of said agreement to Coley

Bartram, and whereas, the said Coley Bartram by a writing dated at Philadelphia, July 24th, A. D. 1835, did transfer to R. W. Lindsay all his interest in the colored woman, Joice Heth, aged 161 years, sold to him by John S. Bowling, of Kentucky, dated June 15, A. D. 1835: Now know all men by these presents, that I, the said R. W. Lindsay, for and in consideration of the sum of one thousand dollars to me in hand paid by PHINEAS T. BARNUM, at or before the sealing of these presents, the receipt whereof is hereby acknowledged, have bargained, sold, transferred, and delivered, and by these presents do bargain, sell, transfer, and deliver unto the said Phineas T. Barnum, his executors, administrators or assigns, the possession of the person of the African woman, JOICE HETH, and the sole right of exhibiting her during the unexpired term of the twelve months mentioned in the agreement dated June 10th, A. D. 1835, in and amongst the cities of the United States, and all my right, title, interest, or claim whatsoever, to the possession of the said Joice Heth, and to the right of exhibiting her as aforesaid. And I do hereby for myself, my heirs, executors, and administrators, covenant, promise, and agree to and with the said Phineas T. Barnum, his heirs and assigns, by these presents, that I, the said R. W. Lindsay, and my heirs, have and do enjoy the just and legal possession of the said Joice Heth, and the sole right of exhibiting her in and amongst the cities of the United States during the unexpired time of the twelve months commencing June 10th, A. D. 1835. And I do further covenant, promise and agree, that the possession of Joice Heth, and the right of exhibiting her as aforesaid, and all my title and interest in Joice Heth, hereby transferred and delivered unto the said Phineas T. Barnum, his heirs and assigns, against me, R. W. Lindsay, and my heirs, and against Coley Bartram, and against John S. Bowling and his heirs, and against all and every other person and persons whatsoever, lawfully claiming or to claim by, from, or under him, them, or any of them, shall and will warrant and for ever defend by these presents.

Provided, always, such claims shall be made previous to the tenth day of June, A. D. 1836. I hold myself clear of all covenants and agreements for the possession of the person of Joice Heth, or the right of exhibiting her after the tenth day of June, A. D. 1836.

In witness whereof, I have hereunto set my hand and seal, this sixth day of August, Anno Domini one thousand eight hundred and thirty-five.

Sealed and delivered in presence of }
SAML. H. TRAQUAIR, W. DELANY. } R. W. LINDSAY. **L.S.**

Received, August 6, 1835, from Phineas T. Barnum, one thousand dollars, being the full consideration of the within conveyance, and of the covenants and agreements contained therein.

(Signed)

R. W. LINDSAY.

I engaged Lindsay to continue the exhibition in Philadelphia for a week, in order to allow me time to make the necessary arrangements for her reception in New York.

I applied to Mr. William Niblo, who, I believe, had seen the old negress in Philadelphia. He did not recognize me as the person who a few months previously had applied to him for the situation of bar-keeper. We soon made a bargain for the exhibition of Aunt Joice in one of the large apartments in his dwelling-house in the vicinity of his saloon, which was at that time a large, open and airy establishment where musical and light entertainments were given, the guests during the intermission, as well as at other times, being supplied with ice-creams and other refreshments, in little alcove-boxes fitted up with tables, and running nearly all the distance around his garden.

These alcoves were tastefully decorated on the outside with festoons of lamps of variegated colors, and the grand walk through the middle of the garden was illuminated on each side by chaste and pretty transparencies, about seven feet high and two feet wide, each surmounted with a large globular lamp. These transparencies were then new in the city of New York, and were very attractive. They were gotten up by W. J. and H. Hannington, who have since become so celebrated for glass-staining and decorative painting. Mr. H. Hannington prepared me several transparencies, two feet by three in size, which I had placed upon a hollow frame and lighted from the inside. It was painted in colors with white letters, and read—

JOICE HETH 161 YEARS OLD

The terms of my engagement with Mr. Niblo were these: He was to furnish the room and lights, pay the expense of printing, advertising, and a ticket-seller, and retain therefor one half of the gross receipts. The result proved an average of about $1500 per week.

I engaged as an assistant in exhibiting "Aunt Joice" Mr. LEVI LYMAN. He was a lawyer by profession, and had been practising in Penn Yan, N. Y. He was a shrewd, sociable, and somewhat indolent Yankee; possessed a good knowledge of human nature; was polite, agreeable, could converse on most subjects, and was admirably calculated to fill the position for which I engaged him.

Of course, in carrying out my new vocation of showman, I spared no reasonable efforts to make it successful. I was aware of the great power of the public press, and I used it to the extent of my ability. Lyman wrote a brief memoir of Joice, and putting it into a pamphlet form, illustrated with her portrait, sold it to visitors on his own account, at six cents per copy.

I had the same portrait printed on innumerable small bills, and also flooded the city with "posters," setting forth the peculiar attractions which "the nurse of Washington" presented. Here are a few specimens of advertisements and notices of that day:

"NIBLO'S GARDEN. – The greatest curiosity in the world, and the most interesting, particularly to Americans, is now exhibiting at the Saloon fronting on Broadway, in the building recently erected for the dioramic view, JOICE HETH, nurse to Gen. George Washington, (the father of our country,) who has arrived at the astonishing age of 161 years, as authentic documents will prove, and in full possession of her mental faculties. She is cheerful and healthy, although she weighs but forty-nine pounds. She relates many anecdotes of her young master; she speaks also of the red-coats during the Revolutionary War, but does not appear to hold them in high estimation.

"She has been visited by crowds of ladies and gentlemen, among whom were many clergymen and physicians, who have pronounced her the most ancient specimen of mortality the oldest of them has ever seen or heard of, and consider her a very great curiosity.

"She has been a member of the Baptist Church for upwards of one hundred years, and seems to take great satisfaction in the conversation of ministers who visit her. She frequently sings and repeats parts of hymns and psalms."

Another advertisement contained a still closer appeal to both patriotism and curiosity:

"JOICE HETH is unquestionably the most astonishing and interesting curiosity in the world. She was the slave of Augustine

Washington, (the father of George Washington,) and was the first person *who put clothes on the unconscious infant* who was destined in after days to lead our heroic fathers to glory, to victory, and to freedom. To use her own language when speaking of her young master, George Washington, 'she raised him.'"

Editorial notices were abundant in many papers of the day, news, literary, political, and religious – of which the following may serve as samples:

"JOICE HETH. – The arrival at Niblo's Garden of this renowned relic of the olden time has created quite a sensation among the lovers of the curious and the marvellous; and a greater object of marvel and curiosity has never presented itself for their gratification. From the length of her limbs and size of her bones, it is probable she was a large, stout woman in her day, but now she comes up exactly to one's idea of an animated mummy. Her weight is said to be less than fifty pounds; her feet have shrunk to mere skin and bone, and her long, attenuated fingers more resemble the claws of a bird of prey than human appendages. Notwithstanding her burden of years and infirmities, she is lively, and seems to retain all her senses wonderfully. Her hearing is almost as acute as that of any person of middle age." – *New York Sun.*

"The 'old one' has arrived, and crowds of ladies and gentlemen have visited her at Niblo's. She is lively, and answers every question cheerfully. From the bill of sale of this old lady from General Washington's father, we can have no doubt that she is 160 years of age. Her appearance is very much like an Egyptian mummy just escaped from its sarcophagus." – *New York Evening Star.*

"We venture to state, that since the flood, a like circumstance has not been witnessed equal to one which is about to happen this week. Ancient or modern times furnish no parallel to the great age of this woman. Methuselah was 969 years old when he died, but nothing is said of the age of his wife. Adam attained nearly the age of his antiquated descendant. It is not unlikely that the sex in the olden time were like the daughters at the present day – unwilling to tell their age. Joice Heth is an exception; she comes out boldly, and says she is rising 160." – *New York Daily Advertiser.*

"This old creature is said to be 161 years of age, and we see no reason to doubt it. Nobody indeed would dispute it if she claimed to be five centuries, for she and the Egyptian mummy at the American Museum appear to be about of an age." – *New York Courier and Enquirer.*

"The dear old lady, after carrying on a desperate flirtation with Death, has finally jilted him. In the future editions, we shall expect to see her represented as the impersonation of Time in the Primer, old Time having given her a season ticket for life. The Wandering Jew and herself are the only two people we wot of that have been put on the free-list of this world for the season of eternity." – *New York Spirit of the Times.*

Joice was an inveterate smoker, and Grant Thorburn (better known as Lawrie Todd) gave some occasion of triumph to many editors by publishing an article in the *Evening Star*, from which the following is an extract:

"I have been to see Joice Heth to-day. I find that with all her other rare qualities, she is *a profound smoker.* Her attendants are obliged to abridge this luxury, else the pipe would never be out of her mouth. I asked her how long she had used the pipe, and she answered, 'One hundred and twenty years!' So, if smoking be a poison, it is, in her case at least, a very slow poison."

Our exhibition usually opened with a statement of the manner in which the age of Joice Heth was discovered, as well as the account of her antecedents in Virginia, and a reading of the bill of sale. We would then question her in relation to the birth and youth of General Washington, and she always gave satisfactory answers in every particular. Individuals among the audience would also frequently ask her questions, and put her to the severest cross-examinations, without ever finding her to deviate from what had every evidence of being a plain unvarnished statement of facts.

Joice was very fond of church-music, to which she would beat time by waving her long withered arm. On one occasion in New York an aged Baptist minister stood by her side as she was singing one of her favorite hymns, and he joined her, and lined each verse. She was much pleased by this circumstance, and sang with renewed animation. After the hymn was finished, the clergyman lined off

the verse of another hymn, and Joice immediately remarking, "I know that hymn," joined him in singing it. He lined in this manner several hymns which were entirely new to me, and in each case Joice knew them, and in one or two instances refreshed his memory when he found himself at a loss to recall the exact language of the verses. Joice loved to converse upon religious subjects, and frequently insisted on the attendance of clergymen for that purpose.

The question naturally arises, if Joice Heth was an impostor, *who* taught her these things? and how happened it that she was so familiar, not only with ancient psalmody, but also with the minute details of the Washington family? To all this, I unhesitatingly answer, *I do not know.* I taught her none of these things. She was perfectly familiar with them all before I ever saw her, and she taught me many facts in relation to the Washington family with which I was not before acquainted.

From Providence, where the exhibition was highly successful, we went to Boston. This was my first appearance in the modern Athens, and I saw much that was new and interesting to me. I attended various churches, and was pleased to see such an almost universal observance of the Sabbath. The theatres, too, were not permitted to be open on Saturday evenings, and my mind reverted to the customs of many of our neighbors in Connecticut, who, according to the old Puritan fashion, "kept Saturday night," that is, they considered that the Sabbath commenced with the setting of the sun on Saturday and closed at sundown on Sunday, at which time they would recommence their labors and recreations.

We opened our exhibition in the small ball-room of Concert Hall, at the corner of Court and Hanover streets. The fame of Joice had preceded her, the city was well posted with large bills announcing her coming, and the newspapers had heralded her anticipated arrival in such a multiplicity of styles, that the public curiosity was on tip-toe. I remember that one of the papers, after giving a description of Joice Heth, and the great satisfaction which her exhibition had given in New York, added, "It *rejoice-heth* us exceedingly to know that we shall be permitted to look upon the old patriarch."

The celebrated Maelzel was exhibiting his equally celebrated "automaton chess-player" in the large ball-room of Concert Hall; but the crowd of visitors to see Aunt Joice was so great, that our room could not accommodate them, and Mr. Maelzel was induced to close his exhibition, and give us his large room. I had frequent

interviews and long conversations with Mr. Maelzel. I looked upon him as the great father of caterers for public amusement, and was pleased with his assurance that I would certainly make a successful showman.

"I see," said he, in broken English, "that you understand the value of the press, and that is the great thing. Nothing helps the showmans like the types and the ink. When your old woman dies," he added, "you come to me, and I will make your fortune. I will let you have my 'carousal,' my automaton trumpet-player, and many curious things which will make plenty of money."

I thanked him for his generous proposals, and assured him that should circumstances render it feasible, I should apply to him.

Our exhibition room continued to attract large numbers of visitors for several weeks before there was any visible falling off. I kept up a constant succession of novel advertisements and unique notices in the newspapers, which tended to keep old Joice fresh in the minds of the public, and served to sharpen the curiosity of the people.

When the audiences began to decrease in numbers, a short communication appeared in one of the newspapers, signed "A Visitor," in which the writer claimed to have made an important discovery. He stated that Joice Heth, as at present exhibited, was a humbug, whereas if the simple truth was told in regard to the exhibition, it was really vastly curious and interesting. "The fact is," said the communication, "Joice Heth is not a human being. What purports to be a remarkably old woman is simply a curiously constructed automaton, made up of whalebone, india-rubber, and numberless springs ingeniously put together, and made to move at the slightest touch, according to the will of the operator. The exhibitor is a ventriloquist, and all the conversations apparently held with the ancient lady are purely imaginary, so far as she is concerned, for the answers and incidents purporting to be given and related by her, are merely the ventriloquial voice of the exhibitor."

Maelzel's ingenious mechanism somewhat prepared the way for this announcement, and hundreds who had not visited Joice Heth were now anxious to see the curious automaton; while many who had seen her were equally desirous of a second look, in order to determine whether or not they had been deceived. The consequence was, our audiences again largely increased.

On one occasion, an ex-member of Congress, his wife, two children, and his aged mother, attended the exhibition. He was one

of the first men in Boston, a gentleman highly esteemed; and as his family approached the bed where Joice was resting, the visitors respectfully gave way for them. I was soon engaged in conversation with the gentleman, answered the numerous questions which he asked, and directed several of my remarks to his wife. In the mean time, his old mother was closely scrutinizing Aunt Joice, under the immediate direction of my helpmate, Lyman.

Presently the old lady spoke up in an audible tone, and with much apparent satisfaction, "There, it is alive after all!"

I caught the remark instantly, and was glad to perceive that her son did not hear it. I kept up a conversation with him, in order that he should not notice the *tête-à-tête* which his mother and Lyman were enjoying; at the same time, however, I listened anxiously to their conversation.

"Why do you think it is alive?" asked Lyman, quietly.

"Because its pulse beats as regularly as mine does," responded the old lady.

"Oh, that is the most simple portion of the machinery," said Lyman. "We make that operate on the principle of a pendulum to a clock."

"Is it possible?" said the old lady, who was now evidently satisfied that Joice was an automaton. Then turning to her son, she said:

"George, this thing is not alive at all. It is all a machine."

"Why, mother," said the son with evident embarrassment, "what are you talking about?"

A half-suppressed giggle ran through the room, and the gentleman and his family soon withdrew. Lyman maintained the utmost gravity of countenance, and the keenest observer would have failed to detect in his visage any evidence of his having played off a joke upon the unsophisticated old lady.

From Boston we went to Hingham, and thence in succession to Lowell, Worcester, Springfield, and Hartford, meeting with most satisfactory success. Everywhere there appeared to be conviction of the extreme longevity of Joice.

We hastened our return to New York to fill a second engagement I had made with Mr. Niblo. The American Institute held its annual Fair at his garden, and my engagement was to commence at the same time. The great influx of visitors to the Fair caused our room to be continually crowded, insomuch that we were frequently compelled to announce to applicants that the hall was full, and no

more could be admitted for the present. In those cases we would hurry up the exhibitions, cut short a hymn or two, answer questions with great rapidity, and politely open the front door as an egress to visitors, at the same time opening the entrance from the garden for the ingress of fresh customers.

From Niblo's we went to New Haven for three days, where the crowds were as large as usual. We then returned to New York and proceeded to Newark, where I met with the usual success. From Newark we returned to New York and went to Albany for one week to fill an engagement made with Mr. Meech, the proprietor of the Museum.

While exhibiting there, light evening entertainments were given in the theatre of the Museum, one part of which consisted of remarkable feats of balancing, plate spinning, stilt walking, etc., by "Signor Antonio." The balancing and spinning of crockery was nearly or quite new in this country – to me it was entirely so. It was also as surprising as it was novel. The daring feats of Antonio upon stilts, his balancing guns with the bayonets resting on his nose, and various other performances which I had never seen before, attracted my attention. I inquired of Mr. Meech where Antonio came from. He informed me that he was an Italian – had sailed from England to Canada, whence he had proceeded to Albany, and had never exhibited in any other American city. Learning that Mr. Meech did not desire his services after that week, I sought an interview with "Antonio," and in ten minutes engaged him to perform for me in any portion of the United States for one year from date, at the salary of $12 per week, besides board and travelling expenses. I did not know exactly where I should use my protégé, but I was certain that there was money in him, and thus I became interested in my second show.

Antonio, Joice Heth, Lyman and myself, left Albany for New York, stopping at the private boarding house in Frankfort street which I had taken the spring previous, but had sold out soon after engaging Aunt Joice. I left my two shows in Frankfort street while I went to join my wife and daughter, who were boarding with a Mr. Knapp, in Cherry street.

The first favor which I asked of Antonio was, that he should submit to be thoroughly washed – an operation to which he had apparently been a stranger for several years; and the second, that he should change his name. I did not think "Antonio" sufficiently "foreign," hence I named him Signor VIVALLA, to both which propositions he consented. I immediately wrote a notice announcing the

extraordinary qualities of Signor Vivalla, who had just arrived from Italy, elaborately setting forth the wonders of his performances. This was published as an article of news in one of the city papers, and I forwarded a dozen copies to the several theatrical managers in New York, and elsewhere.

I first called upon William Dinneford, Esq., manager of the Franklin Theatre, but he declined engaging the "eminent Italian artist." He had seen so many performances of that kind which were vastly more extraordinary than any thing which Vivalla conld do, he would not think of engaging him.

"Now," says I, "Mr. Dinneford, I beg your pardon, but I must be permitted to say that you are mistaken. You have no doubt seen strange things in your life, but, my dear sir, I should never have imported Signor Vivalla from Italy, unless I had authentic evidence that he was the only artist of the kind who ever left that country."

"What are your terms?" asked Dinneford, who (like many worthy young ladies, and many other republicans of the first water) was evidently beginning to melt under the magic influence of a foreign importation.

"You shall have him one night for nothing," I replied. "If you like him after one trial, you shall have him the remainder of the week for fifty dollars – but, understand me, this is only that the public may be able to see what he is. After that, my terms are $50 per night."

My proposition for the one night was accepted. I invoked the powers of "printer's ink" and wood-cuts for three days and nights previous to the first appearance of "the renowned and extraordinary Italian artist, Signor Vivalla," and they were potent for my purpose. The house was crammed. I marched upon the stage as a supernumerary to assist Vivalla in arranging his plates and other "crockery ware," to hand him the gun to fire when he had divested himself of one of his stilts, and was hopping across the stage on one stilt ten feet high, and to aid him in handling his muskets, etc. *This was my "first appearance on any stage."*

The applause which followed each of the Italian's feats was tremendous. It was such as only a Chatham or a Bowery audience could give. Manager Dinneford was delighted, and before we left the stage he engaged Vivalla for the week. At the termination of the performances Vivalla was called before the curtain, and as I did not consider it policy for him to be able to speak English, (although he could do so very well, having travelled several years in England,)

I went out with him and addressed the audience in his name, thanking them for their generosity, and announcing him for the remainder of the week.

In the mean time I had opened the exhibition of Joice Heth in the large hall at the junction of the Bowery and Division street, but as I saw that Vivalla's prospects were bright, and that his success would depend in a great measure upon management, I left Lyman to exhibit Joice. After she had remained in that location for several weeks, he took her to several towns in Connecticut and elsewhere. Vivalla remained a second week at the Franklin Theatre, for which I received $150 – immediately after which, I realized the same sum for his services one week in Boston; and then we proceeded to Washington city to fulfil an engagement I had made with Wemyss, my profits depending on the receipts.

The theatre in Washington was a small out-of-the-way-place, and we opened, Jan. 16, 1836, to a house not exceeding $30. It was a hard beginning, for the stipulations required $50 more before I was entitled to a penny!

This was my first visit to Washington, and I was much interested in viewing the United States Capitol, and other Government buildings, and satisfied a laudable curiosity by having pointed out to me, in their seats in Congress, Clay, Calhoun, Benton, Webster, J. Q. Adams, Polk, Richard M. Johnson, etc.

Mr. Polk was then Speaker of the House of Representatives, and Mr. Van Buren, who was then Vice President of the United States, of course presided over the Senate. I had an opportunity one afternoon, while in the gallery of the Senate, to witness the extraordinary powers of self-control which Mr. Van Buren possesses. In those days of high political excitement, he was called by his enemies "Reynard the Fox," "the Little Magician," etc.; and in fact he was looked upon by many persons as a man so wily as to be able to circumvent every body and every thing short of "Old Horny" himself.

Mr. Calhoun rose to speak. He was intensely excited, and spoke very rapidly as follows: "Mr. President, I am continually annoyed by newspapers sent to me from the New England States, in which are set forth the principles and designs of a class of – I will not say men, for they deserve not the title; but a class of *ingrates*, known as abolitionists. With your permission, Sir, I will read an extract from a newspaper which I received by mail this morning, and which I now hold in my hand."

Mr. Calhoun then read a most violent and bitter attack upon the southern slaveholders, denouncing them as man-stealers, pirates, robbers, murderers, men who set at nought every requirement of the decalogue, and who richly deserved to be butchered by their own slaves. In fact, the editor advised the slaves to execute immediate and bloody vengeance upon their masters.

A thrill of indignation against the editor, whoever he might be, ran through the assembly, and Mr. Calhoun continued: "The political character of this paper, Mr. President, can be judged by the following names which I read from the head thereof: For President, MARTIN VAN BUREN, of New York; for Vice President, R. M. JOHNSON, of Kentucky."

The Senate was convulsed with laughter at this palpable hit. Meanwhile Mr. Van Buren maintained a countenance as placid as a May morning, and the keenest eye could not have detected the slightest evidence that he was any more interested in the speech of Mr. Calhoun than an infant. Mr. Calhoun continued for twenty minutes to denounce the administration in the most scathing language. Van Buren manifested the utmost unconcern, and when the speech was finished, he beckoned to Mr. King, of Alabama, who took the chair, while "little Matty" quietly walked about among the Senators, shaking hands and smilingly conversing with them.

I called on Anne Royall, the authoress of the Black Book, who at that time was quite a celebrated personage. She published a little paper entitled "Paul Pry." I had exchanged with her while I edited the Herald of Freedom; she strongly sympathized with me in my persecutions, and was now delighted to see me – she was even boisterous in her assurances of that fact.

Anne was the most garrulous old woman I ever saw. Her tongue ran like wildfire. She said when she first saw me she thought it was Clayburn, meaning the member of Congress from Mississippi.

"I expect Clayburn here every minute," says she. "Do you know," she continued, "that he is a terrible wag? Yes, Barnum, that Clayburn once passed himself off on me as a clergyman. But never mind, I forgive him, for he is a good fellow after all."

"Come, Sally, put the things in order," said Mrs. Royall, (addressing her help-mate, a tall woman of about thirty, somewhat ragged and considerably dirty,) "get things to rights; you know I am expecting several of the members here this morning. Oh, yes, Mr. Barnum, all the Congressmen call on me; they dare not do otherwise. Enemies and friends all alike, they have to come to me.

And why should they not? I made them – every devil of them. You see how I look, ragged and poor, but thank God I am saucy and independent. The whole Government is afraid of me, and well they may be. I know them all, from top to toe – I can fathom their rascality through all its ins and outs, from the beginning to the end. By the way, Barnum, who do you support for President and Vice President?"

"Well, I believe I shall go for Matty and Richard M.," meaning Martin Van Buren and Richard M. Johnson.

I have seen some fearful things in my day – some awful explosions of tempestuous passion; but never have I witnessed such another terrible tempest of fury as burst from Mrs. Anne Royall, in reply to my response. After a minute, during which her utterance was choked, she broke forth as follows – I kept a diary in those days, and I here copy *verbatim*:

"My God! my God! is it possible? Will you support such a monkey, such a scoundrel, such a villain, such a knave, such an enemy to his country, as Martin Van Buren! Barnum, you are a scoundrel, a traitor, a rascal, a hypocrite! You are a spy, an electioneering fool, and I hope the next vessel you put foot on will sink with you."

"Ha! ha! ha! no, you don't."

"Oh, you villain! laugh, will you? when your country is in danger! laugh, when fire-arms are in preparation to destroy your country! Oh, you don't believe it, but let me tell you, the conspirators know too much to let you foolish Yankees into their secret. Remember, I was once with them, and I know all about it."

"Why, Anne, you must acknowledge there are some good people in our ranks."

"No, I don't. There's not one devil of you who cares a cent for his country. You would not give a farthing to save it from destruction. See how I live! see how I work to save my country! I am at work every moment – see my house – see I have no bed to lie on – no any thing – and then *you* tell about loving your country! Oh, you deserve to be lynched, every devil of you!"

In this style Anne raved for half an hour. I occasionally laughed, which made her worse, and if I tried to slip in a word of excuse, she would exclaim:

"There, that's the way with you Yankees; you won't hear anybody, and that is the reason you don't know any thing."

At last she talked herself out of breath. I had formed a pretty

correct idea of Anne's character, and felt assured, therefore, that although she was a monomaniac upon political subjects, she was nevertheless a good-hearted, generous woman, and that all her present ranting was but an ebullition of her eccentricity, and not any evidence of her disliking me. And so it proved, for, lowering her voice into a calm, she turned the conversation as follows:

"Well, Barnum, you are a good fellow, and I am really glad to see you. How sorry I am that we mentioned politics, for I am so nervous. Now, I want a real good talk with you."

Sally here announced that the papers were ready for mailing, upon which Anne started up and said, "Come, Barnum, go with me into the printing-office, and there we can talk and work together."

We proceeded to a small brick building, near the house, and after experiencing some difficulty in climbing up a dirty pair of stairs, and groping our way through a dark passage in the second story, we reached the printing-office of the "Paul Pry." The whole force of the establishment consisted of one man and a boy. A pile of newspapers in wrappers, and all directed to their places of destination, lay upon the middle of the floor.

"Now, Barnum," said Anne, "I am going to sort these papers for the mails, for our lazy officials in the post-office would not do it in a week, and you shall help me; so sit right down on the floor by my side, and we can work and talk together."

Anne then seated herself upon the dirty floor, and as there was no chair in the room, I sat down beside her, not daring even to spread my handkerchief or in any way remove the dust, lest she should construe it into an insult.

In this way I spent another half hour with Anne, aiding her in assorting her papers, and keeping up with her a very agreeable conversation, during which she gave me briefly her history, which I cannot spare space to record.

Before leaving her, my showman propensities were manifest, inasmuch as I tried to hire her to give a dozen or twenty public lectures upon Government, in the Atlantic cities; but she was not to be tempted by pecuniary reward, and I was obliged to give over that speculation, which, by the way, I am certain would have proved a profitable one.

Upon parting with Mrs. Royall she seemed very grateful to me for calling on her, and said I must certainly never visit Washington without spending a few hours with her. To this I agreed, but never again met the eccentric old lady.

Since writing the foregoing, Mrs. Royall has departed this life. I cut the following slip from a New York paper of October 5, 1854:

"MRS. ANNE ROYALL died at her residence in Washington, on Sunday morning, October 1st, 1854, at a very advanced age. She was the widow of a revolutionary officer, Colonel William Royall, and she published a newspaper in Washington for many years, first as the 'Paul Pry,' which name was afterward changed to 'The Huntress.' The 'Washington Star' says:

"'Ever since the publication of the famous history of her peregrinations throughout the country, fighting the Presbyterians, she has made her residence here. For the last four or five years she has been out and about very little, owing to her increasing infirmities. When about, however, her tongue went as before – always so as to attract a crowd of wonderers around her. Vehement and violent in her antipathies, and the expression of them, she was equally warm in her friendship for those she favored, though from her peculiar way of manifesting her likings, few, indeed, courted her affectionate regards. To the hour of her death she preserved all the peculiarities of thought, temper, and manners, which at one time rendered her so famous throughout the land.'"

There was incessant snow in Washington during Vivalla's engagement, and I was so unexpectedly a loser by the operation, that I had not sufficient funds to return to Philadelphia. After much hesitation, and with a deep feeling of sadness and humiliation, I pawned my watch and chain for thirty-five dollars, promising to redeem it within a month. Fortunately, however, Mr. Wemyss arrived on Saturday morning, bringing with him Lucius Junius Booth and Miss Waring, afterwards Mrs. Sefton. Mr. Wemyss loaned me thirty-five dollars, and I redeemed my watch, paying a dollar for the use of the money a few hours.

Vivalla and myself proceeded to Philadelphia, and opened at the Walnut street, on the 26th, to a slim house. The sleighing was good and theatricals dull. Hadaway, the popular actor, at present engaged at my Museum, was the low comedian at the Walnut, and appeared just as old then as now. I then thought him one of the most chaste and effective comedians of the day, and I think the same of him still. His laugh, his walk, his every look and act is comic – he must be droll in spite of himself – every tone and modulation of his voice is truly comic. He never utters a vulgar expression,

never overacts his part – but possesses a most judicious mind, which, ever bent upon his profession, has made him, with his excellent personal habits, a most worthy and justly popular actor.

"Signor Vivalla's" performances were well received. On the second night, however, I heard two or three distinct hisses from the pit. It was the first time that my protégé had received the slightest mark of disapprobation since I had engaged him, and I was surprised. Vivalla, who, under my management, had become proud of his profession, was excessively annoyed. I proceeded, therefore, to that portion of the house whence the hissing emanated, and found that it came from a circus performer named Roberts and his friends. It seems that Roberts was a balancer and juggler, and he declared he could do all that Vivalla could. I was certain he could *not*, and told him so. Some hard words ensued. I then proceeded to the ticket-office, where I wrote several copies of a "card," and proceeding to the printing-offices of various newspapers, climbing up narrow stairs and threading dark alleys for the purpose, I secured its appearance in the papers of the next morning. The card was headed *"One Thousand Dollars Reward!"* and then proceeded to state that Signor Vivalla would pay the foregoing sum to any man who would publicly accomplish his (Vivalla's) feats, at such public place as Vivalla should designate.

Roberts came out with a card the next day, acccepting Vivalla's offer, calling on him to put up the thousand dollars, to name the time and place of trial, and stating that he could be found at a certain hotel near Green's Circus, of which he was a member. I borrowed a thousand dollars of my friend Oliver Taylor – went to Mr. Warren, treasurer of the Walnut, and asked him what share of the house he would give me if I would get up an excitement that should bring in four or five hundred dollars a night. (The entire receipts the night previous were but seventy-five dollars.) He replied that he would give me one third of the gross receipts. I told him I had a crotchet in my head, and would inform him within an hour whether it would work. I then called upon Roberts and showed him my thousand dollars. "Now," says I, "I am ready to put up this money in responsible hands, to be forfeited and paid to you if you accomplish Signor Vivalla's feats."

"Very well," said Roberts, with considerable bravado; "put the money into the hands of Mr. Green, the proprietor of the circus" – to which I assented.

"Now," said I, "I wish you to sign this card, to be published

in handbills and in to-morrow's newspapers." He read it. It stated
that Signor Vivalla having placed one thousand dollars in hands
satisfactory to himself, to be forfeited to him if he succeeded in
performing the various feats of the said Vivalla, he (Roberts) would
make the public trial to do so on the stage of the Walnut street
Theatre, on the night of the 30th inst.

"You don't expect me to perform *all* of Vivalla's feats, do you?"
said Roberts, after reading the card.

"No, I don't *expect* you *can*, but if you do *not*, of course you
will not win the thousand dollars," I replied.

"Why, I know nothing about walking on stilts, and am not
fool enough to risk my neck in that way," said Roberts.

Several persons, circus-riders and others, had crowded around
us, and exhibited some degree of excitement. My thousand dollars
was still openly displayed in my hand. I saw that Roberts was
determined to back out, and as that would not be consistent with
my plans, I remarked that he and I could do our own business
without the intermeddling of third parties, and I would like to see
him alone. He took me up stairs to his room, and bolting the door,
I thus addressed him:

"Now, Roberts, you said to the public in your card that you
accepted Vivalla's offer. What was that offer? Why, that he would
give a thousand dollars to the man who could accomplish his feats.
Now, you may spin a plate or two as well as Vivalla, but Vivalla
spins ten plates at once, and I doubt whether you can do it – if not,
you lose the reward. Again, you confess that you cannot perform
on stilts. Of course, then, you don't accomplish 'his feats,' and
therefore you could not receive the thousand dollars."

"But I can toss balls and do tricks which Vivalla can't accomplish," said Roberts.

"I have no doubt of that," I replied, "but that has nothing to
do with Vivalla's offer."

"Oh, I see," said Roberts, in a huff, "you have fixed up a
Yankee card to suit yourself, and left a hole to sneak out of."

"Not at all, Mr. Roberts. I have made a specific offer, and am
ready to fulfil it. Do not fret nor be angry, for you shall find me
your friend instead of an enemy."

I then inquired whether he was engaged to Mr. Green.

"Not at present," he replied, "as the circus is closed."

"Well," I responded, "it is evident you cannot gain the thousand dollars. I did not intend you should, but I will give you $30

if you will perform under my directions one night at the Walnut street Theatre, and will keep your own counsel."

He consented to this, and I then asked him to sign the card, and give himself no uneasiness. He signed, and I had it thoroughly published, first closing my bargain with the treasurer of the Walnut for one third of the gross receipts on the trial night, provided there was $400 in the house.

The next day I brought Roberts and Vivalla privately together, and by practising they soon discovered what tricks each could accomplish, and we then proceeded to arrange the manner in which the trial should come off, and how it should terminate.

In the mean time the excitement about the coming trial of skill was fast increasing. Suitable "notices" were inserted in the papers, bragging that Roberts was an American, and could beat the foreigner all hollow. Roberts in the mean time announced in the papers that if, as he expected, he should obtain the thousand dollars, a portion of it should be disbursed for charitable purposes. I set "THE PRESS" at work lustily, in the shape of handbills, squibs, etc. Before the night of trial arrived, the excitement had reached fever heat. I knew that a crowded house was *un fait accompli*.

I was not disappointed. The pit and upper boxes were crowded to suffocation. In fact, the sales of tickets to these localities were stopped because no more persons could possibly gain admittance. The dress circle was not so full, though even that contained many more persons than had been in it at one time during the previous two or three months.

The contest was a very interesting one. Roberts of course was to be beaten, and it was agreed that Vivalla should at first perform his *easiest* feats, in order that the battle should be kept up as long as possible. Roberts successively performed the same feats that Vivalla did. Each party was continually cheered by his friends and hissed by his opponents. Occasionally some of Roberts's friends from the pit would call out, "Roberts, beat the little Frenchman," "One Yankee is too much for two Frenchmen any time," etc. The contest lasted about forty minutes, when Roberts came forward and acknowledged himself defeated. He was obliged to give up on the feat of spinning two plates at once, one in each hand. His friends urged him to try again, but on his declining, they requested him to perform his own peculiar feats, (juggling, tossing the balls, etc.) This he did, and his performances, which continued for twenty minutes, were highly applauded.

As soon as the curtain fell, the two contestants were called for. Before they went out I had concluded a private arrangement with Roberts for a month – he to perform solely as I directed. When he went before the curtain, therefore, he informed the audience that he had a lame wrist, which was indeed the fact. He further informed them that he could do more feats of various kinds than Vivalla could, and he would challenge Vivalla to such a trial at any time and place he pleased, for a wager of five hundred dollars.

"I accept that challenge," said Vivalla, who stood at Roberts's side, "and I name next Tuesday night in this theatre."

"Bravo," cried Vivalla's friends, as vigorously as "bravo" had been shouted by the friends of Roberts.

Three hearty cheers were given by the enthusiastic audience, and the antagonists, looking daggers at each other, withdrew at opposite sides of the curtain. Before the uproar of applause had ceased, Roberts and Vivalla had met upon the stage, shaken hands, and were enjoying a hearty laugh, while little Vivalla, with thumb to his nose, was making curious gyrations to an imaginary picture on the back of the screen, or possibly to a real *tableau vivant* in front of the curtain.

The receipts of the theatre on that night were $593.25, of which I received one third – $197.75.

The contest on the Tuesday night following was nearly as profitable to me as the first one, as so indeed were several similar trials of skill brought forward in Dinneford's Franklin Theatre, New York, and various other places, during the month of Roberts's engagement.

These details may possess little interest to the general reader. They however serve to show (though it may be revealing some of the "tricks of the trade") how such matters are frequently managed in theatres and other places of amusement. The people are repeatedly wrought to excitement and take sides most enthusiastically in trials of skill, when, if the truth were known, the whole affair is a piece of management between the prominent parties. The entertainment of the time may be an offset to the "humbug" of the transaction, and it may be doubted whether managers of theatres will be losers by these revelations of mine, for the public appears disposed to be amused even when they are conscious of being deceived.

Meanwhile poor old Joice had sickened, and with her attendant, a faithful colored woman whom I hired in Boston, had gone

to my brother's house in Bethel, where she was provided with warm apartments and the best medical and other assistance.

On the 21st of February, 1836, my brother's horses and sleigh stopped at the door of my boarding-house in New York. The driver handed me a letter from my brother Philo, stating that Aunt Joice was no more. She died at his house on Friday night, the 19th, and her body was then in the sleigh, having been conveyed to New York for me to dispose of as I thought proper. I at once determined to have it returned to Bethel and interred in our village burial-ground, though for the present it was placed in a small room of which I had the key.

The next morning I called on an eminent surgeon who, upon visiting Joice at Niblo's, had expressed a desire to institute a post-mortem examination if she should die in this country. I agreed that he should have the opportunity, if unfortunately it should occur while she was under my protection. I now informed him that Aunt Joice was dead, and he reminded me of my promise. I admitted it, and immediately proceeded to arrange for the examination to take place on the following day.

In the mean time a mahogany coffin and plate were procured and taken to the hall where the examination was to take place. A large number of physicians, students, and several clergymen and editors were present. Among the last named class was Richard Adams Locke, author of the celebrated "Moon Hoax," who was at that time editor of the New York Sun.

An absence of ossification of the arteries in the immediate region of the heart was deemed by the dissector and most of the gentlemen present an evidence against the assumed age of Joice.

When all had withdrawn excepting the surgeon, his particular friend Locke, Lyman, and myself, the surgeon remarked, addressing me, that there was surely some mistake in regard to the alleged age of Joice; that instead of being 161 years old, she was probably not over eighty.

I stated to him, in reply, what was strictly true, that I had hired Joice in perfect good faith, and relied upon her appearance and the documents as evidence of the truth of her story. The same gentleman had examined her when alive on exhibition at Niblo's. He rejoined that he had no doubt I had been deceived in the matter, that her personal appearance really did indicate extreme longevity, but that the documents must either have been forged, or else they applied to some other individual.

Lyman, who was always ready for a joke, no matter what the cost nor at whose expense, here made a remark regarding the inability of the faculty to decide with much precision in regard to a case of this kind. His observations wounded the feelings of the surgeon, and taking the arm of his friend Locke, they left the hall – I fear in not very good humor.

The "Sun" of the next day (Feb. 25, 1836) contained an editorial, written of course by Locke, commencing as follows:

"DISSECTION OF JOICE HETH. – PRECIOUS HUMBUG EXPOSED. – The anatomical examination of the body of Joice Heth yesterday, resulted in the exposure of one of the most precious humbugs that ever was imposed upon a credulous community."

Mr. Locke then proceeded to give a scientific account of the dissection, and the reasons he had for doubting her story.

Here let me say a word in reply to the captious who may claim that I was over-credulous in accepting the story of Joice and her exhibitor, as a matter of fact. I assert, then, that when Joice Heth was living, I never met with six persons out of the many thousands who visited her, who seemed to doubt the claim of her age and history. Hundreds of medical men assured me that they thought the statement of her age was correct, and Dr. Rogers himself, in his parting conversation above noted, remarked to me that he expected to have spoiled half a dozen knives in severing the ossification in the arteries around the region of the heart and chest. Indeed, Mr. Locke plainly indicated his belief in her story, by the following remarks found in the editorial from which I make the above extract:

"We were half inclined to question the propriety of the scientific curiosity which prompted it," (the dissection.) "We felt as though the person of poor old Joice Heth should have been saved from exposure and mutilation, not so much on account of her extreme old age, and the public curiosity which she had already gratified for the gain of others, *as for the high honor with which she was endowed in being the nurse of the immortal Washington.*"

Locke's editorial asserted that the age of Joice did not exceed seventy-five or eighty years.

When the "Sun" newspaper appeared, and the account of the post-mortem examination was read, thousands of persons who had

seen her when alive, were much astonished. "There must be a mistake," said one, "for her very appearance indicated her age to have been at least a hundred and twenty." "She could not have been less than a hundred," said others; while still others believed she was quite as old as represented.

In this state of the public mind, Lyman determined to put a joke upon James Gordon Bennett, of the Herald. He therefore called at Bennett's office and told him that we had been humbugging Dr. Rogers, that in fact Joice Heth was now being exhibited in Connecticut, and that the body which had been dissected as hers, was that of an old negress who had recently died at Harlem. Bennett swallowed the bait, hook and all. He declared it was the best hoax he ever heard of, eclipsing Locke's "moon hoax" entirely, and he proceeded to jot down the details as they were invented by Lyman's fertile brain. The result was, the appearance of the article from the Sun in the Herald of Feb. 27, 1836, preceded by the following remarks:

"ANOTHER HOAX! – Annexed is a long rigmarole account of the dissection of Joice Heth, extracted from yesterday's Sun, which is nothing more nor less than a complete hoax from beginning to end. *Joice Heth is not dead*. On Wednesday last, as we learn from the best authority, she was living at Hebron, in Connecticut, where she then was. The subject on which Doctor Rogers and the Medical Faculty of Barclay street have been exercising their knife and their ingenuity, is the remains of a respectable old negress called AUNT NELLY, who has lived many years in a small house by herself, in Harlem, belonging to Mr. Clarke. She is, as Dr. Rogers sagely discovers, and Doctor Locke his colleague accurately records, only eighty years of age. Aunt Nelly before her death complained of old age and infirmity. She was otherwise in good spirits. The recent winter, however, has been very severe, and so she gave up the ghost a few days ago.

"Some person in this city, we believe one of the advertising doctors who had been hoaxed by the Lunar Discoveries, in the manufacture of which it is now believed that Dr. Rogers had a principal hand along with Sir Richard A. Locke, resolved, as soon as he heard from a friend of the death of poor AUNT NELLY, to send her body into the city, and contrive to pass her off upon the Medical Faculty for the veritable Joice Heth. The trick took. Several of the hoaxed went, looked, wondered, and held up their hands in astonishment. Her death was announced in the Sun, and a *post-mortem* examination

prepared. The public swallowed the pill. Aunt Nelly, neglected, unknown, unpitied when alive, became an object of deep science and deeper investigation when she died. She looked as old and ugly as Joice herself, and in that respect answered the thing exactly.

"Such is the true version of the hoax, as given us by good authority, of the story told in the following piece of humbug, taken from yester-day's Sun."

This editorial preface of the Herald introduced the account of the dissection as it appeared in the Sun; and Bennett subjoined the comprehensive comment: "Thus far the Joice Heth hoax, for the veracity of which we have names and certificates in our possession."

Upon reading the article from the Herald, a large portion of the public believed it, and consoled themselves by saying, "Ah, I was sure the old woman was considerably more than eighty. The article in the Herald makes the matter all clear."

Locke insisted that he had not been humbugged, and Bennett persisted that he had, and offered to lay a wager of several hundred dollars that Joice was really alive and then being exhibited in Connecticut! After a while the editor of the Herald, finding himself hoaxed, cried still the louder that he was right, and published several fictitious certificates purporting to have been written and signed by persons residing in Harlem, corroborating Lyman's story of "poor Aunt Nelly."

In September of the same year, (while I was absent at the South, Bennett met Lyman in the street, and proceeded to "blow him sky high" for having imposed upon him. Lyman laughed; he said he only meant it as a harmless joke, and that "now, as a recom-pense for the imposition, he would furnish Bennett with 'the veritable history of the rise, progress, and termination of the Joice Heth humbug.'"

Bennett was delighted. They went to his office, and Lyman dictated while the editor took down the heads of what purported to be the history of Joice – of her having been first found by me in the out-house of a plantation in Kentucky – of my having extracted all her teeth – taught her the Washington story – called her 110 years old in Louisville, 121 in Cincinnati – twenty years older in Pittsburgh, and 161 at Philadelphia.

This ridiculous story, being a ten times greater humbug than the one before practised upon the editor of the Herald, was duly written out and embellished by Bennett, as will be found by turning

to the files of the Herald, of Thursday, Sept. 8, and Tuesday, Sept. 13, 1836, where the first article under the editorial head has the title in capitals, "THE JOICE HETH HOAX!" Then follow several columns, purporting to give an account of Joice from her first discovery in Kentucky until her arrival in Philadelphia. On the 17th September follows another chapter under the same caption, surmounted with a wood engraving of her portrait.

The editor of the Herald asserted his full belief in this second and greatest humbug, by the following statement in his paper of the 8th September, already mentioned:

"A full and accurate account of the hoax, perpetrated by Joice Heth and her friends, upon the cities of Philadelphia, New York, and Boston, and particularly the medical faculty of each, will be one of the most interesting histories of this singular exposition of human ingenuity on the one side – and human credulity on the other. Some of the most eminent medical men in these three cities, and especially the famous Doct. Warren of Boston, figured most conspicuously in this laughable development. *There can be no mistake about the facts related*, because we have taken them down from the lips of the very individual who originated, and carried into effect this most stupendous hoax, illustrative of the accuracy of medical science, the skill of medical men, and the general good-nature and credulity of the public."

It would seem, by later developments, as if Bennett had never forgiven me for the ridiculous figure he was made to cut in this "Joice Heth Hoax."

The story of Lyman has since been generally accredited as the true history of the old negress, and never, until the present writing, have I said or written a word by way of contradiction or correction. Newspaper and social controversy on the subject (and seldom have vastly more important matters been so largely discussed) served my purpose as "a showman" by keeping my name before the public.

I will only add, that the remains of Joice were removed to Bethel, and buried respectably.

CHAPTER VIII

The Travelling Circus

My Italian, Signor Vivalla, continued to perform for me in various
theatres and circuses, as well as at Peale's Museum in New York. I
also took him to Danbury, Bridgeport, New Haven, Norwalk, and
other places in Connecticut; and to Newark, Elizabethtown, Rahway,
and New Brunswick, N. J., where I generally met with poor success,
the expenses, licenses, etc., frequently exceeding the receipts.

In April, 1836, I arranged with Aron Turner, a circus propri-
etor, (father of the celebrated riders N. B. and T. V. Turner,) to

connect Vivalla with his travelling circus company for the ensuing summer. I was to be paid for Vivalla the nominal salary of $50 per month and two half-clear benefits, and $30 per month for myself; and also, in consideration of Vivalla's and my own services, I was to receive one fifth of the entire profits of the circus company. I was at this time paying Vivalla $80 per month, so that *his* and *my* nominal salary united, reimbursed my payment, and left me the chance of 20 per cent. of the net receipts for my profits. I was to act as ticket-seller, secretary, and treasurer.

Mr. Turner was an old showman. To me, this travelling and performing in canvas tents was altogether new. I removed my wife and little daughter Caroline to Bethel, where they resided in the dwelling-house over the yellow store.

On Tuesday, the 26th April, our circus company, with all its paraphernalia of wagons, carriages, tents, horses, ponies, band of music, and about thirty-five men and boys, took up its march from Danbury for West Springfield, Mass., where we were to perform on Thursday. The first day, instead of halting on the road to dine as I expected we should, Mr. Turner stopped at a country farmhouse, bought three loaves of rye bread and a pound of butter; then, borrowing a knife from the farmer's wife, he proceeded to cut off pieces of bread, spread them lightly with butter, and handed one to each man. The bread and butter were soon consumed; Turner paid the woman fifty cents, ordered his men to water the horses, and we proceeded on our journey, having tarried less than fifteen minutes.

I thought this was rather scanty fare, and my little Italian began to grumble. I pacified him by the assurance that we should do better after we once commenced performing. There was an opportunity to test the prophecy at West Springfield, where we arrived on the 28th, and began our performances for the season.

Our band of music, expected from Providence, had not arrived, and, at Turner's request, I preceded the performances with a speech announcing the disappointment, and our determination to please the audience even in the absence of music.

The two Turner boys rode admirably. Joe Pentland, the clown, was, and still is, one of the most witty, original, and chaste men in his line in the country. He made up in a great measure for the absence of the band, and this, together with Vivalla's performances and other exercises in the ring, gave satisfaction to the small audience. Our music arrived in a day or two, and we continued to give

one or two performances every week-day, our "houses" constantly growing better as the season advanced. We performed in numerous towns, villages, and cities in New England, New York, New Jersey, Pennsylvania, Delaware, Maryland, District of Columbia, Virginia, and North Carolina, and my diary refreshes my memory with many incidents in the progress of our tour. I have space in these pages for only a few.

At the hotel in Cabotville, Mass., T. V. Turner, two others, and myself, slept in the same room. On retiring, one of my room-mates threw a stump of a cigar into a spittoon filled with dry saw-dust. Unfortunately, the tobacco was still a-fire, and so was the saw-dust in due time. Turner awoke about one o'clock, and the room was filled with dense smoke. In his attempt to reach the window, he fell exhausted to the floor, recovered sufficiently to crawl to the window, and finally succeeded in giving egress to the smoke and ingress to air that had life in it. He promptly awoke us, and we were nearly stupefied. But for the timely discovery of our perilous situation, we should have perished by suffocation in a few minutes.

As was usually my custom, on the Sabbath I attended church in Lenox, Mass. The clergyman took occasion to declaim against our circus; said that all men connected with circuses were destitute of morality, etc. In fact, he called us such hard names, that I wrote a request to be permitted to reply to him, and asked him to give notice from the pulpit that I should do so. I signed it, "P. T. Barnum, connected with the circus, June 5, 1836;" and as soon as he had read the closing hymn, I walked up the pulpit-stairs and handed him the request. He declined noticing it, and immediately after the benediction was pronounced, I strongly lectured him for not granting me an opportunity to vindicate our characters, gave him my opinion of a slanderer, etc.

This incident caused great commotion in the village. Several members of his church apologized for their clergyman's conduct. They said that he had recently lectured them for permitting their children to speak in dialogue at an exhibition of the village-school, censured him for his course regarding the circus, and hoped I would not hold the church responsible for his ill behavior. I was satisfied, and, as Louis Napoleon would say, "tranquility was restored."

A similar scene subsequently occurred at Port Deposit, on the lower Susquehanna, though in the latter case I insisted on addressing

the audience in defence of ourselves from personal assault. I did so for half an hour, and the people attentively listened to me, though the clergyman repeatedly begged them to disperse. I sincerely thought myself entitled to this hearing. Many a time had I collected the circus company on the Sabbath, and read to them the Bible and such printed sermons as I could obtain, and I had repeatedly induced many of them to accompany me to public worship in the towns and villages in our route. We certainly had no religion to boast of, but we felt ourselves not altogether "castaways," and thought we were entitled to gentlemanly treatment at least when in attendance on the gospel ministry.

Aron Turner, the proprietor of the circus, was an original genius; a good judge of human nature, a man from whom much information might be derived. He was withal a *practical joker*. By his untiring industry he amassed a large fortune, and was not a little proud to inform the world that he commenced life without a shilling. Frequently have I heard him say, "Every man who has good health and common sense is capable of making a fortune, if he only *resolves* to do so. As a proof of it, look at me. Who am I? I don't know who I am, or where I came from. I never had father nor mother that I know of; at all events, I must have started from the lowest depths of degradation. I never had any education; I commenced life as a shoemaker. What little I can read, I picked up myself after I was eighteen years of age; and as for writing, why the way I first learned that, was by signing my name to notes of hand! I used at first to make my mark, but being a poor devil, I had occasion to give my note so often that I finally learned to write my name, and so I have got along by degrees. You see what I am now. I have become so by industry, perseverance, and economy; and any man may become rich who will *determine* to do so. There is not such a word as '*cannot*' in the English language. Never say you *can't* do a thing – and never cry 'broke' till you are dead."

While in Annapolis, Md., Turner played a trick upon me which I shall never forget. We arrived there late on a Saturday evening. We had been doing a highly profitable business, which made me feel pretty rich, and I went out that night and bought me a fine suit of black clothes. We were all strangers in that town, never having been there before. On Sunday morning, feeling proud of my sable suit, I dressed myself, and started to stroll about the town. I passed through the bar-room of the hotel. About twenty persons were there, among whom was Turner, who had by that time made

their acquaintance. After I passed out, Turner, pointing in the direction which I had taken, remarked to the company. "I think it's very singular you permit that rascal to march your streets in open day. It wouldn't be allowed in Rhode Island, and I suppose that is the reason the black-coated scoundrel has come down this way."

"Why, who is he?" ejaculated half a dozen at once.

"Don't you know? Why, that is the Rev. E. K. Avery, the murderer of Miss Cornell!" answered Turner.*

"Is it possible!" they exclaimed, all starting for the door, eager to get a look at me, and several swearing vengeance against the hypocritical priest.

Turner having thus put the ball in motion, quietly took a seat, while every person in the bar-room started in pursuit of me. I had turned a corner of the street, and was very innocently, though rather pompously, strutting down the side-walk, when I was overtaken by a dozen or more persons, whose number increased every moment. I observed, as they passed me, that each person looked back and stared at me with apparent wonder. I believe I must have been uncommonly proud of that suit of clothes, for I was vain enough to believe that my *new suit* was what attracted such special attention. I however soon awoke from the happy illusion. The mob passed me five or ten rods, and waited till I came up to them. As I passed, I heard several observations like the following: "The lecherous old hypocrite" – "the sanctified murderer" – "the black-coated villain" – "let's tar and feather him" – "lynch the scoundrel," etc., etc. I passed along totally unconscious that these remarks could possibly have any reference to me. The *dénouement*, however, soon came. The mob, which now numbered at least one hundred, overtook me as I passed another corner, and one fellow seized me by the collar, while five or six others approached, bearing a *rail* between them.

"Come," says the man who collared me, "old chap, you can't walk any farther; we know you, and as we always make gentlemen *ride* in these parts, you may just prepare to straddle that *rail!*"

My surprise may well be imagined. "Good heavens!" I

*The then recent murder of Miss Cornell in Rhode Island, her discovery in a stack-yard, and the trial of Rev. Ephraim K. Avery for the deed, created unparalleled excitement. Leading Methodists defended the accused, but in vain. The general sentiment of the whole country condemned him, and though acquitted by the law, he sunk into disgrace and obscurity. The Lord knows all the facts, and will judge righteously.

exclaimed, as they all pressed around me, "gentlemen, what have I done?"

"Oh, we know you," exclaimed half a dozen voices; "you needn't roll your sanctimonious eyes; that game don't take in this country. Come, straddle the rail, and *remember the stack-yard!*"

I grew more and more bewildered; it seemed like a dream; I could not imagine what possible offence I was to suffer for, and I continued to exclaim, "Gentlemen, what have I done? Don't kill me, gentlemen, but tell me what I have done."

"Come, make him straddle the rail; we'll show him how to hang poor factory girls," shouted some chap from the crowd.

The man who had me by the collar then remarked, "Come, *Mr. Avery*, it's no use, you see we know you, and we'll give you a touch of Lynch law, and start you for home again."

"My name is *not* Avery, gentlemen; you are mistaken in your man," I exclaimed.

"Come, come, none of your gammon; straddle the rail, Ephraim," said the man who had me by the collar.

The rail was brought to such a level as to allow me to be "straddled" on it without difficulty, and I was about to be placed according to orders, as the truth flashed upon me.

"Gentlemen," I exclaimed, "I am not Avery; I despise that villain as much as you can; but my name is Barnum; I belong to the circus which arrived here last night, and I am sure *Old Turner*, my partner, has hoaxed you with this ridiculous story."

"If he has, we'll lynch him," said one of the mob.

"Well, he has, I'll assure you," I replied; "so just walk to the hotel with me, and I'll convince you of the fact."

This arrangement they reluctantly assented to, keeping, however, a close hand upon me. As we walked up the main street on which the new State House is situated, the mob received a reinforcement of some fifty or sixty, and I was marched like a malefactor up to the hotel. Old Turner stood on the piazza ready to burst with laughter. I appealed to him for heaven's sake to explain this matter, that I might be liberated. He continued to laugh, but finally told them "he believed there was some mistake about it. The fact is," said he, "my friend Barnum has a new suit of black clothes on, and it makes him look so much like a priest, I concluded it must be Avery."

The mob saw the joke. Some apologized to me for the rough manner in which I had been handled, (for they had torn my coat

half off my back, and rolled me in the dirt considerably,) while others swore that Old Turner deserved the fate intended for me; but the majority of the people roared with laughter, declared it was a good joke, and advised me to look sharp, and pay my partner off for it. I was exceedingly vexed, and when the mob had dispersed, I asked Old Turner what on earth could induce him to play such an outrageously mean trick upon me.

"My dear Barnum," said he, "it was all for our good. Remember, all we need to insure success is *notoriety*. You will see that this will be noised all about town as a trick played by one of the circus managers upon the other, and our pavilion will be crammed to-morrow night."

It turned out as he conjectured. The joke was in every person's mouth. We soon became acquainted with the whole town, and had immense audiences during our stay. This, however, did not induce me to forgive Old Turner, for I knew full well that self-interest was an after consideration in this case, the joke being prompted solely by a desire to see some fun, no matter at whose expense.

A peculiar incident occurred at Hanover Court House in Virginia. In consequence of heavy rains we could not perform there, and concluded to start for Richmond immediately after dinner. The landlord however informed us that as our agent had engaged three meals and lodging for the company, our bill would be the same if we departed that day as if we remained to breakfast next morning. We backed our remonstrance with an offer to pay for dinner and a portion of the balance of the bill, to compensate for provisions obtained and not consumed, but the landlord stubbornly refused to abate a jot of his first demand.

It was now about eleven o'clock in the forenoon. Mr. Turner was very angry at what he considered the unreasonable demands of the landlord, and told him it would be much to our benefit if we could proceed at once to Richmond.

"I don't prevent you," said the stubborn hotel-keeper; "but you must pay for dinner, supper, lodging, and breakfast. I have made provision according to order, and I must be paid for it."

"At what hours can we have our meals?" asked Turner.

"Whenever you please," was the reply.

"Very well, sir. We will have dinner at twelve o'clock, and supper at half-past twelve. We will lodge at one o'clock this afternoon, and breakfast at half-past one," said Turner.

The landlord was amazed alike by the fact and manner of this

announcement. "You don't want three meals at once, do you?" said he.

"No," said Turner, "nor will we have three at once. You shall set the table and cook us a good dinner. We will eat it. The table shall then be nicely cleared off and reset with clean dishes, and our supper shall be placed upon it. We will eat that, and finish it by one o'clock. Then we will go to bed; and do you see that the supper-table is cleared off, and a good breakfast cooked, with plenty of good coffee, and let it be all ready when we arise at half-past one o'clock. And, mind you, don't think you can re-hash one meal and make it answer for another. We won't stand that. We pay for the best, and we will have the best."

The landlord said it was all right, and started to prepare the dinner. I followed him, and tried again to effect a compromise, but he would hear to nothing of the kind.

A good dinner was on the table at twelve o'clock. We did full justice to it, and Turner then ordered the table to be cleared off and supper brought in at once. It was done punctually by half-past twelve o'clock, and we all did our best towards eating it. By one o'clock we had devoured as much as we possibly could. "Now show us to bed," said Turner, each man by his demand being provided with a lighted candle! The landlord showed us our rooms, and we all (thirty-six in number) undressed and tumbled into bed, previously to which, however, Old Turner hallooed to the landlord from the top of the stairs, "Do you see, sir, that our breakfast is all ready and on the table smoking hot in half an hour."

No response was heard to this request. Turner maintained his gravity, and so did the landlord. Both were angry and made a serious time of it, but for myself, I was convulsed with laughter at the absurdity of the whole thing. All the company indeed were in great glee, but we felt that the tavern-keeper was unreasonable, and therefore we not only obeyed the orders of Turner, but did our best to get the worth of our money. We were up and dressed in half an hour, but our beds exhibited every appearance of having been devoted to at least one night's lodging.

We then all marched down to breakfast. Every thing was cooked and prepared in the best order, and a stranger would have thought, had he seen the victuals disappear, that we had been on short allowance for a fortnight. It has ever been a mystery to me how we managed to live through such a stuffing as we all underwent on that occasion. I have seen my father *cram* turkeys for weeks

preparatory to serving them for a thanksgiving dinner, but that was not a "circumstance" to the *crammed circus company*.

From this place we proceeded to Richmond, where we remained several days. Turner told the Avery joke to all with whom he became acquainted, and I was determined to discharge the obligation, if possible. An opportunity here occurred, and I hastened to embrace it.

One night, after the performances were over, a dozen or more jovial fellows, with "Old Turner" and myself, were enjoying ourselves in the sitting room of the hotel, over a few bottles of wine and a box of prime Havanas. Stories were told, songs sung, etc. Finally one man proposed several difficult and funny arithmetical questions, which were soon solved by the company. "Old Turner," who liked to be "at home" in every thing, named a circumstance which he said had bothered some good scholars.

"A stranger," says he, "went into a boot-maker's store and priced a pair of boots. They were five dollars. He took a pair and handed the owner a fifty-dollar bill. The boot-man could not change it, but took it to a neighbor and received ten five-dollar notes in change. He returned and gave the stranger $45, and a pair of boots. The stranger went out and was never seen again. In a few hours after he left, the boot-maker's neighbor brought in the $50; it was a counterfeit. The boot-maker was obliged to borrow the amount of another neighbor in order to redeem the bill with good money; now, the question is, how much did he lose by the whole operation?"

Simple as this case was, numerous answers were returned. Some said he lost $95 and the boots – others said $50 and the boots, etc. A correct answer was soon returned, however.

Hoping to catch Turner with a trick, I got behind him, and winking to the rest of the company, and pointing at him, I gravely proposed the following question:

"Suppose," said I, "a man is thirty years of age and he has a child one year of age, he is *thirty times* older than his child. When the child is thirty years old, the father, being sixty, is only *twice* as old as his child. When the child is sixty the father is ninety, and therefore only *one third* older than the child. When the child is ninety the father is one hundred and twenty, and therefore only *one fourth* older than the child. Thus you see, gentlemen, the child is gradually but *surely gaining* on the parent, and as he must certainly continue to come nearer and nearer, in time he must overtake him. The question therefore is, suppose it was possible for them to live

long enough, how old would the father be when the child overtook him and became of the same age?"

All the company, except Turner, saw the joke, and perceiving that I intended it for him, they gravely commenced figuring. Presently one of them remarked that it would take too long to figure it out then, though it was plain that such an event would occur if the parties lived long enough.

"I think," I replied, "it is 999 years, but I have almost forgotten, as it is some years since I figured it out."

Turner was much interested in the question. Said he, "I never heard that before, and I would not have believed it; but it is plain that it is so, for the son is gradually gaining on the father, and although I don't know much about arithmetic, one thing is certain, if you give a slow horse five miles or fifty miles the start, and a faster horse is put behind him, I am sure *he must catch the slow one in time if they run far enough!*"

As he appeared to be now convinced beyond doubt, an old gentleman gravely remarked that he knew nothing about figures, but that the idea of a son becoming as old as his father while both were living was nonsense; and he would bet a dozen of champagne that the thing was impossible. Turner, who was a betting man, especially when he felt sure of winning, remarked that it appeared odd, but for reasons just stated it *must* be true, and he therefore took the bet. When the wager was fairly concluded, and judges appointed, the company all burst into laughter, and after much talk, Turner became convinced that although relatively the boy would gain on his father, there must always be thirty years difference between them. Turner paid the champagne, which cost him $25, and it was several months before I could convince him there was any fun in the joke. He acknowledged it at last, however, and we agreed to call the champagne bet a fair offset to the Avery hoax.

One of our musicians, named Butterfield, died at Richmond. The duty of communicating the intelligence to his wife, who resided in Danbury, Ct., devolved upon me. I inclosed her a lock of his hair, and discharged the painful office as delicately as I could. Our company made up a subscription of $60 to defray the funeral expenses and erect a simple stone to his memory, with the accompanying design and inscription.

Mr. Turner was deputed to order the stone and see it erected, but I fear that he never did so. He undoubtedly intended to do it, and perhaps he did, but he was apt to neglect, and finally to defer

altogether, most things which were not immediately connected with his business.

From Richmond we proceeded to Petersburgh, thence to Warrenton, N. C., where, on the 30th October, (my engagement with Turner having expired, with a clear profit to myself of twelve hundred dollars,) I parted with the circus company, and taking Vivalla and a negro singer and dancer named James Sandford, with several musicians, horses, wagons, and a small canvas tent, started off with an exhibition on my own account, intending to travel as far south as Montgomery, Ala. Early in the morning my little company started. I remained behind for half an hour, receiving and reciprocating the kindly wishes of my late companions, and Mr. Turner then conveyed me in his carriage to overtake my own troupe. We rode slowly, because reluctant to part, and twenty miles of road was beguiled by pleasing conversation before we overtook those who had preceded us. My old friend wished me great success, and returned to his circus company. I felt lonely for several days, but my mind was so occupied by business, that I soon became reconciled to my new position.

On Saturday, Nov. 12, 1836, we halted in a settlement known as Rocky Mount Falls, N. C., and I attended the Baptist church on the following Sabbath morning. In going thither from the tavern, I noticed a rostrum and benches in a grove near by, and I said to the landlord, (who accompanied me,) "This is a very pleasant day, and I should like to speak to the people from that stand."

The suggestion pleased him. He was sure, he said, that the congregation, most of whom came a long distance to attend one service on the Sabbath, would be glad to hear a stranger.

Before the conclusion of morning worship, I requested the venerable clergyman to announce that I would speak to the people, after dismission, for half an hour in the grove. He inquired if I was a clergyman, and when I replied in the negative, he expressed a fear that he should give offence by complying with my request, but he had no objection that *I* should make the announcement – which I accordingly did. The congregation, numbering about three hundred, promptly repaired to the grove, and I took my position in the preacher's stand.

I began by informing the people that I was not a clergyman, and had little experience in public speaking; but I felt a deep interest in the subject of religion and morality, and would attempt, in a plain way, to set before them the duties and privileges of man. "The

pleasures of sin for a season," which Moses might have enjoyed in the palaces of Egypt, I compared with "the recompense of reward" which he had respect to, in obeying the commands of God; and I appealed to every man's experience, observation and reason, to confirm the Bible doctrine of wretchedness in vice and happiness in virtue. We cannot violate the laws of God with impunity, and he will not keep back the wages of well-doing. The outside show of things is of very small account. We must look to realities and not to appearances. "Diamonds may glitter on a vicious breast," but "the soul's calm sunshine and the heart-felt joy is virtue's prize." The rogue, the man of rough passions, the drunkard, are not to be envied even at the best, and a conscience hardened in sin is the most sorrowful thing that we can think of. Such a one may enjoy life as a beast enjoys it – perhaps like a beast shut up in a cage or a dungeon, with enough to eat and to drink; but the soul cannot be satisfied or happy without devotion toward God and good-will toward man.

I went on in this strain, with much Scripture and many familiar illustrations, for about three quarters of an hour. When I had finished my speech, several gentlemen shook me by the hand, expressed themselves pleased, begged to know my name, which they wrote down. I had no very high opinion of my performance, but I felt happy in believing that I possibly had done some good in that charming grove on that beautiful Sabbath.

In Raleigh, N. C., I sold one half of my exhibition to a man whom I will here call Henry. He may be a better man *now* than he was then, and I therefore conceal his real name. He had kept along with us during the preceding week, with a wagon-load of ready-made clothing for sale, and finally bought the half-interest above named.

At Camden, S. C., Sandford abruptly left me. I had advertised negro songs; no one of my company was competent to fill his place; but being determined not to disappoint the audience, *I blacked myself thoroughly*, and sung the songs advertised, namely, "Zip Coon," "Gittin up Stairs," and "The Racoon Hunt, or Sitting on a Rail." It was decidedly "a hard push," but the audience supposed the singer was Sandford, and, to my surprise, my singing was applauded, and in two of the songs I was encored!

One of my musicians, a Scotchman named Cochran, was arrested in Camden, for having said to the colored barber who was shaving him, that he ought to escape to the Free States or Canada.

I made strong but vain efforts for his release. He was imprisoned over six months.

After singing my negro songs one evening, and just as I had pulled my coat off in the "dressing-room" of the tent, I heard a slight disturbance outside the canvas. Rushing to the spot, and finding a person disputing with my men, I took their part, and spoke my mind to him very freely. He instantly drew his pistol, exclaiming, "You black scoundrel! dare you use such language to a white man?" and proceeded deliberately to cock it. I saw that he supposed me to be a negro, and might perhaps blow my brains out. Quick as thought I rolled up my shirt sleeves, and replied, "I am as white as *you* are, sir." He absolutely dropped the pistol with fright! Probably he had never seen a white man blacked up before; at all events, he begged my pardon, and I re-entered my "dressing-room," fully realizing that I had incurred a narrow chance of losing my life. Nothing but a presence of mind which never yet deserted me, saved my brains. On four several occasions during my life have I had a loaded pistol pointed at my head, and on each occasion have I escaped by little less than a miracle. Several times, also, have I been in deadly peril by accidents; and now, when I look over my history, and call these things to mind, and especially when, in tracing my career, I find that so many with whom I have had intercourse are tenants of the grave, I cannot but realize that I am deeply indebted to the mercy of God. I may as well add, as one of the sections of my reflective moods, that when I consider the kinds of company into which for a number of years I was thrown, the associations with which I was connected, and the strong temptations to wrong-doing and bad habits which lay in my path, I am astonished as well as grateful that I was not utterly ruined. I honestly believe that, under God, I owe my preservation from the woe of living and dying a loafer and a vagabond, to the single fact, that I was never fond of strong drink. True, I have in my time drank liquor, and have even been intoxicated, but generally I wholly abstained from the use of intoxicating beverages, and am happy to say, that for a number of years past, I have been strictly "a teetotaller."

During my absence from home, I usually wrote twice a week to my family, and nearly as often received letters from my wife. I received one from her, while in Columbia, S. C., stating it as a report current in Connecticut that I was in prison in Canada, on a charge of murder, had received my trial, and was under sentence of death! The story, I believe, originated in the fact that a circus

company in Canada had gotten into difficulty with some rowdies who assaulted them. It certainly was not Turner's, for we met it in Columbia, S. C., Dec. 5, 1836. It was shortly to be disbanded. I bought four horses and two wagons belonging to his side show, and hired Joe Pentland and Robert White to join my company. Pentland, besides being a celebrated clown, is a capital ventriloquist, balancer, comic singer, and performer of legerdemain. White was a negro-singer. This relieved me from the negro-song line, and made my exhibition (of which Henry was half owner) quite attractive. I called it "Barnum's Grand Scientific and Musical Theatre."

Henry acted as treasurer, and I received the tickets at the door. While doing this, at Augusta, Ga., a man attempted to pass. I demanded a ticket. He demurred, and upon inquiring why, he said he was a sheriff. I told him that I knew no particular reason why a sheriff should not pay as well as anybody else, to which he replied, "You had better ask Mr. Henry about that." This startled me, so I passed him in, and hastened to ask Henry what was the matter. He reluctantly informed me that the sheriff had served a writ on him for a debt of $500. Henry had $600 of the company's money in his possession, and I saw that management would be required to prevent "sequestration of the funds." Privately hastening to a lawyer, I procured a bill of sale of all the property of the exhibition, lacking only Henry's signature, and returned to the theatre, where the performances were still in progress. The lawyer of Henry's creditor, and the creditor himself, awaited me. They demanded the keys of the stable, so as to "levy" on the horses and carriages. I declined compliance, whereupon they threatened to break down the doors and seize the property. I begged them to wait a few moments until I could consult with Henry, – and they consented. Henry desired to cheat his creditor, and immediately signed the bill of sale. Lest the sheriff should search him, he handed me $90, stating that he had $500 locked up in a safe place where the sheriff could not find it. Leaving him in the ticket office, I returned to the sheriff and the creditor, and informed them that Henry refused to compromise or to pay the claim. "Then give me the keys," said the sheriff. I declined doing so, and he again threatened to break down the stable doors. "Why will you do this?" said I.

"To attach the horses and carriages," he replied.

"Why do you wish to levy on them?"

"To secure a debt that Mr. Henry owes, and I wish to attach his interest in the property."

"You have not yet levied on the horses and carriages?" I said.

"No, I have not, but I *will* within ten minutes," replied the sheriff.

"Not exactly," said I – at the same time handing the bill of sale to my friend, Jackson O. Brown, with a request to read it. He did so. "Now, gentlemen," said I, addressing the sheriff and creditor, "you see that I am in full possession of the property as entire owner. You confess you have not yet levied on it, and if you touch my property, you do it at your peril."

I do not remember ever having seen two persons look more surprised than did these gentlemen, when they discovered they had been the victims of a "Yankee trick."

The sheriff immediately seized Henry and took him to prison. It was Saturday night, Dec. 17. I privately told Henry to keep up courage; that it was too late to find bail that night, but I would call on him in the morning.

The next morning I learned from unquestionable authority that Henry owed his creditor $1300; that he agreed, so soon as the Saturday evening performance closed, to hand over $500 in cash, (belonging to the company,) and a bill of sale of his interest in the horses, carriage and exhibition; and that, as a consideration, one of the horses should be "ready saddled and bridled" for Henry to decamp, leaving me in the lurch! This conspiracy happened to be defeated by the single fact (succeeded by a little management) that the sheriff sought to pass me at the door of the theatre as "a dead-head."

Under the circumstances, I could have little sympathy for Henry, and I now desired to secure the $500 which he had secreted. Vivalla obtained it from him to keep it from the sheriff, and *I* obtained it from Vivalla on Henry's order, as a means of procuring the required bail on Monday morning. I then paid the creditor the full amount received from Henry as the price of his half-interest in the establishment – received in exchange a guaranty that I should never be troubled by my quondam partner on that score, also an assignment of $500 of the creditor's claim; and thus my "lucky stars" relieved me from one of the most difficult positions of my life.

My "Diary," from which the preceding and much else has here been condensed, contains many incidents which I shall omit. I cannot, however, pass an adventure of mine as Pentland's confederate in several tricks of legerdemain.

His table had the usual trap-door for passing things to his assistant, preparatory to the magical transformations presented to the spectators. The quarters below were painfully narrow for a man of my size, but I volunteered for the occasion in the absence of the diminutive employee in that line of business. Squeezing into the allotted space, I found that my nose and my knees were likely to become acquainted by close contact – nevertheless, though heartily wishing myself out of the scrape, I held a live squirrel in my hand, ready to wind the chain of a watch around his neck and hand him up through the trap-door when needed.

Pentland's arrangements of vases, cups, balls, and divers other accompaniments of legerdemain, were on the table. In due time, he called for a watch with a gold chain. One of the spectators favored him with the article, and it was soon passed into my possession, under a vase and through the little trap-door in the top of the table. Awkwardly performing my part, the squirrel bit me severely; I shrieked with pain, straightened my neck first, then my back, then my legs, overthrew the table, smashed every breakable article upon it, and rushed behind the curtain! The squirrel galloped off with the watch around his neck. Pentland was struck speechless, but if ever there was hooting and shouting in a mass of spectators, it was heard that night.

In passing from Columbus, Georgia, to Montgomery, Alabama, we were obliged to travel eighty miles through a very thinly settled and desolate portion of country known as the "Indian Nation." At this time our government was gathering in the Indians, and lodging them in encampments at various posts under a strong guard, preparatory for their migration to Arkansas. The chief portion of the Indians came in voluntarily, and were willing to be removed to their new home; but there was a good number of "hostiles" who would not come in, but who infested the swamps near the road leading from Columbus to Montgomery, and who almost daily murdered passengers who had occasion to pass through the "Indian Nation." Many considered it hazardous to pass over the road without a strong escort. The day previous to our starting, the mail stage had been stopped, the passengers all murdered, and the stage burned, the driver escaping almost by a miracle. It was with much trepidation that we determined upon incurring the risk. Our chief hope was, that owing to the large number composing our company, and the Indians being scattered in small bands, our appearance would be too formidable

for them to risk an attack. We all armed ourselves with guns, pistols, bowie-knives, etc., and started on our journey.

None of us felt ashamed to acknowledge that we dreaded to incur the risk, except Vivalla. He was probably the greatest coward amongst us, but like most of that class when they feel pretty *safe*, he swaggered and strutted about with much apparent importance, laughing at us for our fears, and swearing that he was afraid of nothing, but if he met fifty Indians "he should give them one devil of a licking, and send dem back to de swamp in no time." The cowardly little braggadocio vexed us much, and we determined if we ever got through to put his courage to the test.

The first day we travelled thirty miles without seeing any Indians, and before night came to a halt at the house of a cotton planter, who kept us safe till morning. The next day we proceeded safely to Tuskeega, a small village where there was an encampment of fifteen hundred Indians, including squaws and children. The third day we arrived at Mount Megs, where there was another "Indian camp" containing twenty-five hundred of the red skins. We were now within fourteen miles of Montgomery, and felt out of all danger. But being determined to play a trick upon the courageous Vivalla, we informed him the next morning that we had to pass over the most dangerous portion of the road, as it was said to be infested with desperate hostile warriors. Vivalla, as usual, was all courage; saying, "he only hoped he should see some of de copper-colored rascals; how he would make dem run." When we had travelled about six miles, and had come to a dismal-looking, thickly wooded place, a large fox squirrel crossed the road, and ran into the adjoining woods. Vivalla proposed pursuing it. This was just what we wanted; so giving a hint to several who were in the secret, we halted, and they went with Vivalla in pursuit of the squirrel. In the mean time Pentland slipped on an old Indian dress with a fringed hunting shirt and moccasins, which we had secretly purchased at Mount Megs, and coloring his face with Spanish brown, which we had obtained for the purpose, and mounting his head with a cap of colored feathers, he shouldered a musket and followed the track of Vivalla and his party, looking as much like a real Indian as any we had seen the day previous in the camp. When he had got near them, he approached stealthily, and was not discovered till he leaped in their very midst, and uttered a tremendous "whoop."

Vivalla's companions, who were all in the joke, instantly fled in the direction of the wagons, and Vivalla himself, half frightened

to death, exhibited great swiftness of foot in his endeavors to take the same route, but the artificial Indian betrayed extreme partiality and malignity in allowing all the others to escape, and devoting his whole attention to "heading" the Italian. The poor little fellow yelled like a wild man, when he saw the musket of the Indian pointed towards him, and found there was no possible means of escape, except by running in the direction opposite to where we were waiting. He ran like a deer, jumping over fallen trees and stumps with remarkable quickness, not daring to look behind him. Pentland, who was the most nimble on foot, allowed the Italian to keep about four rods ahead, while he followed, gun in hand, uttering a horrible Indian yell at every other step. The race continued nearly a mile, when the Signor, completely out of breath, perceiving his red-skin adversary was fast gaining on him, stopped, and throwing himself on his knees begged for life. The Indian, pretending not to understand English, levelled his gun at Vivalla's head, but the poor fellow writhed and screeched like a panther; and carrying on a pantomime, gave the Indian to understand that life was all he asked, and if that was spared every thing he possessed was at the service of his foe. The savage appeared to relent, and to understand the signs made by the Italian. He took his musket by the muzzle and rested the breech upon the ground, at the same time motioning to his trembling victim to "shell out."

Quick as thought, Vivalla turned his pockets inside out, and the Indian seized his purse containing eleven dollars. This was all the money he had about him, the rest being deposited in a trunk in one of our wagons. Gloves, handkerchiefs, knives, etc., were next offered up to appease the wrath of the savage; but he looked upon the offerings with disdain. Then motioning the Italian to rise from his knees, the poor fellow got up, and was led by his conqueror like a lamb to the slaughter. The savage marched him to a large and stately oak, where he proceeded, with the aid of a handkerchief, to tie his arms in the most scientific and Indian-like manner around the trunk of the tree.

The red-skinned warrior then departed, leaving poor Vivalla more dead than alive. Pentland hastened to join us, and doffing his wampum dress and washing his face, we all proceeded in quest of the Italian. We found the little fellow tied to the tree, nearly dead with fright, but when he saw us his joy knew no bounds. We loosened his hands, and he jumped and laughed, and chattered like a monkey. His courage returned instantly, and he swore that after his

companions left him, the Indian was joined by half a dozen others; that if he had kept his gun he should have shot one and beat out the brains of the other six, but being unarmed, he was obliged to surrender. We pretended to believe his story, and allowed him to repeat and brag over his adventures for a week afterwards, at which time we told him the joke. Chagrin and mortification sat on every line of his countenance, but he soon rallied and swore that it was all "one great lie." Pentland offered him his eleven dollars, but he would not touch it, for he "swore like a trooper" that it could not be his, for seven Indians took his money from him. Many a hearty laugh did we have over the valor of the little Italian, but we were at last obliged to drop the subject altogether, for the mere allusion to it made him so angry and surly that we could not get a pleasant word out of him for a week afterwards. But from that time we never heard the Signor boast of his courage, or make any threats against a foe, real or imaginary.

We reached Montgomery, Ala., February 28th, 1837. Here we met a legerdemain performer by the name of Henry Hawley. He was about forty-five years of age, but being prematurely gray, he had the appearance of a venerable gentleman of seventy. He purchased one half of my exhibition.

Hawley had much ready wit – a happy way of localizing most of his tricks – was very popular in that part of the country, where he had been performing for several years – and I never saw him "nonplussed" but once. It was in the performance of the trick called "The Egg Bag and the Old Hen." It is done in the following manner:

The exhibitor has a bag in which he declares there is an old hen, that will lay as many eggs as he pleases. He turns the bag inside out. There is apparently nothing in it; but actually, between the outside of the bag and the lining, is a small pocket so contrived with divisions as to hold six eggs. Having convinced the audience that there is nothing in the bag, he commands the hen to lay, and produces an egg. This he does, showing the inside and outside of the bag, each time, until all are gone but one. Keeping his hand on that part of the bag which covers the last egg, he puts the rest of the bag on the ground, and stamps upon it, to show that there is no deception; then, stating that he can have as many more eggs as he pleases, pulls out the last. "Before I take any more out," he says, "I will satisfy you that the eggs are real." At this time he stands in front of his table, and while breaking upon a plate an egg which he holds in his right hand, the empty bag is in his left hand. All eyes

are turned upon the egg to see whether it is genuine or not. While the exhibitor thus distracts the attention of the audience, he slily passes his left hand to the back of the table, and hangs his empty bag on a hook which is placed there. At the same instant he detaches from another hook, behind the table, a bag exactly similar to the one which held the eggs, but which bag contains a hen.

"Now," says the exhibitor, "having seen that the eggs are real, I will show you the old hen that laid them." Dropping the mouth of the bag upon the ground, he turns out the old hen, to the astonishment of the audience.

On the occasion to which I allude, we did not reach the town where we were to exhibit until two o'clock in the afternoon. We had advertised a performance for three o'clock, and the village was already swarming with country people who came "to see the show." We put up the canvas as soon as possible. Hawley arranged his table, and not having time to prepare his "old hen" trick, he handed the bag to a negro boy attached to the tavern where we stopped, told him to catch an old hen, and put her into the bag, and he should "see the show for nothing." The darkey soon returned, handed the bag to Hawley, and passed in.

The old hen was duly hung up at the back of the table, our fiddler played a tune, (we had but one musician yet,) the curtain rose, and old Hawley opened the performances. He first exhibited several dexterous tricks with cups and balls – swallowed apparently a pound of tow – blew fire from his mouth, and then drew many yards of various-colored ribbons from the same receptacle. These were followed by wonderful tricks with iron rings, strings, and keys; he apparently swallowed a watch, and pulled an unknown quantity of cabbages, turnips and onions from the bosom of a verdant young countryman who volunteered to "assist" at the performances.

Hawley then commenced the great trick of the day, producing egg after egg as if by magic. The audience applauded him to the echo. He felt they were with him, and with triumphant exultation he exclaimed, "And now I will show you the old hen that laid all the eggs." He emptied the bag, and a bird appeared – but, alas, it was a *rooster!* Every one was thunderstruck at the phenomenon, but when the old cock, who was very indignant at his confinement, strutted across the stage, shook his ruffled feathers, and began to crow, as if in defiance – the whole audience burst into a shriek of laughter, and Hawley, confounded and abashed, bolted into the dressing-room, cursed the stupidity of the black "fowl-fancier,"

and threatened to break the rascal's head, at the same time declaring he would not again appear in front of the curtain. Nor did he. He might have turned the accident to good account, and he probably would have done so nine times out of ten, but the thing was so totally unexpected, and the audience had so fair a start in merriment before he could recover self-possession, that he was literally obliged to quit the field.

After the performances, in country places, Hawley usually sat in the village bar-room, and a knot of astonished and credulous persons would gather about him. They were also attracted by the marvellous stories in which he indulged. His gray head, grave countenance, and serious manner, carried conviction in the more probable narratives – the barely possible were swallowed, though with occasional signs of choking – but when he enlarged in his Munchausen vein, some of his auditors would forget his venerable presence, and cry out, "That's a lie, by thunder!" Hawley would laugh heartily and reply, "It is as true as any thing I have yet told you."

He had a singularly lively imagination, and his inventive faculty regarded neither rhyme nor reason. Had he lived in the times of the Arabian Nights' Entertainments, he would have been celebrated, as I think a few specimens of his bar-room stories will show.

"Gentlemen, you have doubtless heard that 'truth is strange, stranger than fiction.' There never was a truer saying. When Bruce, the great African traveller, returned to England and stated that some of the filthy black tribes there cut steaks out of cattle while alive, he was called a liar. Catlin tells us that an Indian who came to one of our seaports, on his return to his own tribe was killed. His crime was telling the truth; but so impossible did his account of ships appear to them, that they said, 'Our brother lies,' and then did his business, and took his scalp. I mention these facts, because some of my own experiences are stranger than any thing you perhaps have ever heard. Without this preface you might not believe me."

"Oh, we should not think of doubting your word," said they.

"Gentlemen, has either of you ever visited the Rocky Mountains?" asked Hawley, as he glanced around at his auditors. They replied in the negative.

"I have been there frequently," he continued, "and am acquainted with many singular facts concerning that region. There is one locality where all the American hunters and trappers in that

vicinity meet every Fourth of July to celebrate 'Independence.' I am happy to say that they make excellent ice-punch, the ice being obtained from a huge cavern in the neighborhood, where it is found in large quantities, at all seasons. On one occasion, we all drank so freely as to use up a cart-load of ice, and we sent a couple of Irishmen for a second load.

"They soon returned in sore affright. In digging the ice, they came upon a pair of boots with real legs in them, and they dare proceed no further. A party of us went down to the cave, assisted in removing the ice, which had probably not been disturbed for fifty years, and succeeded in exhuming a man. The corpse looked as fresh as if it had been alive. It was habited in an antique dress – short breeches and knee-buckles, a queer old-fashioned coat and cocked hat. We placed the body upon the cart and took it to our place of rendezvous. It looked so fresh and life-like, that several of the old trappers insisted it was merely in a dormant state, and could be restored to animation by using the proper means. This seemed to me ridiculous, but they prepared a large kettle of warm water, in which they placed the body, after stripping off the clothing, and then proceeded to pour hot brandy into the mouth.

"In the course of twenty minutes, you may judge my surprise in seeing the man open his eyes and relax the muscles of his face! They then placed him in woollen blankets, and commenced rubbing him briskly. In another quarter of an hour he began to speak, and in a very short time he was fully recovered. We dressed him, he joined us in our convivialities, and seemed for an hour to be as happy as any of the party. He then started to his feet, and thanking us for our courtesy, said he must proceed on his journey, and called for his horse.

"'What horse?'

"'The horse I rode last night.'

"None could answer.

"'Gentlemen, do not detain me, I beg of you,' he exclaimed. 'My business is of the utmost importance. Provide me with a horse, and I will pay you well. You see that I have money.' With this he pulled out a bag or purse, which was stocked with guineas, coined in the reign of George the Third. There was a mystery about the whole affair that we could not fathom, and our curiosity was as great as the stranger's impatience.

"'If you will tell us where you are going, we will,' we said.

"'On your promise not to detain me, I will.'

"We promised.

"'I am going to the army with dispatches from the government.'

"'Oh!' we said, wondering at the strangeness of the man's attire, 'you are going to Florida then?'

"'No, to—.'

"'Why, friend, there's no army there; and what makes you wear such a queer old-fashioned dress?'

"At this, for the first time, he appeared to regard our attire, and looked no less astonished than we really were.

"'Who and what are you?' we exclaimed, our curiosity becoming insupportable.

"'I am in your power,' he said, 'I scorn equivocation. Do with me as you will. I am an officer of King George, whom I am proud to serve.'

"To make a long story short, gentlemen, I will tell you at once, that this officer, as we afterwards learned from his own lips, had been sent on a mission to some Indian tribes during the revolutionary war, and was returning to the army, when he went into a cave to sleep. It was quite dark, and he fell and became insensible. He knew nothing more until we recovered him."

This story created an immense sensation. The auditors looked at old Hawley, saw that his countenance was as grave as that of a judge, glanced at his gray hair, and they swallowed the soldier, head, boots, and all. Emboldened by his success, Hawley proceeded to relate that there was, in that same section, an area of twenty miles where the air was so pure that people never died, unless by accident.

"Never died!" exclaimed several of his hearers in astonishment.

"No, gentlemen, it was quite impossible. The rare purity of the atmosphere prevented it. When persons got too old to be useful, they would sometimes be blown away, and, once outside of the charmed circle, they were lost."

"Is that really possible?" asked one of his hearers, in some doubt.

"A fact, upon my honor," rejoined old Hawley. "Indeed, some years ago several philanthropic gentlemen erected a museum at that place, where persons who became too old for usefulness were put into sacks, labelled, registered at the office, and hung up. If at any subsequent period their friends wished to converse with them, for a fee of fifty cents the old friend would be taken down, placed in a

kettle of tepid water, and would soon be enabled to hold a conversation of half an hour, when he would be taken out, wiped off, and hung up again."

"That *seems* incredible!" remarked one of the listeners.

"Of course it does," replied Hawley. "It is nevertheless true. Why, gentlemen," he continued, "on one occasion I went to the museum, and asked if they had a subject there named Samuel Hawley. I had an uncle by that name who went to the Rocky Mountains thirty years before, and we had not heard from him in a long time. The clerk, having examined the register, replied that Samuel Hawley was in Sack No. 367, and had been there nineteen years. I paid the fee and called for an interview. The contents of that particular sack were placed in the warm water, and in a short time I proceeded to inform my old uncle who I was. He seemed pleased to see me, although I was a child when he left our part of the country. He inquired about my father and other friends. His voice was very weak, and after a conversation of twenty minutes, he said his breath was failing him, and if I had nothing more to say he would like to be hung up again. I remarked that I believed he formerly owned a large gun, and asked him where it was. He informed me that it was lying on the cross-beam in my father's garret, and that I was welcome to it. I thanked him, and bidding him good-bye, the keeper of the museum took him in hand, and soon placed him in his proper locality. If any of you should ever go that way, gentlemen, I hope you will call on my uncle and present him my compliments. Remember his number is 367."

Several of the auditors marked the number on cards, and put them in their pocket-books! "Did you ever find the gun?" asked one of the listeners, who had swallowed the museum story without a gulp.

"Yes, indeed, I found it just where uncle Sam said it was. It was a monstrous large gun. It required one pound of powder and four pounds of shot to load it properly. That same season I returned to my father's house, which was in the western part of the State of New York. He had sown a large field of buckwheat, and the wild pigeons visited it every morning about sunrise in such immense quantities that he feared they would destroy it all. Myself and brothers therefore took our turns in watching it at that particular portion of the day. One morning I took the big gun with me. I arrived at the field an hour too early. I therefore loaded my gun, and resting it on the fence with the muzzle pointed towards the

field, I propped it up and cocked it, so that all should be ready. I then took a seat on a stump to await the coming of the pigeons. I happened to fall asleep, and when I awoke the sun was half an hour high. I looked into our lot and saw that the ground was literally covered with pigeons! I assure you, gentlemen, that you can have no conception of the quantity of pigeons that were devouring our buckwheat. I jumped upon my feet, and, throwing a stick into the field to start them up, placed myself at the gun, prepared to fire at the proper moment. The whole body of pigeons rose exactly together, their shadow absolutely making the ground dark under them. I pulled the trigger of the big gun, and a thundering report followed. Unfortunately I was half a second too late. The birds had risen just above the range of my musket, and I did not kill a pigeon, but I picked up four bushels and a half of feet and legs shot clean off!"

"That's a lie, by thunder!" exclaimed one of the listeners, and the others all agreed with him.

"It is just as true as any thing I have told you to-night," exclaimed Hawley, with a hearty laugh, in which the company joined.

Hawley acquired such a habit of relating his fictitious experiences, that it was difficult to get the truth out of him. I could not name a place in any part of the world that he had not visited. One day I said to him, "Hawley, I think I can name *one* place where you have never been."

"Very likely," he replied; "but where is it?"

"You have never made a balloon ascension," said I.

"There you are very much mistaken," he replied; "for I went up three times with Wise in 1832 from the city of Louisville. One was the highest ascent he ever made."

There was no use in disputing him, but I felt confident there was not a word of truth in his story.

Our company performed in numerous places in Alabama, Kentucky, and Tennessee, and disbanded in Nashville, May, 1837. Vivalla went off on his own account, performed a few months in New York, and thence in the fall he sailed to Cuba, where I heard he died the year following. At a later period in my history, however, the little fellow turns up again.

Hawley remained in Tennessee to take charge of our horses, which had been "turned out to grass," and I returned to "home, sweet home," to spend a few weeks with my dear family. Early in

July I returned to the West, with a new company of performers, rejoined Hawley, and recommenced operations in Kentucky. We were not successful. One of our few employees was incompetent – one was intemperate – both were dismissed; our negro-singer was drowned in the river at Frankfort. Funds were low – I was obliged to leave a horse in *this* town, a carriage in *that*, and my watch in another, as security for tavern bills. Though these articles were afterwards redeemed by better success, I felt for several weeks that the stars were unpropitious.

Dissolving with Hawley in August, I formed a co-partnership with Z. Graves, left him in charge of the establishment, and went to Ohio in quest of Pentland, to re-engage him. I met him at Tiffin.

I was a stranger in the town, but religious conversation at the hotel introduced me to several gentlemen, who solicited me to lecture on certain subjects which we had discussed. I complied, and the town schoolhouse was crowded by an attentive congregation in the afternoon and evening of the Sabbath. A gentleman from Republic urged me to deliver two lectures in that town on the evenings of September 4 and 5, which I did.

Having engaged Pentland and several musicians, I bought his horses and wagons, and we started for Kentucky.

About thirty miles before reaching Cincinnati, we met several men with a large drove of hogs. One of the drovers made an insolent remark, because one of our drivers did not stop his wagon soon enough to prevent the swine from scattering a little. I replied rather tartly, comparing the man to his quadrupeds. Dismounting and approaching me, he drew and cocked a pistol, and, pointing it at my breast, swore he would blow me through if I did not apologize. I begged him to give me a few minutes for reflection, and told him if he would allow me a moment's consultation with a friend in the other wagon, the misunderstanding should be settled satisfactorily. He consented. That friend was a double-barrelled gun, loaded and capped. Seizing it, and approaching the hog drover, whose two mounted assistants were by his side, I said to him, "Now, sir, *you* must apologize, for your brains are in danger. You drew a weapon upon me for a trivial remark. You seem to hold human life at a cheap price; and now, sir, you have the choice between a load of shot and an apology."

He instantly apologized, and we entered into a different sort of conversation. We agreed that many a human life is sacrificed in sudden anger, because one or both the parties carry deadly weapons.

The prominent points at which our company performed in that western and southern tour, were Nashville, (where we visited General Jackson at the Hermitage,) Huntsville, Tuscaloosa, and Vicksburg – of course paying due respect to numerous intermediate places. We met with various success, though on the whole we did remarkably well.

At Vicksburg we sold all our land-conveyances, excepting four horses and the "band wagon;" bought the steamboat "CERES" for $6000, hired the captain and crew, and proceeded down the river, stopping at desirable points to open our "budget of amusement."

At Natchez our "man-cook" left us, and I sought in vain for another. I applied to a white widow who, I had been informed, would answer the purpose. She objected, because she hoped shortly to marry a young painter. We needed a cook; our case was desperate; I called on the lover; mentioned my object; related the story; and asked him if he intended to marry the widow. He had not yet determined.

"Can't you hurry up your ideas, and marry her at once?" said I.

Certainly not. He did not know that she would have *him*, and he did not know that he would have *her*.

This was reasonable, but our case was desperate. "If you will marry her to-morrow morning, I will hire *her* at $25 per month as cook, and *you* at the same price as painter – boarding free for both – and a bonus of $50, cash in hand."

There was a wedding on board the boat the next morning. The bride doffed her white robes, and at noon that day we had a capital dinner.

There was an alarming and yet somewhat ludicrous scene at St. Francisville, Louisiana. During the evening performances, a man attempted to pass me at the door of the tent, claiming to have paid already for admittance. He was slightly intoxicated, and when I refused him, he aimed at me with a slung-shot. The blow mashed my hat, and grazed the protuberance where phrenologists locate "the organ of caution." Perhaps this fact had something to do with what followed.

The rejected party retired, and in a few minutes returned with a frightful gang of his half-drunken companions, each with a pistol, bludgeon, or other weapon. They seemed determined to assault me forthwith. Calling upon the Mayor and other respectable citizens, (who were then in the "theatre,") I claimed protection from the

mob. The Mayor declared his inability to afford it against such odds, but immediate violence was restrained by his intercession.

"We will let you off on one condition," said the more moderate of the ringleaders. "We will give you exactly one hour, and no help, to gather up your 'traps and plunder,' get aboard your steamboat, and be off! Hurry up, for you have no time to lose. If you are on shore one moment more than an hour, look out!"

He looked at his watch, *I* looked at the pistols and bludgeons; and I reckon that a big tent never came down with greater speed. The whole force of the company was exerted to its utmost. Not a citizen was allowed to help us, for love or money; and an occasional "Hurry up!" kept every muscle at work. Our "traps and plunder" were tumbled in confusion on the deck of the vessel; the fireman had gotten up steam; and five minutes before the hour was out, we were ready to cast off our cables and depart.

The scamps who thus hurried us from the village had certainly a streak of both humor and honor. They were amused by our diligence; escorted us and our last load, waving pitch-pine torches; and when the boat swung into the current, they saluted us with a wild "hurrah!"

The New Orleans papers of March 19, 1838, announced the arrival of the "steamer Ceres, Captain Barnum, with a theatrical company." After a week's performances, we started for the Attakapas country. At Opelousas we exchanged the steamer for sugar and molasses; our company was disbanded; and I started for home, arriving in New York, June 4, 1838.

I was thoroughly disgusted with the life of an itinerant showman; and though I felt that I could succeed in that line, I always regarded it, not as an end, but as a means to something better in due time. Aiming for a respectable, permanent business, I advertised for a partner, stating the fact that I had $2500, in cash, to invest, together with unremitting personal attention. *I received ninety-three propositions* – and *such* propositions! Whoever wishes to buy a cheap dollar's worth of knowledge how people live, or hope to live, let him spend that sum in advertising for a partner, announcing, at the same time, that four or five thousand dollars are "in the wind."

One third of my letters were from porter-house keepers. I also had applications from brokers, lottery-policy men, pawnbrokers, inventors in large numbers, patent medicine men, etc. Several of my correspondents declined naming their business, but promised,

in a confidential interview, to open my eyes to mines of gold. I met several of these mysterious personages, and one of them, after much hesitation and repeated promises of secresy, was actually a *counterfeiter*, who proposed that I should join him in the business. He showed me counterfeit coin and bank-notes; told me if I exposed him it would be certain death, but if I joined him, I should reap a rich and safe harvest. He needed the $2500 to purchase paper and ink and procure new "dies."

A sedate, farmer-looking individual, dressed in Quaker costume, applied. He wished me to join him in an oat speculation. He said he was a broken-down merchant, but by dressing in the garb of a Quaker farmer, and buying a horse and wagon, he thought a profitable trade could be driven by purchasing oats at wholesale and selling them in bags from his wagon, in the neighborhood of 21 Bowery. Cartmen and livery-men, he said, would generally purchase more freely, and not be so particular about measuring the grain over again, if they thought they were trading with a Quaker farmer.

"Do you mean to cheat in measuring your grain?" said I.

"I should probably make it hold out," said he, with a leer which convinced me that there were better men in the State prison.

One wool merchant from Pearl street applied. I observed that he failed in business within a month afterwards. One man had a "perpetual motion" that would make our fortunes; but unfortunately, in examining it, I discovered a main-spring slily deposited under one of the hollow posts, and so connected as to make the motion perpetual – until it ran down!

I finally entered into co-partnership with a German named Proler, who brought recommendations from a city alderman. The latter also assured me, in a personal interview, that Mr. Proler was a man of honor. He was a manufacturer of paste-blacking, waterproof paste for leather, Cologne water, and bear's grease. We took the store No. 101½ Bowery, at a rent (including the dwelling) of $600 per annum, and opened a large manufactory of the above articles. Proler manufactured and sold the goods at wholesale in Boston, Charleston, Cleveland, and various other parts of the country. I kept the accounts, and attended to sales in the store, wholesale and retail.

For some months, the business seemed to be prosperous. But when all my capital had been absorbed, and our notes of hand for additional stock were falling due, our goods meanwhile having been sold on long credit, I began to see the beauties of "the credit system."

I *felt* it too, for many a sleepless night did I pass, tormented by the note in the bank that would claim my acquaintance tomorrow.

Proler was a fine-looking man, of plausible manners, but he proved himself a scamp of "the first water." The details of discovery would possess little interest to the reader. Our co-partnership was dissolved in January, 1840, Proler being the purchaser of the entire interest for $2600, on "the credit system." Before his note was due, he packed up "bag and baggage," and sailed for Rotterdam, having swindled me most effectually. All that remained to me were the following recipes, which I present to the public, gratis:

1. "COLOGNE WATER. – To six gallons of Alcohol, add four ounces each of the oils of Lavender, Thyme, Rosemary, Cloves, Nitre, Bergamot, and Lemon. Mix thoroughly three times a day. Let it stand twenty-four hours, then add one and a half gallons of pure spirits, only proof. Stir well, let it stand four hours, then, filter through red blotting paper."

N. B. – As Americans are extremely partial to foreign productions, your sales will be increased by advertising "German Cologne," and copying German labels for your bottles and boxes.

2. "BEAR'S GREASE, [made without the Bear!] Three pounds of hog's lard and one and a half pounds of mutton tallow. Melt them well together. Then mix, in a separate cup, two ounces each of oil of Cloves and oil of Bergamot, and one ounce each of oil of Lavender, Thyme, and Rosemary. Pour them all into the melted grease, and mix and stir them well together."

P. S. – This is the real "Genuine Bear's Grease," which will cover a bald head with beautiful, glossy, curly hair – as quickly as any other composition yet discovered. N. B. – To increase the faith of your customers, exhibit a live Bear in front of the store, with the label, "To be slaughtered next!" The same animal will answer for to-morrow. Occasionally head your advertisements, "Two more Bears killed yesterday!"

3. "BLACKING, [which took the premium at the Great Fair of the American Institute, held at Niblo's in 1838.] Put into a tub three gallons of Molasses and add three pints of Whale Oil. Mix thoroughly, and then add twenty-five pounds of Ivory Black, mixing as fast as added. When twenty pounds are mixed, put in a quart of Vinegar; then add the remaining five pounds of Ivory Black, and

three half pints more of Vinegar. This must be well mixed. Then pour in a quart of Muriatic Acid, and be sure that it is well mixed. Then add a quart of oil of Vitriol. Let it be well stirred for half an hour, and your Blacking is complete. Take care not to work where the sun shines."

4. "WATER-PROOF PASTE. – Ten pounds of Tallow and five pounds of Lard. Put in an iron pot over a slow fire. In another pot, melt very gently two and a half pounds of Beeswax cut in small pieces. Pour this into the large pot, stirring and mixing it well. When this is done, take your pot from the fire and put into it two and a half pounds of Olive Oil and a quart and half pint of Spirits of Turpentine. Then add ten or twelve pounds of Ivory Black, all by small quantities, and keep a boy always stirring for at least half an hour. Then put it aside till it is cold and fill your boxes. Take care not to fill your boxes where the sun is shining."

During my business connection with Proler, (it was in the spring of 1839,) I became acquainted with a lad named John Diamond, who was really a genius in the dancing line. I entered into a contract with his father, put him in charge of an agent, called public attention to his extraordinary merits, (though I did not then appear in the transaction,) and he became justly celebrated as the best negro-dancer and representative of Ethiopian "break-downs" in the land. He was indeed the 'prototype of the numerous performers of the sort who have surprised and amused the public these many years.

In the spring of 1840, I hired from Mr. Bradford Jones the saloon in Vauxhall Garden in New York, and opened it with a variety of performances, including singing, dancing, Yankee stories, etc. Miss Mary Taylor, the celebrated actress and singer, here made her first appearance on the stage.

My enterprise in Vauxhall did not meet my expectations, and I relinquished the establishment in August. What I should do next, was now the question. No one but myself can know how earnestly I struggled against the thought of resuming the life of an itinerant showman; but I had a dependent family, my funds were low, and as nothing better appeared, I determined once more to endure the privations, vexations, and uncertainties of a tour in the West and South.

My *large* company of performers consisted of Mr. C. D. Jenkins, an admirable singer and delineator of Yankee and other eccentric

characters, Master Diamond, and a fiddler! At Troy, N. Y., I added Francis Lynch, an orphan vagabond of fourteen years of age, whose talent afterwards contributed a due portion to the interest of our entertainments. My brother-in-law, Mr. John Hallett, preceded us as agent and advertiser.

Our route of travel passed through Buffalo, Toronto, in Canada, Detroit, Chicago, Ottawa, Springfield, St. Louis, and numerous intermediate places. From the latter city, we took steamer directly to New Orleans – my company of performers having been reduced, by desertions, to Master Diamond and the fiddler!

We arrived in New Orleans, January 2, 1841, and only $100 remained in my purse. I had started from New York with fully that amount – and four months of anxiety and toil had resulted, with the exception of some small remittances to my family, in nothing more than current expenses. In less than a fortnight afterwards my pockets were decidedly at "ebb-tide." A week's boarding was due to our good landlady, Mrs. Gillies, and I received notice to "pay or quit." I begged a little delay, assuring her that I should be in funds when Diamond had his benefit. He was at that time performing, but theatricals were dull and profits were yet in the dim future. Having no high opinion of "showmen," the worthy woman demanded security, and I put my watch into her hands as a pledge.

The tide began to flow on the 16th. That night I received nearly $500 as my half-share of Diamond's benefit, Mr. Manager Caldwell, of the St. Charles Theatre, retaining the other half, as per agreement. The tide continued to flow; for I received $50 the next night, and $479 the third – the latter as my share of the profits of a grand dancing match, very much on the plan of the match in Philadelphia between Vivalla and Roberts.

Engagements at Vicksburg and Jackson did not result so favorably, but on our return to New Orleans we again succeeded admirably – also subsequently in Mobile. Master Diamond, however, after extorting large sums of money from me, finally absconded, and I turned my face homeward by the route of the Mississippi and the Ohio, on the 12th of March.

That seven months' tour was not barren in interesting incidents, but the contrary. I have here done little more than sketch the route, and will add only a few passages of other recollections.

When we arrived in New Orleans, Tyrone Power, the justly celebrated Irish comedian, was about concluding an engagement with manager Caldwell at the St. Charles. I was very happy to make

his acquaintance. He was a man of most genial spirit. In bidding me farewell, (it was January 8, 1841,) he cordially wished me success, and hoped we should meet again. Poor Power! The ship on which he embarked in New York for Liverpool, passed away from these shores, and only the Lord's eye saw her settle down into the bosom of the great deep.

Fanny Ellsler arrived in New Orleans about the 1st of March, to fulfil an engagement at the St. Charles. The best seats in the dress circle were sold by auction on the 4th, at an average of four dollars and a half. I thought the price enormous, and gave her manager the credit of doing what I had considered impossible, in working up public enthusiasm to fever heat. Little did I dream that I should be selling tickets in the same city for a large advance on that price, within twelve years.

When I arrived in Pittsburgh, March 30, I learned that Jenkins, who had enticed Francis Lynch from my service in St. Louis, was exhibiting the lad at the Museum, under the assumed name of "Master Diamond." I visited the performance *incog.*, and the next day wrote Jenkins an ironical review, informing him that, on inquiry, he might possibly find me in Pittsburgh, prepared to have our law-fight forthwith, though if he preferred, I would postpone the matter until we should meet in New York!

We met the next day. He threatened suit for a libellous review, and my laughter probably instigated the revenge he attempted on the morrow. R. W. Lindsay, of whom I hired Joice Heth in Philadelphia in 1835, and whom I had not seen since that day, was at the time in Pittsburgh. By the instigation of Jenkins, Lindsay sued me for the value of a pipe of brandy, which he pretended I had promised him in addition to the purchase-money in the former transaction. The magistrate required me to give bonds of $500. I was among strangers, could not immediately find bail, and was thrown into jail! My counsel, with whom I left such securities as were then in my possession, had me liberated about four o'clock in the afternoon.

The next morning, I arrested Jenkins for trespass in regard to Francis Lynch, and the assumption of "Master Diamond's name and reputation,".etc. He was sent to jail, and liberated about four o'clock in the afternoon! Each of us having had a turn in prison, we adjourned our controversy to New York – and there he got the worst of the bargain. As for Lindsay, he had been merely a tool of Jenkins, and I heard no more of his claim. Twelve years afterwards, he called

upon me in Boston, with an apology. He was miserably poor, and I was highly prosperous. I hope I may be allowed to add that he did not afterwards lack a friend.

While in Pittsburgh, I formed the acquaintance of Mr. C. D. Harker, a gentleman about fifty years of age, who complained that he had nothing to do. Taking up a New York newspaper, "I will find you something to do before I lay down this paper," said I.

Almost immediately, I saw the advertisement of "Sears' Pictorial Illustrations of the Bible, price $2.00 per copy." I had never seen the book – did not know the wholesale price; Mr. Harker thought he could obtain subscribers; I bought him a copy as a specimen, and agreed to furnish him as many as he required at $1.37½. He went at it forthwith, and obtained eighty subscribers in two days, thus netting $50.

I arrived in New York, April 23, 1841, after an absence of eight months; found my family in excellent health, and re-resolved that I would never again be an itinerant showman.

CHAPTER IX

The American Museum

APRIL 26, 1841, I called on Robert Sears, the publisher of "Sears' Pictorial Illustrations of the Bible," and contracted for five hundred copies of the work for $500, accepted the United States agency, opened an office, May 10, at the corner of Beekman and Nassau streets, which was subsequently taken by Mr. Redfield as a book-store, and is the present site of the Nassau Bank. I had thus made another effort to quit the life of a showman for ever, and settle down into a respectable calling. I advertised largely, appointed agents and

sub-agents, and managed in the course of six months to sell thousands of books, and at the same time to place a sufficient number in the hands of irresponsible agents to use up all my profits and all my capital!

In the mean time I again leased Vauxhall saloon, and opened it June 14, 1841. I thought it would be compromising my dignity as a "Bible man" to be known as the lessee of a theatre, and the concern was managed, under my directions, by Mr. John Hallett, my brother-in-law. We closed the season, Sept. 25, having cleared about two hundred dollars above expenses.

Living in the city of New York with nothing to do and a family to support, in a very short time exhausted my funds, and I became about as poor as I should ever wish to be. I looked around in vain for employment congenial to my feelings, that would serve to keep my head above water. I finally obtained the post of writing advertisements and notices for the Bowery Amphitheatre, my duties including daily visits to the upper stories of many newspaper offices to deliver what I had prepared, and see that they were inserted. For this I received $4.00 per week! and was thankful for even that.

I also wrote articles for the Sunday press, for the purpose of enabling me to "keep the pot boiling" at home.

These productions afforded me a fair remuneration, but it was at best a precarious way of living, and I began to realize, seriously, that I was at the very bottom round of fortune's ladder, and that I had now arrived at an age when it was necessary to make one grand effort to raise myself above want, and to think soberly of laying up something for "a rainy day." I had hitherto been careless upon that point. I had engaged in divers enterprises, caring little what the result was, so that I made a present living for my family. I now saw that it was time to provide for the future.

About this period, I received a letter from my esteemed friend, Hon. Thomas T. Whittlesey, of Danbury. He had long held a mortgage of $500 on a piece of property which I owned in that town. He wrote to say that he was satisfied I never would lay up any thing until I could "invent a riddle that would hold water," and as that was not very likely to occur, I might as well pay him now as ever. That letter strengthened the resolutions I had made, and laying it aside unanswered, I said to myself, "Now, Mr. B., no more nonsense, no more living from hand to mouth, but from this moment please to concentrate your energies upon providing permanently for *the future.*"

While engaged as outside clerk for the Bowery Amphitheatre, I casually learned that the collection of curiosities comprising Scudder's American Museum, at the corner of Broadway and Ann street, was for sale. It belonged to the daughters of Mr. Scudder, and was conducted for their benefit by John Furzman, under the authority of Mr. John Heath, administrator. The price asked for the entire collection was $15,000. It had cost its founder, Mr. Scudder, probably $50,000, and from the profits of the establishment he had been able to leave a large competency to his children. The Museum, however, had been for several years a losing concern, and the heirs were anxious to sell it.

It will not be considered surprising, under all the circumstances, that my speculative spirit should look in that direction for a permanent investment. My recent enterprises had not indeed been productive, and my funds were decidedly low; but my family was in poor health, I desired to enjoy the blessing of a fixed home – and so I repeatedly visited that Museum as a thoughtful looker-on. I saw, or believed I saw, that only energy, tact and liberality were needed, to give it life and to put it on a profitable footing; and although it might have appeared presumptuous, on my part, to dream of buying so valuable a property without having any money to do it with, I seriously determined to make the purchase, if possible.

I met a friend one day in the street, and told him my intentions. "*You* buy the American Museum?" said he with surprise, for he knew that my funds were at ebb-tide; "what do you intend buying it with?"

"*Brass*," I replied, "for silver and gold I have none."

It was even so.

The Museum building, I learned, belonged to Mr. Francis W. Olmsted, a retired merchant, who had a suite of rooms in Park Place. How to approach this great man was a question. I was acquainted with no one who knew him, and to enter his presence without an introduction, I considered equivalent to being kicked out of his house. I therefore wrote him a letter, informing him that I desired to purchase the Museum collection, and that although I had no ready means, if it could be purchased upon a reasonable credit I was entirely confident that my tact and experience, added to a most determined devotion to business, would enable me to make the payments when due. On this basis I asked him to purchase the collection in his own name – give me a writing securing it to me provided I made the payments punctually, including the rent

of his building – allow me twelve dollars and a half a week on which to support my family – and if at any time I failed to meet the instalment due, I would vacate the premises and forfeit all that might have been paid to that date. "In fact, Mr. Olmsted," I continued in my earnestness, "you may bind me in any way, and as tightly as you please – only give me a chance to dig out, or scratch out, and I will either do so or forfeit all the labor and trouble which I may have incurred."

I also endeavored to show Mr. Olmsted, that by making this arrangement he would secure a permanent tenant, whereas if I did not make the purchase the Museum would probably soon be closed. I added, that if he would have the goodness to grant me an interview, I should be happy to give him satisfactory references, and would also submit to any reasonable conditions which he might propose.

I took the letter myself, handed it to his servant, and in two days afterwards I received a reply, naming an hour for me to call on him. I was there at the exact moment, and Mr. Olmsted expressed himself pleased with my punctuality. He eyed me closely, and put several home questions regarding my habits and antecedents. I told him frankly my experience in the way of a caterer for public amusements – mentioned Vauxhall Garden, the circus, and several exhibitions that I had managed in the South. I was favorably impressed with Mr. Olmsted's appearance and manner. He indeed tried to assume an austere look, and to affect the aristocrat; but I thought I could see the good, open-hearted, noble *man* peering through his eyes, and a subsequent intimate acquaintance proved the correctness of my impressions respecting him.

"Who are your references?" he inquired.

"Any man in my line," I replied; "from Edmund Simpson, manager of the Park Theatre or William Niblo, to Messrs. Welch, June, Titus, Turner, Angevine, or other circus or menagerie proprietors; also Moses Y. Beach of the New York Sun."

"Can you get any of them to call on me?" he continued.

I informed him that I could, and it was arranged that they should call on him the next day, and myself the day afterwards. My friend Niblo willingly rode down in his carriage, and had an interview with Mr. Olmsted. Mr. Beach and several others among the gentlemen named also called, and on the following morning I waited upon the arbiter of my fate.

"I don't like your references, Mr. Barnum," said Mr. Olmsted abruptly, as soon as I entered the room.

I was confused, and said "I regretted to hear it."

"They all speak too well of you," he added, laughing; "in fact they talk as if they were all partners of yours, and intended to share the profits."

This intelligence, of course, pleased me. Mr. Olmsted then inquired if I could not induce some friend to give bonds as security that I should meet the instalments as they became due. I thought it was doubtful.

"Can you offer me any security in case I should make the purchase for you?" was his still more direct question.

I thought of several small pieces of land which I owned in Connecticut, but they were severely afflicted with mortgages. "I have some land and buildings in Connecticut, but there are encumbrances on them," I replied.

"Yes, yes; I don't want mortgaged property," said Mr. O.; "I should probably have to redeem it."

During further conversation, it was agreed that if he concluded to make the purchase for me, he should retain the property until it was all paid for; and should also appoint (at my expense) a ticket-receiver and accountant, who should render him a weekly statement. It was further stipulated that I should take in an apartment in the adjoining building, hitherto used as a billiard-room, and allow therefor five hundred dollars per year, making the entire rent three thousand dollars per annum, on a lease of ten years. I felt that in all this I had been liberal in my propositions and agreements, and hoped that the wealthy landlord would demand no more concessions. But he wanted something more.

"Now," said he, "if you only had a piece of unencumbered real estate that you could offer as additional security, I think I might venture to negotiate with you."

This seemed the turning-point of my fortune. Thinks I to myself, "It is now or never," and memory rapidly ran over my small possessions in search of the coveted bit of land. *Ivy Island*, in all the beauty in which my youthful imagination had pictured it, came dancing to my relief. I hesitated an instant. He is amply secured already – so I thought within myself – and without *some* piece of land, I may lose the Museum altogether. I saw no particular harm in it, and after a moment's hesitation I replied:

"I have five acres of land in Connecticut which is free from all lien or encumbrance."

"Indeed! what did you pay for it?"

"It was a present from my late grandfather, Phineas Taylor, given me on account of my name."

"Was he rich?" inquired Mr. Olmsted.

"He was considered well off in those parts," I answered.

"Very kind in him to give you the land. It is doubtless valuable. But I suppose you would not like to part with it, considering it was a present."

"I shall not have to part with it, if I make my payments punctually," I replied, "and I am sure I shall do that."

"Well," said Mr. Olmsted, "I think I will make the purchase for you. At all events, I'll think it over, and in the mean time you must see the administrator and heirs of the estate – get their best terms, and meet me here on my return to town a week hence."

I withdrew, and proceeded at once to the house of Mr. John Heath, the administrator. His price was $15,000. I offered him $10,000, payable in seven equal annual instalments, with good security. He could not think of selling at that price, and I agreed to call again.

During the week I had several interviews with Mr. Heath, and it was finally agreed that I should have it for $12,000, payable as above – possession to be given on the 15th November. Mr. Olmsted assented to this, and a morning was appointed to draw and sign the writings. Mr. Heath appeared, but said he must decline proceeding any farther in my case, as he had sold the collection to the directors of Peale's Museum (an incorporated institution) for $15,000, and had received $1000 in advance.

I was thunderstruck. I appealed to his honor. He replied that he had signed no writing with me, was not therefore legally bound, and he felt it his duty to do the best he could for the orphan girls. Mr. Olmsted said he was sorry for me, but could not help me. He would now have permanent tenants who would not require him to incur any risk, and I must necessarily be thrown overboard.

I withdrew, with feelings which I need not attempt to describe. I immediately informed myself as to the character of this Peale's Museum Company. It proved to consist of a company of speculators, headed by an unsuccessful ex-president of a bank, who had bought Peale's collection for a few thousand dollars, were now to join the American Museum with it, issue and sell stock to the amount of $50,000, pocket $30,000 profits, and permit the stockholders to look out for themselves.

I went immediately to several of the editors, including Major

M. M. Noah, M. Y. Beach, my good friends, West, Herrick and Ropes, of the Atlas, and others, and stated my grievances. "Now," said I, "if you will grant me the use of your columns, I'll blow that speculation sky-high." They all consented, and I wrote a large number of squibs, cautioning the public against buying the Museum stock, ridiculed the idea of a board of broken-down bank directors engaging in the exhibition of stuffed monkey and gander skins, appealed to the case of the Zoological Institute, which had failed by adopting such a plan as the one now proposed, and finally told the public that such a speculation would be infinitely more unwise than Dickens's "Grand United Metropolitan Hot Muffin and Crumpet-baking and Punctual Delivery Company."

The stock was as dead as a herring! I then went to Mr. Heath and solicited a confidential conversation. He granted it. I asked him when the directors were to pay the other $14,000. "On the 26th day of December, or forfeit the $1000 already paid," was the reply. I assured him that they would never pay it, that they could not raise it, and that he would ultimately find himself with the Museum collection on his hands, and if once I started off with an exhibition for the South, I would not touch the Museum at *any* price. "Now," said I, "if you will agree with me confidentially, that in case these gentlemen do not pay you on the 26th December, I may have it on the 27th for $12,000, I will run the risk, and wait in this city until that date." He readily agreed to the proposition, but said he was sure they would not forfeit their $1000.

"Very well," said I; "all I ask of you is, that this arrangement shall not be mentioned." He assented. "On the 27th day of December, at ten o'clock A. M., I wish you to meet me in Mr. Olmsted's apartments, prepared to sign the writings, provided this incorporated company do not pay you $14,000 on the 26th." He agreed to this, and by my request put it in writing.

From that moment I felt that the Museum was mine. I saw Mr. Olmsted, and told him so. He promised secrecy, and agreed to sign the documents if the other parties did not meet their engagement.

This was about the 15th November. To all who spoke to me about the Museum, I simply remarked, that I had lost it. In the mean time the new company could not sell a dollar's worth of stock, for I kept up a perfect shower of squibs through the papers.

About the 1st of December, I received a letter from the Secretary of the Peale's Museum Company, or rather the "New York

Museum Company," as it was called, desiring me to meet the directors on the following Monday morning at the Museum, when and where I should probably hear something to my advantage. I saw that the newspaper medicine was doing its office. It was evident that those gentlemen wished to purchase my silence.

I was punctual at the meeting. The "honorable board of directors" was in session. The venerable President, a gray-haired, hawk-eyed old man, who had recently been President of a broken bank, accosted me with his blandest smile and smoothest tone of language. The upshot of the matter was, they proposed to hire me to manage the united museums. I professed to take it all in earnest, and when asked to mention the salary I should expect, I specified $3000 per annum. They complimented me on my character for ability in that department, and engaged me at the sum I demanded, my salary to commence on the 1st day of January, 1842. As I was leaving the "august presence," the amiable President pleasantly remarked, "Of course, Mr. Barnum, we shall have no more of your squibs through the newspapers."

"I ever try to serve the interests of my employers," I replied.

The jolly directors probably had a hearty laugh so soon as I was beyond hearing their unseemly mirth. They probably meant by thus keeping me quiet to sell their stock, and permit the stockholders to throw me overboard as soon as they pleased. They thought they had caught me securely. I *knew* that I had caught *them*.

Finding that I was now removed out of the way, those directors did not fear that any other person would attempt to buy the American Museum, and they concluded not to advertise their stock until the first of January, as that would give the people longer time to forget the attacks which I had made on it. As for their promised payment on the 26th December, unaware that Mr. Heath had contracted to me for $12,000, they thought he would cheerfully wait on them until it suited their pleasure to pay him. In fact, so unconcerned were they upon this point, that they did not even call on the administrator on the 26th inst., nor send him the slightest apology for not doing so!

On the morning of the 27th, I was at Mr. Olmsted's apartment, with my legal counsellor, CHAS. T. CROMWELL, Esq., at half-past nine o'clock. Mr. Heath came with his lawyer punctually at ten, and before two o'clock that day I was put in formal possession of the American Museum. The first act which I performed, after being thus installed, was to write and dispatch the following note:

AMERICAN MUSEUM, NEW YORK, Dec. 27, 1841.
To the President and Directors of the New York Museum:

GENTLEMEN: – It gives me great pleasure to inform you that you are placed upon the Free List of this establishment until further notice.

P. T. BARNUM, Proprietor.

The President was astonished beyond measure, and could scarcely believe his eyes. He called upon Mr. Heath, and learned that I had indeed bought and was in possession of the American Museum. His indignation knew no bounds. He threatened him with a prosecution, but finding that this availed him nothing, he demanded the return of the thousand dollars which had been paid on the agreement. It was refused because forfeited, and the company lost it.

No one will doubt that I now put forth all my energy. It was strictly "neck or nothing." I must either pay for the establishment within a stipulated period, or forfeit it, including all I might have paid on account, provided Mr. Olmsted should insist on the letter of the contract. Let "come what would," I was determined to *deserve* success, and brain and hands and feet were alike busy in forwarding the interests of the Museum.

The system of economy necessary to support my family in the city of New York upon $600 a year, was not only assented to by my treasure of a wife, but she expressed her willingness to reduce the expenses to four hundred dollars per year, if necessary.

One day, about six months after I had purchased the Museum, my friend Mr. Olmsted happened in at my ticket office about twelve o'clock, and found me alone eating my dinner, which consisted of a few slices of corned beef and bread that I had brought from home in the morning. "Is this the way you eat your dinner?" he inquired.

"I have not eaten a warm dinner since I bought the Museum, except on the Sabbath," I replied, "and I intend never to eat another on a week-day until I am out of debt."

"Ah! you are safe, and will pay for the Museum before the year is out," he replied, clapping me familiarly on the shoulder. And he was right, for in less than a year from that period, I was in full possession of the Museum as my own property, every cent having been paid out of the profits of the establishment.

The American Museum, at the date of my purchase, was little more than the nucleus of what it is now. During the thirteen years of my

proprietorship, I have considerably more than doubled the value of the permanent attractions and curiosities of the establishment. The additions were derived, partly from Peale's Museum, (which I bought and transferred to my former collection in the fall of 1842;) partly from the large and rare collection known as the Chinese Museum, (which I removed to the American Museum in 1848;) and partly by purchases wherever I could find curiosities, in both America and Europe.

The space now occupied for my Museum purposes is more than double what it was in 1841. The Lecture Room, which was originally narrow, ill-contrived and uncomfortable, has been several times enlarged and improved, and at present may be pronounced one of the most commodious and beautiful halls of entertainment in New York.

There have been enlargement and improvement in other respects. At first, the Museum was merely a collection of curiosities by day, and in the evening there was a performance, consisting of disjointed and disconnected amusements, such as are still to be found at many of the inferior shows. Saturday *afternoon* was soon appropriated to performances, and shortly afterwards the *afternoon* of Wednesday was added. The programme has for years included the afternoon and evening of every day in the week, (of course excepting the Sabbath,) and on great holidays, we have sometimes given as many as twelve performances.

There has been a gradual change in these, and the transient attractions of the Museum have been greatly diversified. Industrious fleas, educated dogs, jugglers, automatons, ventriloquists, living statuary, tableaux, gipsies, albinoes, fat boys, giants, dwarfs, rope-dancers, caricatures of phrenology, and "live Yankees," pantomime, instrumental music, singing and dancing in great variety, (including Ethiopians,) etc. Dioramas, panoramas, models of Dublin, Paris, Niagara, Jerusalem, etc., mechanical figures, fancy glass-blowing, knitting machines and other triumphs in the mechanical arts, dissolving views, American Indians, including their warlike and religious ceremonies enacted on the stage, etc., etc.

I need not specify the order of time in which these varieties were presented to the public. In one respect there has been a thorough though gradual change in the general plan, for the *moral drama* is now, and has been for several years, the principal feature of the Lecture Room of the American Museum.

Apart from the merit and interest of these performances, and

apart from every thing connected with the stage, my permanent collection of curiosities is, without doubt, abundantly worth the uniform charge of admission to all the entertainments of the establishment, and I can therefore afford to be accused of "humbug" when I add such transient novelties as increase its attractions. If I have exhibited a questionable dead mermaid in my Museum, it should not be overlooked that I have also exhibited cameleopards, a rhinoceros, grisly bears, orang-outangs, great serpents, etc., about which there could be no mistake because they were alive; and I should hope that a little "clap-trap" occasionally, in the way of transparencies, flags, exaggerated pictures, and puffing advertisements, might find an offset in a wilderness of wonderful, instructive, and amusing realities. Indeed I cannot doubt that the sort of "clap-trap" here referred to, is allowable, and that the public like a little of it mixed up with the great realities which I provide. The titles of "humbug," and the "prince of humbugs," were first applied to me by myself. I made these titles a part of my "stock in trade," and may here quote a passage from the "Fortunes of the Scattergood Family," a work by the popular English writer, Albert Smith:

"'It's a great thing to be a humbug,' said Mr. Rossett. 'I've been called so often. It means hitting the public in reality. Anybody who can do so, is sure to be called a humbug by somebody who can't.'"

Among my first extra exhibitions produced at the American Museum, was a model of the Falls of Niagara, belonging to Grain the artist. It was undoubtedly a fine model, giving the mathematical proportions of that great cataract, and the trees, rocks, buildings, etc., in its vicinity. But the absurdity of the thing consisted in introducing water, thus pretending to present a *fac simile* of that great wonder of nature. The falls were about eighteen inches high, every thing else being in due proportion!

I confess I felt somewhat ashamed of this myself, yet it made a good line in the bill, and I bought the model for $200. My advertisements then announced among the attractions of the Museum,

THE GREAT MODEL OF NIAGARA FALLS,
WITH REAL WATER!

A single barrel of water answered the purpose of this model for an entire season; for the falls flowed into a reservoir behind the

scenes, and the water was continually re-supplied to the cataract by means of a small pump.

Many visitors who could not afford to travel to Niagara, were doubtless induced to visit the "model with real water," and if they found it rather "small potatoes," they had the whole Museum to fall back upon for 25 cents, and no fault was found.

One day I was peremptorily summoned to appear before the Board of Croton Water Commissioners the next morning at ten o'clock. I was punctual.

"Sir," said the President, "you pay only $25 per annum for the Croton water at the Museum. That is simply intended to supply the ordinary purposes of your establishment. We cannot furnish water for your Niagara Falls without large extra compensation."

Begging "his honor" not to believe all he read in the papers, nor to be too literal in the interpretation of my large showbills, I explained the operation of the great cataract, and offered to pay a dollar a drop for all the water I used for Niagara Falls exceeding one barrel per month, provided my pump continued in good order! I was permitted to retire, amid a hearty burst of laughter from the Commissioners, in which his honor the President condescended to join.

On one occasion, Louis Gaylord Clark, Esq., the witty and popular editor of the "Knickerbocker," called to view my Museum. I had never had the pleasure of seeing him before, and he introduced himself. I was extremely anxious that my establishment should receive a "first-rate notice" in his popular magazine, and therefore accompanied him through the entire Museum, taking especial pains to point out all objects of interest. We passed the entrance of the hall containing Niagara Falls just as the visitors had entered it from the performances in the Lecture Room, and hearing the pump at work, I was aware that the great cataract was at that moment in full operation.

I desired to avoid that exhibition, feeling confident that if Mr. Clark should see the model Niagara, he would be so much disgusted with the entire show that he would "blow it up" in his "Knickerbocker," or (what I always consider much the worse for me) pass it by in *silent* contempt. Seeing him approach the entrance, I endeavored to call his attention to some object of interest in the other hall, but I was too late. He had noticed a concourse of visitors in the "Falls Room," and his curiosity to know what was going on was excited.

"Hold on, Barnum," said Clark; "let us see what you have here."

"It is only a model of Niagara Falls," I replied.

"Oh, ah, yes, yes, I remember now. I have noticed your advertisements and splendid posters announcing Niagara Falls with real water. I have some curiosity to see the cataract in operation," said Clark, at the same time mounting upon a chair in order to obtain a full view over the heads of the visitors.

I felt considerably sheepish as I saw this movement, and listened to the working of the old pump, whose creakings seemed to me to be worse than ever. I held my breath, expecting to hear the sagacious editor pronounce this the silliest humbug that he ever saw. I was presently, however, as much surprised as delighted to hear him say:

"Well, Barnum, I declare that is quite a new idea. I never saw the like before."

I revived in a moment; and thinking that if Louis Gaylord Clark could see any thing attractive in the old model, he must be particularly green, I determined to do all in my power to assist his verdancy. "Yes," I replied, "it is quite a new idea."

"I declare I never saw any thing of the kind before in all my life," exclaimed Clark with much enthusiasm.

"I flatter myself it is, in point of originality and ingenuity, considerably ahead of any invention of modern times," I replied with a feeling of exultation, as I saw that I had caught the great critic, and was sure of a puff of the best sort.

"Original!" exclaimed the editor. "Yes, it is certainly original. I never dreamed of such a thing; I never saw any thing of the kind before since I was born – and I hope with all my heart I never shall again!"

It is needless to say that I was completely taken in, and felt that any ordinary keyhole was considerably larger than would be necessary for me to crawl through.

We then passed to the upper stories of the Museum, and finally to the roof, where I had advertised an "aerial garden," which consisted of two tubs, each containing a stunted and faded cedar, and ten or twelve pots of wilted flowers, backed up by a dozen small tables and a few chairs for the accommodation of such partakers of ice-cream as could appreciate the beauties of ever-verdant nature, as shown forth in the tubs and pots aforesaid.

The "Knickerbocker" appeared, and I felt happy to see that

while it spoke of the assiduity in business manifested by the new proprietor of the Museum, and a prognostication that he would soon render his establishment highly popular, the editor had kindly refrained from making any allusion to "THE CATARACT OF NIAGARA WITH REAL WATER!"

Some months subsequent to this, Mr. Clark came rushing into the Museum almost out of breath, and with much earnestness saluted me thus: "Friend Barnum, I have come in to ask if you have got the club in the Museum that Captain Cook was killed with?"

Remembering that I had a large lot of Indian war-clubs among the collection of aboriginal curiosities, and feeling that I owed Clark a joke for his Niagara Falls catch, I instantly replied that I was the owner of the club in question.

"Well, I declare I am very glad to hear it," said he; "for do you know that I have for a long time had a singular and irrepressible desire to see that club?"

"Wait here a few minutes, and I will show it to you," I replied.

Passing up stairs, I commenced overhauling a lot of war-clubs, and finally selected a heavy one that looked as if it *might* have killed Captain Cook, or any body else whose head it came in contact with. Having affixed a small label on it, reading "The Capt. Cook Club," I took it down to Mr. Clark, assuring him that this was the instrument of death which he had inquired for.

"Is it possible!" said he, as he took it in his hand. Presently raising it above his head, he exclaimed, "Well, I declare, this is a terrible weapon with which to take a man's life."

"Yes," I replied seriously, but feeling an inward delight that I was now paying off Mr. Clark with interest; "I believe it killed the victim at the first blow!"

"Poor Captain Cook!" exclaimed Clark with a sigh; "I wonder if he was conscious after receiving the fatal blow."

"I don't think he could have been," I responded with a well-feigned look of sorrow.

"You are sure this is the identical club?" inquired Clark.

"We have documents which place its identity beyond all question," I replied.

"Poor Cook! poor Cook!" said Clark musingly. "Well, Mr. Barnum," he continued with great gravity, at the same time extending his hand and giving mine a hearty shake, "I am really very much obliged to you for your kindness. I had an irrepressible desire to see the club that killed Captain Cook, and I felt quite

confident you could accommodate me. I have been in half a dozen smaller museums, and as *they all had it*, I was sure a large establishment like yours would not be without it!"

My laurels were fast withering, and I felt that unless I kept my wits about me and managed to pay Clark at least an instalment on what I owed him, I should be the laughing-stock of all his acquaintances. A few weeks afterwards, therefore, I wrote him a note, saying that I desired to consult him for a few moments at my office on a subject of serious importance to me. He came immediately.

"Now," said I, "I do not want any of your nonsense, but I want your sober advice."

"My dear Barnum," he replied in the fulness of his truly generous heart, "nothing will give me greater pleasure than to serve you in any way in my power."

I proceeded to inform him that a gentleman who had visited Egypt had brought from the river Nile a most remarkable living fish, which he offered to hire for exhibition. The fish, I told him, was of a peculiar formation, and that the owner of it would place $5000 in the hands of a responsible banker, to be forfeited if the fish did not within six weeks pass through a transformation by which its tail would disappear, and it would then have *legs*.

"Is it possible?" exclaimed Clark, in great astonishment.

I assured him that there was no mistake about it. "But," said I, "his price is high, and I want to ask your opinion in regard to its success. He asks $100 per week for the use of it."

"It is cheap enough, my dear fellow. It will draw you more than that sum extra per day. Why, the whole thing is incredible. It will startle the naturalists – wake up the whole scientific world – and draw in the masses."

"Do you really think so?" I asked.

"Upon my honor, I am sure of it," responded Clark with much enthusiasm. "Make an engagement for six months, or for a year if possible, then come out and state the facts regarding this wonderful transformation – announce that $5000 have been deposited in responsible hands which will be forfeited to the poor of this city if the change does not take place as described, and my word for it, your museum will not be large enough to contain your visitors. I declare I believe you will make $20,000 by the operation!"

I thanked Mr. Clark very warmly for his kind counsel, and assured him I should not fail to take his advice. "In fact," said I, "I

thought well of the speculation, excepting that I did not like the name of the fish. I think *that* is an objection."

"Tush, tush, not at all; what's in a name? Nothing. That makes no difference whatever. What *is* the name of the fish?"

"Tadpole, but it is vulgarly called a pollywog," I replied, with becoming gravity.

"Sold, by thunder!" exclaimed Clark, springing to his feet and rushing down stairs.

The "Fejee Mermaid" was by many supposed to be a curiosity manufactured by myself, or made to my order. This is not the fact. I certainly had much to do in bringing it before the public, and as I am now in the confessional mood, I will "make a clean breast" of the ways and means I adopted for that purpose. I must first, however, relate how it came into my possession and its alleged history.

Early in the summer of 1842, Moses Kimball, Esq., the popular proprietor of the Boston Museum, came to New York and exhibited to me what purported to be a mermaid. He stated that he had bought it of a sailor whose father, while in Calcutta in 1817 as captain of a Boston ship, (of which Captain John Ellery was principal owner,) had purchased it, believing it to be a preserved specimen of a veritable mermaid, obtained, as he was assured, from Japanese sailors. Not doubting that it would prove as surprising to others as it had been to himself, and hoping to make a rare speculation of it as an extraordinary curiosity, he appropriated $6000 of the ship's money to the purchase of it, left the ship in charge of the mate, and went to London.

He did not realize his expectations, and returned to Boston. Still believing that his curiosity was a genuine animal and therefore highly valuable, he preserved it with great care, not stinting himself in the expense of keeping it insured, though re-engaged as ship's captain under his former employers to reimburse the sum taken from their funds to pay for the mermaid. He died possessing no other property, and his only son and heir, who placed a low estimate on his father's purchase, sold it to Mr. Kimball, who brought it to New York for my inspection.

Such was the story. Not trusting my own acuteness on such matters, I requested my naturalist's opinion of the *genuineness* of the animal. He replied that he could not conceive how it was manufactured; for he never knew a monkey with such peculiar teeth, arms, hands, etc., nor had he knowledge of a fish with such peculiar fins.

"Then why do you suppose it is manufactured?" I inquired.

"Because I don't believe in mermaids," replied the naturalist.

"That is no reason at all," said I, "and therefore I'll believe in the mermaid, and hire it."

This was the easiest part of the experiment. How to modify general incredulity in the existence of mermaids, so far as to awaken curiosity to see and examine the specimen, was now the all-important question. Some extraordinary means must be resorted to, and I saw no better method than to "start the ball a-rolling" at some distance from the centre of attraction.

In due time a communication appeared in the New York Herald, dated and mailed in Montgomery, Ala., giving the news of the day, trade, the crops, political gossip, etc., and also an incidental paragraph about a certain Dr. Griffin, agent of the Lyceum of Natural History in London, recently from Pernambuco, who had in his possession a most remarkable curiosity, being nothing less than a veritable mermaid taken among the Fejee Islands, and preserved in China, where the Doctor had bought it at a high figure for the Lyceum of Natural History.

A week or ten days afterwards, a letter of similar tenor, dated and mailed in Charleston, S. C., varying of course in the items of local news, was published in another New York paper.

This was followed by a third letter, dated and mailed in Washington city, published in still another New York paper – there being in addition the expressed hope that the editors of the Empire City would beg a sight of the extraordinary curiosity before Dr. Griffin took ship for England.

A few days subsequently to the publication of this thrice-repeated announcement, Mr. Lyman (who was my employee in the case of Joice Heth) was duly registered at one of the principal hotels in Philadelphia as Dr. Griffin of Pernambuco for London. His gentlemanly, dignified, yet social manners and liberality gained him a fine reputation for a few days, and when he paid his bill one afternoon, preparatory to leaving for New York the next day, he expressed his thanks to the landlord for special attention and courtesy. "If you will step to my room," said Lyman, alias Griffin, "I will permit you to see something that will surprise you." Whereupon the landlord was shown the most extraordinary curiosity in the world – a mermaid. He was so highly gratified and interested that he earnestly begged permission to introduce certain friends of his, including several editors, to view the wonderful specimen.

"Although it is no interest of mine," said the curiosity-hunter, "the Lyceum of Natural History, of which I am agent, will not be injured by granting the courtesy you request." And so an appointment was made for the evening.

The result might easily be gathered from the editorial columns of the Philadelphia papers a day or two subsequently to that interview with the mermaid. Suffice it to say, that the plan worked admirably, and the Philadelphia press aided the press of New York in awakening a wide-reaching and increasing curiosity to see the mermaid.

I may as well confess that those three communications from the South were written by myself, and forwarded to friends of mine, with instructions respectively to mail them, each on the day of its date. This fact and the corresponding post-marks did much to prevent suspicion of a hoax, and the New York editors thus unconsciously contributed to my arrangements for bringing the mermaid into public notice.

Lyman then returned to New York with his precious treasure, and putting up at the Pacific Hotel in Greenwich street as Dr. Griffin, it soon reached the ears of the wide-awake reporters for the press that the mermaid was in town. They called at the Pacific Hotel, and the polite agent of the British Lyceum of Natural History kindly permitted them to gratify their curiosity. The New York newspapers contained numerous reports of these examinations, all of which were quite satisfactory.

I am confident that the reporters and editors who examined this animal were honestly persuaded that it was what it purported to be – a veritable mermaid. Nor is this to be wondered at, since, if it was a work of art, the monkey and fish were so nicely conjoined that no human eye could detect the point where the junction was formed. The spine of the fish proceeded in a straight and apparently unbroken line to the base of the skull – the hair of the animal was found growing several inches down on the shoulders of the fish, and the application of a microscope absolutely revealed what seemed to be minute fish scales lying in myriads amidst the hair. The teeth and formation of the fingers and hands differed materially from those of any monkey or orang-outang ever discovered, while the location of the fins was different from those of any species of the fish tribe known to naturalists. The animal was an ugly, dried-up, black-looking, and diminutive specimen, about three feet long. Its mouth was open, its tail turned over, and its

arms thrown up, giving it the appearance of having died in great agony.

Assuming, what is no doubt true, that the mermaid was manufactured, it was a most remarkable specimen of ingenuity and untiring patience. For my own part I really had scarcely cared at the time to form an opinion of the origin of this creature, but it was my impression that it was the work of some ingenious Japanese, Chinaman, or other eastern genius, and that it had probably been one among the many hideous objects of Buddhist or Hindoo worship.

Recently, however, in reading myself up on the history of Japan, I found the following article in a work entitled "Manners and Customs of the Japanese in the Nineteenth Century, from the accounts of recent Dutch residents in Japan, and from the German work of Dr. Ph. Fr. Von Siebold:"

> "Another Japanese fisherman displayed his ingenuity in a less honorable and useful form than Kiyemon, to make money out of his countrymen's passion for whatever is odd and strange. He contrived to unite the upper half of a monkey to the lower half of a fish, so neatly as to defy ordinary inspection. He then gave out that he had caught the creature alive in his net, but that it had died shortly after being taken out of the water; and he derived considerable pecuniary profit from his device in more ways than one. The exhibition of the sea monster to Japanese curiosity paid well; but yet more productive was the assertion that the half-human fish had spoken during the few minutes it existed out of its native element, predicting a certain number of years of wonderful fertility, to be followed by a fatal epidemic, the only remedy against which would be possession of the marine prophet's likeness. The sale of these pictured mermaids was immense. Either this composite animal, or another, the offspring of the success of the first, was sold to the Dutch factory and transmitted to Batavia, where it fell into the hands of a shrewd American, who brought it to Europe, and there, in the years 1822–3, exhibited his purchase as a real mermaid, at every capital, to the admiration of the ignorant, the perplexity of the learned, and the filling of his own purse."

Is it not a plausible conjecture that this account relates to the identical mermaid exhibited in the American Museum? Certainly the method adopted to induce people to buy the likeness, as related by Siebold, fairly entitles my Japanese *confrère* to the palm and title of "Prince of Humbugs."

Smaller specimens, purporting to be mermaids, but less elaborately gotten up, have been seen in various museums. I believe they are all made in Japan. I purchased one in the Peale collection in Philadelphia. It was burnt at the time the Museum opened by me in that city was destroyed by fire in 1851.

A small specimen, I have been informed, is also now lying on a shelf in the Royal Museum of Indian Antiquities at the Hague. I understand that it was purchased for the collection from an American sea captain, who procured it in China, probably an importation from Japan.

While Lyman was preparing public opinion on mermaids at the Pacific Hotel, I was industriously at work (though of course privately) in getting up wood-cuts and transparencies, as well as a pamphlet, proving the authenticity of mermaids, all in anticipation of the speedy exhibition of Dr. Griffin's specimen. I had three several and distinct pictures of mermaids engraved, and with a peculiar description written for each, had them inserted in 10,000 copies of the pamphlet which I had printed and quietly stored away in a back office until the time came to use them.

I then called respectively on the editors of the New York Herald, and two of the Sunday papers, and tendered to each the free use of a mermaid cut, with a well-written description, for their papers of the ensuing Sunday. I informed each editor that I had hoped to use this cut in showing the Fejee Mermaid, but since Mr. Griffin had announced that as agent for the Lyceum of Natural History, he could not permit it to be exhibited in America, my chance seemed dubious, and therefore he was welcome to the use of the engraving and description. The three mermaids made their appearance in the three different papers on the morning of Sunday, July 17, 1842.

Each editor supposed he was giving his readers an exclusive treat in the mermaid line, but when they came to discover that I had played the same game with the three different papers, they pronounced it a *scaly* trick.

The mermaid fever was now getting pretty well up. Few city readers had missed seeing at least one of the illustrations, and as the several printed descriptions made direct allusion to *the* mermaid of Mr. Griffin now in town, a desire to see it was generally prevailing. My 10,000 mermaid pamphlets were then put into the hands of boys, and sold at a penny each, (half the cost,) in all the principal hotels, stores, etc., etc.

When I thought the public was thoroughly "posted up" on the subject of mermaids, I sent an agent to engage Concert Hall, Broadway, for the exhibition, and the newspapers immediately contained the following advertisement:

THE MERMAID, AND OTHER WONDERFUL SPECIMENS OF THE ANIMAL CREATION. – The public are respectfully informed that, in accordance with numerous and urgent solicitations from scientific gentlemen in this city, Mr. J. GRIFFIN, proprietor of the Mermaid, recently arrived from Pernambuco, S. A., has consented to exhibit it to the public, *positively for one week only!* For this purpose he has procured the spacious saloon known as Concert Hall, 404 Broadway, which will open on Monday, August 8, 1842, and will positively close on Saturday the 13th inst.

This animal was taken near the Fejee Islands, and purchased for a large sum by the present proprietor, for the Lyceum of Natural History in London, and is exhibited for this short period more for the gratification of the public than for gain. The proprietor having been engaged for several years in various parts of the world in collecting wonderful specimens in Natural History, has in his possession, and will at the same time submit to public inspection, THE ORNITHORHINCHUS, from New Holland, being the connecting link between the Seal and the Duck. THE FLYING FISH, two distinct species, one from the Gulf Stream, and the other from the West Indies. This animal evidently connects the Bird with the Fish. THE PADDLE-TAIL SNAKE from South-America. THE SIREN, or MUD IGUANA, an intermediate animal between the Reptile and the Fish. THE PROTEUS SANGUIHUS, a subterraneous animal from a grotto in Australia – with other animals forming connecting links in the great chain of Animated Nature.

Tickets of admission 25 cents each.

A large number of visitors attended Concert Hall, and Lyman, alias Griffin, exhibited the mermaid with much dignity. I could not help fearing that some of the Joice Heth victims would discover in Professor Griffin the exhibitor of the "nurse of Washington," but happily no such catastrophe occurred. Lyman, surrounded by numerous connecting links in nature, as set forth in the advertisement, and with the hideous-looking mermaid firmly secured from the hands of visitors by a glass vase, enlightened his audiences by curious accounts of his travels and adventures, and by scientific

harangues upon the works of nature in general, and mermaids in particular.

The public appeared to be satisfied, but as some persons always *will* take things literally, and make no allowance for poetic license even in mermaids, an occasional visitor, after having seen the large transparency in front of the hall, representing a beautiful creature half woman and half fish, about eight feet in length, would be slightly surprised in finding that the reality was a black-looking specimen of dried monkey and fish that a boy a few years old could easily run away with under his arm.

Several days subsequent to the opening of the exhibition at Concert Hall, an old Dutchman came to the Museum and said to me, in a drawling tone of voice, "Where is the *mare*-maid?"

"We have no mermaid here, sir," I replied.

"I've come over from Jarsey on purpose to see the mare-maid. I thought it was here."

I informed him that I had seen it advertised at Concert Hall, Broadway. He started off in pursuit of the object of his curiosity, remarking as he turned to go down stairs, "I have never seen a maremaid. It's alive I s'pose, ain't it?" But I did not profess ability to enlighten him on that point.

Immediately afterwards, I went up to Concert Hall to see how the exhibition was progressing, and just as I passed in, I saw the old Dutchman purchasing a ticket at the foot of the stairs. I found Lyman surrounded with twenty or thirty ladies and gentlemen, to whom he was learnedly descanting on the wonders of nature, as illustrated in the objects on the table before them. They were all attention. Presently the old Dutchman entered, and upon looking around, and being unable to discover the beautiful living lady-fish so elegantly displayed upon the transparency at the door, he approached Lyman, and, interrupting him in his learned discourse, said to him, "I want to see the *mare*-maid."

Lyman, somewhat disconcerted, but with as much dignity and deliberation as he could command, replied, "That is the mermaid, sir," at the same time pointing to the article in question.

The old Dutchman looked upon the diminutive, ugly creature, and exclaimed in great surprise, "Do you call *that* the *mare*-maid?"

"Yes, sir, that is the mermaid," said Lyman, evidently ill at ease. The Dutchman, with a look of scorn such as I have rarely seen equalled, turned to depart, exclaiming, "Well, that is the poorest show I ever *did* see."

On one occasion Lyman left the room for a few minutes. There were few visitors present, principally young students from the Medical College in Barclay street. Perceiving her fish-ship without protector, and being ripe for a joke, they removed the glass vase which covered the mermaid, and thrust into her mouth a cigar from which perhaps half an inch had been "whiffed." They replaced the vase and decamped.

Before Lyman returned, a score or more ladies and gentlemen had entered the room, and it is difficult to say what their feelings were when they saw the little, black, dried mermaid with a cigar in her mouth! They probably felt that the whole thing was an imposition, and that the exhibitor was purposely insulting his customers. Certainly it was the most ridiculous and ludicrous sight that can easily be conceived.

Lyman, wholly unconscious of the wicked trick which had been played upon him, and seeing the respectable number of visitors, approached the table with a dignity which no man could assume better than himself; and, without happening to cast his eyes upon the mermaid, commenced his usual harangue: "You see before you, ladies and gentlemen, the extraordinary mermaid captured at the Fejee Islands. The mermaid has long been deemed a fabulous animal by many persons, including naturalists, but the evidence I possess, as agent for the Lyceum of Natural History in London, places the fact beyond all reasonable doubt, that this identical animal was taken in a fisherman's net at the Fejee Islands. It lived upwards of three hours after its capture."

"Was her ladyship smoking the same cigar when she was captured that she is enjoying at present?" asked one of the gentlemen.

Poor Lyman now for the first time discovered the cigar, and this was probably the first and only time in his life that he was completely nonplussed, and could not utter a word in reply. In relating the incident, (which he afterwards did with great gusto in the private circles of his friends,) he declared that when he discovered that cigar, he began to perspire as if he had been mowing a heavy crop of grass, and that very soon he had not a dry thread upon his back.

The mermaid remained a single week at Concert Hall, and was then advertised to be seen at the American Museum, "without extra charge." Numerous transparencies had been prepared; showbills were posted with a liberal hand; and on Monday morning, a flag representing a mermaid eighteen feet in length was streaming

directly in front of the Museum. Lyman saw it as he was slowly approaching to commence operations. He quickened his pace, entered my office, and demanded, "What in the name of all conscience is that immense flag out for?"

"In order that nobody shall enter Broadway without knowing where to find the mermaid," I replied.

"Well, that flag must come in. Nobody can satisfy the public with our dried-up specimen *eighteen inches* long, after exhibiting a picture representing it as *eighteen feet*. It is preposterous."

"Oh, nonsense," I replied; "that is only to catch the eye. They don't expect to see a mermaid of that size."

"I tell you it won't do," replied Lyman, "I think I ought to know something of the public 'swallow' by this time, and I tell you the mermaid won't go down if that flag remains up."

"That flag cost me over seventy dollars, and it must remain up," I replied.

Lyman deliberately buttoned his coat, and said as he slowly walked towards the door, "Well, Mr. Barnum, if you like to fight under that flag, you can do so, but *I* won't."

"What! you are a deserter, then!" I replied, laughing.

"Yes, I desert false colors when they are too strong," said Lyman; "and *you* will desert them before night," he continued.

I could not spare "Professor Griffin," and was reluctantly compelled to take down the flag. It never saw the light again.[*]

The mermaid was afterwards exhibited in various parts of the country, and finally returned to its owner, Mr. KIMBALL, who has ever since given it a prominent niche in his truly beautiful and attractive "BOSTON MUSEUM." There it will remain until the 31st day of March, 1855. On the 1st of April next, (a most appropriate day,) it will again make its appearance in my AMERICAN MUSEUM, NEW YORK, where it will remain until January 1st, 1856, to the admiration and astonishment, no doubt, of many thousand patrons. On the 2d day of January, 1856, the mysterious lady-fish will again take up her old quarters under the guardianship of her owner, the HON. MOSES KIMBALL, (he having recently been elected to the State Senate, and thus acquired the title,) and from that period the FEJEE MERMAID will be installed as a prominent and interesting *fixture* in the BOSTON MUSEUM.

[*]Lyman afterwards became a prominent Mormon, and removed to Nauvoo, where he died.

That "her ladyship" was an attractive feature, may be inferred from these facts and figures:

The receipts of the American Museum for the four weeks immediately preceding the exhibition of the mermaid, amounted to $1272. During the first four weeks of the mermaid's exhibition, the receipts amounted to $3341.93.*

The New York Museum Company, having failed in selling their stock, let their establishment, known as Peale's Museum, to Yankee Hill. After a management of a few months, he failed. Mr. Henry Bennett then took charge of it, reduced the price to one "York shilling," and endeavored to thrive by burlesquing whatever I produced. Thus, when I exhibited the Fejee Mermaid, he stuck a codfish and monkey together and advertised the *Fudg-ee* Mermaid. When I announced a company of talented vocalists, well known as the "Orphean Family," Bennett advertised the "*Orphan* Family." It was an invention creditable to his genius, and created some laughter at my expense, but it also served to draw attention to my Museum.

After the novelty of Bennett's opposition died away, he did a losing business, and on the 2d of January, 1843, he closed his Museum, having lost his last dollar. The entire collection fell into the hands of the proprietor of the building, on a claim of arrearages of rent amounting to six or eight thousand dollars. I purchased it privately for $7000, cash, hired the building, and secretly engaging Bennett as my agent, we run a spirited opposition. I found profit in the arrangement by attracting public attention, and at the end of six months, the whole establishment, including the splendid Gallery of American Portraits, was transferred to my American Museum.

I do not here intend to disparage Bennett's ability nor to glorify my own. Independently of any thing personal to either of us, I had

*The receipts of the Museum for the three years Immediately preceding my purchase, as compared with the first three years of my administration, were as follows:

1839 Receipts, $11,780	1842 Receipts, $27,912 62			
1840 " 11,169	1843 " 32,623 35			
1841 " 10,862	1844 " 39.893 46			
Aggregate $83,811	Aggregate $100,429 43			

In the year 1853, the receipts amounted to $136,250, being in one year, more than in the six years above quoted. It will of course be understood that the expenses of the Museum increased in a corresponding ratio.

superior advantages; and if the result of the real strife between us had at any time been doubtful, my lucky stars soon put me in possession of a means of overwhelming all opposition.

Being in Albany on business in November, 1842, the Hudson River was frozen tight, and I returned to New York by way of the Housatonic Railroad. I stopped one night in Bridgeport, Ct., my brother, Philo F., keeping the Franklin Hotel at the time.

I had heard of a remarkably small child in Bridgeport; and by my request my brother brought him to the hotel. He was the smallest child I ever saw that could walk alone. He was not two feet in height, and weighed less than sixteen pounds. He was a bright-eyed little fellow, with light hair and ruddy cheeks, was perfectly healthy, and as symmetrical as an Apollo. He was exceedingly bashful, but after some coaxing he was induced to converse with me, and informed me that his name was CHARLES S. STRATTON, son of Sherwood E. Stratton.

He was only five years old, and to exhibit a dwarf of that age might provoke the question, How do you know that he *is* a dwarf? Some license might indeed be taken with the facts, but even with this advantage I really felt that the adventure was nothing more than an experiment, and I engaged him for the short term of *four weeks at three dollars per week* – all charges, including travelling and boarding of himself and mother, being at my expense.

They arrived in New York on Thanksgiving Day, Dec. 8, 1842, and Mrs. Stratton was greatly astonished to find her son heralded in my Museum bills as Gen. TOM THUMB, a dwarf of eleven years of age, just arrived from England!

This announcement contained two deceptions. I shall not attempt to justify them, but may be allowed to plead the circumstances in extenuation. The boy was undoubtedly a dwarf, and I had the most reliable evidence that he had grown little, if any, since he was six months old; but had I announced him as only five years of age, it would have been impossible to excite the interest or awaken the curiosity of the public. The thing I aimed at was, to assure them that he was *really a dwarf* – and in *this*, at least, they were not deceived.

It was of no consequence, in reality, where he was born or where he came from, and if the announcement that he was *a foreigner* answered my purpose, the people had only themselves to blame if they did not get their money's worth when they visited the exhibition. I had observed (and sometimes, as in the case of

Vivalla, had taken advantage of) the American fancy for European exotics; and if the deception, practised for a season in my dwarf experiment, has done any thing towards checking our disgraceful preference for foreigners, I may readily be pardoned for the offence I here acknowledge.

I took great pains to train my diminutive prodigy, devoting many hours to that purpose, by day and by night, and succeeded, because he had native talent and an intense love of the ludicrous. He became very fond of me. I was, and yet am, sincerely attached to him, and I candidly believe him at this moment to be the most interesting and extraordinary natural curiosity of which the world has any knowledge.

Four weeks expired, and I re-engaged him for a year at seven dollars per week, (and a gratuity of fifty dollars at the end of the agreement,) with privilege of exhibition in any section of the United States. His parents were to accompany him, and I was to pay all travelling expenses. Long before the year was out, I voluntarily increased his weekly salary to $25 – and he fairly earned it, for he speedily became a public favorite. I frequently exhibited him for successive weeks in my Museum, and when I wished to introduce fresh novelties there, I sent him to numerous cities and towns in many of the States, accompanied by my friend Fordyce Hitchcock.

In the mean time, I had entirely paid for the American Museum, and entered into an agreement with Gen. TOM THUMB for his services another year, at fifty dollars per week and all expenses, with the privilege of exhibition in Europe.

CHAPTER X

European Tour – Tom Thumb

On Thursday, January 18, 1844, I stepped on board the new and
splendid packet ship *Yorkshire*, Capt. D. G. Bailey, bound for

Liverpool. My party consisted of Gen. Tom Thumb, both his parents, his tutor, Professor Guillaudeu the French naturalist, and myself. The City Brass Band kindly volunteered to escort us to Sandy Hook, and we were accompanied by many of our personal friends.

At half-past one o'clock, the bell of one of the steamers that towed our ship down the bay, announced the hour of separation. There was the usual bustle, the rapidly-spoken yet often-repeated words of farewell, the cordial grip of friendship – and I acknowledge that I was decidedly in "the melting mood."

My name has so long been used in connection with incidents of the mirthful kind, that many persons, probably, do not suspect that I am susceptible of sorrowful emotion, and possibly the general tenor of these pages may confirm the suspicion. No doubt my natural bias is to merriment, and I have encouraged my inclination to "comedy," because enough of "tragedy" will force itself upon the attention of every one in spite of his efforts to the contrary; yet I should be either more or less than human, were I incapable of serious thought, or did I not frequently indulge in the sober meditation which becomes the solemn realities of life.

I do not now refer only to scenes of parting with friends, or of leaving country and home for a few months, or even years, but I speak of the ordinary occasions of experience. I have had, and hope always to have, my seasons of loneliness and even sadness; and, though many people may not see how my profession of "a showman" can be made to appear consistent with my profession of another kind, I must claim having always revered the Christian Religion. I have been indebted to Christianity for the most serene happiness of my life, and I would not part with its consolations for all things else in the world. In all my journeys as "a showman," the Bible has been my companion, and I have repeatedly read it attentively, from beginning to end. Whether I have or have not been profited by its precepts, is a question not here to be considered; but the scriptural doctrine of the government of God and its happy issue in the life to come, has been my chief solace in affliction and sorrow, and I hope always to cherish it as my greatest treasure.

The "melting mood" was upon me, for the pathway of the ship was toward the wide sea with its deep mysteries, and my heart clung to my family and home. I successively grasped for the last time the hand of each parting friend as he passed to the tow-boat, and I could not restrain my emotion; and when the band struck up "Home, Sweet Home!" my tears flowed thick and fast.

The distance between the ship and the steamer rapidly increased. We stood on the quarter-deck, waving our handkerchiefs, and when the strains of "Yankee Doodle" floated over the waters and distinctly saluted us, we all gave three cheers, and I wept freely, overpowered as I was with mingled feelings of regret and joy. At two o'clock the pilot left us, and thus was broken the last visible living link that bound us to our country.

The voyage to Liverpool has so frequently been described in print, that I shall abstain from entering into details. Abundant material is before me, in the first two of a series of one hundred letters which I furnished while in Europe, as correspondent of the New York Atlas, but I shall do no more than transcribe or adopt such facts and adventures as will serve to keep up the chain of my history.

In consequence of calms and some adverse winds, we were nineteen days on the passage. Never was there a better ship nor a more admirable Captain. Only a few of the passengers were called upon for the customary sacrifice to Neptune or the fishes – and, contrary to my expectations, I was one of the party exempted. Good fellowship prevailed, and the time passed with sufficient rapidity, and some jokes.

Our fellow-passengers were chiefly English merchants from Canada. One of the number reckoned himself as A No. 1, and frequently hinted that he was a little too "cute" for any Yankee. He boasted so often of his shrewdness, that a Yankee friend on board and myself resolved to give it a test before we arrived. On the tenth day of our passage, an opportunity offered itself. We were nearly becalmed, and the time hung heavily on our hands. I thought of an old Yankee trick, which I concluded to try on John Bull. So, having contrived the matter with my brother Yankee from New York, I proceeded to put it in execution. Coming out of my state-room in great apparent pain, from an obdurate *tooth*, I asked the steward if there was an instrument in the medicine chest for extracting a painful masticator. Being answered in the negative, I inquired of my fellow-passengers what was good for the toothache. My Yankee friend (and confederate) recommended heating *tobacco*, and holding it to my face. I therefore borrowed a little tobacco, and putting it in a paper of a peculiar color, placed it on the stove to warm. I then retired for a few minutes, during which time the Yankee proposed playing a trick on me by emptying the tobacco, and filling the paper with *ashes*. The passengers liked the joke, and the Englishman

thought it would be very fine, and he at once threw the tobacco in the fire and put ashes in its stead.

I soon appeared, and with much gravity placed the paper to my face, and commenced walking up and down the cabin, the very picture of misery. The passengers found much difficulty in concealing their mirth. In my pocket I had a paper containing *tobacco*, and as that paper was of the same color as the one I held to my face, I contrived to change it while I was at the further end of the cabin. Presently, the merry Englishman cried out:

"Mr. Barnum, what have you got in that paper?"

"Tobacco," I replied.

"What will you bet it is tobacco?" said the Englishman.

"Oh, don't bother me," said I; "my tooth pains me sadly; I know it is tobacco, for I put it there myself."

"I'll bet you a dozen of champagne that it is not tobacco," said the Englishman.

"Nonsense," I replied, "I will not bet, for it would not be fair; I know it is tobacco."

"I'll bet you fifty dollars it is not," said John Bull, and he counted ten sovereigns upon the table.

"I'll not bet the money," I replied, "for I tell you I *know* it is tobacco; I placed it there myself."

"You dare not bet!" he rejoined.

At last, *merely to accommodate him*, I bet a dozen of champagne. The Englishman jumped with delight, and roared out:

"Open the paper! open the paper!"

The passengers crowded round the table in great glee to see me open the paper, for all but the Yankee thought I was taken in. I quietly opened the paper, and remarked:

"There, I told you it was tobacco – how foolish you were to suppose it was not – for *I put it there myself!*"

The passengers looked blank for a moment – it was *but* a moment, and then the laugh turned against the Englishman with redoubled force. I never saw a man look so *foolish* in my life as he did. The biter was bit. He could not speak for five minutes. At last he called to the steward to bring on the champagne, and turning to my fellow-countryman, he remarked, with most chop-fallen disdain, "It was a contemptible Yankee trick!" Several days elapsed before he recovered his good-humor. At last, however, he laughed as heartily at the joke as any of us, but he bragged no more of his extra shrewdness.

On the eighteenth day out, the cry of "Land ho!" brought us to the deck in great glee. The snow-capped mountains of Wales soon appeared in sight, and in three hours we were safely in the Liverpool docks. A large throng of persons were gathered upon the wharves, and many were anxiously inquiring for Tom Thumb, as it had previously been announced in Liverpool that he would arrive in the Yorkshire. His mother managed to smuggle him on shore without being noticed, for they little thought that he was small enough to be carried in arms, like an infant.

Our baggage was taken to the custom-house, and, after paying duties on every thing we could not swear was of English manufacture, we were permitted to depart. We took apartments at the Waterloo Hotel – the best in the city – and after paying some half dozen porters half a crown each for *looking* at our luggage, for not half that number *touched* it, we washed down our indignation with a bottle of port, and dined upon a noble sirloin of English roast beef, accompanied with a rich delicacy known as "fried soles and shrimp sauce."

After discussing dinner, I walked out to take a look at the town. A few squares brought me to the Nelson monument. While admiring its many beauties, a venerable-looking, well-dressed old gentleman, kindly volunteered to explain to me the various devices and inscriptions. His whole soul appeared centred in that pillar raised to perpetuate the fame of a noble and valiant hero. As he went on explaining the many interesting details so elegantly set forth in this great work of art, I found myself becoming singularly attached to him. I had heard much of the coldness and haughty bearing of the English people, and I was rejoiced to be able so soon to testify that they had been seriously slandered.

Here, said I to myself, is one of their own soldiers, no doubt wealthy and respected, who kindly volunteers to come with the most friendly familiarity, and devote an hour to a stranger in pointing out the beauties of a noble pile, which gratifies his and his country's patriotism and pride. I began involuntarily to guess how much he was worth, and at last set down his income at £10,000 per annum. Human nature rose at least a hundred degrees in my estimation as I reflected that an "old English gentleman" could at once be so wealthy and so kind and disinterested. I already expected every moment to be invited to spend a week at his mansion, and to ride about the city in his splendid equipage, and therefore I gave him a parting bow of thanks, half ashamed that I had so long trespassed

on his kindness, when he extended his hand, and in the voice of a mendicant remarked that he would be thankful for any *remuneration* I thought fit to bestow for his trouble!

My pretty vision of all his greatness was annihilated, and thrusting a shilling into his hand, I walked away with a rapid pace, giving an extra pull to the strings of my purse as I slipped it into my pocket. Before I had proceeded five rods my ideas of the magnanimity of human nature fell twenty degrees below *zero*, and I set it down as an established fact, that in England it costs two and sixpence to look at a man, and just a crown to speak to him. It was a first impression merely, and I soon had reason to remember that there are "queer fish" hailing from other than British waters.

Towards evening of the same day, a tall, raw-boned man called on me at the hotel. He introduced himself by saying that he was a brother Yankee, and would be happy in pointing out the many wonders in Liverpool that a *stranger* would be pleased to see.

I asked him how long he had been in Liverpool, and he replied, "*Nearly a week!*" I declined his proffered services abruptly, remarking, that if he had been there only a week, I probably knew as much about England as *he* did.

"Oh," said he, "you are mistaken. I have been in England before, though never till recently in Liverpool."

"What part of England?" I inquired.

"Opposite Niagara Falls," he replied; "I spent several days there with the British soldiers."

I laughed in his face, and reminded him that England did not lie opposite Niagara Falls. The impudent fellow was confused for a moment, and then triumphantly exclaimed:

"I didn't mean *England*. I know what country it is as well as *you* do."

"Well, what country is it?" I asked, quite assured that he did not know.

"Great Britain, of course," said he.

It is needless to add that the honor of his company as a guide in Liverpool was declined, and he went off apparently in a huff because his abilities had not been appreciated.

The preceding interviews may have had some influence in depressing my spirits, by lowering my estimate of human nature, and merriment was not greatly promoted by still another incident of the same day, and later in the evening.

I was called upon by the proprietor of a cheap show of wax-figures

at three ha'pence admission. Having heard of the arrival of the great
American curiosity, he had taken the earliest opportunity to make
proposals for the engagement of the General and myself, at about
ten dollars per week, to add somewhat to the attractions of his
already remarkable exhibition!

I could but laugh at the novelty of the joke, and yet there was
a sadness settling down upon me in the thought that dwarfs were
at rather a low figure in the fancy-stocks of England. Under other
circumstances, the shadow on my path would have speedily passed
away, but a sort of home-sickness had taken hold of me, and the
world began to look very dark. I was a stranger in a strange land.
My letters of introduction had not yet been delivered. Outside the
little circle of my own company, I had not seen a familiar face nor
heard a familiar voice. The crowded streets of Liverpool were grad-
ually deserted as the veil of night was being drawn over the earth.
I felt all alone, and, at the risk of being laughed at, I must acknowl-
edge that I had a solitary hearty crying-spell! My dreams that night
were of "Home, sweet Home."

There was a gleam of sunshine next morning. It was in the
following note;

> "Madame CELESTE presents her compliments to Mr. Barnum, and
> begs to say that her private box is quite at his service, any night, for
> himself and friends.
>
> "Theatre Royal, Williamson Square."

This polite invitation was thankfully accepted on the evening
of its reception. In the box adjoining that of Celeste (occupied by
my party, including the General, who was partly concealed by his
tutor's cloak) sat an English lady and gentleman whose appearance
indicated the respectability of both intelligence and wealth. The
General's interest in the performance attracted their attention, and
the lady remarked to me:

"What an intelligent-looking child you have! He appears to
take quite an interest in the stage."

"Pardon me, madam," said I, "this is not a child. This is
General Tom Thumb."

"Indeed!" exclaimed both the lady and the gentleman in a
breath. They had seen the announcements of our visit, which had
largely preceded us, and what they had heard of the pigmy-prodigy
was more than confirmed by what they saw. The reality of their

gratification could not be questioned, for they immediately advised me, in the most complimentary and urgent terms, to bring the General to Manchester, (where they resided,) with the assurance that his exhibition in that place would be highly profitable.

Here, thought I, is a fair offset to the depressing proposal of the wax-figure man; these respectable people know how to appreciate a curiosity. It is not remarkable, therefore, that I forthwith had pleasing visions of prosperity among the Cotton Lords of Manchester.

I thanked my new friends for their counsel and encouragement, and ventured to ask them what price they would recommend me to charge for admission.

"The General is so decidedly a curiosity," said the lady, "that I think you might put it as high as tup-pence" (two-pence).

She was, however, promptly interrupted by her husband, who was evidently the economist of the family. "I am sure you would not succeed at that price," said he; "you should put admission at *one penny*, for that is the usual price for seeing giants and dwarfs in England."

Worse, and more of it! "What a fall was there, my countrymen!" But the reaction promptly brought me to my feet; the old spirit was awakened; I was myself again; and I answered, "Never shall the price be less than one shilling sterling, and some of the nobility and gentry of England will yet pay gold to see General Tom Thumb!"

It had been my intention to proceed directly to London and begin operations at "head-quarters" – that is, at the Palace, if possible. But I learned that the royal family was in mourning because of the death of Prince Albert's father, and would not permit the approach of entertainments. My letters of introduction speedily brought me into relations of friendship with many excellent families, and I was induced to hire a hall and present the General to the public in Liverpool for a short time.

Meanwhile I had confidential advices from London that Mr. Maddox, Manager of Princess's Theatre, was coming down to witness my exhibition, with a view to making an engagement. He came privately, but I was "posted up" as to his presence and object. A friend pointed him out to me in the hall, and when I stepped up to him, and called him by name, he was "taken all a-back," and avowed his purpose in visiting Liverpool. An interview resulted in an engagement of the General for three nights at Princess's Theatre.

I was unwilling to contract for a longer period, and even this short engagement, though on liberal terms, was acceded to only as a means of advertisement.

The General made so decided a "hit" at Princess's Theatre, that it might have been difficult to decide *which* party was the best pleased, the spectators, the manager, or myself. The first were pleased because they could not help it; the second was pleased because he had coined money by the operation; and *I* was pleased because I had a visible guarantee of success in London. I was offered a much higher figure for a re-engagement, but my purpose had been sufficiently answered. The news was out that General Tom Thumb was on the tapis, as an unparalleled curiosity, and it only remained for me to bring him before the public, "on my own hook," in my own time and way.

I had taken a furnished house in Grafton street, Bond street, West End, in the centre of fashion. Lord Brougham, and half a dozen families of the blood-aristocracy and many of the gentry, were my neighbors. The house had been occupied by Lord Talbot for several years previously. From this magnificent mansion, I sent letters of invitation to the editors and several of the nobility, to visit the General. Most of them called, and were highly gratified. The word of approval was indeed so passed around in high circles, that uninvited parties drove to my door in crested carriages, *and were not admitted.*

This procedure, though in some measure a stroke of policy, was not either singular or hazardous, under the circumstances. I had not yet announced a public exhibition, and as a private American gentleman it became me to maintain the dignity of my position. I therefore instructed my servant, dressed in the tinselled and powdered style of England, to deny admission to my mansion to see my "ward," excepting to persons who brought cards of invitation. He did it in a proper manner, and no offence could be taken – though I was always particular to send an invitation immediately to such as had not been admitted.

During our first week in London, Mr. Everett, the American Minister, to whom I had letters of introduction, called and was highly pleased with his diminutive though renowned countryman. We dined with him the next day, by invitation, and his family loaded the young American with presents. Mr. Everett kindly promised to use influence at the Palace in person, with a view to having Tom Thumb introduced to Her Majesty Queen Victoria.

A few evenings afterwards the Baroness Rothschild sent her carriage for us. Her mansion is a noble structure in Piccadilly, surrounded by a high wall, through the gate of which our carriage was driven and brought up in front of the main entrance. Here we were received by half a dozen servants elegantly dressed in black coats and pantaloons, white vests and cravats, white kid gloves, and, in fact, wearing the *tout ensemble* of gentlemen. One old chap was dressed in livery – a heavy laced coat, breeches, a large, white powdered and curled wig, and every thing else to match. The hall was brilliantly illuminated, and each side was graced with the most beautiful statuary. We were ushered up a broad flight of marble stairs, and our names announced at the door of the drawing-room by an elegantly-dressed servant, who under other circumstances I might have supposed was a member of the noble family.

As we entered the drawing-room, a glare of magnificence met my sight which it is impossible for me to describe. The Baroness was seated on a gorgeous couch covered with rich figured silk damask, (there were several similar couches in the room,) and several lords and ladies were seated in chairs elegantly carved and covered with gold, looking indeed like solid gold, except the bottoms, which were rich velvet. On each side of the mantlepiece were specimens of marble statuary – on the right of which stood glazed cabinets containing urns, vases, and a thousand other things of the most exquisite workmanship, made of gold, silver, diamonds, alabaster, pearl, etc. The centre table, and several tables about the size and something like the shape of a pianoforte, all covered with gold, or made of ebony thickly inlaid with pearls of various hues, were loaded with *bijous* of every kind, surpassing in elegance any thing I had ever dreamed of. The chairs at one end of the room were made of ebony, inlaid with pearl and gold, elegantly cushioned with damask. The walls were panelled and heavily gilt – the curtains and ornaments of the most costly kind. The immense chandeliers, candelabras, etc., exceeded all my powers of description; and I confess my total inability to give a correct idea of the splendor in which lived the wife of the most wealthy banker in the world.

Here we spent about two hours. About twenty lords and ladies were present. On taking our leave, an elegant and well-filled purse was quietly slipped into my hand, and I felt that the golden shower was beginning to fall!

It could not be a delusion, for precisely the same trick was

played upon me shortly afterwards, at the mansion of Mr. Drummond, another eminent banker.

I now engaged the "Egyptian Hall," in Piccadilly, and the announcement of my unique exhibition was promptly answered by a rush of visitors, in which the wealth and fashion of London were liberally represented.

I made these arrangements because I had little hope of being soon brought to the Queen's presence, (for the reason before mentioned,) but Mr. Everett's generous influence secured my object. I breakfasted at his house one morning, by invitation, in company with Mr. Charles Murray, an author of creditable repute, who held the office of Master of the Queen's Household.

In the course of conversation, Mr. Murray inquired as to my plans, and I informed him that I intended going to the Continent shortly, though I should be glad to remain if the General could have an interview with the Queen – adding that such an event would be of great consequence to me.

Mr. Murray kindly offered his good offices in the case, and soon afterwards one of the Life Guards, a tall noble-looking fellow, bedecked as became his station, brought me a note, conveying the Queen's invitation to General Tom Thumb and his guardian, Mr. Barnum, to appear at Buckingham Palace on an evening specified. Special instructions were the same day orally given me by Mr. Murray, by Her Majesty's command, to suffer the General to appear before her, as he would appear anywhere else, without any training in the use of the titles of royalty, as the Queen desired to see him act naturally and without restraint.

Determined to make the most of the occasion, I put a placard on the door of the Egyptian Hall: "Closed this evening, General Tom Thumb being at Buckingham Palace by command of Her Majesty."

On arriving at the Palace, the Lord in Waiting put me "under drill" as to the manner and form in which I should conduct myself in the presence of royalty. I was to answer all questions by Her Majesty through *him*, and in no event to speak directly to the Queen. In leaving the royal presence I was to "back out," keeping my face always towards Her Majesty, and the illustrious Lord kindly gave me a specimen of that sort of backward locomotion. How far I profited by his instructions and example, will presently appear.

We were conducted through a long corridor to a broad flight of marble steps, which led to the Queen's magnificent picture

gallery, where Her Majesty and Prince Albert, the Duchess of Kent, and twenty on thirty of the nobility, were awaiting our arrival. They were standing at the farther end of the room when the doors were thrown open, and the General toddled in, looking like a wax-doll gifted with the power of locomotion. Surprise and pleasure were depicted on the countenances of the royal circle, at beholding this *mite* of humanity so much smaller than they had evidently expected to find him.

The General advanced with a firm step, and as he came within hailing distance made a very graceful bow, and exclaimed, "Good evening, *Ladies and Gentlemen!*"

A burst of laughter followed this salutation. The Queen then took him by the hand, led him about the gallery, and asked him many questions, the answers to which kept the party in an unintermitted strain of merriment. The General familiarly informed the Queen that her picture gallery was "first-rate," and told her he should like to see the Prince of Wales. The Queen replied that the Prince had retired to rest, but that he should see him on some future occasion. The General then gave his songs, dances, imitations, etc., and after a conversation with Prince Albert and all present, which continued for more than an hour, we were permitted to depart.

Before describing the process and incidents of "backing out," I must acknowledge how sadly I broke through the counsel of the Lord in Waiting. While Prince Albert and others were engaged with Tom, the Queen was gathering information from *me* in regard to his history, etc. Two or three questions were put and answered through the process indicated in my drill. It was a round-about way of doing business not at all to my liking, and I suppose the Lord in Waiting was seriously shocked, if not outraged, when I entered directly into conversation with Her Majesty. She, however, seemed not disposed to check my boldness, for she immediately spoke directly to me in obtaining the information which she sought. I felt entirely at ease in her presence, and could not avoid contrasting her sensible and amiable manners with the stiffness and formality of upstart gentility at home or abroad.

The Queen was modestly attired in plain black, and wore no ornaments. Indeed, surrounded as she was by ladies arrayed in the highest style of magnificence, their dresses sparkling with diamonds, a stranger would have selected her as the last person in the circle who could have been the Queen of England.

The Lord in Waiting was perhaps mollified toward me when

he saw me following his illustrious example in retiring from the royal presence. He was accustomed to the process, and therefore was able to keep somewhat a-head (or rather a-back) of me, but even *I* stepped rather fast for the other member of the retiring party. We had a considerable distance to travel in that long gallery before reaching the door, and whenever the General found he was losing ground, he turned around and ran a few steps, then resumed the position of "backing out," then turned around and ran, and so continued to alternate his methods of getting to the door, until the gallery fairly rang with the merriment of the royal spectators. It was really one of the richest scenes I ever saw, especially the concluding section. Running, under the circumstances, was an offence sufficiently heinous to excite the indignation of the Queen's favorite poodle-dog, and he vented his displeasure by barking so sharply as to startle the General from his propriety. He however recovered immediately, and with his little cane commenced an attack on the poodle, and a funny fight ensued, which renewed and increased the merriment of the royal party.

This was near the door of exit. We had scarcely passed into the ante-room, when one of the Queen's attendants came to us with the expressed hope of Her Majesty, that the General had sustained no damage – to which the Lord in Waiting playfully added, that in case of injury to so renowned a personage, he should fear a declaration of war by the United States!

The courtesies of the Palace were not yet exhausted, for we were escorted to an apartment in which refreshments had been provided for us. We did ample justice to the viands, though my mind was rather looking into the future than enjoying the present. I was anxious that the "Court Journal" of the ensuing day should contain more than a mere line in relation to the General's interview with the Queen, and, on inquiry, I learned that the gentleman who had charge of that portion of the daily papers was then in the Palace. He was sent for by my solicitation, and promptly acceded to my request for such a notice as would attract attention. He even generously desired me to give him an outline of what I sought, and I was pleased to see, afterwards, that he had inserted my notice *verbatim*.

This increased attraction required me to obtain a more commodious hall for my exhibition. I accordingly removed to the larger room in the same building, for some time previously occupied by our countryman, Mr. Catlin, for his great Gallery of Portraits of

American Indians and Indian Curiosities, all of which remained as an adornment.

On our second visit to the Queen, we were received in what is called the "Yellow Drawing Room," a magnificent apartment, surpassing in splendor and gorgeousness any thing of the kind I had ever seen. It is on the north side of the gallery, and is entered from that apartment. It was hung with drapery of rich yellow satin damask, the couches, sofas and chairs being covered with the same material. The vases, urns and ornaments were all of modern patterns, and the most exquisite workmanship. The room was panelled in gold, and the heavy cornices beautifully carved and gilt. The tables, pianos, etc., were mounted with gold, inlaid with pearl of various hues, and of the most elegant devices.

We were ushered into this gorgeous drawing-room before the Queen and royal circle had left the dining-room, and, as they approached, the General bowed respectfully, and remarked to Her Majesty that "he had seen her before," adding, "I think this is a prettier room than the picture gallery; that chandelier is very fine."

The Queen smilingly took him by the hand, and said she hoped he was very well.

"Yes, ma'am," he replied, "I am first-rate."

"General," continued the Queen, "this is the Prince of Wales."

"How are you, Prince?" said the General, shaking him by the hand; and then standing beside the Prince, he remarked, "The Prince is taller than I am, but I *feel* as big as any body" – upon which he strutted up and down the room as proud as a peacock, amid shouts of laughter from all present.

The Queen then introduced the Princess Royal, and the General immediately led her to his elegant little sofa, which we took with us, and with much politeness sat himself down beside her. Shortly rising from his seat, he went through his various performances as before, and the Queen handed him an elegant and costly souvenir, which had been expressly made for him by her order – for which, he told her, "he was very much obliged, and would keep it as long as he lived."

The Queen of the Belgians (daughter of Louis Philippe) was present on this occasion. She asked the General where he was going when he left London?

"To Paris," he replied.

"Whom do you expect to see there?" she continued.

Of course all expected he would answer, "The King of the French," but the little fellow replied:

"I shall see Monsieur Guillaudeu in Paris."

The two Queens looked inquiringly to me, and when I informed them that Mons. G. was my French naturalist, who had preceded me to Paris, they laughed most heartily.

On our third visit to Buckingham Palace, Leopold, King of the Belgians, was also present. He was highly pleased, and asked a multitude of questions. Queen Victoria desired the General to sing a song, and asked him what song he preferred to sing.

"Yankee Doodle," was the prompt reply.

This answer was as unexpected to me as it was to the royal party. When the merriment it occasioned somewhat subsided, the Queen good-humoredly remarked, "That is a very pretty song, General. Sing it, if you please." The General complied, and soon afterwards we retired.

I ought to add, that after each of our three visits to Buckingham Palace, a handsome *douceur* was sent to me, of course by the Queen's command. This, however, was the smallest part of the advantage derived from these interviews, as will be at once apparent to all who consider the force of Court example in England.

The British public were now fairly excited. Not to have seen General Tom Thumb was voted to be decidedly unfashionable, and from the 20th of March until the 20th of July the levees of the little General at Egyptian Hall were continually crowded – the receipts averaging during the whole period about $500 per day, sometimes going considerably beyond that sum. At the fashionable hour, between fifty and sixty carriages of the nobility have been counted at one time standing in front of our exhibition rooms in Piccadilly.

Portraits of the little General were published in all the pictorial papers of the time. Polkas and quadrilles were named after him, and songs were sung in his praise. He was an almost constant theme for the "London Punch," which served the General and myself up so daintily that it no doubt added vastly to our receipts.

The expenses of the hall were only £44 per month, and our family expenses (as we now kept house) averaged but one pound per week each. Altogether I reckon our entire disbursements, including printing, and every thing appertaining to the exhibition, at $50 per day.

Besides his three public performances per day, the little General attended from three to four private parties per week, for which we were paid eight to ten guineas each. Frequently we would

visit two parties in the same evening, and the demand in that line was much greater than the supply.

The Queen Dowager Adelaide requested the General's attendance at Marlborough House one afternoon. He went in his court dress, consisting of richly embroidered brown silk-velvet coat and short breeches, white satin vest with fancy-colored embroidery, white silk stockings and pumps, wig, bag-wig, cocked hat, and a dress sword.

"Why, General," said the Dowager Queen, "I think you look very smart to-day."

"I guess I do," said the General complacently.

A large party of the nobility were present. The old Duke of Cambridge offered the little General a pinch of snuff, which he declined.

The General sang his songs, performed his dances, and cracked his jokes, to the great amusement and delight of the distinguished circle of visitors.

"Dear little General," said the kind-hearted Queen, taking him upon her lap, "I see you have got no watch. Will you permit me to present you with a watch and chain?"

"I would like it very much," replied the General, his eyes glistening with joy as he spoke.

"I will have them made expressly for you," responded the Queen Dowager; and at the same moment she called Lord H—, her friend, and desired him to see that the proper order was executed. A few weeks thereafter we were called again to Marlborough House.

A number of the children of the nobility were present, as well as some of their parents. After passing a few compliments with the General, Queen Adelaide presented him with a beautiful little gold watch, placing the chain around his neck with her own hands. The little fellow was delighted, and scarcely knew how sufficiently to express his thanks. The good Queen gave him some excellent advice in regard to his morals, which he strictly promised to obey. Indeed, I am happy to say in this place that I never knew the General to utter a profane or vulgar word in his life. His morals in all respects are unobjectionable, and his disposition is most amiable.

After giving his performances, we withdrew from the royal presence, and the elegant little watch presented by the hands of Her Majesty the Queen Dowager was not only duly heralded, but was also placed upon a pedestal in the hall of exhibition, together with the present from Queen Victoria, and covered with a glass

vase. These presents, to which were soon added an elegant gold snuffbox mounted with turquoise, presented by his Grace the Duke of Devonshire, and many other costly gifts of the nobility and gentry, added greatly to the attractions of the exhibition. The Duke of Wellington called frequently to see the little General at his public levees. The first time he called, the General was personating Napoleon Bonaparte, marching up and down the platform, and apparently taking snuff in deep meditation. He was dressed in full military uniform. I introduced him to the "Iron Duke," who inquired the subject of his meditations. "I was thinking of the loss of the battle of Waterloo," was the little General's immediate reply. That brilliant display of wit was chronicled through the country, and was of itself worth thousands of pounds to the exhibition.

While we were in London in June, 1844, the Emperor of Russia visited Queen Victoria. I saw him on several public occasions.

I was present on the 5th of June at a grand review of the Queen's troops in Windsor Park, in honor and in presence of the Emperor of Russia and the King of Saxony. General Tom Thumb had visited the latter royal personage, as well as Ibrahim Pacha, the week previous.

The way to Windsor presented an almost uninterrupted line of vehicles and pedestrians, reminding me of the Epsom road on the Derby day, which races I attended, but have not room to describe. The Queen and her illustrious visitors arrived at the great Windsor Park about twelve o'clock. The approach of the royal *cortège* from the Great Walk was intimated by the shouts of hundreds of spectators. In one of the carriages were the Prince of Wales and the Royal Princesses. The Emperor of Russia preceded the Queen's carriage on horseback, with Prince Albert (who wore his field-marshal's uniform) on the left, and the King of Saxony on his right. The Emperor's dress was a Russian uniform, the color dark green, and a black helmet with white feathers. The Duke of Wellington rode immediately behind the Emperor, surrounded by noblemen and officers in uniform. Sir Robert Peel rode amongst them, and his usual blue frock-coat and buff waistcoat contrasted strikingly with the splendid dresses around him. The Duke of Cambridge rode near the Emperor.

At the various parties which we attended, we met, in the course of the season, nearly all of the nobility. That a single member of the nobility failed to see General Tom Thumb either at their own

houses, the house of a friend, or at his public levees at Egyptian Hall, I do not believe.

With some of the first personages in the land he was a great pet. Among these may be mentioned Sir Robert and Lady Peel, the Duke and Duchess of Buckingham, Duke of Bedford, Duke of Devonshire, Count d'Orsay, Lady Blessington, Daniel O'Connell, Lord Adolphus Fitzclarence, Lord Chesterfield, Mr. and Mrs. Joshua Bates, of the firm of Baring Brothers & Co., etc., etc.

We had the free entrée to all the theatres, public gardens, and places of entertainment, and frequently met the principal artists, editors, poets, and authors of the country.

Albert Smith was and is a particular friend of mine. He wrote a play for the General called "Hop o' my Thumb," which he played with great success at the Lyceum Theatre, London, and in several of the provincial theatres. We were absent from America over three years, and visited nearly every town in England and Scotland, besides Belfast and Dublin, in Ireland.* In Dublin our receipts on the last day, after having exhibited the previous week in the great Rotunda Hall, were £261, or $1305. Besides that, we received £50, or $250, for playing the same evening at the Theatre Royal. We also visited nearly every town in France, and Brussels and several other towns in Belgium, at which latter city we appeared before King Leopold and the Queen at their palace.

In France we visited King Louis Philippe and the royal family on four different occasions, besides attending at the Palace of the Tuileries by invitation, for our own amusement, to witness the fireworks, etc., on the King's birth-day. Louis Philippe and the Queen, as also the King's sister, Princess Adelaide, were unusually partial and friendly to the General, and gave him numerous valuable presents, as also did the Duchess d'Orleans and other members of the royal family. Louis Philippe conversed with me quite freely regarding America, told me he had slept in the wigwams of several tribes of Indians, and the whole family conversed as freely and were as void from ceremony as any well-bred family

On the last occasion of our visiting this excellent family, which was at the Palace of St. Cloud, five miles from Paris, I saw a sight which gladdened my eyes, and which might afford a good lesson to the English nobility, as well as our American aristocracy.

*I had several times met Daniel O'Connell in private life, but here I heard him give a most powerful and eloquent "Repeal" speech in Conciliation Hall.

The little General spent an hour with the royal family, which on that evening included not only the King and Queen and Princess Adelaide, but also the Duchess d'Orleans and her son the Count de Paris, Prince de Joinville, Duke and Duchess de Nemours, the Duchess d'Aumale, etc. They each gave him a present at parting, and almost smothering him with kisses bade him a "bon voyage," and wished him a long and happy life. On that *only* occasion in France (and that by particular request of the King) did the General represent Napoleon Bonaparte in full costume. After bidding the royal party adieu, we retired to another portion of the palace to make a change of the General's costume, and partake of some refreshments which were prepared for us. Half an hour afterwards, as we were about leaving the palace, we went through a hall leading to the front door, and in doing so passed the sitting-room in which the royal family were spending the evening. The door was open, and some of them happening to espy the General, called out for him to come in and shake hands with them once more. We entered the apartment, and there found the royal ladies sitting around a square table, each provided with two candles, and every one of them, including the Queen, was engaged in working at embroidery, while a young lady was reading aloud for their edification. I am sorry to say, I believe this is a sight seldom seen in families of the aristocracy on either side of the water. At the church fairs in Paris, I had frequently seen pieces of embroidery for sale, which were labelled as having been presented and worked by the Duchess d'Orleans, Princess Adelaide, Duchess de Nemours, etc.

In Paris the General made a great hit as an actor. He performed for two months at one of the leading theatres, in a French play, written expressly for him, entitled "Petit Poucet."[*]

From Paris we made the tour of France. For this purpose we purchased several travelling carriages, including one covered wagon on springs, which carried the little General's small Shetland ponies and miniature carriage. We went first to Rouen, and from thence to Toulon, visiting all the intermediate towns, including Orleans, Nantes, Brest, Bordeaux, Toulouse, Montpellier, Nismes, Marseilles, etc., thence branching off to Lille, and crossing into Belgium.

While at Bordeaux, I witnessed a review by the Dukes de Nemours and d'Aumale, of twenty thousand troops which were encamped within a few miles of the city. The evolutions of horse

[*]The General was elected a member of the French Dramatic Society.

and foot, and a regiment of flying artillery, were very perfect and highly interesting.

We were in the south of France in the vintage season. Nothing can well surpass the richness of that country at that time of the year. We travelled for many miles where the eye could see nothing but the beautiful vineyards loaded with luscious grapes and groves of olive trees in full bearing. It is strictly a country of wine and oil.

While I was in Brussels I could do no less than visit the battle-field of Waterloo. I proposed that our party should be composed of Professor Pinte, (our interpreter,) Mr. Stratton, father of Gen. Tom Thumb, Mr. H. G. Sherman, and myself. Going a sight-seeing was quite a new business to Stratton, and as it was necessary to start by four o'clock in the morning in order to accomplish the distance, (sixteen miles,) and return in time for our afternoon performance, he demurred. "I don't want to get up before daylight and go off on a journey for the sake of seeing a darned old field of wheat," said Stratton. "Sherwood, do try to be like somebody once in your life, and go," said his wife. The appeal was irresistible, and he consented. We engaged a coach and horses the night previous, and started punctually at the hour appointed. We stopped at the neat little church in the village of Waterloo for the purpose of examining the tablets erected to the memory of some of the English who fell in the contest. Thence we passed to the house in which the leg of Lord Uxbridge (Marquis of Anglesey) was amputated. A neat little monument in the garden designates the spot where the shattered member had been interred. In the house is shown a part of the boot which is said to have once covered the unlucky leg. The visitor feels it but considerate to hand a franc or two to the female who exhibits the monument and limb. I did so, and Stratton, though he felt that he had not received the worth of his money, still did not like to be considered penurious, so he handed over a piece of silver coin to the attendant. I expressed a desire to have a small piece of the boot to exhibit in my Museum; the lady cut off, without hesitation, a slip three inches long by one in width. I handed her a couple more francs, and Stratton desiring, as he said, to "show a piece of the boot in old Bridgeport," received a similar slip and paid a similar amount. I could not help thinking that if the lady was thus liberal in dispensing pieces of the "identical boot" to all visitors, this must have been about the 99,867th boot that had been cut up as the "Simon pure" since 1815.

With the consoling reflection that the female purchased all

the cast-off boots in Brussels and its vicinity, and rejoicing that somebody was making a trifle out of that accident besides the inventor of the celebrated "Anglesey leg," we passed on towards the battlefield, lying about a mile distant.

Arriving at Mont Saint Jean, a quarter of a mile from the ground, we were beset by some eighteen or twenty persons who offered their services, as guides to indicate the most important localities. Each applicant professed to know the exact spot where every man had been placed who had taken part in the battle, and each of course claimed to have been engaged in that sanguinary contest, although it had occurred thirty years before, and some of these fellows were only, it seemed, from twenty-five to twenty-eight years of age! We accepted an old man who, at first, declared that he was killed in the battle, but perceiving our looks of incredulity, consented to modify his statement so far as to assert that he was horribly wounded and lay upon the ground three days before receiving assistance.

Once upon the ground, our guide with much gravity pointed out the place where the Duke of Wellington took his station during a great part of the action; the locality where the reserve of the British army was stationed; the spot where Napoleon posted his favorite guard; the little mound on which was erected a temporary observatory for his use during the battle; the portion of the field at which Blucher entered with the Prussian army; the precise location of the Scotch Greys; the spot where fell Sir Alexander Gordon, Lieut. Col. Canning, and many others of celebrity. I asked him if he could tell me where Captain Tippitiwichet of the Connecticut Fusileers was killed. "*Oui, Monsieur*," he replied, with perfect confidence, for he felt bound to know, or to pretend to know, every particular. He then proceeded to point out exactly the spot where my unfortunate Connecticut friend had breathed his last. After indicating the locations where some twenty of my other fictitious friends from Coney Island, New Jersey, Cape Cod and Saratoga Springs, had given up the ghost, we handed him his commission and declined to give him further trouble. Stratton grumbled at the imposition as he handed out a couple of francs for the information received.

Upon quitting the battle-field we were accosted by a dozen persons of both sexes with baskets on their arms or bags in their hands, containing relics of the battle, for sale. These consisted of a great variety of implements of war, pistols, bullets etc., besides brass French eagles, buttons, etc. I purchased a number of them for the

Museum, and Stratton was equally liberal in obtaining a supply for his friends in "Old Bridgeport." Then we purchased maps of the battle-ground, pictures of the triumphal mound surmounted by the colossal Belgic Lion in bronze, etc., etc. These frequent and renewed taxations annoyed Stratton very much, and as he handed out a five franc piece for a "complete guide-book," he remarked, that "he guessed the battle of Waterloo had cost a darned sight more since it was fought than it did before!"

But his misfortunes did not terminate here. When we had proceeded four or five miles upon our road home, crash went the carriage. We alighted, and found that the axle-tree was broken. It was now a quarter past one o'clock. The little General's exhibition was advertised to commence in Brussels at two o'clock, and could not take place without us. We were unable to walk the distance in double the time required, and as no carriage was to be got in that part of the country, I concluded to take the matter easy, and forego all idea of exhibiting before evening. Stratton however could not bear the thought of losing the chance of taking in six or eight hundred francs, and he determined to take matters in hand, in order, if possible, to get our party into Brussels in time to save the afternoon exhibition. He hastened to a farm-house accompanied by the interpreter Professor Pinte, Sherman and myself leisurely bringing up the rear. Stratton asked the old farmer if he had a carriage. He had not. "Have you no vehicle?" he inquired.

"Yes, I have *that* vehicle," he replied, pointing to an old cart filled with manure, and standing in his barn-yard.

"Thunder! is that all the conveyance you have got?" asked Stratton. Being assured that it was, Stratton concluded that it was better to ride in a manure cart than not get to Brussels in time.

"What will you ask to drive us to Brussels in three-quarters of an hour?" demanded Stratton.

"It is impossible," replied the farmer; "I should want two hours for my horse to do it in."

"But ours is a very pressing case, and if we are not there in time we lose more than five hundred francs," said Stratton.

The old farmer pricked up his ears at this, and agreed to get us to Brussels in an hour, for eighty francs. Stratton tried to beat him down, but it was of no use.

"Oh, go it, Stratton," said Sherman; "eighty francs you know is only sixteen dollars, and you will probably save a hundred by it, for I expect a full house at our afternoon exhibition to-day."

But I have already spent about ten dollars for nonsense," said Stratton, "and we shall have to pay for the broken carriage besides."

"But what *can* you do better?" chimed in Professor Pinte.

"It is an outrageous extortion to charge sixteen dollars for an old horse and cart to go ten miles. Why, in old Bridgeport I could get it done for three dollars," replied Stratton in a tone of vexation.

"It is the custom of the country," said Professor Pinte, "and we must submit to it."

By the way, that was a favorite expression of the Professor's. Whenever we were imposed upon, or felt that we were not used right, Pinte would always endeavor to smooth it over by informing us it was "the custom of the country."

"Well, it's a thundering mean custom, any how," said Stratton, "and I won't stand such an imposition."

"But what shall we do?" earnestly inquired Mr. Pinte. "It may be a high price, but it is better to pay that than, to lose our afternoon performance and five or six hundred francs."

This appeal to the pocket touched Stratton's feelings; so submitting to the extortion, he replied to our interpreter, "Well, tell the old robber to dump his dung-cart as soon as possible, or we shall lose half an hour in starting."

The cart was "dumped," and a large lazy-looking Flemish horse was attached to it with a rope harness. Some boards were laid across the cart for seats, the party tumbled into the rustic vehicle, a red-haired boy, son of the old farmer, mounted the horse, and Stratton gave orders to "get along." "Wait a moment," said the farmer, "you have not paid me yet." "I'll pay your boy when we get to Brussels, provided he gets there within the hour," replied Stratton.

"Oh, he is sure to get there in an hour," said the farmer, "but I can't let him go unless you pay me in advance." The minutes were flying rapidly, the anticipated loss of the day exhibition of General Tom Thumb flitted before his eyes, and Stratton, in very desperation, thrust his hand into his pocket and drew forth sixteen five-franc pieces, which he dropped, one at a time, into the hand of the farmer, and then called out to the boy, "There now, do try to see if you can go ahead."

The boy did go ahead, but it was with such a snail's pace that it would have puzzled a man of tolerable eyesight to have determined whether the horse was moving or standing still. To make it still more interesting, it commenced raining furiously. As we had left Brussels in a coach, and the morning had promised us a pleasant

day, we had omitted our umbrellas. We were soon soaked to the skin. We grinned and bore it awhile without grumbling. At length Stratton, who was almost too angry to speak, desired Mr. Pinte to ask the red-haired boy if he expected to *walk* his horse all the way to Brussels.

"Certainly," replied the boy; "he is too big and fat to do any thing but walk. We never trot him."

Stratton was terrified as he thought of the loss of the day exhibition; and he cursed the boy, the cart, the rain, the luck, and even the battle of Waterloo itself. But it was all of no use, the horse would not run, but the rain would – down our backs.

At two o'clock, the time appointed for our exhibition, we were yet some seven miles from Brussels. The horse walked slowly and philosophically through the pitiless storm, the steam majestically rising from the old manure-cart, to the no small disturbance of our unfortunate olfactories. "It will take two hours to get to Brussels at this rate," growled Stratton. "Oh, no," replied the boy, "it will only take about two hours from the time we started."

"But your father agreed to get us there in an hour," answered Stratton.

"I know it," responded the boy, "but he knew it would take more than two."

"I'll sue him for damage, by thunder," said Stratton.

"Oh, there would be no use in that," chimed in Mr. Pinte, "for you could get no satisfaction in this country."

"But I shall lose more than a hundred dollars by being two hours instead of one," said Stratton.

"They care nothing about that; all they care for is your eighty francs," remarked Pinte.

"But they have lied and swindled me," replied Stratton.

"Oh, you must not mind that, it is the custom of the country."

Stratton gave "the country," and its "customs," another cursing.

All things will finally have an end, and our party did at length actually arrive in Brussels, cart and all, in precisely two hours and a half from the time we left the farmer's house. Of course we were too late to exhibit the little General. Hundreds of visitors had gone away disappointed.

With feelings of utter desperation, Stratton started for a barber's shop. He had a fine, black, bushy head of hair, of which he was a little proud, and every morning he submitted it to the

curling-tongs of the barber. His hair had not been cut for several weeks, and after being shaved, he desired the barber to trim his flowing locks a little. The barber clipped off the ends of the hair, and asked Stratton if that was sufficient. "No," he replied, "I want it trimmed a little shorter; cut away, and I will tell you when to stop."

Stratton had risen from bed at an unusual hour, and after having passed through the troubles and excitements of the unlucky morning, he began to feel a little drowsy. This feeling was augmented by the soothing sensations of the tonsorial process, and while the barber quietly pursued his avocation, Stratton as quietly fell asleep. The barber went entirely over his head, cutting off a couple of inches of hair with every clip of his scissors. He then rested for a moment, expecting his customer would tell him that it was sufficient; but the unconscious Stratton uttered not a word, and the barber thinking he had not cut the hair close enough, went over the head again. Again did he wait for an answer, little thinking that his patron was asleep. Remembering that Stratton had told him to "cut away, and he would tell him when to stop," the innocent barber went over the head the third time, cutting the hair nearly as close as if he had shaved it with a razor! Having finished, he again waited for orders from his customer, but he uttered not a word. The barber was surprised, and that surprise was increased when he heard a noise which seemed very like a *snore* coming from the nasal organ of his unconscious victim. The poor barber saw the error that he had committed, and in dismay, as if by mistake, he hit Stratton on the side of the head with his scissors, and woke him. He started to his feet, looked in the glass, and to his utter horror saw that he was unfit to appear in public without a wig! He swore like a trooper, but he could not swear the hair back on to his head, and putting on his hat, which dropped loosely over his eyes, he started for the hotel. His despair and indignation were so great that it was some time before he could give utterance to words of explanation. His feelings were not allayed by the deafening burst of laughter which ensued. He said it was the first time that he ever went a sight-seeing, and he guessed it would be the last!

As an evidence of how little interest Stratton usually feels in public events, I will mention that in the months of May and June, 1843, he spent six weeks in Boston, the General being exhibited at that time at Kimball's Museum. Stratton had nothing to do but stroll about and see the city if he desired it, but he did not. He was

there on the 17th June, on which occasion President Tyler and Cabinet attended. Thousands of persons went hundreds of miles to attend that celebration, to listen to the speech of Mr. Webster, and to see the monument. Stratton remained in the hotel wholly unemployed, and he has never seen Bunker Hill Monument yet!

Several months subsequent to our visit to Waterloo, I was in Birmingham, and there made the acquaintance of a firm who manufactured to order, and sent to Waterloo, barrels of "relics" every year. At Waterloo these "relics" are planted, and in due time dug up, and sold at large prices as precious remembrances of the great battle. Our Waterloo purchases looked rather cheap after this discovery.

We returned from Brussels to London, where the General again opened his "Levees" with undiminished success, and also played at the theatres in "Hop o' my Thumb." He also performed in the Surrey Zoological Gardens, under the direction of its proprietor and my particular friend, Mr. TYLER. From London we went to Scotland, stopping to exhibit in important places by the way, and finally all returned to America in February, 1847.

The General had been absent for somewhat more than three years, during which space, leaving him in charge of faithful agents, I had twice visited the United States.*

The first of these visits was in October, 1844. Twenty months of pecuniary prosperity appeared to have effected some change in the views or conduct of certain people regarding me – a change which I afterwards alluded to in one of my letters to the Sunday Atlas in the following terms:

"A source of great amusement to me on my return to New York, was the discovery of many *new* friends. I could hardly credit my senses, when I discovered so many wealthy men extending their hands to me and expressing their delight at seeing me again, who before I left New York would have looked down on me with disdain had I presumed to speak to them. I really forgot, until they forced the truth upon my mind, that since I left them I had accumulated a few more dirty dollars, and that now therefore we stood on equal ground! On the other hand, I met some honest friends in humble circumstances, who approached me with diffidence never before exhibited – and then again I felt ashamed of human nature. What

*On my first visit, my wife and children returned with me to Europe, and remained nine months. My second visit to America was in April, 1846.

a pitiful state of society it is, which elevates a booby or a tyrant to its summit, provided he has more gold than others – while a good heart or a wise head is contemptuously disregarded if their owner happens to be poor!

"No man can be truly happy who, because he chances to be rich, mounts upon stilts, and attempts to stride over his fellow-beings. For my own part, the only special benefit which, as I conceive, wealth can confer upon an individual is, that while it enables him to secure the comforts and conveniences of life, it affords him an opportunity to contribute to the wants of his fellow-beings. My sincere prayer is, that I may be reduced to beggary, rather than become a pampered, purse-proud aristocrat.

"This coat, I am sorry to say, will fit many of my acquaintances in New York. I beg them, for their own sakes and for mine, to wear it. I wish *them*, and all the world, to know that my father was *a tailor*, and that I am '*a showman*' by profession, and all *the gilding* shall make nothing else of me. When a man is ashamed of his origin, or gets above his business, he is a poor devil, who merits the detestation of all who know him. The idea that a shoemaker or a tinker cannot be a gentleman, is simply ridiculous; but it is not as much so as that which assumes every man necessarily to be a gentleman if he happens to be wealthy. Money should in no sense be made the standard of respectability or honor. We should never worship 'golden calves.'"

In my account of our European tour, I have confined myself principally to incidents connected with the exhibition of Tom Thumb. It must not be supposed that I had no recreation meanwhile, or that I restricted myself to a circle of observation with a golden rim. Of course, I constantly had "an eye to business," but this still left me an eye to look around upon men and things, without respect to my vocation of a showman. Every part of Europe which we visited was indeed a great "curiosity shop" to me, and I had great pleasure in viewing its many departments. Usually it was done in "double quick time," though thoroughly. I shall here mention one of the occasions, and I cannot do better than to call it

A DAY WITH ALBERT SMITH.

While in London, my friend ALBERT SMITH, who is a jolly companion, as well as a witty and sensible a author, promised that when I reached Birmingham he would come and spend a day with me in

THE LIFE OF P. T. BARNUM

"sight-seeing," including a visit to the house in which Shakspeare was born.

Early one morning in the month of September, 1844, the sun rose in unusual splendor for that country, finding my friend Smith and myself on the box-seat of an English mail-coach, whirling at the rate of twelve miles an hour over the magnificent road leading from Birmingham to Stratford. The distance is thirty miles. At a little village four miles before reaching Stratford, we found that the genius of the bard of Avon had travelled thus far, for we noticed a sign over a miserable barber's shop, "Shakspeare hair-dressing – a good shave for a penny." In twenty minutes more we were set down at the door of the Red Horse Hotel in Stratford. The coachman and guard were each paid half a crown as their perquisites.

While breakfast was preparing, we called for a guide-book to the town, and the waiter brought in a book, saying that we should find in it the best description extant of the birth and burial-place of Shakspeare. I was not a little proud to find this volume to be no other than the "Sketch-Book" of our illustrious countryman, Washington Irving; and in glancing over his humorous description of the place, I discovered that he had stopped at the same hotel where we were then awaiting breakfast.

After examining the Shakspeare House, as well as the tomb and the church in which all that is mortal of the great poet rests, we ordered a post-chaise for Warwick Castle. While the horses were being harnessed, a stage-coach stopped at the hotel, and two gentlemen alighted. One was a sedate, sensible-looking man; the other an addle-headed fop. The former was mild and unassuming in his manners; the latter was all talk, without sense or meaning – in fact, a regular Charles Chatterbox. He evidently had a high opinion of himself, and was determined that all within hearing should understand that he was – somebody. Presently the sedate gentleman said:

"Edward, this is Stratford. Let us go and see the house where Shakspeare was born."

"Who the devil is Shakspeare?" asked the sensible young gentleman.

Our post-chaise was at the door; we leaped into it, and were off, leaving the "nice young man" to enjoy a visit to the birth-place of an individual of whom he had never before heard. The distance to Warwick is fourteen miles. We went to the Castle, and approaching the door of the Great Hall, were informed by a well-dressed porter

that the Earl of Warwick and family were absent, and that he was permitted to show the apartments to visitors. He introduced us successively into the "Red Drawing-Room." "The Cedar Drawing-Room," "The Gilt Room," "The State Bed-Room," "Lady Warwick's Boudoir," "The Compass Room," "The Chapel," and "The Great Dining-Room." As we passed out of the Castle, the polite porter touched his head (he of course had no hat on it) in a style which spoke plainer than words, "Half a crown each, if you please, gentlemen." We responded to the call, and were then placed in charge of another guide, who took us to the top of "Guy's Tower," at the bottom of which he touched his hat a shilling's worth; and placing ourselves in charge of a *third* conductor, an old man of seventy, we proceeded to the Greenhouse to see the Warwick Vase. The old gentleman mounted a rostrum at the side of the vase and commenced a set speech, which we began to fear was interminable; so tossing him the usual fee, we left him in the middle of his oration.

Passing through the porter's lodge on our way out, under the impression that we had seen all that was interesting, the old porter informed us that the most curious things connected with the Castle were to be seen in his lodge. Feeling for our coin, we bade him produce his relics, and he showed us a lot of trumpery, which, he gravely informed us, belonged to that hero of antiquity, Guy, Earl of Warwick. Among these were his sword, shield, helmet, breast-plate, walking-staff, and tilting-pole, each of enormous size – the horse armor nearly large enough for an elephant, a large pot which would hold seventy gallons, called "Guy's Porridge Pot," his flesh-fork, the size of a farmer's hay-fork, his lady's stirrups, the rib of a mastodon which the porter pretended belonged to the great "Dun Cow," which, according to tradition, haunted a ditch near Coventry, and after doing injury to many persons, was slain by the valiant Guy. The sword weighed nearly 200 pounds, and the armor 400 pounds!

I told the old porter he was entitled to great credit for having concentrated more *lies* than I had ever before heard in so small a compass. He smiled, and evidently felt gratified by the compliment.

"I suppose," I continued, "that you have told these marvellous stories so often, that you almost believe them yourself?"

"*Almost!*" replied the porter, with a grin of satisfaction that showed he was "up to snuff," and had really earned two shillings.

The "Warwick races" were then coming off within half a mile

of the village. We therefore went down and spent an hour with the multitude.

There was very little betting or excitement regarding the races, and we concluded to take a tour through the "penny shows," the *vans* of which lined one side of the course for the distance of a quarter of a mile. On applying to enter one van, which had a large pictorial sign of giantesses, white negro, Albino girls, learned pig, big snakes, etc., the keeper exclaimed, "Come, Mister, you is the man what hired Randall, the giant, for 'Merika, and you shows Tom Thumb; now *can* you think of paying less than sixpence for going in here?"

The appeal was irresistible; so, satisfying his demands, we entered. Upon coming out, a whole bevy of showmen from that and neighboring vans surrounded me, and began descanting on the merits and demerits of General Tom Thumb.

"Oh," says one, "I knows two dwarfs what is better ten times as Tom Thumb."

"Yes," says another, "there's no use to talk about Tom Thumb while Melia Patton is above the ground."

"Now, I've seen Tom Thumb," added a third, "and he is a fine little squab, but the only 'vantage he's got is he can *chaff* so well. He chaffs like a man; but I can learn Dick Swift in two months so that he can chaff Tom Thumb crazy."

"Never mind," added a fourth, "I've got a chap training what you none on you knows, what'll beat all the 'thumbs' on your grapplers."

"No he can't," exclaimed a fifth, "for Tom Thumb has got the name, and you all know the name's every thing. Tom Thumb couldn't never shine, even in my van, 'long side of a dozen dwarfs I knows, if this Yankee hadn't bamboozled our Queen – God bless her – by getting him afore her half a dozen times."

"Yes, yes – that's the ticket," exclaimed another; "our Queen patronizes every thing *foreign*, and yet she wouldn't visit my beautiful wax-works to save the crown of *H*ingland."

"Your *beautiful* wax-works!" they all exclaimed with a hearty laugh.

"Yes, and who says they *h*aint beautiful?" retorted the other; "they was made by the best *H*italian *h*artist in this country."

"They was made by Jim Caul, and showed all over the country twenty years ago," rejoined another; "and arter that they laid five years in pawn in old Moll Wiggins's cellar, covered with mould and dust."

"Well, that's a good 'un, that is!" replied the proprietor of the beautiful wax-works, with a look of disdain.

I made a move to depart, when one of the head showmen exclaimed, "Come, Mister, don't be shabby; *can* you think of going without standing treat all round?"

"Why should I stand treat?" I asked.

"'Cause 'tain't every day you can meet such a bloody lot of jolly brother-showmen," replied Mr. Wax-works.

I handed out a crown, and left them to drink bad luck to the "foreign wagabonds what would bamboozle their Queen with inferior dwarfs, possessing no advantage over the *natyves* but the power of *chaffing.*"

While in the showmen's vans seeking for acquisitions to my Museum in America, I was struck with the tall appearance of a couple of females who exhibited as the "Canadian giantesses, each seven feet in height." Suspecting that a cheat was hidden under their unfashionably long dresses, which reached to the floor and thus rendered their feet invisible, I attempted to solve the mystery by raising a foot or two of the superfluous covering. The strapping young lady, not relishing such liberties from a stranger, laid me flat upon the floor with a blow from her brawny hand. I was on my feet again in tolerably quick time, but not until I had discovered that she stood upon a pedestal at least eighteen inches high.

We returned to the hotel, took a post-chaise, and drove through decidedly the most lovely country I ever beheld. Since taking that tour, I have heard that two gentlemen once made a bet, each, that he could name the most delightful drive in England. Many persons were present, and the two gentlemen wrote on separate slips of paper the scene which he most admired. One gentleman wrote, "The road from Warwick to Coventry;" the other had written, "The road from Coventry to Warwick."

In less than an hour we were set down at the outer walls of Kenilworth Castle, which Scott has greatly aided to immortalize in his celebrated novel of that name.

This once noble and magnificent castle is now a stupendous ruin, which has been so often described that I think it unnecessary to say any thing further about it here. We spent half an hour in examining the interesting ruins, and then proceeded by post-chaise to Coventry, a distance of six or eight miles. Here we remained four hours, during which time we visited St. Mary's Hall, which has attracted the notice of many antiquaries. We also took a peep at the

effigy of the celebrated "Peeping Tom," after which we visited an exhibition called the "Happy Family," consisting of about two hundred birds and animals of opposite natures and propensities, all living in harmony together in one cage. This exhibition was so remarkable that I bought it for $2500, (£500,) and hired the proprietor to accompany it to New York, where it has ever since been an attractive feature in my Museum.

We took the cars the same evening for Birmingham, where we arrived at ten o'clock, my friend Albert Smith remarking, that never before in his life had he accomplished a day's journey on the Yankee go-ahead principle. He afterwards published a chapter in Bentley's Magazine, entitled "A Day with Barnum," in which he said we accomplished business with such rapidity, that when he attempted to write out the accounts of the day, he found the whole thing so confused in his brain that he came near "locating" Peeping Tom in the house of Shakspeare, while Guy of Warwick *would* stick his head above the ruins of Kenilworth – the Warwick Vase appearing in Coventry, etc.

During our journey, I amused him with many of my adventures, including the history of Joice Heth, the Mermaid, the Buffalo Hunt, etc., which he afterwards served up in his "Scattergood Family," making me the hero. At this time my friend was an author, dramatist and dentist, but subsequently he was exalted to the dignity of a "showman," and I am most happy to learn that he has accumulated a fortune from the exhibition of the panorama illustrating his extraordinary ascent of Mont Blanc.

I introduce the foregoing merely as a sample of my many adventures in examining the great curiosity shop of Europe. Indeed, I have in my possession sufficient material, as shadowed forth in my letters to the New York Atlas, to form volumes.

I was not wholly free from the usual infirmity of travellers, viz., a desire to look at the old castles of feudal times, whether in preservation or in ruins; but there was one of our party, Mr. H. G. Sherman, who had a peculiar and irresistible taste for the antique. He gathered trunks full of stone and timber mementoes from every place of note which we visited; and if there was any thing which he admired more than all else, it was *an old castle.* He spent many hours in clambering the broken walls of Kenilworth, in viewing the towers and dungeons of Warwick, and climbing the precipices of Dumbarton. When travelling by coach, Sherman always secured an

outside seat, and, if possible, next to the coachman, so as to be able to make inquiries regarding every thing which he might happen to see.

On our journey from Belfast to Drogheda, Sherman occupied his usual seat beside the driver, and asked him a thousand questions. The coachman was a regular wag, with genuine Irish wit, and he determined to have a little bit of fun at the expense of the inquisitive Yankee. As we came within eight miles of Drogheda, the watchful eye of Sherman caught the glimpse of a large stone pile, appearing like a castle, peering up among some trees in a field half a mile from the road-side.

"Oh, look here! what do you call that?" exclaimed Sherman, giving the coachman an elbowing in the ribs which was any thing but pleasant.

"Faith," replied the coachman, "you may well ask what we call that, for divil a call do we know what to call it. That is a castle, sir, beyond all question the oldest in Ireland – indade, none of the old books nor journals contain any account of it. It is known, however, that Brian Borrhoime inhabited it some time, though it is supposed to have been built centuries before his day."

"I'll give you half-a-crown to stop the coach long enough for me to run and bring a scrap of it away," said Sherman.

"Sure, and isn't this the royal *mail* coach? and I would not dare detain it for half the Bank of Ireland," replied the honest coachman.

"How far is it to Drogheda?" inquired Sherman.

"About eight miles, more or less," answered the coachman.

"Stop your coach, and let me down, then," replied Sherman; "I'll walk to Drogheda, and would sooner walk three times the distance than not have a nearer view, and carry off a portion of the oldest castle in Ireland."

With that Sherman dismounted, and raising his umbrella to protect him from the cold rain which was falling in torrents, he marched off in the mud, calling out to me that I might expect him in Dublin by the next train to that which would take us from Drogheda – the railroad being then completed only to that point from Dublin.

We arrived in Dublin about five o'clock, cold and uncomfortable; but warm apartments and good fires were in waiting for us, and in a few hours we had partaken of an excellent supper, and were as happy as lords. About nine o'clock in the evening, the door

of our parlor was opened, and who should come in but poor Sherman, drenched to the skin with cold rain – the legs of his boots pulled over the bottoms of his pantaloons, and covered with thick mud to the very tops, and himself looking like a half-famished, weary and frozen traveller.

"For heaven's sake, let me get to the fire!" exclaimed Sherman, and we were too much struck with his suffering appearance not to heed it.

"Well, Sherman," I remarked, "that must have been a tedious walk for you – eight long Irish miles, through the rain and mud."

"I guess you would have thought so, if you had walked it yourself," replied Sherman doggedly.

"I hope you have brought away trophies enough from the castle to pay you for all this trouble," I continued.

"Oh, *curse* the castle!" exclaimed Sherman.

"What do you mean by that?" I replied in astonishment.

"Oh, you need not look surprised," replied Sherman, "for I have no doubt that you and that bog-trotting Irish coachman have had fun enough at my expense before this time."

I assured him that I positively had not heard the coachman speak on the subject, and begged him to tell me what had occurred to vex him in this manner.

"Why, if you don't already know," replied Sherman, "I would not have you know for twenty pounds, for you would be sure to publish it. However, now your curiosity is excited, you would be certain to find it all out, if you had to hire a post-chaise and ride there on purpose; so I may as well tell you."

"Do tell me," I replied, "for I confess my curiosity is excited, and I am unable to guess why you are so angry, for I know you love to see *old castles* – and that pleasure you surely have enjoyed, for I caught a glimpse of one myself."

"No, you have not seen a castle to-day, nor I either!" exclaimed Sherman.

"What on earth was it, then?" I asked.

"A thundering old *lime kiln!*" exclaimed Sherman; "and I only wish I could pitch that infernal Irish coachman into it while it was under full blast!"

It was many a long day before Sherman heard the last of the lime kiln; in fact, this trick of the Irish coachman rendered him cautious in making inquiries of strangers.

One day we rode to Donnybrook, the place so much celebrated

for its fairs and its black eyes – for it would be quite out of character for Pat to attend a fair without having a flourish of the shillelah, and a *scrimmage* which would result in a few broken heads and bloody noses.

Near Donnybrook we saw something on the summit of a hill which appeared like a round stone tower. It was probably sixty feet in circumference and twenty-five feet high.

"I would like to know what that is," said Sherman.

I advised him to inquire of the first *coachman* that came along, but with a forced smile he declined my advice.

"It can't be a lime kiln, at any rate," continued Sherman; "it must be a castle of some description."

The more we looked at it the more mysterious did it appear to us, and Sherman's castle-hunting propensities momentarily increased. At last he exclaimed: "A man who travels with a tongue in his head is a fool if he don't use it; and I am not coming within a hundred rods of what may be the greatest curiosity in Ireland without knowing it."

With that he turned our horse's head towards a fine-looking mansion on our right, where we halted. Sherman jumped from the carriage, opened the small gate, proceeded up the alley of the lawn fronting the house, and rang the bell. A servant appeared at the door; but Sherman, knowing the stupidity of Irish servants, was determined to apply at head-quarters for the information he so much desired.

"Is your master in?" asked Sherman.

"I will see, sir. What name, if you plaze?"

"A stranger from the United States of America!" replied Sherman.

The servant departed, and in a minute returned and invited Sherman to enter the parlor. He found the gentleman of the mansion sitting by a pleasant fire, near which were also his lady and several visitors and members of the family. Sherman was not troubled with diffidence. Being seated, he hoped he would be excused for having called without an invitation – but the fact was, he was an American traveller, desirous of picking up all important information that might fall in his way.

The gentleman politely replied that no apology was necessary, that he was most happy to see him, and that any information which he could impart regarding that or any other portion of the country should be given with pleasure.

"Thank you," replied Sherman; "I will not trouble you except on a single point. I have seen all that is important in Dublin and its vicinity, and in and about Donnybrook; there is but one thing respecting which I want information, and that is the stone tower or castle which we see standing on the hill about a quarter of a mile south of your house. If you could give me the name and history of that pile, I shall feel extremely obliged."

"Oh, nothing is easier," replied the gentleman, with a smile. "That 'pile,' as you call it, was built some forty years ago by my father – and it was a lucky 'pile' for him, for it was the only *wind-mill* in these parts, and always had plenty to do; but a few years ago a hurricane carried off the wings of the mill, and ever since that it has stood as it now does, a memorial of its former usefulness. Is there any other *important* information that I can give you?" asked the gentleman with a smile.

"Not any," replied Sherman, rising to depart; "but perhaps I can give *you* some, and that is, that Ireland is beyond all dispute the meanest country I ever travelled in. The only two objects worthy of note that I have seen in all Ireland, are a lime kiln and the foundation for a wind-mill!"

Upon resuming his seat in the carriage, Sherman laughed immoderately, although he evidently felt somewhat chagrined by this second mistake in searching for ancient castles.

For my own part, I was exceedingly pleased with the Irish people. The educated classes are as refined and courteous as any persons I ever was acquainted with, and the poorer classes are blessed with a "mother-wit" which softens the rigors of their sorrowful necessities.

I had abundant reason to be pleased also with the English and the Scotch, though I acknowledge that the hilarity of the French character was more in unison with the merriment of my own spirit. I must therefore devote a few pages to incidents of our tour in *la belle France*.

In Paris, we found great difficulty in procuring a proper *interpreter* for the General's public exhibitions. We engaged half a dozen different ones, each of whom proved more incompetent than his predecessor; for they were all English, and their pronunciation of the French was so bad that they were sure to be laughed at. At last I engaged a Frenchman, who was a professor of one of the colleges, and although he spoke English indifferently, he, of course, gave the public *pure French*. He was, withal, a *perfect gentleman*, and I found

some difficulty in engaging him, as he feared it would be compromising his *dignity*. I however, at last, convinced him that to be the *preceptor* and interpreter of "*Gen. Tom Pouce*" would not be considered a menial office, and he accepted the situation. On arriving at the Belgian frontier, he had no *passport*, whereupon I remarked, "Monsieur Pinte, you will never be a good *showman* till you learn to remember every thing, and not thus be caught in a scrape through your own negligence or forgetfulness."

"Do you consider me a *showman*, then?" asked Monsieur Pinte, whose dignity was evidently wounded.

"Certainly," I replied, laughing; "*we are all showmen*, and you can make nothing else of it."

The poor fellow was in a brown study for the next four hours. He felt that his dignity had departed, and that the quondam "professor" was now nothing more nor less than a travelling *showman*. He, however, at last concluded to suffer the indignity, for he was quite a philosopher, and a good fellow at heart.

After a few hours, he good-naturedly said to me, "Mr. B., what are the requisite qualifications of a good showman?"

I smilingly replied, that "the first qualification necessary was a thorough knowledge of human nature, which of course included the faculty of judiciously applying *soft soap*."

"And what is that you call '*sof sup?*'" eagerly inquired the anxious Professor Pinte.

I told him it was the faculty to please and flatter the public so judiciously as not to have them suspect your intention.

In passing the custom-house we had a large quantity of medals, books, and engravings, (lithographs of the General.) I knew that these were subject to duty, but I was very prodigal in *presenting* them to the custom-house officers, and by that means got them through duty-free.

"Is that what you call '*sof sup?*'" inquired Professor Pinte.

"Exactly," I replied.

After passing the frontier, the directors and servants of the railway, who had witnessed my liberality in giving away the engravings, came begging for some. I could do no less than give them.

"The people have *very dirty hands* in this country, to require so much '*sof sup*' to keep them clean," remarked Monsieur Pinte, with a laugh, which seemed to indicate that he was fast becoming reconciled to his lot as a "showman."

We did not always escape difficulty at the custom-houses. At

Courtrai, a frontier town in Belgium, we had to endure the pleasures of a search and tax. They demanded a duty for the General's ponies and carriage; but when I showed them a document proving that the French government allowed them to enter duty-free, they did the same. At the custom-house at Lille, it was deemed necessary to measure and describe the ponies, in order to prevent our substituting other ponies on our return to France. As the General's beautiful equipage was passing through the custom-house, the chief officer, eyeing the General's *petit* coachman and footman in livery, seriously asked if the General was a *prince* in his own country.

"Certainly!" replied Sherman, with much gravity, "he is Prince *Charles* the First, of the dukedom of Bridgeport and kingdom of Connecticut."

The officer made a profound bow, and swallowed it all for gospel truth!

A person may frequently travel through the larger towns in France, for days together, without being called on for his passport; but it not unfrequently happens that, in a little insignificant village, he is waited on quite unexpectedly by a *gendarme*, who demands permission to see the precious document. Such was one day the case with me.

I was quietly enjoying my dinner, at a neat little rustic inn, when the door was suddenly opened, and a full-accoutred, heavy-moustachioed *gendarme* entered, and demanded my passport. It was in my trunk on the top of the diligence, and so I told him; but he insisted on seeing it. Not taking the trouble of getting it, I searched my pockets, and finding an old insurance policy, which I had accidentally brought from America, I drew it forth, and, exclaiming, "Oh, here is my passport!" handed it to the officer. He eyed it rather closely, and looked very wise while turning it backwards and forwards, but it was all Greek to him, for he could not read a word of English. After retaining it for a minute or two, he politely handed it back, with a "*Très bien!*" ("Very well!") and took his leave!

This is not always a safe trick, however, as most of the *gendarmes* know the stamp of the Prefecture of Police at Paris; and, as that stamp is not *always* found on an old American insurance policy, it would be rather unpleasant for a man to attempt to travel in France with *no other* passport. In my case, however, if I had been detected, I could easily have rectified the mistake.

Whenever I dined at a French *table d'hôte*, (and I always did

so when I could, on account of the excellence and great variety of dishes,) I usually expected to partake of about six dishes with which I was acquainted, and of as many as *sixteen* of the composition of which I had not the remotest conception. If a person asked me if I ever ate serpents or lizards, or any thing else, I dare not answer no; for I did not know what I had not eaten in France!

While we were in Brussels, Mrs. Stratton, the mother of the General, tasted some *sausages* which she declared the best things she had eaten in France or Belgium; in fact, she said "she had found little that was fit to eat in this country, for every thing was so Frenchified and covered in gravy, she dared not eat it; but there was something that tasted *natural* about these sausages; she had never eaten any as good, even in America." She sent to the landlady to inquire the name of them, for she meant to buy some to take along with her. The answer came that they were called "saucisse de Lyons," (Lyons sausages,) and straightway Mrs. Stratton went out and purchased half a dozen pounds. Mr. Sherman soon came in, and, on learning what she had in her package, he remarked: "Mrs. Stratton, do you know what Lyons sausages are made of?"

"No," she replied; "but I know that they are *first rate!*"

"Well," replied Sherman, "they may be good, but they are made from donkeys!" which is said to be the fact. Mrs. Stratton said she was not to be fooled so easily – that she knew better, and that she should stick to the sausages.

Presently Mr. Pinte, our French interpreter, entered the room. "Mr. Pinte," said Sherman, "you are a Frenchman, and know every thing about edibles; pray tell me what Lyons sausages are made of."

"Of asses," replied the inoffensive professor.

Mrs. Stratton seized the package, the street window was open, and, in less than a minute, a large brindle dog was bearing the "Lyons sausages" triumphantly away.

Such trifling incidents as these served to amuse us occasionally in a land of strangers, but I frequently had much more than amusement in that journey of ours in a foreign land. On several occasions I felt entirely at home, especially on the fourth of July, 1844.

Being that day in Grenelle, outside the barriers of Paris, I remembered that I had the address of Monsieur Regnier, an eminent mechanician, who lived in the vicinity. Wishing to purchase a variety of instruments such as he manufactured, I called at his residence. He received me very politely, and I soon was deeply interested in

this intelligent and learned man. He was a member of many scientific institutions, was "Chevalier of the Legion of Honor," etc.

While he was busy in making out my bill, I was taking a cursory view of the various plates, drawings, etc., which adorned his walls, when my eyes fell on a portrait which was familiar to me. I was certain that I could not be mistaken, and on approaching nearer it proved to be, as I expected, the engraved portrait of Benjamin Franklin. It was placed in a glazed frame, and on the *outside* of the glass were placed *thirteen stars* made of metal, forming a half circle round his head.

"Ah!" I exclaimed, "I see you have here a portrait of my fellow-countryman, Dr. Franklin."

"Yes," replied M. Regnier, "and he was a great and an excellent man. When he was in Paris in '98, he was honored and respected by all who knew him, and by none more so than the scientific portion of the community. At that time, Dr. Franklin was invited by the President of the Society of Emulation to decide upon the merits of various works of art submitted for inspection, and he awarded my father, for a complicated lock, the prize of a gold medal.

"While my father was with him at his hotel, a young Quaker called upon the Doctor. He was a total stranger to Franklin, but at once proceeded to inform him that he had come to Paris on business, had unfortunately lost all his money, and wished to borrow six hundred francs to enable him to return to his family in Philadelphia. Franklin inquired his family name, and upon hearing it immediately counted out the money, gave the young stranger some excellent advice, and bade him adieu. My father was struck by the generosity of Dr. Franklin, and as soon as the young man had departed, he told the Doctor that he was astonished to see him so free with his money to a stranger; that people did not do business in that way in Paris; and what he considered very careless was, that Franklin took no receipt nor even a scratch of a pen from the young man. Franklin replied that he always felt a duty and pleasure in relieving his fellow-men, and especially in this case, as he knew the family, and they were honest and worthy persons. My father, himself a generous man," continued M. Regnier, "was affected nearly to tears, and begged the Doctor to present him with his portrait. He did so, and this is it. My father has been dead some years. He bequeathed the portrait to me, and there is not money enough in Paris to buy it."

I need not say that I was delighted with this recital. I remarked to M. Regnier that he should double the number of stars, as we

now (in 1844) had twenty-six States instead of thirteen, the original number.

"I am aware of that," he replied; "but I do not like to touch the work which was left by my father. I hold it sacred; and," added he, "I suppose you are not aware of the uses we make of these stars?" Assuring him in the negative – "Those stars," said he, "are made of *steel*, and on the night of every anniversary of American Independence, (which is this night,) it was always the practice of my father, and will always be mine, to collect our family and children together, darken the room, and by means of electricity, these stars, which are connected, are *lighted up*, and the portrait illuminated by *electricity*, Franklin's favorite science – thus forming a halo of glory about his head, and doing honor to the name of a man whose fame should be perpetuated to eternity."

In continuing the conversation, I found that this good old gentleman was perfectly acquainted with the history of America, and he spoke feelingly of what he believed to be the high and proud destiny of our republic. He insisted on my remaining to supper, and witnessing his electrical illumination. Need I say that I accepted the invitation? Could an American refuse?

We partook of a substantial supper, upon which the good old gentleman invoked the blessing of our Father in Heaven, and at the conclusion he returned hearty thanks. At nine o'clock the children and family of M. Regnier and his son-in-law were called in, the room was darkened, the electrical battery was charged, and the wire touched to one of the outer stars. The whole thirteen became instantly bright as fire, and a beautiful effect was produced. What more simple and yet beautiful and appropriate manner could be chosen to honor the memory of Franklin? And what an extraordinary coincidence it was that I, a total stranger in Paris, should meet such a singular man as M. Regnier at all, and more especially on that day of days, the anniversary of our Independence! At ten o'clock I took my leave of this worthy family, but not till we had all joined in an excellent bottle of champagne, drinking the following toast proposed by M. Regnier:

"*Washington, Franklin, and Lafayette* – Heroes, philosophers, patriots, and honest men. May their names stand brightest on the list of earthly glory, when in after ages this whole world shall be one universal republic, and every individual under heaven shall acknowledge the truth that man is capable of self-government."

It will not be considered surprising that I should feel at home

with Monsieur Regnier. Both the day and the man conspired to excite and gratify my patriotism, and the presence of Franklin my love of my "native land."

The companionship of two distinguished "live Americans" in Paris, did not diminish this feeling. They were fine specimens of Yankee character, and illustrated the fruits of perseverance, backed by intelligence, genius, and probity. I refer to the celebrated dentist, Dr. C. S. BREWSTER, whose prosperous professional career in Russia and France is well known, and HENRY SUMNER, Esq., whose success in challenging the courtesy of Nicholas was equalled only by the high position he occupied in the social and literary circles of Paris. To both these gentlemen, as well as to Mr. JOHN NIMMO, an English gentleman connected with "Galignani's Messenger," Mr. LORENZO DRAPER, the American Consul, and DION BOURCICAULT, Esq., I was largely indebted for attention, and I cannot better close this account of my European tour, than by here recording their names. In London, two gentlemen especially merit in this place my warm acknowledgments for many valuable favors. I refer to THOMAS BRETTELL, Esq., publisher, Haymarket; and Mr. R. FILLINGHAM, Jr., Fenchurch street. I was also indebted to Mr. G. P. PUTNAM, at that time a London publisher, for much useful information.

It will naturally be supposed that I promptly made use of General Tom Thumb's European reputation, on our arrival in New York, in February, 1847. He immediately appeared in the American Museum, and for four weeks drew such crowds of visitors as had never been seen there before. He afterwards spent a month in Bridgeport, with his kindred. To prevent being annoyed by the curious who would be sure to throng the houses of his relatives, he exhibited two days at Bridgeport. The receipts, amounting to several hundred dollars, were presented to the Bridgeport Charitable Society. The Bridgeporters were much delighted to see their old friend "little Charlie" again. They little thought, when they saw him playing about the streets a few years previously, that he was destined to create such a sensation among the crowned heads of the old world; and now returning with his European reputation, he was of course a great curiosity to his former acquaintances, as well as the public generally. His Bridgeport friends found that he had not increased in size during the four and a half years of his absence, but they discovered that he had become sharp and witty, abounding in "foreign airs and native graces;" in fact, that he was

quite unlike the little diffident country fellow whom they had formerly known.

"We never thought Charlie much of a phenomenon when he lived among us," said one of the first citizens of the place, "but now that he has become 'Barnumized,' he is a rare curiosity."

"How old are you, General?" asked one of his acquaintances.

"As Mr. Barnum makes it out, I am fifteen," said the General, laughing, for he was aware that the inquirer knew his true age to be only nine!

I was surprised to find that I had also become a curiosity during my absence. If I showed myself about the Museum or wherever else I was known, I found eyes peering and fingers pointing at me, and could frequently overhear the remark, "There's Barnum," "That's old Barnum," etc. By the way, I can't understand how it is that most people whom I do not know, and many whom I do, will insist upon calling me "*Old* Barnum." I am now but forty-four years of age, and I have been called "old Barnum" these ten years.

On one occasion, soon after my return from abroad, I was sitting in the ticket-office reading a newspaper. A man came and purchased a ticket of admission. "Is Barnum in the Museum?" he asked. The ticket-seller, pointing to me, answered, "This is Mr. Barnum." Supposing the gentleman had business with me, I looked up from the paper. "Is this Mr. Barnum?" he asked. "It is," I replied. He stared at me for a moment, and then, throwing down his ticket, he exclaimed, "It's all right. I have got the worth of my money;" and away he went, without going into the Museum at all!

I should before have said that after the 1st of January, 1845, my engagement with General Tom Thumb on a salary having ceased, we made a new arrangement, by which we were to be equal partners – the General (or his father for him) taking one half of the profits and myself the other half. A reservation, however, was made of the first four weeks after our arrival in New York, during which he was to exhibit at my Museum for $200.

When we returned to America, Mr. Stratton (the General's father) had acquired a handsome fortune, and settling a large sum upon the little General personally, he placed the balance at interest, secured by bond and mortgage, excepting $30,000, with which he purchased land near the city limits of Bridgeport, and erected a large and substantial mansion, where he now resides, and in which his only two daughters have been married, one in 1850, the other in 1853. His only son, besides the General, is

three years old. All the family, except "little Charlie," are of the usual size.

After spending a month in visiting his friends, it was determined that the General and his parents should travel through the United States. I agreed to accompany them one year, sharing the profits equally, as in England. We proceeded to Washington city, where the General held his levees in April, 1847, visiting President Polk and lady at the White House – thence to Richmond, returning to Baltimore and Philadelphia. Our receipts in Philadelphia in twelve days were $5594.91. The tour for the entire year realized about the same average. The expenses were from $25 to $30 per day. From Philadelphia we went to Boston, Lowell, and Providence. Our receipts on one day in the latter city were $976.97. We then visited New Bedford, Fall River, Salem, Worcester, Springfield, Albany, Troy, Niagara Falls, Buffalo, and intermediate places, and in returning to New York we stopped at the principal towns on the Hudson river. After this we visited New Haven, Hartford, Portland, Me., and intermediate towns.

In November, 1847, we started for Havana, taking the steamer from New York to Charleston, where the General exhibited, as well as at Columbia, Augusta, Savannah, Milledgeville, Macon, Columbus, Montgomery, Mobile, and New Orleans. At this latter city we remained three weeks, including Christmas and New Year's. We arrived in Havana by the schooner Adams Gray in January, 1848, and were introduced to the Captain-General and the Spanish nobility. We remained a month in Havana and Matanzas, the General proving an immense favorite, and frequently receiving a doubloon for his autograph. In Havana he was the especial pet of Count Santovania. In Matanzas we were very much indebted to the kindness of a princely American merchant, Mr. Brinckerhoff. J. S. Thrasher, Esq., the American patriot and gentleman, was also of great assistance to us, and placed me under deep obligations.

The hotels in Havana are not good. An American who is accustomed to substantial living finds it difficult to get enough to eat. We stopped at the Washington House, which at that time was "first-rate bad." It was filthy, and kept by a woman who was drunk most of the time. Several Americans boarded there who were regular gormandizers. One of them, seeing a live turkey on a New Orleans vessel, purchased and presented it to the landlady. It was a small one, and when it was carved there was not enough of it to "go round." An American (a large six-footer and a tremendous eater)

who resided on a sugar plantation near Havana, happened to sit near the carver, and seeing an American turkey so near him, and feeling that it was a rare dish for that latitude, kept helping himself, so that when the carving was finished, he had eaten about one half of the turkey. Unfortunately the man who bought it was sitting at the further end of the table, and did not get a taste of the coveted bird. He was indignant, especially against the innocent gormandizer from the sugar plantation, who of course was not acquainted with the history of the turkey. When they arose from the table, the planter smacked his lips, and patting his stomach, remarked, "That was a glorious turkey. I have not tasted one before these two years. I am very fond of them, and when I go back to my plantation I mean to commence raising turkeys."

"If you don't *raise* one before you leave town, you'll be a dead man!" replied the disappointed poultry-buyer.

Among the passengers on board the vessel which took us from Havana to New Orleans, was a Yankee who had a large quantity of Spanish tobacco for the American market. I learned from him that this tobacco was grown in Connecticut, and shipped to New Orleans *viâ* Havana. Of course the New Orleans purchasers, buying it from an Havana packet, supposed they were purchasing Cuba tobacco, and little dreamed that it was raised in the "wooden-nutmeg" State. Verily, as the old proverb has it, "there's cheating in all trades but ours."

From New Orleans we proceeded to St. Louis, stopping at the principal towns on the Mississippi river, and returning *viâ* Louisville, Cincinnati, and Pittsburgh. We reached the latter city early in May, 1848. From this point it was agreed between Mr. Stratton and myself, that I should go home and henceforth travel no more with the little General. I had competent agents who could exhibit him without my personal assistance, and I preferred to relinquish a large portion of the profits, rather than be any longer a travelling showman.

I reached my residence in Bridgeport, Ct., the latter part of May, and was rejoiced to find my family and friends in good health. I had now been a straggler from home most of the time for thirteen years, and I cannot describe the feelings of gratitude with which I reflected, that having by the most arduous toil and deprivations succeeded in securing a satisfactory competence, I should henceforth spend my days in the bosom of my family. I was fully determined that no pecuniary temptation should again induce me to forego the enjoyments only to be secured in the circle of home.

The years 1848 and 1849 were chiefly spent with my family. A portion of my time and attention, however, was occupied in looking after the interests of the American Museum, and also in opening a new Museum in Philadelphia, the particulars of which are given in another section of this book.

CHAPTER XI

The Jenny Lind Enterprise

In October, 1849, I first conceived the idea of bringing JENNY LIND
to this country. I had never heard her sing, inasmuch as she arrived
in London a few weeks after I quitted it with General Tom Thumb.
Her reputation, however, was sufficient for me. I usually jump at
conclusions, and almost invariably find that my first impressions
are the most correct. It struck me, when I first thought of this

speculation, that if properly managed it must prove immensely profitable, provided I could engage the "Swedish Nightingale" on any terms within the range of reason. As it was a great undertaking, I considered the matter seriously for several days, and all my "cipherings" and calculations gave but one result – immense success.

Reflecting that very much would depend upon the manner in which she should be brought before the public, I saw that my task would be an exceedingly arduous one. It was possible, I knew, that circumstances might occur which would make the enterprise disastrous. "The public" is a very strange animal, and although a good knowledge of human nature will generally lead a caterer of amusements to hit the people right, they are fickle, and ofttimes perverse. A slight misstep in the management of a public entertainment, frequently wrecks the most promising enterprise. Taking all things into the account, I arrived at the following conclusions:

1st. The chances were greatly in favor of immense pecuniary success; and 2d. Inasmuch as my name has long been associated with "humbug," and the American public suspect that my capacities do not extend beyond the power to exhibit a stuffed monkey-skin or a dead mermaid, I can afford to lose fifty thousand dollars in such an enterprise as bringing to this country, in the zenith of her life and celebrity, the greatest musical wonder in the world, provided the engagement is carried out with credit to the management.

I thought that the sum above named would be amply sufficient to cover all possible loss, and, caring little for the personal anxiety and labor which I must necessarily encounter, I cast about for the purpose of finding the proper agent to dispatch to Europe to engage the "divine Jenny," if possible.

I found in Mr. John Hall Wilton, an Englishman who had visited this country with the Sax-Horn Players, the best man whom I knew for that purpose. A few minutes sufficed to make the arrangement with him, by which I was to pay only his expenses if he did not succeed in his mission, but by which also he was to be paid a large sum of money if he succeeded in bringing Jenny Lind to our shores, on any terms within a liberal schedule, which I set forth to him in writing.

On the 6th of November, 1849, I furnished Wilton with the necessary documents, including a letter of general instructions which he was at liberty to exhibit to Jenny, and to any other musical notables whom he thought proper, and a private letter, containing hints and suggestions not embodied in the former. I also gave him

letters of introduction to my former bankers, Baring Brothers & Co. of London, as well as to many friends in England, France, etc.

The gist of all my instructions to Wilton (public and private) amounted to this: He was to engage Jenny *on shares*, if possible, so that my risk would be inconsiderable, unless he could secure her for one hundred nights for the sum of sixty thousand dollars, which terms I preferred to that of sharing. I however authorized him, if he could do no better, to engage her for one hundred and fifty nights for the sum of one hundred and fifty thousand dollars and all her expenses, including servants, carriages, secretary, etc., besides also engaging such musical assistants, not exceeding three in number, as she should select – let the terms be what they might. If necessary, I should place the entire amount of money named in the engagement in the hands of London bankers before Jenny sailed.

Wilton's compensation was arranged on a kind of sliding scale, to be governed by the terms which he made for me – so that the farther he kept below my utmost limits, the better he should be paid for making the engagements.

Wilton proceeded to London, and opened a correspondence with Miss Lind, who was then on the Continent. He learned from the tenor of her letters, that if she could be induced to visit America at all, she must be accompanied by Mr. JULIUS BENEDICT, the accomplished composer, pianist, and musical director, and also that she was impressed with the belief that Signor BELLETTI, the fine baritone, would be of essential service. Wilton therefore at once called upon Mr. BENEDICT and also Signor BELLETTI, who were both then in London, and in numerous interviews was enabled to learn the terms on which they would consent to engage to visit this country with Miss Lind. Having thus obtained the information desired, he proceeded at once to Lubec, in Germany, to seek an interview with Miss Jenny herself. Upon ariving at her hotel, he sent his card, requesting her to specify an hour for an interview. She named the following morning, and he was punctual to the appointment.

In the course of the first conversation, she frankly told him that during the time occupied by their correspondence, she had written to friends in London, including my friend Mr. Joshua Bates, of the house of Baring Brothers, and informed herself respecting my character, capacity, and responsibility, which she assured him were quite satisfactory. She informed him, however, that at that time there were four persons anxious to negotiate with her for an American tour. One of these gentlemen was a well-known Opera

manager in London; another, a theatrical manager in Manchester; a third, a musical composer and *Chef d' Orchestra* of Her Majesty's Opera in London; and the fourth, a man who had conducted a successful speculation some years previously by visiting America in charge of a celebrated *danseuse*. Several of these parties had called upon her personally, and the last-mentioned, upon hearing my name from her lips, attempted to deter her from making any engagement with me, by assuring her that I was a humbug and a showman, and that, for the sake of making money by the speculation, I would not scruple to put her into a box and exhibit her through the country at twenty-five cents a head!

This, she confessed, somewhat alarmed her, and she wrote to Mr. Bates upon the subject. He entirely disabused her mind, by kindly assuring her that he knew me personally, and that in treating with me she was not dealing with an ordinary theatrical manager, who might make her remuneration depend entirely upon the success of the enterprise, but that I was able to carry out all my engagements, let them prove never so unprofitable, and that she could place the fullest reliance upon my honor and integrity.

"Now," said she to Mr. Wilton, "I am perfectly satisfied upon that point, for I know the world pretty well, and am aware how far jealousy and envy will sometimes carry persons; and as those who are trying to treat with me are all anxious that I should participate in the profits or losses of the enterprise, I much prefer treating with you, since your principal is willing to assume all the responsibility, and take the entire management and chances of the result upon himself."

Several interviews ensued, during which she learned from Wilton that he had settled with Messrs. Benedict and Belletti, regarding the amount of their salaries provided the engagement was concluded, and in the course of a week, Mr. Wilton and herself had settled the terms and conditions on which she was ready to conclude the negotiations. As these terms were within the limits fixed in my private letter of instructions, the following agreement was duly drawn in triplicate, and signed by herself and Wilton, at Lubec, on the ninth day of January, 1850; and the signatures of Messrs. Benedict and Belletti were affixed in London a few days afterwards:

MEMORANDUM of an agreement entered into this ninth day of January, in the year of our Lord one thousand eight hundred and fifty, between John Hall Wilton, as agent for PHINEAS T. BARNUM, of

New York, in the United States of North America, of the one part, and Mademoiselle JENNY LIND, Vocalist, of Stockholm in Sweden, of the other part, wherein the said Jenny Lind doth agree,

1st. To sing for the said Phineas T. Barnum in one hundred and fifty concerts, including oratorios, within (if possible) one year or eighteen months from the date of her arrival in the city of New York – the said concerts to be given in the United States of North America and Havana. She, the said Jenny Lind, having full control as to the number of nights or concerts in each week, and the number of pieces in which she will sing in each concert, to be regulated conditionally with her health and safety of voice, but the former never less than one or two, nor the latter less than four; but in no case to appear in operas.

2d. In consideration of said services the said John Hall Wilton, as agent for the said Phineas T. Barnum of New York, agrees to furnish the said Jenny Lind with a servant as waiting-maid, and a male servant to and for the sole service of her and her party; to pay the travelling and hotel expenses of a friend to accompany her as a companion; to pay also a secretary to superintend her finances; to pay all her and her party's travelling expenses from Europe, and during the tour in the United States of North America and Havana; to pay all hotel expenses for board and lodging during the same period; to place at her disposal in each city a carriage and horses with their necessary attendants, and to give her in addition the sum of two hundred pounds sterling, or one thousand dollars, for each concert or oratorio in which the said Jenny Lind shall sing.

3d. And the said John Hall Wilton, as agent for the said Phineas T. Barnum, doth further agree to give the said Jenny Lind the most satisfactory security and assurance for the full amount of her engagement, which shall be placed in the hands of Messrs. Baring Brothers of London previous to the departure and subject to the order of the said Jenny Lind, with its interest due on its current reduction, by her services in the concerts or oratorios.

4th. And the said John Hall Wilton, on the part of the said Phineas T. Barnum, further agrees, that should the said Phineas T. Barnum, after seventy-five concerts, have realized so much as shall, after paying all current expenses, have returned to him all the sums disbursed, either as deposits at interest, for securities of salaries, preliminary outlay, or moneys in any way expended consequent on this engagement, and in addition, have gained a clear profit of at least fifteen thousand pounds sterling, then the said Phineas T.

Barnum will give the said Jenny Lind, in addition to the former sum of one thousand dollars current money of the United States of North America, nightly, one fifth part of the profits arising from the remaining seventy-five concerts or oratorios, after deducting every expense current and appertaining thereto; or the said Jenny Lind agrees to try with the said Phineas T. Barnum fifty concerts or oratorios on the aforesaid and first-named terms, and if then found to fall short of the expectations of the said Phineas T. Barnum, then the said Jenny Lind agrees to reorganize this agreement, on terms quoted in his first proposal, as set forth in the annexed copy of his letter; but should such be found unnecessary, then the engagement continues up to seventy-five concerts or oratorios, at the end of which, should the aforesaid profit of fifteen thousand pounds sterling have not been realized, then the engagement shall continue as at first – the sums herein after expenses for Julius Benedict and Giovanni Belletti to remain unaltered except for advancement.

5th. And the said John Hall Wilton, agent for the said Phineas T. Barnum, at the request of the said Jenny Lind, agrees to pay to Julius Benedict of London to accompany the said Jenny Lind as musical director, pianist, and superintendent of the musical department, also to assist the said Jenny Lind in one hundred and fifty concerts or oratorios, to be given in the United States of North America and Havana, the sum of five thousand pounds (£5000) sterling, to be satisfactorily secured to him with Messrs. Baring Brothers of London, previous to his departure from Europe; and the said John Hall Wilton agrees further for the said Phineas T. Barnum to pay all his travelling expenses from Europe, together with his hotel and travelling expenses during the time occupied in giving the aforesaid one hundred and fifty concerts or oratorios – he, the said Julius Benedict, to superintend the organization of oratorios, if required.

6th. And the said John Hall Wilton, at the request, selection, and for the aid of the said Jenny Lind, agrees to pay to Giovanni Belletti, baritone vocalist, to accompany the said Jenny Lind during her tour and in one hundred and fifty concerts or oratorios in the United States of North America and Havana, and in conjunction with the aforesaid Julius Benedict, the sum of two thousand five hundred pounds (£2500) sterling, to be satisfactorily secured to him previous to his departure from Europe, in addition to all his hotel and travelling expenses.

7th. And it is further agreed that the said Jenny Lind shall be at full liberty to sing at any time she may think fit for charitable

institutions or purposes independent of the engagement with the said Phineas T. Barnum, she, the said Jenny Lind, consulting with the said Phineas T. Barnum with a view to mutually agreeing as to the time and its propriety, it being understood that in no case shall the first or second concert in any city selected for the tour be for such purpose, or wherever it shall appear against the interests of the said Phineas T. Barnum.

8th. It is further agreed that should the said Jenny Lind by any act of God be incapacitated to fulfil the entire engagement before mentioned, that an equal proportion of the terms agreed upon shall be given to the said Jenny Lind, Julius Benedict, and Giovanni Belletti, for services rendered to that time.

9th. It is further agreed and understood, that the said Phineas T. Barnum shall pay every expense appertaining to the concerts or oratorios before mentioned, excepting those for charitable purposes, and that all accounts shall be settled and rendered by all parties weekly.

10th. And the said Jenny Lind further agrees that she will not engage to sing for any other person during the progress of this said engagement with the said Phineas T. Barnum of New York for one hundred and fifty concerts or oratorios, excepting for charitable purposes as before mentioned; and all travelling to be first and best class.

In witness hereof to the within written memorandum of agreement we set hereunto our hand and seal.

JOHN HALL WILTON, Agent for PHINEAS T. BARNUM, of
 New York, U. S.
JULIUS BENEDICT.
GIOVANNI BELLETTI.
In the presence of C. AHILLING, Consul of His Majesty the King
 of Sweden and Norway.

Extract from a Letter addressed to John Hall Wilton by PHINEAS T. BARNUM, *and referred to in paragraph No. 4 of the annexed agreement.*

NEW YORK, *November 6th*, 1849.
MR. J. HALL WILTON:
 SIR: – In reply to your proposal to attempt a negotiation with Mlle. Jenny Lind to visit the United States professionally, I propose to enter into an arrangement with her to the following effect: I will engage to pay all

her expenses from Europe, provide for and pay for one principal tenor and one pianist, their salaries not exceeding together one hundred and fifty dollars per night; to support for her a carriage, two servants, and a friend to accompany her and superintend her finances. I will furthermore pay all and every expense appertaining to her appearance before the public, and give her half of the gross receipts arising from concerts or operas. I will engage to travel with her personally and attend to the arrangements, provided she will undertake to give not less than eighty nor more than one hundred and fifty concerts, or nights' performances.

Phineas T Barnum

I certify the above to be a true extract from the letter.

J. H. WILTON.

I was at my Museum in Philadelphia when Wilton arrived in New York, February 19, 1850, and he immediately telegraphed me that he had signed an engagement with Jenny Lind, by which she was to commence her concerts in America in the following September. I was somewhat startled by this sudden announcement, and feeling that the time to elapse before her arrival was so long that it would be policy to keep the engagement private for a few months, I immediately telegraphed him not to mention it to any person, and that I would meet him the next day in New York.

When we reflect how thoroughly Jenny Lind, her musical powers, her character, and wonderful successes, are now known by all classes in this country as well as throughout the whole civilized world, it is difficult to realize that, at the time this engagement was made, she was comparatively unknown on this side the water. We can hardly credit the fact, that millions of persons in America had never heard of her, that other millions had merely read her name, but had no distinct idea of who or what she was. Only a small portion of the public were really aware of her great musical triumphs in the old world, and this portion was confined almost entirely to musical people, travellers who had visited the old world, and the conductors of the press.

The next morning I started for New York. On arriving at Princeton, we met the cars, and, purchasing the morning papers, I was overwhelmed with surprise and dismay to find in them a full account of my engagement with Jenny. However, this premature announcement could not be recalled, and I put the best face upon the matter. Being anxious to learn how this communication would

strike the public mind, I informed the gentlemanly conductor (whom I well knew) that I had made an engagement with Jenny Lind, and that she would surely visit this country in the following August.

"Jenny Lind! Is she a dancer?" asked the conductor.

I informed the gentleman who and what she was, but his question had chilled me as if his words were ice. Really, thought I, if this is all that a man in the capacity of a railroad conductor between Philadelphia and New York knows of the greatest songstress in the world, I am not sure that six months will be too long a time for me to occupy in enlightening the entire public in regard to her merits.

I had an interview with Wilton, and learned from him that, in accordance with the agreement, it would be requisite for me to place the entire amount stipulated, $187,500, in the hands of the London bankers. I instantly resolved to ratify the agreement, and immediately sent the necessary documents to Miss Lind and Messrs. Benedict and Belletti.

I then commenced preparing the public mind through the newspapers for the reception of the great songstress. How effectually this was done is still within the remembrance of the American public. As a sample of the manner in which I accomplished my purpose, I present the following extract from my first letter to the reading community. It appeared in the New York papers of February 22, 1850:

> "Perhaps I may not make any money by this enterprise; but I assure you that if I knew I should not make a farthing profit, I would ratify the engagement, so anxious am I that the United States should be visited by a lady whose vocal powers have never been approached by any other human being, and whose character is charity, simplicity, and goodness personified.

> "Miss Lind has numerous better offers than the one she has accepted from me; but she has great anxiety to visit America. She speaks of this country and its institutions in the highest terms of praise, and as money is by no means the greatest inducement that can be laid before her, she is determined to visit us. In her engagement with me, (which includes Havana,) she expressly reserves the right to give charitable concerts whenever she thinks proper.

> "Since her *début* in England, she has given to the poor from her own private purse more than the whole amount which I have engaged to pay her, and the proceeds of concerts for charitable purposes in

Great Britain, where she has sung gratuitously, have realized more
than ten times that amount"

The people soon began to talk about Jenny Lind, and I was
particularly anxious to obtain a good portrait of her. Fortunately, a
fine opportunity occurred. One day, while I was sitting in the office
of the Museum, a foreigner approached me with a small package
under his arm. He informed me in broken English that he was a
Swede. He said he was an artist, and had just arrived from
Stockholm, where Jenny Lind had kindly given him a number of
sittings, and he now had with him the portrait of her which he had
painted upon copper. He unwrapped the package, and showed me
a beautiful picture of the Swedish Nightingale, inclosed in an elegant
gilt frame, about fourteen by twenty inches. It was just the thing I
wanted. His price was $50. I purchased it at once. Upon showing
it to an artistic friend the same day, he quietly assured me that it
was a cheap lithograph pasted on a tin back, neatly varnished, and
made to appear like a fine oil painting to a novice in the arts like
myself. The intrinsic value of the picture did not exceed 37½ cents!

After getting together all my available funds for the purpose
of transmitting them to London in the shape of United States bonds,
I found a considerable sum still lacking to make up the amount. I
had some second mortgages which were perfectly good, but I could
not negotiate them in Wall street. Nothing would answer there short
of first mortgages on New York or Brooklyn city property.

I went to the President of the bank where I had done all my
business for eight years. I offered him, as security for a loan, my
second mortgages, and as an additional inducement, I proposed to
make over to him my contract with Jenny Lind, with a written
guarantee that he should appoint a receiver, who, at my expense,
should take charge of all the receipts over and above three thousand
dollars per night, and appropriate them towards the payment of my
loan. He laughed in my face, and said: "Mr. Barnum, it is generally
believed in Wall street, that your engagement with Jenny Lind will
ruin you. I do not believe you will ever receive so much as three
thousand dollars at a single concert."

I was indignant at his want of appreciation, and answered him
that I would not at that moment take $150,000 for my contract;
nor would I.

I found, upon further inquiry, that it was useless in Wall street
to offer the Nightingale in exchange for goldfinches.

271

I finally was introduced to Mr. John L. Aspinwall, of the firm of Howland & Aspinwall, and he gave me a letter of credit from his firm on Baring Brothers, for a large sum, on collateral securities, which a friendly spirit, instead of strict banker's rules, induced him to accept.

After disposing of several pieces of property for cash, I footed up the various amounts, and still discovered myself $5000 short. I felt that it was indeed "the last feather that breaks the camel's back." Happening casually to state my desperate case to a clergyman, for many years a friend of mine, he promptly placed the requisite amount at my disposal. I gladly accepted his proffered friendship, and felt that he had removed a mountain-weight from my shoulders. That clergyman was the Rev. ABEL C. THOMAS of Philadelphia.[*]

After the engagement with Miss Lind was consummated, she declined several liberal offers to sing in London, but at my solicitation gave two concerts in Liverpool, on the eve of her departure for America. My object in making this request was, to add the *éclat* of *that* side to the excitement on *this* side of the Atlantic, which was already nearly up to fever heat.

The first of the two Liverpool concerts was given the night previous to the departure of a steamer for America. My agent had procured the services of a musical critic from London, who finished his account of this concert at half-past one o'clock the same night, or rather the following morning, and at two o'clock my agent was overseeing its insertion in a Liverpool morning paper, numbers of which he forwarded to me by the steamer of the same day. The republication of the criticism in the American papers, including an account of the enthusiasm which prevailed at her trans-Atlantic concert, had the desired effect.

On Wednesday morning, August 21, 1850, Jenny Lind and Messrs. Benedict and Belletti departed from Liverpool in the steamship Atlantic, in which I had long before engaged the necessary accommodations, and on board of which I had shipped a piano for their use. They were accompanied by my agent, Wilton, also by Miss Ahmansen and Mr. Hjortzberg, cousins of Miss Lind, the latter

[*] He is a self-made man, in early life a printer. He has been twenty-six years in the ministry. His "Autobiography," recently published, is one of the most interesting books I ever read.

being her secretary, also by her two servants, and the valet of Messrs. Benedict and Belletti.

It was expected that the steamer would arrive on Sunday, September 1, but, determined to meet the songstress on her arrival whenever it might be, I went to Staten Island on Saturday night, and slept at the hospitable residence of my friend, Dr. A. Sidney Doane, who was at that time the Health Officer of the port of New York. A few minutes before twelve o'clock on Sunday morning, the Atlantic hove in sight, and immediately afterwards, through the kindness of my friend Doane, I was on board the ship, and had taken Jenny Lind by the hand.

After a few moments' conversation, she asked me when and where I had heard her sing.

"I never had the pleasure of seeing you before in my life," I replied.

"How is it possible that you dared risk so much money on a person whom you never heard sing?" she asked in surprise.

"I risked it on your reputation, which in musical matters I would much rather trust than my own judgment," I replied.

I may as well here state, that although I relied prominently upon Jenny Lind's reputation as a great musical *artiste*, I also took largely into my estimate of her success with all classes of the American public, her character for extraordinary benevolence and generosity. Without this peculiarity in her disposition, I never would have dared make the engagement which I did, as I felt sure that there were multitudes of individuals in America who would be prompted to attend her concerts by this feeling alone.

Thousands of persons covered the shipping and piers, and other thousands had congregated on the wharf at Canal street, to see her. The wildest enthusiasm prevailed as the noble steamer approached the dock. So great was the rush on a sloop near the steamer's berth, that one man, in his zeal to obtain a good view, accidentally tumbled overboard amid the shouts of those near him. Jenny witnessed this incident, and was much alarmed. He was however soon rescued, after taking to himself a cold *duck* instead of securing a look at the Nightingale. A superb bower of green trees, decorated with beautiful flags, was discovered upon the wharf, together with two triumphal arches, on one of which was inscribed, "Welcome, Jenny Lind!" The second was surmounted by the American eagle, and bore the inscription, "Welcome to America!" These decorations were probably not produced by magic, and I do

not know that I can reasonably find fault with some persons who suspected that I had a hand in their erection. My private carriage was in waiting, and Jenny Lind was escorted to it by Captain West. The rest of the musical party entered the carriage, and, mounting the box at the driver's side, I directed him to the Irving House. As a *few* of the citizens had probably seen me before, my presence on the outside of the carriage aided those who filled the windows and side-walks along the whole route in coming to the conclusion that Jenny Lind had arrived.

A reference to the journals of that day will show, that seldom before had there been such enthusiasm in the city of New York, or indeed in America.

Within ten minutes after our arrival at the Irving House, not less than ten thousand persons had congregated around the entrance in Broadway, nor was the number diminished before nine o'clock in the evening. At her request, I dined with her that afternoon, and when, according to European custom, she prepared to pledge me in a glass of wine, she was somewhat surprised at my saying, "Miss Lind, I do not think you can ask any other favor on earth which I would not gladly grant; but I am a teetotaller, and must beg to be permitted to drink your health and happiness in a glass of cold water."

At twelve o'clock that night, she was serenaded by the New York Musical Fund Society, numbering on that occasion two hundred musicians. They were escorted to the Irving House by about three hundred firemen in their red shirts, bearing torches. At least twenty thousand persons were present. The calls for Jenny Lind were so vehement that I led her through a window to the balcony. The loud cheers from the throng lasted for several minutes, before the serenade was permitted again to proceed.

I have here briefly intimated a portion of the incidents of Jenny Lind's first day in America. For weeks afterwards the excitement was unabated. Her rooms were thronged by visitors, including the magnates of the land in both Church and State. The carriages of the *beau monde* could be seen in front of her hotel at all fashionable hours, and it was with some difficulty that I prevented the fashionables from monopolizing her altogether, and thus, as I believed, sadly marring my interests by cutting her off from the warm sympathies which she had awakened among the masses. Presents of all sorts were showered upon her. Milliners, mantua-makers, and shopkeepers vied with each other in calling her attention to their wares,

of which they sent her many valuable specimens, delighted if in return they could receive her autograph acknowledgment. Songs, quadrilles and polkas were dedicated to her, and poets sung in her praise. We had Jenny Lind gloves, Jenny Lind bonnets, Jenny Lind riding hats, Jenny Lind shawls, mantillas, robes, chairs, sofas, pianos – in fact, every thing was Jenny Lind.

Her movements were constantly watched, and the moment her carriage appeared at the door, it was surrounded by multitudes, eager to catch a glimpse of the Swedish Nightingale.

In looking over my "scrap-books" of extracts from the New York papers of that day, in which all accessible details concerning her were duly chronicled, it seems almost incredible that such a degree of enthusiasm should have existed.

An abstract of the "sayings and doings" in regard to the Jenny Lind mania for the first ten days after her arrival, appeared in the London Times of Sept. 23, 1850, and although it was an ironical "showing up" of the American enthusiasm, filling several columns, it was nevertheless a faithful condensation of facts, which at this late day seem even to myself more like a dream than reality.

Before her arrival I had offered $200 for a prize ode, "Greeting to America," to be sung by Jenny Lind at her first concert. Several hundred poems were sent in from all parts of the United States and the Canadas. The duties of the Prize Committee, in reading these effusions and making choice of the one most worthy the prize, were truly arduous. The "offerings" were the merest doggerel trash, with perhaps a dozen exceptions. The prize was awarded to Bayard Taylor for the following ode:

GREETING TO AMERICA.

WORDS BY BAYARD TAYLOR – MUSIC BY JULIUS BENEDICT.

I greet with a full heart the Land of the West,
 Whose Banner of Stars o'er a world is unrolled;
Whose empire o'ershadows Atlantic's wide breast,
 And opens to sunset its gateway of gold!
The land of the mountain, the land of the lake,
 And rivers that roll in magnificent tide –
Where the souls of the mighty from slumber awake,
 And hallow the soil for whose freedom they died!

Thou Cradle of Empire! though wide be the foam
 That severs the land of my fathers and thee,
I hear, from thy bosom, the welcome of home,
 For Song has a home in the hearts of the Free!
And long as thy waters shall gleam in the sun,
 And long as thy heroes remember their scars,
Be the hands of thy children united as one,
 And Peace shed her light on thy Banner of Stars!

This award, although it gave general satisfaction, yet was met with disfavor by several disappointed poets, who, notwithstanding the decision of the committee, persisted in believing and declaring their own productions to be the best. This state of feeling was doubtless, in part, the cause which led to the publication, at about this time, of a very witty pamphlet entitled.

"Barnum's Parnassus; being Confidential Disclosures of the Prize Committee on the Jenny Lind Song."

It gave some capital hits, in which the committee, the enthusiastic public, the Nightingale, and myself, "suffered some." The following is a pretty good specimen from the work in question:

BARNUMOPSIS.

A RECITATIVE.

When to the common rest that crowns his days,
 Dusty and worn the tired pedestrian goes,
What light is that whose wide o'erlooking blaze
 A sudden glory on his pathway throws?

'Tis not the setting sun, whose drooping lid
 Closed on the weary world at half-past six;
'Tis not the rising moon, whose rays are hid
 Behind the city's sombre piles of bricks.

It is the Drummond Light, that from the top
 Of Barnum's massive pile, sky-mingling there,
Darts its quick gleam o'er every shadowed shop,
 And gilds Broadway with unaccustomed glare.

There o'er the sordid gloom, whose deep'ning tracks
 Furrow the city's brow, the front of ages,
Thy loftier light descends on cabs and hacks,
 And on two dozen different lines of stages!

O twilight Sun, with thy far-darting ray,
 Thou art a type of him whose tireless hands
Hung thee on high to guide the stranger's way,
 Where, in its pride, his vast Museum stands.

Him, who in search of wonders new and strange,
 Grasps the wide skirts of Nature's mystic robe,
Explores the circles of eternal change,
 And the dark chambers of the central globe.

He, from the reedy shores of fabled Nile,
 Has brought, thick-ribbed and ancient as old iron,
That venerable beast the crocodile,
 And many a skin of many a famous lion.

Go lose thyself in those continuous halls,
 Where strays the fond papa with son and daughter,
And all that charms or startles or appals,
 Thou shalt behold, and for a single quarter!

Far from the Barcan deserts now withdrawn,
 There huge constrictors coil their scaly backs,
There, cased in glass, malignant and unshorn,
 Old murderers glare in sullenness and wax.

There many a varied form the sight beguiles,
 In rusty broad-cloth decked and shocking hat,
And there the unwieldy Lambert sits and smiles
 In the majestic plenitude of fat.

Or for thy gayer hours, the orang-outang
 Or ape salutes thee with his strange grimace,
And in their shapes, stuffed as on earth they sprang,
 Thine individual being thou canst trace!

And joys the youth in life's green spring, who goes
 With the sweet babe and the gray-headed nurse,
To see those Cosmoramic orbs disclose
 The varied beauties of the universe.

And last, not least, the marvellous Ethiope,
 Changing his skin by preternatural skill,
Whom every setting sun's diurnal slope
 Leaves whiter than the last, and whitening still.

All that of monstrous, scaly, strange and queer,
 Has come from out the womb of earliest time,
Thou hast, O Barnum, in thy keeping here,
 Nor is this all – for triumphs more sublime

Await thee yet! I, Jenny Lind, who reigned
 Sublimely throned, the imperial queen of song,
Wooed by thy golden harmonies, have deigned
 Captive to join the heterogeneous throng.

Sustained by an unfaltering trust in coin,
 Dealt from thy hand, O thou illustrious man,
Gladly I heard the summons come to join
 Myself the innumerable caravan.

Besides the foregoing, this pamphlet contained eleven poems, most of which abounded in wit. I have room for but a single stanza. The poet speaks of the various curiosities in the Museum, and representing me as still searching for further novelties, makes me address the Swedish Nightingale as follows:

"So Jenny, come along! you're just the card for me,
And quit these kings and queens, for the country of the free;
They'll welcome you with speeches, and serenades, and rockets,
And you will touch their hearts, and I will tap their pockets;
And if between us both the public isn't skinned,
Why, my name isn't Barnum, nor your name Jenny Lind!"

Jenny Lind's first concert was fixed to come off at Castle Garden, on Wednesday evening, September 11, and most of the tickets were sold at auction on the Saturday and Monday previous

to the concert. Genin the hatter laid the foundation of his fortune by purchasing the first ticket at $225.*

The proprietors of the Garden saw fit to make the usual charge of one shilling to all persons who entered the premises, yet three thousand persons were present at the auction. One thousand tickets were sold on the first day for an aggregate sum of $10,141.

On the Tuesday after her arrival I informed Miss Lind that I wished to make a slight alteration in our agreement. "What is it?" she asked in surprise.

"I am convinced," I replied, "that our enterprise will be much more successful than either of us anticipated. I wish, therefore, to stipulate that you shall always receive $1000 for each concert, besides all the expenses, as heretofore agreed on, and that after taking $5500 per night for expenses and my services, the balance shall be equally divided between us."

Jenny looked at me with astonishment. She could not comprehend my proposition. After I had repeated it, and she fully understood its import, she grasped me cordially by the hand, and exclaimed, "Mr. Barnum, you are a gentleman of honor. You are generous. It is just as Mr. Bates told me. I will sing for you as long as you please. I will sing for you in America – in Europe – anywhere!"

Upon drawing the new contract, a condition was inserted, by Miss Lind's request, that she should have the right to terminate the engagement with the one hundredth concert, instead of the hundred and fiftieth, if she should desire to do so, upon paying me $25,000.

Let it not be supposed that the increase of her compensation was wholly an act of generosity on my part. I had become convinced that there was money enough in the enterprise for all of us, and I also felt that although she should have been satisfied by my complying with the terms of the agreement, yet envious persons would doubtless endeavor to create discontent in her mind, and it would be a stroke of policy to prevent the possibility of such an occurrence.

On Tuesday, September 10, I informed Miss Lind that, judging by present appearances, her portion of the proceeds of the first concert would amount to $10,000. She immediately resolved to

*It has been extensively believed that Mr. Genin and myself are brothers-in-law. Our relations are merely those of friendship and business.

devote every dollar of it to charity; and, sending for Mayor Woodhull, she acted under his and my advice in selecting the various institutions among which she wished the amount to be distributed.

My arrangements of the concert room were very complete. The great *parterre* and gallery of Castle Garden were divided by imaginary lines into four compartments, each of which was designated by a lamp of a peculiar color. The tickets were printed in colors corresponding with the location which the holders were to occupy, and one hundred ushers, with rosettes and bearing wands tipped with ribbons of the same hue, enabled every individual to find his or her seat without the slightest difficulty. Every seat was of course numbered to correspond with the check, which each person retained after giving up an entrance ticket at the door. These arrangements were duly advertised, and every particular was also printed upon each ticket. In order to prevent confusion, the doors were opened at five o'clock, although the concert did not commence until eight. The consequence was, that although five thousand persons were present at the first concert, their entrance was marked with as much order and quiet as was ever witnessed in the assembling of a congregation at church. These precautions were observed at all the concerts given throughout the country under my administration, and the good order which always prevailed was the subject of numberless encomiums from the public and the press.

The reception of Jenny Lind on her first appearance, in point of enthusiasm, was probably never before equalled in the world. As Mr. Benedict led her towards the foot-lights, the entire audience rose to their feet and welcomed her with three cheers, accompanied by the waving of thousands of hats and handkerchiefs. This was by far the largest audience that Jenny had ever sung before. She was evidently much agitated, but the orchestra commenced, and before she had sung a dozen notes of "Casta Diva," she began to recover her self-possession, and long before the *scena* was concluded, she was as calm as if sitting in her own drawing-room. Towards the last portion of the *cavatina*, the audience were so completely carried away by their feelings, that the remainder of the air was drowned in a perfect tempest of acclamation. Enthusiasm had been wrought to its highest pitch, but the musical powers of Jenny Lind exceeded all the brilliant anticipations which had been formed, and her triumph was complete.

At the conclusion of the concert, Jenny Lind was loudly called for, and was obliged to appear three times before the audience could

be satisfied. They then called vociferously for "Barnum," and I reluctantly responded to their demand.

On this first night, Mr. Julius Benedict confirmed with the American people his European reputation, as a most accomplished conductor and musical composer; while Signor Belletti inspired an admiration which grew warmer and deeper in the minds of the American people, to the end of his career in this country.

It would seem as if the Jenny Lind mania had reached its culminating point before hearing her, and I confess that I feared the anticipations of the public were too high to be realized, and hence that there would be a reaction after the first concert, but I was happily disappointed. The transcendent musical genius of the Swedish Nightingale was superior to all the pictures which fancy could paint, and the *furore* did not attain its highest point until she had been heard. The people were in ecstasies; the powers of editorial acumen, types and ink, were inadequate to sound her praises. The Rubicon was passed. The successful issue of the Jenny Lind enterprise was established. I think there were a hundred men in New York, the day after her first concert, who would have willingly paid me $200,000 for my contract. I received repeated offers for an eighth, a tenth, or a sixteenth, equivalent to that price. But mine had been the risk, and I was determined mine should be the triumph. So elated was I with my success, in spite of all obstacles and false prophets, that I do not think a million of dollars would have tempted me to relinquish the enterprise.

No one can imagine the amount of head-work and hand-work which I performed during the first four weeks after Jenny Lind's arrival. Anticipating much of this, I had spent some time in August at the White Mountains to recruit my energies. Of course I had not been idle during the summer. I had put innumerable means and appliances into operation for the furtherance of my object, and little did the public see of the hand that indirectly pulled at their heartstrings, preparatory to a relaxation of their purse-strings; and these means and appliances were continued and enlarged throughout the whole of that triumphal musical campaign.

After the first month the business became somewhat systematized, and by the help of such agents as my faithful treasurer, L. C. Stewart, and the indefatigable Le Grand Smith, my labors were materially relieved; but from the first concert on the 11th of September, 1850, until the ninety-third concert on the 9th of June, 1851, (a space of nine months,) I did not know a waking moment that was entirely free from oppressive anxiety.

I could not hope to be exempted from trouble and perplexity in managing an enterprise which depended altogether on popular favor, and which involved great consequences to myself; but I did not expect the numerous petty annoyances which beset me, especially in the early period of the concerts. Miss Lind did not dream, nor did anybody else, of the unparalleled enthusiasm that would greet her; and the immense assembly at Castle Garden somewhat prepared her, I suspect, to listen to evil advisers. It would seem that the terms of our contract were sufficiently liberal to *her* and sufficiently hazardous to myself, to justify the expectation of perfectly honorable treatment, (and of large profits too, because the risks were great;) but certain envious intermeddlers appeared to feel differently. "Do you not see, Miss Lind, that Mr. Barnum is coining money out of your genius?" said they. Of course she saw it, and perhaps regretted that she had not marked a figure somewhat higher than $1000 per concert, net; but the high-minded Swede despised and spurned such advisers as recommended her to repudiate her contract with me at all hazards, and take the enterprise into her own hands – possibly to put it into theirs. I however suffered much from the unreasonable interference of her lawyer. Benedict and Belletti behaved like men, and Jenny afterwards expressed to me her regret that she had for a moment listened to the vexatious exactions of her legal counsellor.

The great assembly at Castle Garden was not gathered by Jenny Lind's great musical genius and powers alone. She was effectually brought before the public before they had seen or heard her. She appeared in the presence of a jury already excited to enthusiasm in her behalf. She more than met their expectations, and all the means I had adopted to prepare the way were thus abundantly justified.

As a manager, I worked by setting others to work. Biographies of the Swedish Nightingale were largely circulated; "Foreign Correspondence" glorified her talents and triumphs by narratives of her benevolence; and "printer's ink" was employed, in every possible form, to put and keep Jenny Lind before the people. I am happy to say that the Press generally echoed the voice of her praise, from first to last. I could fill many volumes with printed extracts now in my "scrap books." They are nearly all of a similar tenor to the following unbought, unsolicited editorial article, which appeared in the "New York Herald," of September 10, 1850, (the day before the first concert given by Miss Lind in the United States:)

"JENNY LIND AND THE AMERICAN PEOPLE. – What ancient monarch was he, either in history or in fable, who offered half his kingdom (the price of box tickets and choice seats in those days) for the invention of an original sensation, or the discovery of a fresh pleasure? That sensation – that pleasure which royal power in the old world failed to discover, has been called into existence at a less price, by Mr. Barnum, a plain republican, and is now about to be enjoyed by the sovereigns of the new world.

"Jenny Lind, the most remarkable phenomenon in musical art which has for the last century flashed across the horizon of the old world, is now among us, and will make her *debut* to-morrow night to a house of nearly ten thousand listeners, yielding, in proceeds by auction, a sum of forty or fifty thousand dollars. For the last ten days our musical reporters have furnished our readers with every matter connected with her arrival in this metropolis, and the steps adopted by Mr. Barnum in preparation for her first appearance. The proceedings of yesterday, consisting of the sale of the remainder of the tickets, and the astonishing – the wonderful sensation produced at her first rehearsal on the few persons, critics in musical art, who were admitted on the occasion, will be found elsewhere in our columns.

"We concur in every thing that has been said by our musical reporter, describing her extraordinary genius – her unrivalled combination of power and art. Nothing has been exaggerated, not an iota. Three years ago, more or less, we heard Jenny Lind on many occasions, when she made the first great sensation in Europe, by her *début* at the London Opera House. *Then* she was great in power – in art – in genius; *now* she is greater in all. We speak from experience and conviction. Then she astonished, and pleased, and fascinated the thousands of the British aristocracy; now she will fascinate, and please, and delight, and almost make mad with musical excitement, the millions of the American democracy. To-morrow night, this new sensation – this fresh movement – this excitement excelling all former excitements – will be called into existence, when she pours out the notes of *Casta Diva*, and exhibits her astonishing powers – her wonderful peculiarities, that seem more of heaven than of earth – more of a voice from eternity, than from the lips of a human being.

"We speak soberly – seriously – calmly. The public expectation has run very high for the last week – higher than at any former period of our past musical annals. But high as it has risen, the reality – the fact – the concert – the voice and power of Jenny Lind will

far surpass all past expectation. Jenny Lind is a wonder, and a prodigy in song – and no mistake."

Upon settling the receipts of the first concert, they were found to be somewhat less than I anticipated. The sums bid at the auction sales, together with the tickets purchased at private sale, amounted to more than $20,000. It proved, however, that many of the tickets bid off at from $12 to $25 each, were not called for. In some instances, probably the zeal of the bidders cooled down when they came out from the scene of excitement, and once more breathed the fresh sea-breeze which came sweeping up from "the Narrows," while perhaps, in other instances, bids were made by parties who never intended to take the tickets. I can only say, once for all, that I was never privy to a false bid, and was so particular upon that point, that I would not permit one of my employees to bid on or purchase a ticket at auction, though requested to do so for especial friends.

The amount of money received for tickets to the first concert was $17,864.05. As this made Miss Lind's portion too small to realize the $10,000 which had been announced as devoted for charity, I proposed to divide equally with her the proceeds of the first two concerts, and not count them at all in our regular engagement. Accordingly, the second concert was given September 13, and the receipts, amounting to $14,203.03, were, like those of the first concert, equally divided. Our third concert, but which, as between ourselves, we called the "first regular concert," was given on Tuesday, September 17, 1850.

It is not my purpose to enter into details of all Jenny Lind's concerts. I have, however, prepared a table of the place and total receipts of each concert, which, besides gratifying curiosity, will sufficiently indicate our route of travel, and shall here devote a few pages to the incidents which I think will be most interesting to the public.

Jenny Lind's character for benevolence became so generally known, that her door was beset by persons asking charity, and she was in the receipt, while in the principal cities, of numerous letters, all on the same subject. Her secretary examined and responded favorably to some of them. He undertook at first to answer them all, but finally abandoned that course in despair. I knew of many instances in which she gave sums of money to applicants, varying in amount from $20, $50, $500, to $1000, and in one instance $5000, to a Swedish friend; and none but "He who seeth in secret," knows the extent of her benevolence.

One night, while giving a concert in Boston, a girl approached the ticket-office, and laying down $3 for a ticket, remarked, "There goes half a month's earnings, but I am determined to hear Jenny Lind." Her secretary heard the remark, and a few minutes afterwards coming into Jenny's room, he laughingly related to her the circumstance. "Would you know the girl again?" asked Jenny, with an earnest look. Upon receiving an affirmative reply, she placed a $20 gold-piece in his hand, and said, "Poor girl! give her that with my best compliments."

The night after Jenny's arrival in Boston a good display of fireworks was given in her honor, in front of the Revere House, after which followed a beautiful torch-light procession by the Germans of that city.

On her return from Boston to New York, Jenny, her companion, and Messrs. Benedict and Belletti, stopped at my residence in Bridgeport, where they remained until the following day. The morning after her arrival, she took my arm and proposed a promenade through the grounds. She seemed much pleased, and said, "I am astonished that you should have left such a beautiful place for the sake of travelling through the country with me."

The same day she told me in a playful mood that she had heard a most extraordinary report. "I have heard that you and I are about to be married," said she; "now how could such an absurd report ever have originated?" she continued.

"Probably from the fact that we are 'engaged,'" I replied. She enjoyed a joke, and laughed heartily.

Jenny always desired to reach a place in which she was to sing, without having the time of her arrival known, thus avoiding the excitement of promiscuous crowds. I considered however that the interests of the enterprise depended in a great degree upon these excitements. Although it frequently seemed inconceivable to her how so many thousands should have discovered her secret and consequently gathered together to receive her, *I* was not so much astonished, inasmuch as my agent always had early telegraphic intelligence of the time of her anticipated arrival, and was not slow in communicating the information to the public.

On reaching Philadelphia, a large concourse of persons awaited the approach of the steamer which conveyed her. With difficulty we pressed through the crowd, and were followed by many thousands to Jones's Hotel. The street in front of the building was densely packed by the populace, and poor Jenny, who was suffering under

a severe headache, retired to her apartments. I tried to induce the crowd to disperse, but they declared they would not do so until Jenny Lind should appear upon the balcony. I would not disturb her, and knowing that the tumult might prove an annoyance to her, I placed her bonnet and shawl upon her companion, Miss Ahmansen, and led her out on the balcony. She bowed gracefully to the multitude, who gave her three hearty cheers and quietly dispersed. Miss Lind was so utterly averse to any thing like deception, that we never ventured to tell her the part which her bonnet and shawl had played in the absence of their owner.

Jenny was in the habit of attending church whenever she could do so without attracting notice. She always preserved her nationality also, by inquiring out and attending Swedish churches wherever they could be found. She gave $1000 to a Swedish church in Chicago.

While in Boston, a poor Swedish girl, a domestic in a family at Roxbury, called on Jenny. She detained her visitor several hours, talking about "home" and other matters, and in the evening took her in her carriage to the concert, gave her a seat, and sent her back to Roxbury in a carriage at the close of the performances. I have no doubt the poor girl carried with her substantial evidences of her countrywoman's bounty.

My daughter Caroline, and her friend Mrs. Lyman, of Bridgeport, accompanied me on the tour from New York to Havana, and thence home *via* New Orleans and the Mississippi.

We were at Baltimore on the Sabbath, and my daughter, accompanying a friend to church who resided in the city, took a seat with her in the choir, and joined in the singing. A number of the congregation, who had seen Caroline with me the day previous, and supposed her to be Jenny Lind, were yet laboring under the same mistake, and it was soon whispered through the church that Jenny Lind was in the choir! The excitement was worked to its highest pitch when my daughter arose as one of the musical group. Every ear was on the alert to catch the first notes of her voice, and when the notes gushed forth, glances of satisfaction passed through the assembly. Caroline, quite unconscious of the attention she attracted, continued to sing to the end of the hymn. Not a note was lost upon the ears of the attentive congregation. "What an exquisite singer!" "Heavenly sounds!" "I never heard the like!" and similar expressions were whispered through the church.

At the conclusion of the services, my daughter and her friend

found the passage way to their carriage blocked up by a crowd of persons who were anxious to obtain a nearer view of the Swedish Nightingale. The *cause* of the excitement now for the first time discovered what a mistake the people were laboring under, but she did not undeceive them, and many persons that afternoon boasted, in good faith, that they had listened to the extraordinary singing of the great Swedish songstress. The pith of the joke is that we have never discovered that my daughter has any extraordinary claims as a vocalist.

Our orchestra in New York consisted of sixty. When we started on our southern tour, we took with us permanently as the orchestra, twelve of the best musicians we could select, and in New Orleans augmented the force to sixteen. We increased the number to thirty-five, forty or fifty, as the case might be, by choice of musicians residing where the concerts were given. On our return to New York from Havana, we enlarged the orchestra to one hundred persons.

The morning after our arrival in Washington, President Fillmore called, and left his card, Jenny being out. When she returned and found the token of his attention, she was in something of a flurry. "Come," said she, "we must call on the President immediately."

"Why so?" I inquired.

"Because he has called on *me*, and of course that is equivalent to a *command* for me to go to his house."

I assured her that she might make her mind at ease, for whatever might be the custom with crowned heads, our Presidents were not wont to "command" the movements of strangers, and that she would be quite in time if she returned his call the next day. She did so, and was charmed with the unaffected bearing of the President, and the warm kindnesses expressed by his amiable wife and daughter, (now, alas! both tenants of the grave,) and consented to spend the evening with them in conformity with their request. She was accompanied to the "White House" by Messrs. Benedict, Belletti and myself, and several happy hours were spent in the private circle of the President's family.

Mr. Benedict, who engaged in a long quiet conversation with Mr. Fillmore, was highly pleased with the interview. A foreigner, accustomed to court etiquette, is generally surprised at the simplicity which characterizes the Chief Magistrate of this Union. In 1852 I called on the President with my friend Brettell, of London, who

resides in St. James Palace, and is quite a worshipper of the Queen, and an ardent admirer of all the dignities and ceremonies of royalty. He expected something of the kind in visiting the President of the United States, and was highly pleased with his disappointment.

Both concerts in Washington were attended by the President and his family, and every member of the Cabinet. I noticed also among the audience, Messrs. Clay, Benton, Cass, General Scott, etc. On the following morning, she was called upon by Mr. Webster, Mr. Clay, General Cass, and Colonel Benton, and all parties were evidently gratified. I had introduced Mr. Webster to Jenny in Boston. Upon hearing one of her wild mountain songs in New York, also in Washington, Mr. Webster signified his approval by rising, drawing himself up to his full height, and making a profound bow. Jenny was delighted by this expression of praise from the great statesman.

We visited the Capitol while both Houses were in session. Miss Lind took the arm of Hon. C. F. Cleveland, representative from Connecticut, and was by him escorted into various parts of the Capitol, the grounds, etc., with all of which she was much pleased.

While in Washington, I was invited with Miss Lind and her immediate friends to visit Mount Vernon, with Colonel Washington, the present proprietor, and Mr. Seaton, ex-Mayor of Washington, and Editor of the Intelligencer. Colonel Washington chartered a steamboat for the purpose. We were landed a short distance from the tomb, which we first visited. Proceeding to the house, we were introduced to Mrs. Washington and several other ladies. Much interest was manifested by Miss Lind in examining the mementoes of the great man whose home it had been. A beautiful collation was spread out and arranged in fine taste. Before leaving, Mrs. Washington presented Jenny with a book from the library, with the name of Washington written by his own hand. She was much overcome at receiving this present, called me aside, and expressed her desire to give something in return. "I have nothing with me," she said, "excepting this watch and chain, and I will give that if you think it will be acceptable." I knew the watch was very valuable, and told her that so costly a present would not be expected, nor would it be proper. "The expense is nothing, compared to the value of that book," she replied with deep emotion; "but as the watch was a present from a dear friend, perhaps I should not give it away." Jenny Lind, I am sure, will never forget the pleasurable emotions of that day.

At Richmond, half an hour previous to her departure, hundreds

of young ladies and gentlemen had crowded into the halls of the house to secure a glimpse of her at parting. I informed her that she would find difficulty in passing out. "How long is it before we must start?" she asked. "Half an hour," I replied. "Oh, I will clear the passages before that time," said she with a smile; whereupon she went into the upper hall, and informed the people that she wished to take the hands of every one of them, upon one condition, viz.: they should pass by her in rotation, and as fast as they had shaken hands, proceed down stairs, and not block up the passages any more. They joyfully consented to the arrangement, and in fifteen minutes the course was clear. Poor Jenny had shaken hands with every person in the crowd, and I presume she had a *feeling* remembrance of the incident for an hour or two at least. She was waited on by many members of the Legislature while in Richmond, that body being in session while we were there.

The voyage from Wilmington to Charleston was an exceedingly rough and perilous one. We were about thirty-six hours in making the passage, the usual time being seventeen. There was really great danger of our steamer being swamped, and we were all apprehensive that we should never reach the port of Charleston alive. Some of the passengers were in great terror. Jenny Lind exhibited more calmness upon this occasion than any other person, the crew excepted. Occasionally when a heavy wave dashed against our vessel, forcing it upon one side, she was startled, but instantly recovering herself, she would say in a low voice, "A kind Father controls all; let His will be done." We arrived safely at last, and I was grieved to learn that for twelve hours the loss of the steamer had been considered certain, and the same had been announced by telegraph in the northern cities.

We remained at Charleston about ten days, to take the steamer Isabel on her regular trip to Havana. Jenny had been through so much excitement at the North, that she determined to have quiet here, and therefore declined receiving any calls. This disappointed many ladies and gentlemen. One young lady, the daughter of a wealthy planter near Augusta, was so determined upon seeing her in private, that she paid one of the servants to allow her to put on a cap and white apron, and carry in the tray for Jenny's tea. I afterwards told Miss Lind of the joke, and suggested that after such an evidence of admiration, she should receive a call from the young lady.

"It is not admiration – it is only *curiosity*," replied Jenny, "and I will not encourage such folly."

Christmas was at hand, and Jenny determined to honor it in the way she had often done in Sweden. She had a beautiful Christmas tree privately prepared, and from its boughs depended a variety of presents for members of the company. These gifts were encased in paper, with the names of the recipients written on each.

After spending a pleasant evening in her drawing-room, she invited us into the parlor, where the "surprise" awaited us. Each person commenced opening the packages bearing his or her address, and although every individual had one or more pretty presents, she had prepared a joke for each. Mr. Benedict, for instance, took off wrapper after wrapper from one of his packages, which at first was as large as his head, but after having removed some forty coverings of paper, it was reduced to a size smaller than his hand, and the removal of the last envelope exposed to view a piece of cavendish tobacco. One of *my* presents, choicely wrapped in a dozen coverings, was a jolly young *Bacchus* in Parian marble – intended as a pleasant hit at my temperance principles!

The night before New-Year's day was spent in her apartment with great hilarity. Enlivened by music, singing, dancing, and story-telling, the hours glided swiftly away. Miss Lind asked me if I would dance with her. I told her my education had been neglected in that line, and that I had never danced in my life. "That is all the better," said she; "now dance with me in a cotillion. I am sure you can do it." Jenny is a beautiful dancer, and I never saw her laugh more heartily than she did at my awkwardness. She said she would give me the credit of being the poorest dancer she ever saw!

About a quarter before twelve, Jenny suddenly checked our merriment, by saying, "Pray, let us have quiet; do you see, in fifteen minutes more, this year will be gone for ever!"

She immediately took a seat, and rested her head upon her hand in silence. We all followed her example, and for a quarter of an hour of the most profound quiet reigned in the apartment. The remainder of the scene I transcribe from a description written the next day by Mrs. Lyman, who was present on the occasion:

"The clock of a neighboring church struck the knell of the dying year. All were silent – each heart was left to its own communings, and the bowed head and tearful eye told that memory was busy with the Past. It was a brief moment, but thoughts and feelings were crowded into it, which render it one never to be forgotten. A moment more – the last stroke of the clock had fallen upon the ear – the last

faint vibration ceased; another period of time had passed for ever away – a new one had dawned, in which each felt that they were to live and act. This thought recalled them to a full consciousness of the present, and all arose and quietly but cordially presented to each other the kind wishes of the season. As the lovely hostess pressed the hands of her guests, it was evident that she too had wept – she, the gifted, the admired, the almost idolized one. Had she, too, cause for tears? Whence were they? – from the overflowings of a grateful heart, from tender associations, or from sad remembrances? None knew, none could ask, though they awakened deep and peculiar sympathy. And from one heart, at least, arose the prayer, that when the dial of time should mark the last hour of her earthly existence, she should greet its approach with joy and not with grief – that to her soul spirit-voices might whisper, 'Come, sweet sister! come to the realms of unfading light and love – come, join your seraphic tones with ours, in singing the praises of Him who loved us, and gave himself for us' – while she, with meekly-folded hands and faith-uplifted eye, should answer, 'Yes, gladly and without fear I come, for I KNOW THAT MY REDEEMER LIVETH.'"

I had arranged with a man in New York to transport furniture to Havana, provide a house, and board Jenny Lind and our immediate party during our stay. When we arrived, we found the building converted into a semi-hotel, and the apartments left unoccupied were any thing but comfortable. Jenny was vexed. Soon after dinner, she took a volante and an interpreter, and drove into the suburbs. She was absent four hours. Whither or why she had gone, none of us knew. At length she returned and informed us that she had hired a commodious furnished house in a delightful location outside the walls of the city, and invited us all to go and live with her during our stay in Havana. We did so, and a more agreeable month than was spent there by all the party, it would be difficult to conceive.

Jenny was now freed from all annoyances; her time was her own, she received no calls, went and came when she pleased, had no meddlesome advisers about her, legal or otherwise, and was as merry as a cricket. We had a large court-yard in the rear of the house, and here she would come and romp and run, sing and laugh, like a young school-girl. "Now, Mr. Barnum, for another game of ball," she would say half a dozen times a day; whereupon she would take an india-rubber ball, (of which she had two or three,) and commence a game of throwing and catching, which would be kept

up until, being completely tired out, I would say, "I give it up." Then her rich, musical laugh would be heard ringing through the house, as she exclaimed, "Oh, Mr. Barnum, you are too fat and too lazy; you cannot stand it to play ball with me!"

Her countrywoman, Miss Bremer, spent a few days with us very pleasantly.

I found, soon after arriving in Havana, that a strong prejudice existed against our musical enterprise. I might rather say that the Habaneros, not accustomed to the high figure which tickets had commanded in the States, were determined on forcing me to adopt their opera prices – whereas I paid $1000 per night for the Tacon Opera House, and other expenses being in proportion, I was determined to receive remunerating prices, or give no concerts. This determination on my part annoyed the Habaneros, who did not wish to be thought penurious, though they really were so. Their principal spite, therefore, was against *me*; and one of their papers politely termed me a "Yankee pirate," who cared for nothing excepting their doubloons. They attended the concert, but were determined to show the great songstress no favor. I perfectly understood this feeling in advance, but studiously kept all knowledge of it from Miss Lind. I went to the first concert, therefore, with some misgivings regarding her reception. The following article, which I copy from the Havana correspondence of the New York Tribune, gives a correct account of it:

"Jenny Lind soon appeared, led on by Signor Belletti. Some three or four hundred persons clapped their hands at her appearance, but this token of approbation was instantly silenced by at least two thousand five hundred decided hisses. Thus, having settled the matter that there should be no *forestalling* of public opinion, and that if applause was given to Jenny Lind in that house it should first be incontestably *earned*, the most solemn silence prevailed. I have heard the Swedish Nightingale often in Europe as well as America, and have ever noticed a distinct tremulousness attending her first appearance in any city. Indeed this feeling was plainly manifested in her countenance as she neared the foot-lights; but when she witnessed the kind of reception in store for her – so different from any thing she had reason to expect – her countenance changed in an instant to a haughty self-possession, her eye flashed defiance, and, becoming immovable as a statue, she stood there, perfectly calm and beautiful. She was satisfied that she now had an ordeal to pass and a victory

to gain worthy of her powers. In a moment her eye scanned the immense audience, the music began, and then followed – how can I describe it? – such heavenly strains as I verily believe mortal never breathed except Jenny Lind, and mortal never heard except from her lips. Some of the oldest Castilians kept a frown upon their brow and a curling sneer upon their lip; their ladies, however, and most of the audience began to look surprised. The gushing melody flowed on increasing in beauty and glory. The *caballeros*, the *señoras* and *señoritas* began to look at each other; nearly all, however, kept their teeth clenched and their lips closed, evidently determined to resist to the last. The torrent flowed faster and faster, the lark flew higher and higher, the melody grew richer and richer; still every lip was compressed. By and by, as the rich notes came dashing in rivers upon our enraptured ears, one poor critic involuntarily whispered a 'brava.' This outbursting of the soul was instantly hissed down. The stream of harmony rolled on till, at the close, it made a clean sweep of every obstacle, and carried all before it. Not a vestige of opposition remained, but such a tremendous shout of applause as went up was never before heard.

"The triumph was most complete. And how was Jenny Lind affected? She, who stood a few moments previous like adamant, now trembled like a reed in the wind before the storm of enthusiasm which her own simple notes had produced. Tremblingly, slowly, and almost bowing her face to the ground, she withdrew. The roar and applause of victory increased. *Encore! encore! encore!* came from every lip. She again appeared, and, curtsying low, again withdrew; but again, again, and again did they call her forth, and at every appearance the thunders of applause rang louder and louder. Thus *five* times was Jenny Lind called out to receive their unanimous and deafening plaudits."

I cannot express what my feelings were as I watched this scene from the dress circle. Poor Jenny! I deeply sympathized with her when I heard that first hiss. I indeed observed the resolute bearing which she assumed, but was apprehensive of the result. When I witnessed her triumph, I could not restrain the tears of joy that rolled down my cheeks; and rushing through a private box, I reached the stage just as she was withdrawing after the fifth encore. "God bless you, Jenny, you have settled them!" I exclaimed.

"Are you satisfied?" said she, throwing her arms around my neck. She, too, was crying with joy, and never before did she look so beautiful in my eyes as on that evening.

One of the Havana papers, notwithstanding the great triumph, continued to cry out for low prices. This induced many to absent themselves, expecting soon to see a reduction. It had been understood that we would give twelve concerts in Havana; but when they saw, after the fourth concert, which was devoted to charity, that no more were announced, they became uneasy. Committees waited upon us requesting more concerts, but we peremptorily declined. Some of the leading Dons, among whom was Count Penalver, then offered to guarantee us $25,000 for three concerts. My reply was, that there was not money enough on the island of Cuba to induce me to consent to it. That settled the matter, and gave us a pleasant opportunity for recreation.

We visited, by invitation, Mr. Brinckerhoff, the eminent American merchant at Matanzas whom I had met at the same place three years previously, and who subsequently had visited my family in Connecticut. The gentlemanly host did every thing in his power to render our stay agreeable; and Jenny was so delighted with his attentions and the interesting details of sugar and coffee plantations which we visited through his kindness, that as soon as she returned to Havana, she sent on the same tour of pleasure Mr. Benedict, who had been prevented by illness from accompanying us.

I found my little Italian plate-dancer, VIVALLA, in Havana. He called on me frequently. He was in great distress, having lost the use of his limbs on the left side of his body by paralysis. He was thus unable to earn a livelihood, although he still kept a performing dog, which turned a spinning-wheel and performed some curious tricks. One day, as I was passing him out of the front gate, Miss Lind inquired who he was. I briefly recounted to her his history. She expressed deep interest in his case, and said something should be set apart for him in the "benefit" which she was about to give for charity. Accordingly, when the benefit came off, Miss Lind appropriated $500 to him, and I made the necessary arrangements for his return to his friends in Italy. At the same benefit $4000 was distributed between two humane hospitals and a convent.

A few mornings after the benefit our bell was rung, and the servant announced that I was wanted. I went to the door and found a large procession of children, neatly dressed and bearing banners, attended by ten or twelve priests, arrayed in their rich and flowing robes. I inquired their business, and was informed that they had come to see Miss Lind, to thank her in person for her benevolence. I took their message, and informed Miss Lind that the leading priests

of the convent had come in great state to see and thank her. "I will not see them," she replied; "they have nothing to thank me for. If I have done good, it is no more than my duty, and it is my pleasure. I do not deserve their thanks. I will not see them." I returned her answer, and the leaders of the grand procession turned away in disappointment.

The same day Vivalla called, and brought her a basket of the most luscious fruit that he could procure. The little fellow was very happy and extremely grateful. Miss Lind had gone out for a ride.

"God bless me! I am so happy; she is such a good lady. I shall see my brothers and sisters again. Oh, she is a very good lady," said poor Vivalla, overcome by his feelings. He begged me to thank her for him, and give her the fruit. As he was passing out of the door, he hesitated a moment, and then said, "Mr. Barnum, I should like so much to have the good lady see my dog turn a wheel; it is very nice; he can spin very good. Shall I bring the dog and wheel for her? She is such a good lady, I wish to please her very much." I smiled, and told him she would not care for the dog; that he was quite welcome to the money, and that she refused to see the priests from the convent that morning, because she never received thanks for favors.

When Jenny came in I gave her the fruit, and laughingly told her that Vivalla wished to show her how his performing dog could turn a spinning-wheel.

"Poor man, poor man, do let him come; it is all the good creature can do for me," exclaimed Jenny, and the tears flowed thick and fast down her cheeks. "I like that, I like that," she continued; "do let the poor creature come and bring his dog. It will make him so happy."

I confess it made *me* happy, and I exclaimed, for my heart was full, "God bless you, it will make him cry for joy; he shall come to-morrow."

I saw Vivalla the same evening, and delighted him with the intelligence that Jenny would see his dog perform the next day, at four o'clock precisely.

"I will be punctual," said Vivalla, in a voice trembling with emotion; "but I was sure she would like to see my dog perform."

For full half an hour before the time appointed did Jenny Lind sit in her window on the second floor and watch for Vivalla and his dog. A few minutes before the appointed hour, she saw him coming. "Ah, here he comes! here he comes!" she exclaimed in delight, as

she ran down stairs and opened the door to admit him. A negro boy was bringing the small spinning-wheel, while Vivalla led the dog. Handing the boy a silver coin, she motioned him away, and taking the wheel in her arms, she said, "This is very kind of you to come with your dog. Follow me. I will carry the wheel up stairs." Her servant offered to take the wheel, but no, she would let no one carry it but herself. She called us all up to her parlor, and for one full hour did she devote herself to the happy Italian. She went down on her knees to pet the dog and to ask Vivalla all sorts of questions about his performances, his former course of life, his friends in Italy, and his present hopes and determinations. Then she sang and played for him, gave him some refreshments, and finally insisted on carrying his wheel to the door, from whence her servant accompanied Vivalla to his boarding-house.

Poor Vivalla! He was probably never so happy before, but his enjoyment did not exceed that of Miss Lind. That scene alone would have paid me for all my labors during the entire musical campaign.

In New Orleans the wharf was crowded by a great concourse of persons, as the steamer Falcon, on which we had taken passage from Havana, approached. Jenny had enjoyed a month of quiet, and dreaded the excitement which she must now again encounter.

"Mr. Barnum, I am sure I can never get through that crowd," said she, in despair.

"Leave that to me. Remain quiet for ten minutes, and there shall be no crowd here," I replied.

Taking my daughter on my arm, she threw her veil over her face, and we descended the gangway to the dock. The crowd pressed around. I had beckoned for a carriage before leaving the ship.

"That's Barnum, I know him," called out several persons at the top of their voices.

"Open the way, if you please, for Mr. Barnum and Miss Lind!" cried Le Grand Smith over the railing of the ship, the deck of which he had just reached from the wharf.

"Don't crowd her, if you please, gentlemen," I exclaimed, and by dint of pushing, squeezing and coaxing, we reached the carriage, and drove for the Montalba buildings, where Jenny's apartments had been prepared, and the whole crowd came following at our heels. In a few minutes afterwards, Jenny and her companion came quietly in a carriage, and were in the house before the ruse was discovered. In answer to incessant calls, she appeared a moment

upon the balcony, waved her handkerchief, received three hearty cheers, and the crowd dispersed.

A poor blind boy, residing in the interior of Mississippi, a flute-player, and an ardent lover of music, visited New Orleans expressly to hear Jenny Lind. A subscription had been taken up among his neighbors to defray the expenses. This fact coming to the ears of Jenny, she sent for him, played and sang for him, gave him many words of joy and comfort, took him to her concerts, and sent him away considerably richer than he had ever been before.

A funny incident occurred at New Orleans. Our concerts were given in the St. Charles Theatre, then managed by my good friend, Sol Smith. In the open lots near the theatre were exhibitions of mammoth hogs, five-footed horses, grizzly bears, etc.

A gentleman had a son about twelve years old, who had a wonderful ear for music. He could whistle or sing any tune after hearing it once. His father did not know nor care for a single note, but so anxious was he to please his son, that he paid thirty dollars for two tickets to the concert.

"I liked the music better than I expected," said he to me the next day, "but my son was in raptures. He was so perfectly enchanted that he scarcely spoke the whole evening. I would on no account disturb his delightful reveries. When the concert was finished, we came out of the theatre. Not a word was spoken. I knew that my musical prodigy was happy among the clouds, and I said nothing. I could not help envying him his love of music, and considered my thirty dollars as nothing, compared to the bliss which it secured to him. Indeed, I was seriously thinking of taking him to the next concert, when he spoke. We were just passing the numerous shows upon the vacant lots. One of the signs attracted him, and he said, 'Father, let us go in and see the big hog!' The little scamp! I could have horsewhipped him!" said the father, who, loving a good joke, could not help laughing at the ludicrous incident.

I made arrangements with the captain of the splendid steamer Magnolia, of Louisville, to take our party as far as the junction of the Mississippi and Ohio rivers, stipulating for sufficient delay in Natchez, Miss., and in Memphis, Tenn., to give a concert in each place. It was no unusual thing for me to charter a steamboat or special train of cars for our party. With such an enterprise as that, time and comfort were paramount to money.

The time on board the steamer was whiled away in reading,

viewing the scenery of the Mississippi, etc. One day we had a pleasant musical festival in the ladies' saloon for the gratification of the passengers, at which Jenny volunteered to sing *sans ceremonie*. It seemed to us she never sang so sweetly before.

For the amusement of the passengers I related many anecdotes picked up in my travels, and gave them some of my own experiences. I also performed a number of legerdemain tricks, which pleased and surprised them.* One of the tricks consisted in placing a quarter-dollar upon my knee, covering it with a card, and then causing it mysteriously to disappear.

I found after the second day that the mulatto barber declined taking my money, assigning as his only reason that I was welcome to his services. The truth, however, soon leaked out. He had been a looker-on, by stealth, and his superstitious notions invested me with the powers of a league with the devil.

The next morning I seated myself for the operation of shaving, and the colored gentleman ventured to dip into the mystery. "Beg pardon, Mr. Barnum, but I have heard a great deal about you, and I saw more than I wanted to see last night. Is it true that you have sold yourself to the devil, so that you can do what you've a mind to?"

"Oh, yes," was my reply, "that is the bargain between us."

"How long did you agree for?" was the question next in order.

"Only nine years," said I. "I have had three of them already. Before the other six are out, I shall find a way to nonplus the old gentleman – and I have told him so to his face."

At this avowal, a larger space of white than usual was seen in the darkey's eyes, and he inquired, "Is it by this bargain that you get so much money?"

"Certainly. No matter *who* has money, nor where he keeps it, in his box or till, or any where about him, I have only to speak the words, and it comes."

The shaving was completed in silence, but thought had been busy in the barber's mind, and he embraced the speediest opportunity to transfer his bag of coin to the iron safe in charge of the clerk.

*I had performed them in that western and southern country, many years before, under very different circumstances. Sickness or desertion on the part of my employees in that line, repeatedly put me to the necessity of substituting myself in the legerdemain business.

The movement did not escape me, and immediately a joke was a-foot. I had barely time to make two or three details of arrangement with the clerk, and resume my seat in the cabin, ere the barber sought a second interview, bent on testing the alleged powers of Beelzebub's colleague.

"Beg pardon, Mr. Barnum, but where is my money? Can you get it?"

"I do not want your money," was the quiet answer. "It is safe."

"Yes, I know it is safe – ha! ha! – it is in the iron safe in the clerk's office – safe enough from *you!*"

"It is *not* in the iron safe," said I. This was said so quietly, yet positively, that the colored gentleman ran to the office, and inquired if all was safe. "All right," said the clerk. "Open, and let me see," replied the barber. The safe was unlocked – lo! the money was gone!

In mystified terror the loser applied to me for relief. "You will find the bag in your drawer," said I – and *there* it was found!

In all this I of course had a confederate, and also in a trick which immediately followed. "Now," said I, "hand me a cent. I will send it to his Infernal Highness, and bring it back forthwith." A cent was handed me – I tossed it into the air, and it disappeared!

"Where will you have it returned?"

"Under this shaving-cup," was the answer. The cup was turned – and lo! the cent was there! The barber lifted it from the table, and instantly dropped it. It was scorching hot! "The devil has had it. It is hot yet," said the barber. It was another cent which my confederate had heated and slyly placed there a moment before.

"And now," continued I, "I will turn you into a cat, and change you back again directly."

"You can't do *that*," said the barber, but evidently with some suspicion of his own judgment.

"You shall see," I replied, solemnly. "You run only one risk," I continued: "if any thing happens to me, by losing remembrance of his Majesty's pass-word, or any thing of the kind, you will remain a black cat for ever. Are you ready?"

The barber fled in consternation, and was so seriously troubled, that Captain Brown feared he would jump overboard. On being informed of this extremity of the joke, I explained the whole thing to the subject of my fun.

"By golly!" said the barber, in the exultation characteristic of his race, "by golly! when I get back to New Orleans I'll come Barnum over de colored people. Ha! ha!"

During our stay at St. Louis I gave a temperance lecture in the theatre, and among other signers to the teetotal pledge was the famous comedian, "SOL SMITH." "Uncle Sol," as he is called by everybody, resides with his family in St. Louis, and is still concerned in theatricals both there and in New Orleans, unless he has retired and is enjoying the *otium cum dignitate* which he has long promised himself, and which his pecuniary ability would fully justify.

At the first ticket auction in Nashville, the excitement was considerable and the bidding spirited, as was generally the case. After it was concluded, one of my men, happening in at a dry-goods store in the town, heard the proprietor say, "I'll give five dollars to any man who will take me out and give me a good horsewhipping! I deserve it, and am willing to pay for having it done. To think that I should have been such a fool as to have paid forty-eight dollars for four tickets for my wife, two daughters, and myself, to listen to music for only two hours, makes me mad with myself, and I want to pay somebody for giving me a thundering good horsewhipping!"

I am not sure that others similarly situated have not experienced a somewhat similar feeling, when they became cool and rational, and the excitement of novelty and competition had passed away.

While at Nashville, Jenny Lind and her party, including my daughter, Mrs. Lyman, and myself, visited "the Hermitage," the late residence of General Jackson. On that occasion, for the first time that season, we heard the wild mocking-birds singing in the trees. This gave Jenny great delight, as she had never before heard them sing except in their wire-bound cages.

The first of April occurred while we were in Nashville. I was considerably annoyed during the forenoon by the calls of members of the company who came to me under the belief that I had inquired for them. After dinner I concluded to give them all a touch of "April fool." The following article, which appeared the next morning in the "Nashville Daily American," to the editor of which my amanuensis had imparted the secret, will show how it was done:

"A series of laughable jokes came off yesterday at the Veranda in honor of All Fools' Day. Mr. Barnum was at the bottom of the mischief. He managed in some mysterious manner to obtain a lot of blank telegraphic dispatches and envelopes from one of the offices in this city, and then went to work and maunfactured 'astounding intelligence' for most of the parties composing the Jenny Lind suite. Almost

every person in the company received a telegraphic dispatch written by E. T. Nichols, under the direction of Barnum. Mr. Barnum's daughter was informed that her mother, her cousin, and several other relatives were waiting for her in Louisville, and various other important and extraordinary items of domestic intelligence were communicated to her. Mr. Le Grand Smith was told by a dispatch from his father that his native village in Connecticut was in ashes, including his own homestead, etc. Several of Barnum's employees had most liberal offers of engagements from banks and other institutions at the North. Burke, and others of the musical professors, were offered princely salaries by opera managers, and many of them received most tempting inducements to proceed immediately to the World's Fair in London.

"One married gentleman in Mr. Barnum's suite received the gratifying intelligence that he had for two days been the father of a pair of bouncing boys, (mother and children doing well,) an event which he had been anxiously looking for during the week, though on a somewhat more limited scale. In fact, nearly every person in the party engaged by Barnum received some extraordinary telegraphic intelligence, and as the great Impressario managed to have the dispatches delivered simultaneously, each recipient was for some time busily occupied with his own personal news.

"By-and-by, each began to tell his neighbor his good or bad tidings; and each was, of course, rejoiced or grieved according to circumstances. Several gave Mr. Barnum notice of their intention to leave him, in consequence of better offers; and a number of them sent off telegraphic dispatches and letters by mail, in answer to those received.

"The man who had so suddenly become the father of twins telegraphed to his wife to 'be of good cheer,' and that he would 'start for home to-morrow.' At a late hour last night the secret had not got out, and we presume that many of the victims will first learn from our columns that they have been taken in by BARNUM and *All Fools' Day!*"

From Nashville, Jenny Lind and a few friends went by way of the Mammoth Cave to Louisville, while the rest of the party proceeded by steamboat.

While in Havana, I engaged Signor Salvi for a few months, to commence about the 10th of April. He joined us at Louisville, and sang there with great satisfaction to the public. Mr. Prentice, of the Louisville Journal, and his beautiful and talented lady, who had

contributed much to the pleasure of Miss Lind and party, accompanied us to Cincinnati.

A citizen of Madison had applied to me on our first arrival in Louisville, for a concert in that town. I replied that the town was too small to afford it, whereupon he offered to take the management of it into his own hands, and pay me $5000 for the receipts.* As the steamer from Louisville to Cincinnati would arrive at Madison about sundown, and would wait long enough for us to give a concert, I agreed to his proposition.

We were not a little surprised to learn upon arriving, that the concert must be given in a "pork house" – a capacious shed which had been fitted up and decorated for the occasion! We concluded, however, that if the inhabitants were satisfied with the accommodations, we should not object. The party who had contracted for it came $1300 short of his agreement, which I consequently lost – and at ten o'clock we were again on board the fine steamer "Ben Franklin" for Cincinnati.

The next morning, the crowd upon the wharf was immense. I was fearful that an attempt to repeat the New Orleans ruse with my daughter would be of no avail, as the joke had been published in the Cincinnati papers; so I gave my arm to Miss Lind, and begged her to have no fears, for I had hit upon an expedient which would save her from annoyance. We then descended the plank to the shore, and as soon as we had touched it, Le Grand Smith called out from the boat as if he had been one of the passengers, "That's no go, Mr. Barnum; you can't pass your daughter off for Jenny Lind this time."

The remark elicited a peal of merriment from the crowd, several persons calling out, "That won't do, old Barnum! you may fool the New Orleans folks, but you can't come it over the 'Buckeyes.' We intend to stay here until you bring out Jenny Lind!" They readily allowed me to pass with the lady whom they supposed to be my daughter, and in five minutes afterwards the Nightingale was complimenting Mr. Coleman upon the beautiful and commodious apartments which were devoted to her in the Burnett House. The crowd remained an hour upon the wharf before they would be convinced that the person whom they took for my daughter was in fact the veritable Swede. When the fact was discovered, a general

*The last concert In Louisville, and the concerts in Natchez and Wheeling, were each given under a similar agreement, though in more agreeable quarters and with better pecuniary results than in Madison.

laugh followed the exclamation from one of the victims, "Well, old Barnum has humbugged us after all!"

In passing up the river to Pittsburgh, the boat waited four hours to enable us to give a concert in Wheeling. It was managed by a couple of gentlemen in that city, who purchased it for $5000 in advance, by which they made a handsome profit for their trouble. The concert was given in a church.

At Pittsburgh, the open space surrounding the concert room became crowded with thousands of persons, who, foolishly refusing to accommodate each other by listening to the music, disturbed the concert and determined us to leave the next morning for Baltimore, instead of giving a second concert that had been advertised.

Le Grand Smith here paid me off for my "April-fool" joke. He induced a female of his acquaintance to call on me and reveal an arrangement which she pretended accidentally to have overheard between some scoundrels, who were resolved to stop our stage coach on the Alleghany mountains and commit highway robbery. The story seemed incredible, and yet the woman related it with so much apparent sincerity, that I swallowed the bait, and remitting to New York all the money I had, except barely enough to defray our expenses to Baltimore, I purchased several revolvers for such members of the company as were not already provided, and we left Pittsburgh armed to the teeth! Fortunately, Jenny and several of the company had left before I made this grand discovery, and hence she was saved any apprehensions on the subject. It is needless to say we found no use for our firearms.

We reached New York early in May, 1851, and gave fourteen concerts in Castle Garden and Metropolitan Hall. The last of these made the ninety-second regular concert under our engagement. Jenny had now again reached the atmosphere of her "advisers," and I soon discovered the effects of their influence. I, however, cared little what course they advised her to pursue. I indeed wished they would prevail upon her to close with her hundredth concert, for I had become weary with constant excitement and unremitting exertions. I was confident that if Jenny undertook to give concerts on her own account, she would be imposed upon and harassed in a thousand ways; yet I felt it would be well for her to have a trial at it, if she saw fit to credit their assurance that I had not managed the enterprise as successfully as it might have been done.

At about the eighty-fifth concert, therefore, I was most happy to learn from her lips that she had concluded to pay the forfeiture

of twenty-five thousand dollars, and terminate the concerts with the one hundredth.

We went to Philadelphia, where I had advertised the ninety-second, ninety-third, and ninety-fourth concerts, and had engaged the large National Theatre in Chestnut street. It had been used for equestrian and theatrical entertainments, but was now thoroughly cleansed and fitted up by Max Maretzek for Italian Opera. It was a convenient place for our purpose. One of her "advisers," a subordinate in her employ, who was already itching for the position of manager, made the selection of this building a pretext for causing dissatisfaction in the mind of Miss Lind. I saw the influences which were at work, and not caring enough for the profits of the remaining seven concerts to continue the engagement at the risk of disturbing the friendly feelings which had hitherto uninterruptedly existed between that lady and myself, I wrote her a letter offering to relinquish the engagement, if she desired it, at the termination of the concert which was to take place that evening, upon her simply allowing me a thousand dollars per concert for the seven which would yet remain to make up the hundred, besides paying me the sum stipulated as a forfeiture for closing the engagement at the one hundredth concert. Towards evening I received the following reply:

"To P. T. BARNUM, ESQ.

"MY DEAR SIR: – I accept your proposition to close our contract to-night, at the end of the ninety-third concert, on condition of my paying you seven thousand dollars in addition to the sum I forfeit under the condition of finishing the engagment at the end of one hundred concerts.

"I am, dear Sir, yours truly,
JENNY LIND.

"*Philadelphia*, 9th of June, 1851."

I met Jenny at the concert in the evening. She was polite and friendly as ever. Between the first and second parts of the concert, I introduced General Welch, the lessee of the National Theatre, who informed her that he was quite willing to release me from my engagement of the building, if she did not desire it longer. She replied, that upon trial, she found it much better than she expected, and she would therefore retain it for the remainder of the concerts.

In the mean time, her advisers had been circulating the story that I had compelled Jenny to sing in an improper place, and when they heard that she had concluded to remain there, they beset her

with arguments against it, until at last she consented to remove her concerts to a smaller hall.

I had thoroughly advertised the *three* concerts in the newspapers within a radius of one hundred miles from Philadelphia, and had sent admission tickets to the editors. On the day of the second concert, one of the new agents, who had aided in bringing about the dissolution of our engagement, refused to recognize these tickets. I urged upon him the injustice of such a course, but received no satisfaction. I then stated the fact to Miss Lind, and she gave immediate orders for them to be received. Country editors' tickets, which were offered after I left Philadelphia, were however refused by her agents, (undoubtedly contrary to Miss Lind's wish and knowledge,) and the editors, having come from a distance with their wives, purchased tickets, and I subsequently remitted the money to numerous gentlemen whose tickets were thus repudiated.

Jenny gave several concerts with varied success, and then retired to Niagara Falls, and afterwards to Northampton, Mass. While sojourning at the latter place, she visited Boston and was married to Mr. OTTO GOLDSCHMIDT, a German composer and pianist, to whom she was much attached, and who had studied music with her in Germany. He played several times in our concerts. He seemed a very quiet, inoffensive gentleman, is an accomplished musician, and I have no doubt he makes Miss Lind a good husband.

I met her several times after our engagement terminated. She was always affable. On one occasion, while passing through Bridgeport, she told me that she had been sadly harassed in giving her concerts. "People cheat me and swindle me very much," said she, "and I find it very annoying to give concerts on my own account."

I was always supplied with tickets when she gave concerts in New York, and on the occasion of her last appearance in America, I visited her in her room back of the stage, and bade herself and husband adieu, with my best wishes. She expressed the same feeling to me in return. She told me she should never sing much if any more in public, but I begged her, for the public's sake, not to retire altogether; to which she replied, that she might occasionally give some concerts. I believe nothing would induce her again to appear in opera.

After so many months of anxiety, labor and excitement, in the Jenny Lind enterprise, it will readily be believed that I desired tranquillity. I spent a week at Cape May, and then "came home" to Iranistan, where I remained the entire summer.

JENNY LIND CONCERTS.

TOTAL RECEIPTS, EXCEPTING OF CONCERTS DEVOTED TO CHARITY.

——	New York,	$17,864 05	No. 46.	Havana,	$2,931 95
——	"	14,203 03	47.	New Orleans,	12,599 85
			48.	"	10,210 42
No. 1.	"	12,519 59	49.	"	8,131 15
2.	"	14,266 09	50.	"	6,019 85
3.	"	12,174 74	51.	"	6,644 00
4.	"	16,028 39	52.	"	9,720 80
5.	Boston,	16,479 50	53.	"	7,545 50
6.	"	11,848 62	54.	"	6,053 50
7.	"	8,639 92	55.	"	4,850 25
8.	"	10,169 25	56.	"	4,495 35
9.	Providence	6,525 54	57.	"	6,630 85
10.	Boston,	10,524 87	58.	"	4,745 10
11.	"	5,240 00	59.	Natchez,	5,000 00
12.	"	7,586 00	60.	Memphis,	4,539 56
13.	Philadelphia	9,291 25	61.	St. Louis,	7,811 85
14.	"	7,547 00	62.	"	7,961 92
15.	"	8,458 65	63.	"	7,708 70
16.	New York	6,415 90	64.	"	4,086 50
17.	"	4,009 70	65.	"	3,044 70
18.	"	5,982 00	66.	Nashville,	7,786 30
19.	"	8,007 10	67.	"	4,248 00
20.	"	6,334 20	68.	Louisville,	7,833 90
21.	"	9,429 15	69.	"	6,595 60
22.	"	9,912 17	70.	"	5,000 00
23.	"	5,773 40	71.	Madison,	3,693 25
24.	"	4,993 50	72.	Cincinnati,	9,339 75
25.	"	6,670 15	73.	"	11,001 50
26.	"	9,840 33	74.	"	8,446 30
27.	"	7,097 15	75.	"	8,954 18
28.	"	8,263 30	76.	"	6,500 40
29.	"	10,570 25	77.	Wheeling,	5,000 00
30.	"	10,646 45	78.	Pittsburgh,	7,210 58
31.	Philadelphia	5,480 75	79.	New York,	6,858 42
32.	"	5,728 65	80.	"	5,453 00
33.	"	3,709 88	81.	"	5,463 70
34.	"	4,815 48	82.	"	7,378 35
35.	Baltimore	7,117 00	83.	"	7,179 27
36.	"	8,357 05	84.	"	6,641 00
37.	"	8,406 50	85.	"	6,917 13
38.	"	8,121 33	86.	"	6,642 04
39.	Washington City	6,378 55	87.	"	3,738 75
40.	"	8,507 05	88.	"	4,335 28
41.	Richmond	12,385 21	89.	"	5,339 23
42.	Charleston	6,775 00	90.	"	4,087 03
43.	"	3,653 75	91.	"	5,717 00
44.	Havana	4,666 17	92.	"	9,525 80
45.	"	2,837 92	93.	Philadelphia,	3,852 75

CHARITY CONCERTS. – Of Miss Lind's half-receipts of the first two Concerts, she devoted $10,000 to charity in New York. She afterwards gave Charity Concerts in Boston, Baltimore, Charleston, Havana, New Orleans, New York, and Philadelphia, and donated large sums for the like purposes in Richmond, Cincinnati, and elsewhere.

There were also several Benefit Concerts, for the Orchestra, Le Grand Smith, etc.

RECAPITULATION

New York,. . . . 35 Concerts.Receipts, $236,216 64				Average, $8,177 50
Philadelphia, . . . 8	""	48,884 41		" . . 6,110 55
Boston, 7	""	70,388 16		" . . 10,055 45
Providence, 1	""	6,525 54		" . . 6,525 54
Baltimore, 4	""	32,001 88		" . . 8,000 47
Washington, . . . 2	""	15,385 60		" . . 7,692 80
Richmond, 1	""	12,385 21		" . . 12,385 21
Charleston, 2	""	10,428 75		" . . 5,214 37
Havana, 3	""	10,436 04		" . . 3,478 68
New Orleans,. . 12	""	87,646 12		" . . 7,308 84
Natchez,. 1	""	5,000 00		" . . 5,000 00
Memphis, 1	""	4,539 56		" . . 4,539 56
St. Louis, 5	""	30,613 67		" . . 6,122 73
Nashville, 2	""	12,034 30		" . . 6,017 15
Louisville,. 3	""	19,429 50		" . . 6,476 50
Madison, 1	""	3,693 25		" . . 3,693 25
Cincinnati, 5	""	44,242 18		" . . 8,848 43
Wheeling,. 1	""	5,000 00		" . . 5,000 00
Pittsburgh, 1	""	7,210 58		" . . 7,210 58
Total, 95 Concerts.Receipts, $712,161 34				Average, $7,496 43

JENNY LIND'S RECEIPTS.

From the Total Receipts of Ninety-five Concerts, $712,161 54
Deduct the receipts of the first two, which, as between
 ourselves, were aside from the contract, and are not
 numbered in the Table, . 32,067 08

Total Receipts of Concerts from No. 1 to No. 93,$680,094 26
Deduct the receipts of the 28 Concerts, each
 of which fell short of $5,500,$123,811 15
Also deduct $5,500 for each of the
 remaining 65 Concerts,357,500 00 480,811 15

Leaving the total excess, as above, . $199,283 11
Being equally divided, Miss Lind's portion was. $99,641 55
I paid her $1,000 for each of the 93 Concerts,. 93,000 00
Also one-half the receipts of the first two Concerts,. 1 6,033 54

Amount paid to Jenny Lind,. $208,675 09
She refunded to me as forfeiture, per contract, in case she withdrew
 after the 100th Concert, .$25,000
She also paid me $1,000 each for the seven
 Concerts relinquished, . 7,000 . . 32,000 00

Jenny Lind's net avails of 95 Concerts, . $176,675 09
P. T. Barnum's gross receipts, after paying Miss Lind, . 535,486 25

Total Receipts of 95 Concerts, .$712,161 34

PRICE OF TICKETS. – The highest prices paid for tickets were at auction, as follows:–John N. Genin, in New York, $225; Ossian G.

Dodge, in Boston, $625; Col. William C. Ross, in Providence, $650; M. A. Root, in Philadelphia, $625 ; Mr. D'Arcy, in New Orleans, $240 ; a keeper of a refreshment saloon in St. Louis, $150 ; a Daguerreotypist in Baltimore, $100. I cannot now recall the names of the last two. After the sale of the first ticket, the premium usually fell to $20, and so downward in the scale of figures. The fixed price of tickets ranged from $7 to $8. Promenade tickets were from $2 to $1 each.

CHAPTER XII

"Side Shows" – Buffalo Hunt, Etc.

Moving Shakspeare's House – Swiss Bell Ringers –
Various Enterprises – Philadelphia Museum – Travelling
Menagerie – The Woolly Horse – Fremont's Nondescript
– His Last Kick – The Herd of Buffaloes – A Free
Exhibition – Buffalo Hunt – Pleased with Humbug –
Circumstances alter Cases – Monkey and Gander Skins.

In attending to what might be termed my "side shows," or temporary enterprises, I have never neglected the American Museum. This was my first really successful effort in life, and I have constantly endeavored to increase its attractions, regardless of expense.

While in Europe, I was constantly on the look-out for novelties. Not a fair was held, within a reasonable distance, that I did not visit, with a view to buy or hire such exhibitions as I thought would "pay" in the United States.

I obtained verbally through a friend the refusal of the house in which Shakspeare was born, designing to remove it in sections to my Museum in New York; but the project leaked out, British pride was touched, and several English gentlemen interfered and purchased the premises for a Shakspearian Association. Had they slept a few days longer, I should have made a rare speculation, for I was subsequently assured that the British people, rather than suffer that house to be removed to America, would have bought me off with twenty thousand pounds.

The models of machinery exhibited in the Royal Polytechnic

Institution in London pleased me so well, that I procured a duplicate; also duplicates of the Dissolving Views, the Chromatrope and Physioscope, including many American scenes painted expressly to my order, at an aggregate cost of $7000. After being exhibited in my Museum, they were sold to itinerant showmen, and some of them are now on exhibition in various parts of the United States.

I visited the great quinquennial Exposition, held in Paris in 1844, and expended $4000 in purchasing Robert Houdin's ingenious automaton writer, many pieces of moving mechanism, superior cosmoramic views, etc. The popular Panoramic Diorama of the Funeral Obsequies of Napoleon was made to my order in Paris, at a cost of $3000. Every event of that grand pageant, from the embarkation of the body at St. Helena to its entombment at the Hotel des Invalides, amid the most gorgeous parades ever witnessed in France, was wonderfully depicted. This exhibition, after having had its day at the American Museum, was sold, and extensively and profitably exhibited elsewhere.

While on the subject, though out of the order of time, I may mention the splendid Panorama of the Crystal Palace, painted to my order by the celebrated DE LAMANO. He was accompanied to London by Col. JOHN S. DU SOLLE, the able and accomplished editor, who wrote the lecture of description. The great work has as yet been exhibited in only a few towns, but it will be a curiosity for many years, as commemorating the great World's Fair.

Having heard, while in London in 1844, of a company of "Campanalogians, or Lancashire Bell Ringers," performing in Ireland, I induced them to meet me in Liverpool, and there engaged them for an American tour. One of my stipulations was, that they should suffer their moustaches to grow, assume a picturesque dress, and be known as the "Swiss Bell Ringers." They at first objected, in the broad and almost unintelligible dialect of Lancashire, because, as they said, they spoke only the English language, and could not pass muster as Swiss people; but the objection was withdrawn when I assured them, that if they continued to speak in America as they had just spoken to me, they might safely claim to be Swiss, or any thing else, and no one would be any the wiser.

As in other cases, so in this, the deception as to birth-place was of small account, and did no injury. Those seven men were really admirable performers, and by means of their numerous bells, of various sizes, they produced the most delicious music. They attracted much attention in various parts of the United States, in Canada, and in Cuba.

As a compensation to England for the loss of the Bell Ringers,

I dispatched an agent to America for a party of Indians, including squaws. He proceeded to Iowa, and returned to London with a company of sixteen. They were exhibited by Mr. Catlin on our joint account, and were finally left in his sole charge.

On my first visit to America from Europe, I engaged Mr. Faber, an elderly and ingenious German, who had constructed an automaton speaker. It was made of life-size, and upon being worked with keys similar to those of a piano, it really articulated words and sentences with surprising distinctness. My agent exhibited it for several months in Egyptian Hall, London, and also in the provinces.

On the same visit to New York, I was called upon by "Hervio Nano," who was known to the public as the "gnome fly," and was also celebrated for his representations of the monkey. His malformation caused him to appear much like that animal when properly dressed. He wished me to exhibit him in London, but having my hands already full, I declined. He, however, made immediate arrangements with two Americans, who took him to London. They stained his face and hands, and covered him with a dress made of hair, and resembling the skin of an animal. They then advertised him as a curious "nondescript," called "WHAT IS IT?" and claimed that "the strange animal" was captured in the mountains of Mexico; that it appeared like a "wild man," but could not speak, although it manifested much intelligence. I was let into the secret, on condition of "keeping dark." The exhibition opened in Egyptian Hall, and as a matter of curiosity I attended at the opening. Before half an hour had elapsed, one of the visitors, who knew "Hervio Nano," recognized him through his disguise and exposed the imposition. The money was refunded to visitors, and that was the first and last appearance of "What is it?" in that character. He soon afterwards died in London.

In June, 1851, I sent the BATEMAN Children to London. They performed in St. James's Theatre, London, and in the principal provincial theatres. Before leaving for England, they played several weeks at the American Museum.

The giants whom I sent to America were not the greatest of my curiosities – the dwarfs were the least; and the Scotch boys were interesting, not so much on account of their weight, as for the mysterious method by which one of them, though blindfolded, answered questions put by the other respecting objects presented by spectators.

In June, 1850, I added the celebrated Chinese Collection to the attractions of the American Museum. I also engaged the Chinese

Family, consisting of two men, two women, and two children. My agent exhibited them in London during the World's Fair.

In October, 1852, having stipulated with Col. Henry Sanford and Mr. George A. Wells that they should share in the enterprise and take the entire charge, I engaged Miss Catharine Hayes and Herr Begnis to give sixty concerts in California, and the engagement was completed to our satisfaction.

I have been engaged in many lesser enterprises on my sole account, such as the Kilmiste Family, travelling panoramas, etc.; but the remembrance is not of sufficient interest to be recorded in this place.

In 1845, while in Europe, I bought by my agent, Fordyce Hitchcock, the Baltimore Museum, and placed my uncle, Alanson Taylor, in charge. He was taken seriously ill in April, was removed to Bethel, Ct., and died in June, 1846. I then sold the Baltimore Museum to the "Orphean Family."

In 1849, I opened a Museum in Dr. Swaim's building, corner of Chestnut and Seventh streets, in Philadelphia. It was fitted up in elegant style, and was successfully conducted for several years. Though aided by a good manager, the establishment occupied too much of my time and attention, and in 1851 I sold it to C. Spooner, Esq., for $40,000. The building and contents were destroyed by fire in the close of 1851. Mr. Spooner was insured. The loss was a serious one to Philadelphia. The Museum was a highly popular family resort, and Mr. Spooner conducted it in a style which commanded the encomiums and enlisted the friendship of the first families in that city, who were extremely anxious that he should rebuild the establishment, but other highly profitable business connections prevented his doing so.

While my Philadelphia Museum was in full operation, Peale's Museum run me a strong opposition at the Masonic Hall. That enterprise proved disastrous, and I purchased the collection at sheriff's sale, for five or six thousand dollars, on joint account of my friend Moses Kimball and myself. The curiosities were equally divided. One half went to his Boston Museum, and the other half to my American Museum in New York.

In 1849, I projected a great travelling museum and menagerie. Having neither time nor inclination to manage such a concern, I induced Mr. Seth B. Howes, justly celebrated as "a showman," join me, and take the sole charge. Mr. Sherwood E. Stratton, father of General Tom Thumb, was also introduced, the interest being in thirds.

In carrying out a portion of the plan, we chartered the ship

"Regatta," Captain Pratt, and dispatched her, together with our agents, Messrs. June and Nutter, to Ceylon. The ship left New York in May, 1850, and was absent one year. Their mission was to procure, either by capture or purchase, twelve or more living elephants, besides such other wild animals as they could secure. In order to provide sufficient drink and provender for a cargo of these huge animals, we purchased a large quantity of hay in New York. Five hundred tons of it was left at the island of St. Helena, to be taken on the return trip of the ship. Staves and hoops of water-casks were also left at St. Helena.

Our agents, being unable to purchase the required number of elephants, either in Columbo or Kandy, the principal towns of the island, (Ceylon,) took one hundred and sixty native assistants, and plunged into the jungles, where, after many most exciting adventures, they succeeded in securing thirteen elephants of a suitable size for their purpose, with a female and her calf or "baby" elephant, only six months old. In the course of the expedition, Messrs. Nutter and June killed large numbers of the huge beasts, and had numerous encounters of the most terrific description with the formidable animals, one of the most fearful of which took place on the 23d November, 1850, near Anarajah Poora, while endeavoring by the aid of the natives and trained elephants to drive the wild herd of beasts into an Indian kraal.

They arrived in New York with ten of the elephants, and also brought with them one of the natives who was competent to their management. We added a caravan of wild animals and many museum curiosities – the entire outfit, including horses, vans, carriages, tent, etc., costing $109,000 – and commenced operations, with the presence and under the patronage of Gen. Tom Thumb! who has now travelled four years as one of the attractions of "Barnum's great Asiatic Caravan, Museum, and Menagerie."

The popularity of this exhibition attracted numerous "side-shows" by other parties, greatly to our annoyance. In self-defence we fitted out a circus company, which performs on the same day and in the same neighborhood that the menagerie and museum are exhibited. Should an opposition threaten interference with us, we need only connect our two companies at the single price of admission, and competition is impossible. Our receipts in four years reached nearly one million dollars.

It will be admitted that these enterprises are legitimate, though I have been engaged in several which have been considered doubtful. It is not my business to dispute the point, but to narrate the facts – as follows:

THE WOOLLY HORSE. – In the summer of 1848, while in Cincinnati with General Tom Thumb, my attention was arrested by handbills announcing the exhibition of a "woolly horse." Being always on the *qui vive* for every thing curious with which to amuse or astonish the public, I visited the exhibition, and found the animal to be a veritable curiosity. It was a well-formed horse of rather small size, without any mane or the slightest portion of hair upon his tail. The entire body and limbs were covered with a thick fine hair or wool curling tight to his skin. He was foaled in Indiana, was a mere freak of nature, and withal a very curious-looking animal. I purchased him and sent him to Bridgeport, Ct., where he was placed quietly away in a retired barn, until such time as I might have use for him.

The occasion at last occurred. Col. Fremont was lost among the trackless snows of the Rocky Mountains. The public mind was excited. Serious apprehensions existed that the intrepid soldier and engineer had fallen a victim to the rigors of a severe winter. At last the mail brought intelligence of his safety. The public heart beat quick with joy. I now saw a chance for the "woolly horse." He was carefully covered with blankets and leggings, so that nothing could be seen excepting his eyes and hoofs, conveyed to New York, and deposited in a rear stable, where no eye of curiosity could reach him.

The next mail was said to have brought intelligence that Col. Fremont and his hardy band of warriors had, after a three days' chase, succeeded in capturing, near the river Gila, a most extraordinary nondescript, which somewhat resembled a horse, but which had no mane nor tail, and was covered with a thick coat of wool. The account further added that the Colonel had sent this wonderful animal as a present to the U. S. Quarter-master.

Two days after this announcement, the following advertisement appeared in the New York papers:

"COL. FREMONT'S NONDESCRIPT OR WOOLLY HORSE will be exhibited for a few days at the corner of Broadway and Reade street, previous to his departure for London. Nature seems to have exerted all her ingenuity in the production of this astounding animal. He is extremely complex – made up of the Elephant, Deer, Horse, Buffalo, Camel, and Sheep. It is the full size of a Horse, has the haunches of the Deer, the tail of the Elephant, a fine curled wool of camel's hair color, and easily bounds twelve or fifteen feet high. Naturalists and the oldest trappers assured Col. Fremont that it was never known previous to his discovery. It is undoubtedly 'Nature's last,' and the

richest specimen received from California. To be seen every day this
week. Admittance 25 cents; children half price."

The building where he was exhibited, exactly opposite Stuart's
immense dry-goods store, was mounted by several large transpar-
encies representing the "Nondescript" in full flight, pursued by the
brave Fremont and his hardy handful of soldiers. The streets were
also lined with handbills and posters, illustrating in wood-cuts the
same thrilling event. On the next page is a fac-simile of the picture.
It was drawn by my favorite artist, T. W. STRONG. He is a regular
original, as his popular "Yankee Notion" abundantly proves. If the
nondescript had made the fearful leap here represented, he would
have jumped not less than five miles; and if he was alive when he
struck on the other side of the valley, I imagine that even the speed
of the gallant Fremont's horses would have been inadequate to his
capture.

But the public appetite was craving something tangible from
Col. Fremont. The community was absolutely famishing. They were
ravenous. They could have swallowed any thing, and like a good
genius, I threw them, not a "bone," but a regular tit-bit, a bon-bon
– and they swallowed it at a single gulp!

My agent tried "Old Woolly" in several of the provincial towns
with tolerable success, and finally he was taken to Washington city,
to see if the wool could be pulled over the eyes of politicians. It was
successfully done for several days, when Col. Benton, ever regardful
of the reputation of his son-in-law, caused my agent to be arrested
on a grand-jury complaint for obtaining from him twenty-five cents
under false pretences, and the Senator from Missouri testified, that
having no mention of this horse in any of the numerous letters received
from his son-in-law, he was sure Col. Fremont never saw the animal.

Such testimony could not prove a negative. The complaint was
ruled out, and "Old Woolly" came off victorious. The excitement which
Col. Benton unconsciously produced added materially to the receipts
for the succeeding few days. But, always entertaining the greatest
respect for "Old Bullion," and out of regard to his feelings, I ordered
the horse back to Bridgeport, where in due time he gave his last kick.

For some time, however, he was turned loose in a field lying
on the public road, where occasional New York patrons recognized
their woolly friend in his retirement.

THE BUFFALO HUNT. – I attended the great Bunker Hill cele-
bration, June 17, 1843, and heard Mr. Webster's oration. I found

exhibiting near the monument, under an old canvas tent, a herd of calf buffaloes a year old. There were fifteen in number, and I purchased the lot for $700. I had an idea in my head which, if I could carry it out, would make the buffaloes a profitable investment, and I was determined to try it. The animals were poor and remarkably docile, having been driven from the plains of the Great West. I had them brought to New York, and placed in a farmer's barn in New Jersey, near Hoboken. Mr. C. D. French, of whom I purchased them, understood throwing the *lasso*, and I hired him for $30 per month to take care of the buffaloes, until such time as I had matured my plans.

Paragraphs were soon started in the papers announcing that a herd of wild buffaloes, caught by the lasso when quite young, were now on their way from the Rocky Mountains to Europe, *via* New York, in charge of the men who captured them. In a few days communications appeared in several papers, suggesting that if the buffaloes could be safely secured in some race course, and a regular buffalo chase given by their owners, showing the use of the *lasso*, etc., it would be a treat worth going many miles to see. One correspondent declared it would be worth a dollar to see it; another asserted that fifty thousand persons would gladly pay to witness it, etc. One suggested the Long Island Race Course; another thought a large plot of ground at Harlem, inclosed expressly for the purpose, would be better; and a third suggested Hoboken as just the place. In due time, the following advertisement appeared in the public prints, and handbills and posters of the same purport, illustrated by the following picture of wild buffaloes pursued by Indians on horseback, were simultaneously circulated, far and near, with a liberal hand:

"GRAND BUFFALO HUNT, FREE OF CHARGE. – At Hoboken, on Thursday, August 31, at 3, 4, and 5 o'clock P. M. ☞ Mr. C. D. French, one of the most daring and experienced hunters of the West, has arrived thus far on his way to Europe, with a HERD OF BUFFALOES, captured by himself, near Santa Fé. He will exhibit the method of hunting the Wild Buffaloes, and throwing the lasso, by which the animals were captured in their most wild and untamed state. This is perhaps one of the most exciting and difficult feats that can be performed, requiring at the same time the most expert horsemanship and the greatest skill and dexterity. Every man, woman and child can here witness *the wild sports of the Western Prairies*, as the exhibition is to be free to all, and will take place on the extensive grounds and Race Course of the Messrs. Stevens, within a few rods of the

Hoboken Ferry, where at least fifty thousand ladies and gentlemen can conveniently witness the interesting sport. The Grand Chase will be repeated at three distinct hours. At 3 o'clock P. M., from twelve to twenty Buffaloes will be turned loose, and Mr. French will appear dressed as an Indian, mounted on a Prairie Horse and Mexican saddle, chase the Buffaloes around the Race Course, and capture one with the lasso. At 4 and 5 o'clock, the race will be repeated, and the intervals of time will be occupied with various other sports. The City Brass Band is engaged.

"No possible danger need be apprehended, as a double railing has been put around the whole course, to prevent the possibility of the Buffaloes approaching the multitude. Extra ferry-boats will be provided, to run from Barclay, Canal, and Christopher streets. If the weather should be stormy, the sport will come off at the same hours the first fair day."

The mystery of a free exhibition of the sort, though not understood at the time, is readily explained. I had engaged all the ferry-boats to Hoboken, at a stipulated price, and all the receipts on the day specified were to be mine.

The assurance that no danger need be apprehended from the buffaloes was simply ridiculous. The poor creatures were so weak and tame that it was doubtful whether they would run at all, notwithstanding my man French had been cramming them with oats to get a little extra life into them.

The eventful day arrived. Taking time by the forelock, multitudes of people crossed to Hoboken before ten o'clock, and by noon the ferry-boats were constantly crowded to their utmost capacity. An extra boat, the Passaic, was put on, and the rush of passengers continued until five o'clock. Twenty-four thousand persons went by the ferry-boats to Hoboken that day. Each paid six and a quarter cents going, and as much returning, and the aggregate receipts, including the ferriage of carts and carriages, and the hire for refreshment-stands on the ground, were $3500. Many thousand persons were present from various parts of New Jersey, and these, though bringing "grist to my mill," of course escaped my "toll" at the ferries.

The band of music engaged for the occasion, did its best to amuse the immense crowd until three o'clock. At precisely that hour the buffaloes emerged from a shed in the centre of the inclosure – my man French having previously administered a punching with a sharp stick, hoping to excite them to a trot on their first appearance.

He immediately followed them, painted and dressed as an Indian, mounted on a fiery steed, with lasso in one hand and a sharp stick in the other, but the poor little calves huddled together, and refused to move! This scene was so wholly unexpected, and so perfectly ludicrous, that the spectators burst into uncontrollable uproarious laughter. The shouting somewhat startled the buffaloes, and, goaded by French and his assistants, they started off in a slow trot. The uproar of merriment was renewed, and the multitude swinging their hats and hallooing in wild disorder, the buffaloes broke into a gallop, ran against a panel of the low fence, (consisting of two narrow boards,) tumbled over, and scrambled away as fast as they could. The crowd in that quarter offered no obstruction. Seeing the animals approach, and not being sufficiently near to discover how harmless they were, men, women and children scattered pell-mell! Such a scampering I never saw before. The buffaloes, which were as badly frightened as the people, found shelter in a neighboring swamp, and all efforts to disengage them proved ineffectual. French, however, captured one of them with his lasso, and afterwards amused the people by lassoing horses and riders – and good-humor prevailed.

No one seemed to suspect the ferry-boat arrangement – the projector was *incog.* – the exhibition had been free to the public – there had been much amusement for twelve and a half cents each, and no one complained. It was, however, nearly midnight before all the visitors found ferry accommodations to New York.

N. P. Willis, of the "Home Journal," wrote an article illustrating the perfect good-nature with which the American public submits to a clever humbug. He said that he went to Hoboken to witness the Buffalo Hunt. It was nearly four o'clock when the boat left the foot of Barclay street, yet it was so densely crowded that many persons were obliged to stand upon the railings and hold on to the awning posts. When they reached the Hoboken side, a boat equally crowded was leaving that wharf. The passengers of the boat just arriving cried out to those in the boat just returning, "Is the Buffalo Hunt over?" To which came the reply, "Yes, and it was the biggest humbug you ever heard of!" Willis added, that the passengers on the boat with him were so delighted, that they instantly gave three cheers for the author of the humbug, whoever he might be.

The day after the chase at Hoboken, I met my friend Frederick West, of the "Sunday Atlas," who was not in the secret. "That French," said he, "is almost as great a humbug as *you* are." Thanking him for the honorable exception, I told him that I had

been much amused at witnessing the scene. "What amused me the most," said I, "was, to see the people running and screeching with fear, when the little harmless calves broke through the fence, and were scampering for the swamp."

"Where were you at the time?" asked West.

"Near the building, at the starting-point," I replied.

"Well," answered West, with a smile of discontent, "as I happened to be among the party that fled in affright, I don't see the fun of the thing as *you* do!"

The same experiment was subsequently tried, successfully at Camden, N. J., opposite Philadelphia; after which a number of the buffaloes were sent to England and sold, and the rest were fattened and disposed of in steaks in Fulton Market at fifty cents per pound.

It is but justice to myself to remind the reader that, at the time of their occurrence, the public did not suspect that I had any connection whatever with the exhibition of the Woolly Horse, or the herd of Buffaloes. The entire facts in these cases came to light only through my own voluntary admissions.

This is not exactly the place to introduce a newspaper, but the incidental mention of Mr. West suggests the "Sunday Atlas," which was always a favorite of mine. I knew its proprietors, West, Herrick and Ropes, when they commenced its publication. They were my early friends, and rendered me many favors, which I cheerfully reciprocated whenever opportunity offered. My European correspondence, before alluded to, was written for this paper.

The incident I am about to relate requires me to mention, that the proprietors of the Atlas had published my portrait with a brief sketch of my life, interspersed with numerous anecdotes.

At the time Adams was murdered by Colt, the excitement in New York was intense; and when the body of the victim was discovered, cut up, packed in a box, and shipped for New Orleans, a pamphlet was issued purporting to give a correct portrait of the murdered Adams. Like thousands of others, I desired to know how the poor man looked, and greedily purchased a pamphlet. I found that the stereotype of *my portrait* had been purchased from the Atlas, and was published as the portrait of Adams! I fancied then, as well as many times before and since, that "humbug" did not belong exclusively to the "show" business.

In about 1843, the editors of the Atlas were much annoyed by a series of libel suits. The first case required bonds of $5000. I

gave them. A second suit from the same party was immediately instituted, and I again gave the same amount of bonds. A third suit followed, and I again offered myself as their bail. The lawyer of the plaintiff, having hoped by bringing so many suits to give the defendants trouble in obtaining bonds, was much annoyed at my continually offering myself as their bail.

On my third appearance before the judge for that purpose, the lawyer being much vexed became impertinent. "Mr. Barnum," said he, "you have already given bail to the amount of $10,000, and now you offer yourself for $5000 more. Are you worth $15,000, sir?"

"I am, sir," I replied.

"Of what does your property consist, sir?" he asked peremptorily.

"Do you desire a list of it?" I inquired.

"I do, sir, and I insist upon your giving it before you are accepted as further security," he replied firmly.

"With pleasure, sir. Have the kindness to mark it down as I call it off."

"I will, sir," he answered, taking a sheet of paper and dipping his pen in the ink for that purpose.

"One preserved elephant, $1000," said I.

He looked a little surprised, but marked it down.

"One stuffed monkey skin, and two gander skins, good as new – $15 for the lot."

"What does this mean? What are you doing, sir?" said he, starting to his feet in indignation.

"I am giving you an inventory of my Museum. It contains only five hundred thousand different articles," I replied with due gravity.

"I appeal to the court for protection from insult," exclaimed the lawyer, his voice trembling with anger, and the blood rushing to his face as he spoke.

Judge Ulshoeffer decided that I was doing just what the lawyer had required, and that if he was unwilling to take an affidavit as to my responsibility, I must go on with the "catalogue" of the Museum. The lawyer mutteringly decided to accept the affidavit and bail without going further into the "bill of particulars."

CHAPTER XIII

Temperance and Agriculture

My Temperance Movements – An Inextricable Dilemma
– My Conversion – Self-delusion – The Maine Law –
Temperance Lectures – A Question answered – Cold
Victuals – A Man without Friends – Gratifying Incident
– Temperance Tract – Agriculture – Small Potatoes –
Grafts and Suckers – Indigestible Food – Importance
of Agriculture – Labor and Taste – The Merchant –
Astounding Facts – Pickpocket on Show – In the same
Trap – Taking in a Passenger – The Wrong Barnum –
Farming Stock – The Game-keeper.

IN the fall of 1847, while exhibiting Gen. Tom Thumb at Saratoga
Springs, where the New York State Fair was then being held, I saw
so much intoxication among men of wealth and intellect, filling the
highest positions in society, that I began to ask myself the question,
What guarantee is there that *I* may not become a drunkard? I
reflected that many wiser and better men than myself had fallen
victims to intemperance; and although I was not in the habit of
partaking often of strong drink, I was liable to do so whenever I
met friends, which in my travels occurred every day. Hence I
resolved to fly the danger, and I pledged myself at that time never
again to partake of any kind of spirituous liquors as a beverage.

I now felt that I was out of danger, and the sensation was a
pleasant one. True, I continued to partake of wine, for I had been
instructed, in my European tour, that this was one of the innocent

321

and charming indispensables of life. I however regarded myself as a good temperance man, and soon began to persuade my friends to refrain from the intoxicating cup. Seeing need of reform in Bridgeport, I invited my friend the Rev. E. H. Chapin to visit us, for the purpose of giving a public temperance lecture. I had never heard him on that subject, but I knew that on whatever topic he spoke, he was as logical as eloquent.

He lectured in the Baptist Church in Bridgeport. His subject was presented in three divisions: The liquor-seller, the moderate drinker, and the indifferent man. It happened, therefore, that the second, if not the third clause of the subject, had a special bearing upon *me* and my position.

The eloquent gentleman overwhelmingly proved that the so-called respectable liquor-seller, in his splendid saloon or hotel bar, and who sold only to "gentlemen," inflicted much greater injury upon the community than a dozen common groggeries – which he abundantly illustrated.

He then took up the "moderate drinker," and urged that *he* was the great stumbling-block to the temperance reform. He it was, and not the drunkard in the ditch, that the young man looked at as an example when he took his first glass. That when the drunkard was asked to sign the pledge, he would reply, "Why should I do so? What harm can there be in drinking, when such men as respectable Mr. A, and moral Mr. B, drink wine under their own roof?" He urged that the higher a man stood in the community, the greater was his influence either for good or for evil. He said to the moderate drinker: "Sir, you either do or you do not consider it a privation and a sacrifice to give up drinking. Which is it? If you say that you can drink or let it alone, that you can quit it for ever without considering it a self-denial, then I appeal to you as a man, to do it for *the sake of your suffering fellow-beings.* If, on the other hand, you say that you like to indulge moderately in the use of intoxicating drinks, and that it would be a self-denial on your part to abandon the practice, then, sir, I warn you in the light of all human experience, that you are *in danger*, and should give it up *for your own sake.* When appetite has so far got its hold upon you as to make the thought of abandoning strong drink uncomfortable, I tell you that the chances are strongly in favor of your dying a drunkard, unless you renounce the use of intoxicating beverages altogether."

I do not pretend to give the precise language of the eloquent Mr. Chapin, and no man can depict the overwhelming power with

which he urged his position. But I have given the gist of his argument as applied to the moderate drinker. It sank most deeply into my heart. I returned home and went to bed, but not to sleep. These arguments continued to ring in my ears, and though striving to find a reasonable answer to them, I spent a wretched and sleepless night. I had become fully conscious that I was pursuing a path of wrongdoing, and one which was not only causing great wrong to the community, but was also fraught with imminent danger to myself.

I arose from my bed, and feeling that as a man I could not persist in a practice which I could not conscientiously and logically defend, I took my champagne bottles, knocked off their heads, and poured their contents upon the ground. I then called upon Mr. Chapin, asked him for the teetotal pledge, and signed it.

God knows I am determined never to break that pledge, and my gratitude is so deep at being thus placed in a position to benefit my fellow-man, as well as perhaps to save myself, that I trust there is little danger of my ever again being brought within the charmed circle of the cup. Upon informing my wife that I had signed the teetotal pledge, I was surprised to see tears running down her cheeks. I was afterwards astonished to know from her, that she had passed many a weeping night, fearing that my wine-bibbing was leading me to a drunkard's path. I reproached her for not telling me her fears, but she replied that she knew I was self deluded, and that any such hint from her would have been received in anger.

This, let me here observe, is the case of thousands of individuals to-day. They are moving in respectable society, and regard intemperance as a dreadful evil. They would despise the thought of ever becoming intemperate themselves, and would look upon such a suggestion as the height of impudence and folly. The man who commences tippling is the last person in the world to discover his danger. If he has a wife, she probably is the first to know and shudder at his position. His neighbors know it long before he is aware of it, and if instead of passing it by in silence, as is usually the case, they would candidly point out to him the perilous course he is pursuing, many a valuable member of society would be saved from degradation, and his happy family snatched from misery, disgrace and despair.

I thanked Mr. Chapin, from my heart of hearts, for being the instrument of saving me, and great was his astonishment in discovering that I was not already a teetotaller. He supposed such was the case from the fact that I had invited him to lecture, and he little thought, at the time of his delivering it, that his argument to the

moderate drinker was at all applicable to me. But it was, and through the mercy of God, it saved me.

I now felt that I had a great duty to perform. I had been groping in darkness, was rescued, and I knew it was my duty to try and save others. The morning that I signed the pledge, I obtained over twenty signatures in Bridgeport. I talked temperance to all whom I met, and very soon commenced lecturing upon the subject in the adjacent towns and villages. I spent the entire winter and spring of 1851–2 in lecturing through my native State, always travelling at my own expense, and I was glad to know that I aroused many hundreds, perhaps thousands, to the importance of the temperance reform. I also lectured frequently in the cities of New York and Philadelphia, as well as in other towns in the neighboring States.

About this time the Maine Law was enacted, and its successful workings filled the hearts of temperance men and temperance women with hope and joy. We soon learned that in order to stay the plague, we must have a total prohibition of the sale of intoxicating drinks as a beverage. Neal Dow (may God bless him!) had opened our eyes. We saw that moral suasion had done much good. We could see that the Washingtonians and Sons of Temperance, the Daughters of Temperance, the Rechabites, and the Temples of Honor, had discharged their mission of peace and love; but we also saw that large numbers who were saved by these means, fell back again to a lower position than ever, because the tempter was permitted to live and throw out his seductive toils.

Our watchword now was, "Prohibition!" We had become convinced that it was a matter of life and death; that we must *kill* Alcohol, or Alcohol would kill *us*, or our friends.

While in Boston with Jenny Lind, I was earnestly solicited to deliver two temperance lectures in the Tremont Temple, where she gave her concerts. I did so, and although an admission of twelve and a half cents was charged for the benefit of a benevolent society, the building on each occasion was crowded.

In the course of my tour with Jenny Lind, I was frequently solicited to lecture on temperance on evenings when she did not sing. I always complied when it was in my power. In this way I lectured in Baltimore, Washington, Charleston, New Orleans, St. Louis, Cincinnati, etc. – also in the ladies' saloon of the steamer Lexington, on Sabbath morning.

In August, 1853, I lectured in Cleveland, Ohio, and several other towns, and afterwards in Chicago, Illinois, and in Kenosha,

Wisconsin. In the latter State I found the field was nearly ready for the harvest, but there were few reapers. A State election was to come off in October, on which occasion the people were to decide by ballot whether they would or would not approve of a prohibitory liquor law. Owing to an immense German population, who in the main were opposed to prohibition, the temperance friends were apprehensive of the result. They solicited my services for the ensuing month. I could not refuse them. I therefore hastened home to transact some business which required my presence for a few days, and then returned, and lectured on my way in Toledo and Norwalk, Ohio, and Chicago, Illinois. I made the tour of the State of Wisconsin, delivering two lectures per day for four consecutive weeks, to crowded and attentive audiences. I was glad to believe that my efforts contributed to a good result. The voice of the people declared, by a wholesome majority, in favor of a prohibitory liquor law, but a political legislature, hostile to so beneficent an act, refused to give it to them. I trust their deliverance is not far off.

In my temperance speeches, I have frequently been interrupted, and sometimes interrogated by opponents. I always take things coolly, let them have their say, and endeavor to give them a "Roland for an Oliver."

At New Orleans, I lectured in the great Lyceum Hall in St. Charles street, a new building just completed by the Second Municipality. I did so on the invitation of Mayor Crossman, and several other influential gentlemen. The immense Hall contained more than three thousand auditors, including the most respectable portion of the New Orleans public. I was in capital humor, and had warmed myself into a pleasant state of excitement, feeling that the audience was with me. While in the midst of an argument illustrating the poisonous and destructive nature of alcohol to the animal economy, some opponent called out, "How does it affect us, externally or internally?"

"*E*-ternally," I replied.

Scarcely ever have I heard such tremendous and simultaneous merriment as followed this reply. I was not allowed to proceed for several minutes, on account of the repetition of applause. I heard no more from the inquisitive gentleman, and have not the remotest idea who he was. My reply however was so sudden, that one gentleman who considered himself "up to snuff," remarked the next day in the Verandah Hotel, that if the truth could be known, he would wager a thousand dollars that I placed the man there on purpose to put the question. "By heavens," said he, "Barnum got

out 'eternally' before the fellow had finished 'internally.'" The gentleman's suspicion, although wholly unfounded, I regarded as a compliment.

While lecturing in front of the Court House in Cleveland, Ohio, one afternoon in 1853, in presence of a large crowd, including many farmers, an auditor, who I afterwards learned was an extensive liquor dealer, called out, "What will become of all the grain, if you stop the distilleries?"

"Feed it to the drunkard's wife and children; they have been without it long enough," I replied. "The husband and father will then be a sober man," I continued, "and will be able and willing to pay for it. You will find that the sober, industrious man and his family will require more grain than is now necessary to rot into whiskey to keep him drunk."

I then related the anecdote, that soon after the enactment of the Maine Law, a gentleman met a little girl in the streets of Portland, who had been in the habit of coming to his house as a beggar. "Why don't you come to our house now-a-days for cold victuals?" said he.

"Because father can't get any liquor, and he is sober and works every day, and we have plenty of *warm* victuals at our house now, I thank you, sir," replied the little girl.

The old farmers greatly enjoyed that reply, and "the liquor seller (said a correspondent of the New York Tribune) hauled off to repair damages."

On the first evening that I lectured in Cleveland, (it was in the Baptist Church,) I commenced in this wise: "If there are any ladies or gentlemen present, who have never suffered in consequence of the use of intoxicating drinks as a beverage, either directly, or in the person of a dear relative or friend, I will thank them to rise."

A man with a tolerably glowing countenance arose. "Had you never a friend who was intemperate?" I asked.

"Never!" was the positive reply.

A giggle ran through the opposition portion of the audience. "Really, my friends," I said, "I feel constrained to make a proposition which I did not anticipate. I am, as you are all aware, a showman. I am always on the look-out for curiosities. This gentleman is a stranger to me, but if he will satisfy me to-morrow morning that he is a man of credibility, and that no friend of his was ever intemperate, I will be glad to engage him for ten weeks at $200 per week, to exhibit him in my American Museum in New York, as the greatest curiosity in this country."

A laugh that *was* a laugh followed this announcement.

"They may laugh, but it is a fact," persisted my opponent with a look of dogged tenacity.

"The gentleman still insists that it is a fact," I replied. "I would like therefore to make one simple qualification to my offer. I made it on the supposition that, at some period of his life, he had friends. Now if he never had any friends, I withdraw my offer; otherwise, I will stick to it."

This, and the shout of laughter that ensued, was too much for the gentleman, and he sat down. I noticed throughout my speech that he paid strict attention, and frequently indulged in a hearty laugh. At the close of the lecture he approached me, and extending his hand, which I readily accepted, he said, "I was particularly green in rising to night. Having once stood up, I was determined not to be put down, but your last remark fixed me!" He then complimented me very highly on the reasonableness of my arguments, and declared that ever afterwards he would be found on the side of temperance.

Among the most gratifying incidents of my life, have been several of a similar nature to the following:

After a temperance speech in Philadelphia, a man about thirty years of age came forward, signed the teetotal pledge, and then, giving me his hand, he said, "Mr. Barnum, you have this night saved me from ruin. For the last two years I have been in the habit of tippling, and it has kept me continually under the harrow. This gentleman (pointing to a person at his side) is my partner in business, and I know he is glad I have signed the pledge to-night."

"Yes, indeed I am, George, and it is the best thing you ever did," replied his partner, "if you'll only stick to it."

"That will I do till the day of my death; and won't my dear little wife Mary cry for joy to-night when I tell her what I have done!" he exclaimed in great exultation.

At that moment he was a happy man – but he could not have been more so than I was.

I need not farther pursue this theme, than to add that I have lectured in Montreal, Canada, and many towns in the United States not here set down, always gladly doing so at my own expense; and one of the greatest consolations I how enjoy, is that of believing I have carried happiness to the bosom of many a family.

In the course of my life I have written much for newspapers, on various subjects, and always with earnestness, but in none of these have I felt so deep an interest as in that of the Temperance

Reform. Were it not for this fact, I should be reluctant to mention, that besides numerous articles for the daily and weekly press, I wrote a little tract on "The Liquor Business," which expresses my practical view of the use and traffic in intoxicating drinks.*

In 1848 I was elected President of the Fairfield County Agricultural Society in Connecticut. Although not practically a farmer, I had purchased about one hundred acres of land in the vicinity of my residence, and felt and still feel a deep interest in the cause of Agriculture.

In 1849 it was determined by the Society that I should deliver the annual address. I begged to be excused on the ground of incompetency, but my excuses were of no avail. Being unable to instruct my auditors upon the subject of farming, I gave them several specimens of mistakes which I had committed, and entreated them to profit by my errors. Two of my mistakes were related in this wise:

"In the fall of 1848, my head gardener reported that I had fifty bushels of potatoes to spare. I thereupon directed him to barrel them up and ship them to New York for sale. He did so, and received two dollars per barrel, or about sixty-seven cents per bushel. But unfortunately, after the potatoes had been shipped, I found that my gardener had selected all the *largest* for market, and left my family nothing but '*small potatoes*' to live on during the winter. But the worst is still to come. My potatoes were all gone before March, and I was obliged to buy, during the spring, over fifty bushels of potatoes *at* $1.25 *per bushel!*

"I trust that, inasmuch as I missed a figure or two in this operation, my friends will profit by my ignorance, and never be in a hurry to *sell* their productions until they have discovered that they have more on hand than will be required for family use!

"My next experiment, which was in the horticultural line, will not, I fear, redound more to my credit than the potato operation. Last spring I observed my gardener cutting off from our young maple trees all the small limbs and shoots which had started out from the body from two to six or eight feet from the ground. I inquired the object of this, and he informed me that these shoots were not only useless

*It was published by my worthy friends, FOWLERS & WELLS, of New York. They have long been pre-eminent in the Phrenological line, and have also done much to enlighten the public on Temperance, Physiology, and other important matters. Few men have published a larger number of useful books.

to the trees, but were, in fact, an injury, inasmuch as they absorbed the sap, which was needed in the upper branches. I immediately saw the philosophy of this, and feeling that, as 'President of the Fairfield County Agricultural Society,' it was my duty to have some *practical* experience in farming matters, I soon proceeded to the house, and having selected a large and very sharp carving-knife, went at once on to my grounds, with the full determination of destroying every worthless limb, sprout, and 'sucker' which came in my way.

"I soon found myself between a couple of rows of thrifty-looking young cherry trees, but, strange to say, their bodies were covered with 'suckers' or 'sprouts.' Here was a sad neglect of my gardener; but I held in my hand a weapon capable of neutralizing the results of his forgetfulness, and at it I went, right and left. The carving-knife, in my determined hand, worked wonders; and in less than an hour, I had trimmed every cherry tree nearly as high as I could reach, and looked with pleasure upon their symmetrical and much improved appearance. While thus beholding the fruit of my labor, and feeling a conscious pride over this, my first grand achievement in farming, my gardener came up, and with a feeling of satisfaction that I shall never forget, I pointed to the quantities of cherry sprouts which I had brought to the ground. The gardener started suddenly, gave a look of surprise, which instantly changed to despair, and clasping his hands as if in the deepest agony, he exclaimed, '*Merciful heavens! you have cut off all the grafts.*'

"This was a sad blow to my farming aspirations! It has caused me, not exactly to abandon the business in despair, but rather to be cautious about using the *pruning knife* until I know a sprout from a graft! I am convinced, from the foregoing experiments, that my education in the agricultural line was sadly neglected!"

To show the importance of manuring our land, I introduced the following considerations:

"Land being more plenty than people, it is *cheap* here, in comparison with other countries, and therefore the farmer settles on new land, which is bought for a trifle, and when he has nearly exhausted his soil, instead of attempting to renew it, he adopts what he considers a cheaper course; he sells his farm for what he can get, pulls up stakes, and moves away to some other new land, the soil of which, without the trouble or expense of manuring, is ready to bring forth large crops upon merely receiving the seed from the hand of the owner. Well, this system may have been very well once; it has served to push our backwoodsmen further towards our borders in the Great West, and

thus aid in peopling our magnificent territory, and developing our vast resources; but as it is important that we somehow manage to keep a *few* farmers in our New England and Middle States, it stands us in hand to see that they pay attention to improvements in agriculture and the creation of new soils, so that they may not be tempted to run away to the rich prairies of the West, and leave those engaged in other occupations to eat their own productions. For my own part, as a showman, I should be sadly puzzled if I was forced to eat stuffed monkeys, Fejee mermaids, or woolly horses; and I have no doubt that many others would be bothered to digest their own productions. I will merely instance the blacksmith, the shoemaker, the clergyman, the dentist, the saddler, the carpenter, and the stone mason. Surely the blacksmith would be obliged to pick his teeth with one of his own nail-rods, after having made a breakfast of horse-shoes or ox-chains; the shoemaker, after dining on sole-leather and black wax, would hope it was his *last* and his *all;* the clergyman, who could digest nothing but his own sermons, would consider it a terrible sentence to be forced to 'eat his words;' the carpenter would declare it was the hardest *deal* he ever *saw*, if he was obliged to swallow deal boards for his lunch; the dentist would starve to death 'in spite of his teeth,' if he had nothing but teeth for his food; the saddler would rather be a horse, and wear the saddle on the outside, than to find a place for a *stir-up* in his interior; and the stone mason would soon be at work building his own sepulchre, if he saw that he must gnaw nothing but granite till 'dust returned to dust.'

"It seems quite necessary, therefore, that we should keep the farmers among us; and as this is only to be done by letting them have land worth tilling, it is highly important that they should know how to *make* such land.

"Let the farmer learn the best and cheapest method of procuring or manufacturing manure, and then see that plenty of that kind of manure which his particular soil requires is applied to the land. Let him never half-manure a field: it is like administering half a dose of physic; it makes the patient stomach-sick and qualmish, but does not operate. Land half manured gives the farmer just as much trouble to cultivate it as if it was thoroughly done; and after all his trouble he gets but half a crop. If you can only procure half the amount of manure sufficient to enrich your land thoroughly, put it all on one half the land, and let the other half lie idle until you *can* manure it; you then save the trouble of tilling one half the quantity of land, and your crop will be as great as if put upon the whole land, half manured. Any

thing that is worth doing at all, is worth doing *well*. It is the cheapest and best way in the end. Half-way measures and half-way men are like flying squirrels – neither one thing nor the other – neither bird nor beast – neither useful nor ornamental. But no farmer's land need stand idle because he cannot procure manure. The system of 'green cropping' – that is, sowing crops, and ploughing them in while green, for the purpose of enriching the land – is now, I believe, generally acknowledged as an excellent substitute for other manures. Therefore, don't *desert* your land the moment it exhibits weakness, but give it *strength* – nurse it – doctor it – *cure* it, and it is as good as ever again."

I am sensible that an autobiography is not precisely the place for such remarks as these; but supposing it possible that my book may be read, not by farmers only, but by young men who are looking around them for a business, and being persuaded that agriculture is destined to occupy a higher position in men's thoughts than it has hitherto done, I am impelled to add another extract from my lecture. It relates to the dignity of labor and the utility of taste.

"The farmer, as well as every other person, should pursue his avocation with an eye to *pleasure* as well as profit. He should render the old homestead attractive; and certainly no place can so easily be made beautiful as the farm-house, and no beauty within the power of art can equal that with which nature can clothe the habitation of the farmer. His door-yard should be filled with flowers and shrubbery; the roadside leading to his house should be hedged with roses, and lined with trees, of all the varieties that nature produces, or that our climate and soil will suffer to grow; his porches and piazzas, and the sides of his house, should be trellised with vines, and its windows adorned with flowers. The farmer, with his bowers of roses, his plants, shrubs, and flowers, has a palace more beautifully adorned than if covered with rubies and diamonds. Festoons of natural flowers are as much more elegant than strings of pearls, as nature is superior to art. The king may obtain all that wealth can procure to decorate his palace, but the humblest farmer has a decorator whose knowledge is infinite; and the simplest flower that God ever made as far exceeds in real beauty and sublimity the richest trinket that the handicraft of man ever produced, as the bright tints of the rainbow surpass the coarsest daub of the painter's apprentice.

"It is a very singular and lamentable fact that agriculture, in this great and emphatically agricultural country, does not stand so high in the scale of human occupations and industry as it deserves. From some cause, which it will be the object of this essay to discover,

the *farmer* is not elevated in the estimation of community to the eminence to which his calling justly entitles him. He is looked upon as a being quite below the lawyer, the physician, the divine, the artist, the merchant, or even the merchant's clerk. To be a farmer is to be a nobody, a mere clodhopper, a delver in bogs, a digger in ditches, and a dirty wallower in '*free soil.*' He is regarded as a mere swine-herd, a hewer of wood and drawer of water, a senseless lump of clay, gifted with *animation* solely that he may root up the clay that is *inanimate.* I propose to inquire whether this is the necessary position of the tiller of the soil, and to learn whether, in fact, the farmer's is not one of the most, if not *the* most honorable and independent calling in the universe. Look candidly at this subject, and see whether there is any thing degrading in the life of the husbandman. Compare him with those engaged in other pursuits, and my word for it, we will find the farmer the very foundation of our social being, our true happiness, our manly independence; and when we have piled up every other calling and occupation until we have raised a pyramid whose summit shall kiss the clouds, we will find the honest, hard-working, practical farmer at the very 'top of the heap.'

"While we would give all due honor to the professions, we must not elevate them *above* their deserts, and thrust down the farmer, the real producer and public benefactor, below his proper level.

"It will always be well to remember that the learned professions depend solely for support upon the misfortunes, miseries, or foibles of mankind.

"If all men were inclined to honesty and peace, the lawyer would pocket no fees, and must abandon his profession or go supperless to bed.

"If men were abstemious in their habits, and were not the victims of accident or misfortune, the doctor would be obliged to take up some other pursuit to gain his bread – unless he choose to eat his own pills. And if all mankind would be righteous, and break off from their sins, the clergy might exclaim with Othello, 'Our occupation's gone.'

"The farmer, therefore, who *produces* food and raiment for the comfort and sustenance of the human family, need not feel that he is *below* occupations which exist to so large a degree on the miseries of humanity.

"The highest aspiration of many parents is, that their son may become a merchant. This is the very acme of their desires. To be a *merchant* they fancy is to be a prince, a potentate, who can stand, as

it were, in the very centre of the earth, and call to him all the productions of the world. They see no care in the life of the merchant. They do not think of the hopes and fears which agitate his breast from early morn to the noon of night. What do they know of his anxiety as he seizes the morning's paper, to read of the loss of his favorite and most valuable ship, or the destruction by fire of the store-house in which was centred his all? The merchant lives in an agony of excitement. The market is dull, and his large stock hangs on his hands unsold, and perhaps unpaid for. But pay-day must come, and then his misery is enhanced. He rises from his sleepless pillow, frantic with the reflection that the banks have stopped discounting – that his note comes due this day, and unless paid before three o'clock, must be protested, and he become a ruined man. He thinks over his resources, but alas! they are all exhausted. He considers his list of friends, but they are as badly off as himself. He has only one despairing hope left. He must go again to the usurer, and borrow money to pay borrowed. Borrow, did I say? No, he must *buy* the use of it, and perhaps pay cent. per cent. for the purchase. Thus he goes on from one day to another, living in misery, and yet forced to *appear* happy; sweating out his very life-blood over his desk and between the horrible brick walls. Cut off from the fresh air and the enjoyments of life – pent up in the close unhealthy city – not an hour that he can call his own – his opportunities for rest, reflection, or recreation gone for ever – he is a mere plodding, hard-working machine, obliged every day to go its rounds of toil and misery, till at last misfortune closes his mercantile career, he is declared a bankrupt, and he flies to the country with his shattered fortune and ruined health, and there he is found inhaling the pure air and refreshing breeze, and declaring from his heart of hearts that this is the first feeling of pleasure he has enjoyed for years, and that if his health was good – poor as he is – he could really be happy in the glorious country. Poor man! had he clung to the old farm, he would have had health, happiness, and competence. He would have known nothing of bank discounts, or the tender mercies of note shavers; he would have been ignorant of dull markets, over trading, or over imports; but he would have been independent, healthy, and happy, and engaged in an occupation that would have elevated his mind, instead of cramping it into the narrow prison of a trader, whose highest ambition frequently consists in driving a sharp bargain, carrying out a nice operation in the stocks, or being able to meet his notes without a *protest*.

"Statistics reveal the astounding fact that sixty-seven out of

every hundred retail merchants in the city of Boston fail in business, and that ninety-three in every hundred wholesale merchants become bankrupt! And yet this swopping, trading, bargaining, health-destroying occupation holds out its *false* colors, its glittering allurements, and leads the sturdy, hearty young yeoman to pant, as for very life, for the chance of quitting his father's noble fields, his native hills and verdant valleys, in order that he can become a *clerk* in a store! Quit the good old farm, with its invigorating exercises, its manly occupations, its delightful air, the fragrance of its flowers, the beauties of its golden harvests, and the delights of its season of fruits, for the great privilege of learning to sweep out a store, take down and put up window shutters; and finally, after spending years in acquiring this beautiful elementary branch, get to be a clerk out of employ, or possibly have the privilege of starting a store on his own account, and receive all the pleasures just named, as the certain accompaniment of the merchant. And when a merchant proves successful – when, after years of toil and pain, of strife, excitement, and misery, he accumulates a fortune – what does he do then? Where then does he look for happiness as the reward for all his life of labor and self-denial? Why, to the *country!* His great desire is to retire to fields where he can raise his own corn and potatoes, eat butter and cheese from his own dairies, and pluck fruit from his own vines and trees! Thus, at nearly the termination of his life, he is able to become a farmer, and enjoy what he might have delighted in during the previous thirty years, if he had not been dazzled with the *false* idea that the merchant is *more respectable* than the agriculturist."

During my administration the annual Fairfield County Agricultural Fair and Cattle Show has been held six times, four of which were in Bridgeport and two in Stamford. The interest has seemed to increase from year to year.

Pickpockets are generally represented at these country fairs, as indeed they are on nearly all occasions where crowds of people congregate.

In 1849 a young lady had the chain of her gold watch cut, and watch and chain stolen by one of these gentry, who escaped undiscovered. Nearly every year somebody's pocket has been picked during the Fair. In 1853 a man was caught in the act of taking a pocket-book from a country farmer, and two or three other persons had suffered in the same way. The scamp was arrested, and proved to be a celebrated English pickpocket. As the Fair would close the

next day, and as most persons had already visited it, we expected our receipts would be light.

Early in the morning the detected party was legally examined, plead guilty, and was bound over to the upper court for trial. I obtained consent from the sheriff that the culprit should be put in the Fair room for the purpose of giving those who had been robbed an opportunity to identify him. For this purpose he was handcuffed and placed in a conspicuous situation, where of course he was "the observed of all observers." I then issued handbills, stating that as it was the last day of the Fair, the managers were happy to announce that they had secured *extra attractions* for the occasion, and would accordingly exhibit, safely handcuffed, and without extra charge, *a live pickpocket*, who had been caught in the act of robbing an honest farmer the day previous. Crowds of people rushed in "to see the show." Some good mothers brought their children ten miles for that purpose, and our treasury was materially benefited by the operation.

The present season (1854) I was requested to deliver the opening speech at our County Fair, which was held at Stamford. Not being able to give agricultural advice, I delivered a portion of my lecture on the "Philosophy of Humbug." The next morning, as I was being shaved in the village barber's shop, which was at the time crowded with customers, the ticket-seller to the Fair came in.

"What kind of a house did you have last night?" asked one of the gentlemen in waiting.

"Oh, first-rate, of course. Old Barnum always draws a crowd," was the reply of the ticket-seller, to whom I was not known.

Most of the gentlemen present, however, knew me, and they found much difficulty in restraining their laughter.

"Did Barnum make a good speech?" I asked.

"I did not hear it. I was out in the ticket-office. I guess it was pretty good, for I never heard so much laughing as there was all through his speech. But it makes no difference whether it was good or not," continued the ticket-seller, "the people *will* go to see old Barnum. First he humbugs them, and then they pay to hear him tell how he did it! I believe if he should swindle a man out of twenty dollars, the man would give a quarter to hear him tell about it."

"Barnum must be a curious chap," I remarked.

"Well, I guess he is up to all the dodges."

"Do you know him?" I asked.

"Not personally," he replied; "but I always get into the Museum for nothing. I know the doorkeeper, and he slips me in free."

335

"Old Barnum would not like that, probably, if he knew it," I remarked.

"But it happens he don't know it," replied the ticket-seller, in great glee.

"Barnum was on the cars the other day, on his way to Bridgeport," said I, "and I heard one of the passengers blowing him up terribly as a humbug. He was addressing Barnum at the time, but did not know him. Barnum joined in lustily, and endorsed every thing the man said. When the passenger learned whom he had been addressing, I should think he must have felt rather flat."

"I should think so, too," said the ticket-seller.

This was too much, and we all indulged in a burst of laughter. Still the ticket-seller suspected nothing. After I had left the shop, the barber told him who I was. I called into the ticket-office on business several times during the day, but the poor ticket-seller kept his face turned from me, and appeared so chop-fallen that I did not pretend to recognize him as the hero of the joke in the barber's shop.

This incident reminds me of numerous similar ones which have occurred at various times. On one occasion, it was in 1847, I was on board the steamboat from New York to Bridgeport. As we approached the harbor of the latter city, a stranger desired me to point out "Barnum's house" from the upper deck. I did so, whereupon a bystander remarked, "I know all about that house, for I was engaged in painting there for several months while Barnum was in Europe." He then proceeded to say that it was the meanest and most illy contrived house he ever saw. "It will cost old Barnum a mint of money, and not be worth two cents after it is finished," he added.

"I suppose old Barnum don't pay very punctually," I remarked.

"Oh yes, he pays punctually every Saturday night – there's no trouble about that; he has made half a million by humbugging the public with a little boy whom he took from Bridgeport and represented to be twice his real age," replied the painter.

Soon afterwards one of the passengers told him who I was, whereupon he secreted himself, and was not seen again while I remained on the boat.

On another occasion I went to Boston by the Fall River route. Arriving before sunrise, I found but one carriage at the dépôt. I immediately engaged it, and giving the driver the check for my baggage, told him to drive me directly to the Revere House, as I was in great haste, and enjoined him to take in no other passengers,

and I would pay his demands. He promised compliance with my wishes, but soon afterwards appeared with a gentleman, two ladies, and several children, whom he crowded into the carriage with me, and placing their trunks on the baggage rack, started off. I thought there was no use in grumbling, and consoled myself with the reflection that the Revere House was not far. He drove up one street and down another, for what seemed to me a very long time, but I was wedged in so closely that I could not see what route he was taking.

After half an hour's drive he halted, and I found we were at the Lowell Railway Dépôt. Here my fellow-passengers alighted, and after a long delay the driver delivered their baggage, received his fare, and was about closing the carriage door preparatory to starting again. I was so thoroughly vexed at the shameful manner in which he had treated me, that I remarked, "Perhaps you had better wait till the Lowell train arrives; you may possibly get another load of passengers. Of course my convenience is of no consequence. I suppose if you land me at the Revere House any time this week, it will be as much as I have a right to expect."

"I beg your pardon," he replied, "but that was Barnum and his family. He was very anxious to get here in time for the first train, so I stuck him for $2, and now I'll carry you to the Revere House free."

"What Barnum is it?" I asked.

"The Museum and Jenny Lind man," he replied.

The compliment and the shave both having been intended for me, I was of course mollified, and replied, "You are mistaken, my friend; *I* am Barnum."

Coachee was thunderstruck, and offered all sorts of apologies. "A friend at the other dépôt told me that I had Mr. Barnum on board," said he, "and I really supposed he meant the other man. When I come to notice you, I perceive my mistake, but I hope you will forgive me. I have carried you frequently before, and hope you will give me your custom while you are in Boston. I never will make such a mistake again." I had to be satisfied!

I resigned the office of President of the Fairfield County Agricultural Society in 1853, but the members accepted my resignation only on condition that it should not go into effect until after the Fair of 1854.

I have not gone largely into stock on my farm – the only animals that I have imported being the Alderney cows, a superior

337

breed for rich milk and butter, and the Suffolk swine, a specimen of fine-grained pork which is always fat enough for the butcher, and requires not more than one-third the food given to many other breeds.

I have also some fine specimens of poultry and rare birds, among which are the Dorking, black Spanish, Bolton gray, Seabright, silver-spangled and African bantams, black swan, white swan, Egyptian geese, Barnacle geese, Mandarin and other species of rare ducks, gold and silver and English pheasants, etc.

I must not pass from facts and incidents, directly or indirectly connected with farming, without narrating the following:

I have a friend whom I will here call John D. Jameson, who lives in a splendid house a quarter of a mile west of my residence. I own several acres of land on the corner of two streets directly adjoining his homestead. I recently surrounded it with high pickets and converted it into a deer park by introducing a number of Rocky Mountain elk, reindeer, etc. Strangers passing by would naturally suppose that the deer park belonged to Jameson's estate. To render the illusion more complete, his son-in-law placed a sign in the park, fronting on the street, and reading:

"ALL PERSONS ARE FORBID TRESPASSING ON THESE GROUNDS OR DISTURBING THE DEER. J. D. JAMESON."

I "acknowledged the corn," and was much pleased with the joke. Jameson was delighted, and bragged considerably of having got ahead of Barnum. The sign remained undisturbed for several days. It happened at length that a party of friends came to visit him from New York. They arrived in the evening. Jameson told them he had got a capital joke on Barnum. He would not explain, but said they should see it for themselves the next morning. Bright and early he led them into the street, and after conducting them a proper distance, wheeled them around in front of the sign. To his dismay he discovered that I had added directly under his name the words, "*Game-keeper to P. T. Barnum.*" His friends, as soon as they understood the joke, enjoyed it mightily, but it was said that neighbor Jameson laughed out of "the wrong side of his mouth."

CHAPTER XIV

Sundry Business Enterprises

Fire Annihilator – Pequonnock Bank – Illustrated News
– New York Crystal Palace – Copper Mines – Begging
Letters – My Agents – Rules for Making a Fortune –
Retrospective View – Iranistan – "Home, Sweet Home!"

IN this, the closing chapter of my Autobiography, I purpose
mentioning sundry business enterprises in which I have been or
still am engaged; together with matters in which I feel at present
more deeply interested than in all other things combined, viz., my
family and my homestead.

THE FIRE ANNIHILATOR.

Late in August, 1851, I was visited at Bridgeport by a
gentleman who was interested in an English invention patented in
this country, and known as Phillips's Fire Annihilator. He showed
me a number of certificates from men of eminence and reliability
in England, setting forth the merits of the invention in the highest
terms. The principal value of the machine seemed to consist in its
power to extinguish flame, and thus prevent the spread of fire when
it once broke out. Besides, the steam or vapor generated in the
Annihilator was not prejudicial to human life. Now, as water has
no effect whatever upon flame, it was obvious that the Annihilator
would at the least prove a great *assistant* in extinguishing confla-
grations, and that, especially in the incipient stage of a fire, it would

extinguish it altogether, without damage to goods or other property, as is usually the case with water.

Hon. Elisha Whittlesey, First Controller of the United States Treasury at Washington, was interested in the American patent, and the gentleman who called upon me desired that I should also take an interest in it. I had no disposition to engage in any speculation; but, believing this might prove a beneficent invention, and be the means of saving a vast amount of human life as well as property, I visited Washington City for the purpose of conferring with Mr. Whittlesey, Hon. J. W. Allen, and other parties interested.

I was there shown numerous certificates of fires having been extinguished by the machine in Great Britain, and property to the amount of many thousands of pounds saved. I also saw that Lord Brougham had proposed in Parliament that every Government vessel should be compelled to have the Fire Annihilator on board. Mr. Whittlesey expressed his belief in writing, that "if there is any reliance to be placed on human testimony, it is one of the greatest discoveries of this most extraordinary age." I fully agreed with him, and have never yet seen occasion to change that opinion.

I agreed to join in the enterprise. Mr. Whittlesey was elected President, and I was appointed Secretary and General Agent of the Company. I opened the office of the Company in New York, and sold and engaged machines and territory in a few months to the amount of about $180,000. I refused to receive more than a small portion of the purchase money until a public experiment had tested the powers of the machine, and I voluntarily delivered to every purchaser an agreement signed by myself in the following words:

"If the public test and demonstration are not perfectly successful, I will at any time when demanded, within ten days after the public trial, refund and pay back every shilling that has been paid into this office for machines or territory for the sale of the patent."

The public trial came off in Hamilton Square on the 18th December, 1851. It was an exceedingly cold and inclement day. Mr. Phillips, who conducted the experiment, was interfered with and knocked down by some rowdies who were opposed to the invention, and the building was ignited and consumed after he had extinguished the previous fire. Subsequently to this unexpected and unjust opposition, I refunded every cent which I had received, sometimes against the wishes of those who had purchased, for they were willing to wait the result of further experiments; but I was utterly disgusted with

the course of a large portion of the public upon a subject in which they were much more deeply interested than I was.

If I had been governed by the system of morals which is too prevalent in the trading community, I could have withheld the pledge which I gave to refund the money, and could thus have put many thousands of dollars into the treasury of the Annihilator Company. Being a mere showman, however, I was actuated by somewhat different principles, and chose voluntarily to make every man whole who had in any manner misapprehended the true merits of the invention. The arrangements of the Annihilator Company with Mr. Phillips, the inventor, predicated all payments which he was to receive on *bonâ fide* sales which we should actually make; therefore he really received nothing, and the entire losses of the American Company, which were merely for advertising and the expense of trying experiments, hire of an office, etc., amounted to less than $30,000, of which my portion was less than $10,000.

I disposed of my interest in the concern to Horatio Allen, Esq., of the firm of Stillman, Allen & Co., at the Novelty Works.

Mr. Allen has great confidence in the machine, and I understand the Company is continually making and disposing of large quantities of them for ships, factories, stores, dwellings, etc. It is believed that Mr. Allen's sales will eventually enable him to make up to the American Company all their losses. When a fire has broken out and is raging furiously, especially if the wind is blowing, the Annihilator cannot be used to advantage, and in that respect I was deceived by the representations of the man who first called upon me. But that it is a valuable machine for all fires in their incipient state, and should be kept in every building, and especially on board of every species of sailing or steam vessel, I most conscientiously believe. My experiences in life have convinced me that real merit does not always succeed as well as "humbug ;"* and I consider Phillips's Fire Annihilator a fair exemplification of the fact.

*It has often occurred to me that the true History of Humbug would prove a highly valuable and interesting publication. Every period has had its humbugs, and they are found scattered alike in the annals of every calling and profession. My researches upon this subject have by no means been confined to the sphere of a showman; and, having been convinced that an elaborate *exposé* of its bearings, through the entire range of history, would startle as well as enlighten the community, I am preparing, and hope in good time to publish, a work that I trust will do full justice to that universal science.

PEQUONNOCK BANK.

In the spring of 1851 the Connecticut Legislature chartered the Pequonnock Bank of Bridgeport, with a capital of two hundred thousand dollars. I had no interest whatever in the charter, and did not even know that an application was to be made for it. More banking capital was needed in Bridgeport in consequence of the great increase of trade and manufactures in that growing and prosperous city, and this fact appearing in evidence, the charter was granted as a public benefit. The stock-books were opened under the direction of State Commissioners according to the laws of the commonwealth, and nearly double the amount of capital was subscribed on the first day. The stock was distributed by the Commissioners among several hundred applicants. Circumstances unexpectedly occurred which induced me to accept the Presidency of the Bank, in compliance with the unanimous vote of its directors. Feeling that I could not, from my many avocations, devote the requisite personal attention to the duties of the office, C. B. HUBBELL, Esq., the present Mayor of Bridgeport, was at my request appointed Vice-President of the institution. Mr. Hubbell is a retired merchant, whose large family has been reared in Bridgeport, where for many years he has been esteemed as one of its most prominent citizens. His long experience as a director in the Bridgeport Bank renders him peculiarly qualified for the station he now fills; and the Pequonnock Bank, from the day of its opening, has conducted its business in the most honorable and legitimate manner, redounding alike to the pecuniary benefit and satisfaction of its customers and its stockholders.

On several occasions, the credit of this institution has been attacked without the slightest justice or reason. On at least one occasion, the attack had a squinting towards "black mail;" but as that is an operation that I never did and never will submit to, the attempt was of course ineffectual. When the last effort was made to throw suspicion upon the soundness of this institution, it was by a Bank-Note List Reporter, and, without consulting the directors or any other person, I voluntarily pledged in the public journals my private fortune for the redemption of all its notes. The "Reporter," finding he had "caught a Tartar," immediately issued an Extra retracting what he had said on the previous day, and informing the public (of what it already knew) that the Pequonnock Bank was a safe and sound institution.

The New England system of banking is as safe for both bill

and stockholders as probably any that has ever been devised. It is the duty of the Bank Commissioners, first to see that the stock is not monopolized by any capitalist or clique, but properly divided among all applicants. The laws of Connecticut prohibit any director of a bank from being its debtor directly or indirectly to an amount exceeding five thousand dollars. The various other restrictions and guards which, in that State, have existed in relation to the amount of specie to be kept on hand, the stated reports necessarily made by the cashier of each bank, the personal examination of these institutions by the State Commissioners, etc., have proved salutary and sufficient in all cases where there has not been a palpable neglect of duty on the part of the Commissioners.

Occasionally, however, legislators are elected who are not content to "let well enough alone," and feeling that they must do something to render themselves conspicuous, they generally commence "tinkering the currency," and meddling with the banks.

The Connecticut Legislature of 1854 passed several unwise and superfluous enactments in regard to banks. They serve to injure the interests both of borrowers and stockholders, and unless speedily repealed, will occasion great embarrassment if not loss to the manufacturing and mercantile community, whose prosperity depends in a great degree upon proper bank facilities.

NEW CITY — EAST BRIDGEPORT.

In 1851, I purchased from William H. Noble, Esq., of Bridgeport, the undivided half of his late father's homestead, consisting of fifty acres of land lying on the east side of the river, opposite the city of Bridgeport. We intended this as the nucleus of a "new city," which we had concluded could soon be built up, in consequence of many natural advantages that it possesses.

Before giving publicity to our plans, however, we purchased one hundred and seventy-four acres contiguous to that which we already owned. We then laid out the entire property in regular streets, and lined them with trees, reserving a beautiful grove of six or eight acres, which we inclosed and converted into a public park. We then commenced selling alternate lots at the same price which the land cost us by the acre. Our sales were always made on the condition that a suitable dwelling-house, store, or manufactory should be erected upon the land within one year from the date of purchase; that every building should be placed at a certain distance from the

street, in a style of architecture approved by us; that the grounds should be inclosed with acceptable fences, and kept clean and neat, with other conditions which would render the locality a desirable one for respectable residents, and operate for the mutual benefit of all persons who should become settlers in the new city.

This entire property consists of a beautiful plateau of ground lying within less than half a mile of the centre of Bridgeport city, and had only been kept from market by the want of means of access. A new foot-bridge was built, connecting this place with the city of Bridgeport, and a public toll-bridge which belonged to us was thrown open to the public free. We also obtained from the State Legislature a charter for erecting a toll-bridge between the two bridges already existing, and under that charter we put up a fine covered draw-bridge at a cost of $16,000, which also we made free to the public. We built and leased to a union company of young coachmakers a large and elegant coach manufactory, which was one of the first buildings erected there, and which went into operation on the first of January, 1852.

This building is now occupied by Messrs. Brewster. More recently a similar establishment has been erected in the new city by Messrs. Hubbell and Haight. It is believed that more carriages are manufactured in Bridgeport than in any other city in the Union, and it is not saying too much to affirm that no better family carriages are made in the world than are annually turned out in large numbers at East Bridgeport. There is also now in progress of erection an immense clock establishment known as the "Terry and Barnum Manufacturing Company," with a stock capital of $100,000. This alone will add six hundred inhabitants to our new city. The President of the Company is Theodore Terry, Esq., formerly of the Ansonia Clock Company, a gentleman thoroughly conversant with the business. This establishment will manufacture over five thousand clocks per month.

Besides the inducement which we held out to purchasers to obtain their lots at a merely nominal price, we advanced one half, two thirds, and frequently all the funds necessary to erect their buildings, permitting them to repay us in sums as small as five dollars, at their own convenience. This arrangement enabled many persons to secure and ultimately pay for homes which they could not otherwise have obtained. We of course looked for our profits solely to the rise in the value of the reserved lots, which we were confident must ensue.

Of course, these extraordinary inducements led many persons to build in the new city, and it is at this time increasing with a rapidity rarely if ever before witnessed in this portion of our country. At this present writing, only two years and a half have elapsed since the first building was erected upon our property, and there are already dwellings, stores, factories, etc., which have cost an aggregate of nearly one million dollars. A fine church and a schoolhouse have been erected, and lots which were purchased two years ago for two hundred dollars, would now readily command from one to two thousand dollars exclusive of the buildings.

This speculation may properly be termed a profitable philanthropy. I some time since offered Mr. Noble, for his interest in the estate, sixty thousand dollars more than the prime cost, which he declined. I am relieved from much personal attention to this portion of my property, by the diligence of my esteemed son-in-law, DAVID W. THOMPSON, who devotes his entire time to that branch of my business.

ILLUSTRATED NEWS.

In the fall of 1852 a proposition was made by certain parties to commence the publication of an illustrated weekly newspaper in the city of New York. The field seemed to be open for such an enterprise, and I invested twenty thousand dollars in the concern, as special partner, in connection with two other gentlemen, who each contributed twenty thousand dollars as general partners.

Within a month after the publication of the first number of the "Illustrated News," which was issued on the first day of January, 1853, our weekly circulation had reached seventy thousand. Numerous and almost insurmountable difficulties, for novices in the business, continued however to arise, and my partners, becoming wearied and disheartened with constant over-exertion, were anxious to wind up the enterprise at the end of the first year. The engravings and good-will of the concern were sold to the proprietor of Gleason's Pictorial in Boston, who merged our subscription-list with his. I came out of this enterprise without loss.

NEW YORK CRYSTAL PALACE.

In 1851, when the idea of opening a World's Fair in New York was first broached, I was waited upon by Mr. Riddell and

the other originators of the scheme, and invited to join in getting it up. I declined, giving as a reason that such a project was, in my opinion, premature. I felt that it was following quite too closely upon its London prototype, and assured the projectors that I could see in it nothing but certain loss. The plan, however, was carried out, and a charter obtained from the New York Legislature. The building was erected on a plot of ground upon Reservoir Square, leased to the Association, by the City of New York, for one dollar per annum. The location, being four miles distant from the City Hall, was enough of itself to kill the enterprise. The stock was readily taken up, however, and the Crystal Palace opened to the public in July, 1853. Many thousands of strangers were brought to New York, and however disastrous the enterprise may have proved to the stockholders, it is evident that the general prosperity of the city has been promoted far beyond the entire cost of the whole speculation.

In February, 1854, numerous stockholders applied to me to accept the Presidency of the Crystal Palace, or, as it was termed, "The Association for the Exhibition of the Industry of all Nations." I utterly declined listening to such a project, as did also my friend and neighbor Genin, and both of us forbade the use of our names in connection with the institution.

Subsequently, seeing our names published in the New York papers, as likely to be connected with a new direction, and feeling assured that this was done for the purpose of imparting a fictitious value to the stock, we published a card denying all intention of having any thing to do with the Crystal Palace management, stating as a reason our inability "to raise the dead." This was done in good faith, and without the remotest idea, on my part, of ever having any connection with the enterprise. I have no doubt that such was also the case with Mr. Genin.

Shortly afterwards, however, I was waited upon by numerous influential gentlemen, and strongly urged to allow my name to be used. I repeatedly objected to this, and at last consented much against my own judgment. Having been elected one of the Directors, I was by that body chosen President. I accepted the office conditionally, reserving the right to decline if I thought, upon investigation, that there was no vitality left in the institution.

Upon examining the accounts said to exist against the Association, many were pronounced indefensible by those who I supposed knew the facts in the case, while various debts existing

against the concern were not exhibited when called for, and I knew nothing of their existence until after I accepted the office of President.

I finally accepted it, only because no suitable person could be found who was willing to devote his entire time and services to the enterprise, and because I was frequently urged by directors and stockholders to take hold of it for the benefit of the city at large, inasmuch as it was well settled that the Palace would be permanently closed early in April, 1854, if I did not take the helm.

These considerations moved me, and I entered upon my duties with all the vigor which I could command. To save it from bankruptcy, I advanced large sums of money for the payment of debts, and tried by every legitimate means to create an excitement and bring it into life. By extraneous efforts, such as the Re-inauguration, the Monster Concerts of Jullien, the Celebration of Independence, etc., it was temporarily *galvanized*, and gave several life-like *kicks*, generally without material results, except prostrating those who handled it too familiarly; but it was a corpse long before I touched it, and I found, after a thorough trial, that my first impression was correct, and that so far as my ability was concerned, "the dead could not be raised."

I never labored so hard, night and day, during three months, as I did while President of the Crystal Palace, and finding that its creditors seemed to look upon me as the debtor, and expected me to cancel all the obligations instead of the "Association," I resigned in July.

One of the Directors of the Crystal Palace was Horace Greeley. He was always punctual at the Directors' meeting, much more so than any other member of the Board. I frequently remarked to him, that I wished the other members were as punctual as he. "Some persons never have time to meet engagements, but I always have plenty of time," was his reply. And yet I know of no man who works so hard, and accomplishes so much in a year, as does Mr. Greeley. From daylight until midnight he knows no rest. He travels at all hours, and in all directions. He seems to have the powers of ubiquity. At one time we see him announced as giving an Agricultural Address in Indiana, and within a few days afterwards he is speaking on Temperance in Vermont, and the same morning we read an article in the Tribune, which we know is from his vigorous pen, by the summary and effectual manner in which the argument is put and his opponent "used up."

On one occasion a point of considerable interest was being debated in the Board of Directors, and some feeling was manifested.

"I am always a strict constructionist," said one of the members.

"I am always a loose constructionist," said Mr. Greeley, "and I never yet heard the doctrine of strict construction urged, without finding there was some rascality at the bottom of it."

"I hope there is nothing personal in that remark," said the director.

"Not at all," replied Mr. Greeley, "but I state exactly my own experience on the subject."

In a very important sense the Crystal Palace has proved a paying concern. Besides the great improvement that it caused in the public taste for the fine arts, and the many advantages it conferred upon inventors, manufacturers, etc., it undoubtedly added millions of dollars to the wealth of New York city. Indeed, many of those who subscribed for the stock, did it for the purpose of aiding their business, by bringing strangers to the city; and although they may have never realized a penny for their stock, numerous merchants, hotel keepers, etc., would be glad to do the same thing in relation to any other enterprise which would produce the same results.

What disposition will be finally made of the Crystal Palace is more than I can tell. I do not own a dollar's worth of stock in the Association, and have no special interest in its future disposition. Various projects have been suggested. One relates to selling it to the United States Government, another proposes removing it to Boston, another to Philadelphia, still another to the Battery, and a fifth, to the City Hall Park in New York. I consider that New Yorkers are already disgraced by the coldness with which they have ever regarded the subject, and that this disgrace will be seriously enhanced if they ever permit the removal of that magnificent building to a rival city.

COPPER MINES, ETC.

There is neither limit nor end to the plans which have been, and continually are submitted to me for money-making. Most of them are as wild and unfeasible as a railroad to the moon, while perhaps once in a thousand times something reasonable is suggested.

Hundreds of patent rights have been offered me, (the owners of which scarcely ever intimate a profit of less than $100,000, and

frequently from $500,000 to $1,000,000,) on the plan of dividing the profits, provided I furnish the means to bring the patent before the public.

Thousands of acres of wild lands have been placed at my disposal, free of charge, provided I would lend my name to help sell as much more of the same sort.

Mining and other speculative stocks without number have been offered me on the same conditions, the plan in such cases being to procure some person of known or supposed substance, to be used as a "stool pigeon" to swindle the public.

I hope it is needless to say that I never did, and never will, lend myself to any operation of that sort.

The only mining stock that I ever owned, was that of a copper mine in Litchfield, Ct., being the same vein which, in Bristol, Ct., has yielded and is still yielding the venerable Dr. Nott, President of Union College, Schenectady, such immense revenues. I have expended $10,000 in exploring this vein, and having become convinced, by actual observation and the reports of numerous geologists and mineralogists who have examined it, that it is a valuable mine, I shall at a proper time have it worked by a stock company, the members of which shall not be required nor permitted to be assessed any faster than the money is absolutely needed to conduct the operation.

Applicants lately, who have "grand speculations" in view, usually commence in about this manner: "Mr. Barnum, I know you are always ready to join in any thing that will make money on a large scale. Now I have a project by which $200,000 can be made in a year. Of course, if I divulge it to you, I want you to pledge your honor to take no advantage of it, if you do not join me in the speculation."

To which I generally reply: "You are much mistaken in supposing that I am so ready or anxious to make money. On the contrary, there is but one thing in the world that I desire – that is, tranquillity. I am quite certain your project will not give me that, for you probably would not have called upon me if you did not wish to draw upon my brains or my purse – very likely on both. Now of the first, I have none to spare. Of the second, what I have is invested, and I have no desire to disturb it."

"Oh no, my project will require little of your attention, and no capital to speak of, compared to the immense profit which is sure to ensue. It must be done by a stock company."

"Well, my friend, before telling me what your plan is, permit me to make one remark. If you should propose to get up a stock company for converting paving stones into diamonds, with a prospect of my making a million a year, I would not join you. If your speculation therefore is not something better than that, you need not divulge it, for I certainly should not engage in it."

This generally relieves me from hearing what the plan is, but not always – for some enthusiasts will still believe they have something that will "tempt me," and insist on explaining it.

Sometimes a man will call and ask me when I shall be at leisure. My reply is, "Never; I do not practically know the meaning of the word."

"I wish to have half an hour's conversation with you when you can spare it. I have a great project to unfold."

"My dear sir, step in and hint the nature of it, for I have no doubt we can settle it in half a minute instead of half an hour."

"I thank you, sir. I have come to the city to get up a stock company of capitalists, and you are the first I have applied to. I own some fifty thousand acres of land beautifully situated in—"

"That is enough, sir. I am very sorry to disappoint you, but I would not accept it all, as a free gift. I have done speculating. I am trying to simplify my business and get back into the country where I can find rest."

"But the money that is to be made—"

"I do not want to make any money, sir; I have sufficient already to spoil my children, and I have done."

One man came from Nashville, Tenn., to induce me to join him in getting up a cemetery in that town on speculation. "I should not think the people would die fast enough there to make it an object," I replied.

"Oh," he responded, "the money is not to be made out of the necessities of the dead, but from the pride of the living."

I believed he was more than half right, but "respectfully declined."

Another person had a magnificent plan for carrying passengers by the overland route to California on camels. I told him that I thought asses were better than camels, but I should not be one of them.

A year ago I received the following letter from PROFESSOR GARDNER, the celebrated New England soap man, accompanied by a dozen cakes of his soap:

PROVIDENCE, R. I., *Oct. 20th*, 1853.

BARNUM: – I never saw you, nor you me, yet we are not strangers. You have soaped the community, and so have I. You are rich, I am not. I have a plan to add half a million to your wealth, and many laurels to your brow. I manufacture by far the best soap ever known, as a million of gentlemen, and three millions of God's greatest work, beautiful women, will testify. I send you a sample to prove the truth of my words. Try it, and when you find that I state FACTS, put $10,000 in the soap business, join me as an equal partner, and we will thoroughly soap the American Continent in three years, at a profit of a million dollars.

By doing this, sir, you will erect a monument in the hearts of the people worthy of your name! You will have the satisfaction of knowing that you have conferred a boon upon your countrymen. Cleanliness is next to godliness. You, sir, can aid in cleaning and purifying at least ten millions of your dirty fellow-citizens. It is a duty you owe to them and yourself. Look at my portrait on the soap wrapper, and you will see the face of an honest man. Send me your check next week for $5000, and the week after for $5000 more. This additional capital will enable me to supply the demand for my unrivalled soap, and I will send you quarterly returns of profits. Come, old fellow, fork over, and no grumbling! You will thus become a public benefactor, and unwashed millions shall chant your name in praise.

My soap makes soft hands, and cures soft heads. It removes paint and grease, is unsurpassed for shaving, cures chaps on hands or face, and is death on foul teeth. It cures eruptions to a charm. I have no doubt that a sufficient quantity, properly applied, would cure the eruption of Vesuvius.

Address me immediately at Providence, Rhode Island.

Yours, etc.,
PROFESSOR. GARDNER,
Known as the New England Soap Man.

Notwithstanding the glowing offers and temptations of the "Professor," I felt bound to decline and withstand them. I tried his soap, however, and found it excellent.

BEGGING LETTERS.

I receive innumerable begging letters, and more than half of them commence in this manner: "Sir, you will no doubt be surprised at receiving a letter from me, a stranger, but having read and heard," etc. Whereas the truth is, I should "be surprised" if the letter was

not from a stranger, and still more surprised if it was not a letter soliciting money.

The sums required range from $100 to $10,000, and when it is proposed to borrow the money, the security named as collateral is always "my honor," or "a life insurance policy." Many persons suppose that the latter article is good as gold.

A stranger once called to borrow $5000 for three years. He would insure his life, and leave the policy in my hands as security. I told him that in order to make the document of any value to me, he must sign a bond agreeing to expire the day before the policy did, for if he should live, of course I could collect nothing on it. He had never thought of that, and declined signing the bond!

A year since, I received a letter from a man in the West, requesting me to loan him $15,000, and to send it by express to his address. He said he had no security to offer, but he proposed going into a speculation which, if successful, would make his fortune, and he would repay me with interest; "but if I lose it," he added, "the amount would be nothing for you – you would never miss it, and you would have the consolation of knowing that it had been expended in trying to assist a poor man to make a fortune!" A postscript requested me to send *"bankable* money!"

A woman wrote from Ohio, asking me to present her with $500, to enable herself and family to visit their friends in Maine, and spend the summer at Saratoga Springs, Niagara, etc. She said she had lived in Ohio twenty-five years, and had not visited New England in all that time. "We are not poor," she added; "we have a good farm, which is paid for, but we cannot spare money to visit on, and I am sure you would never feel it, if you gave us $500. I understand that you take in that sum at your Museum in a single night."

I find no fault with these and similar applications, but only state them as samples of a cabinet of curiosities in my possession.

MY AGENTS.

To enable me to prosecute, with tolerable success, the various enterprises in which I have been engaged, it was of the highest importance that I obtained agents and assistants of the most reliable and competent character. In the selection of such men, I have been peculiarly fortunate.

My friend, Mr. FORDYCE HITCHCOCK, was most indefatigable

for seven or eight years as assistant manager of the American Museum, and during my absence of three years in Europe, as well as for some time after my return, he not only conducted that establishment with consummate tact as well as the strictest fidelity, but he also had nearly the entire management of my financial arrangements, investments, etc.

Finally, much against my will and contrary to my urgent advice, he embarked in the dry-goods business on his own account. After several years he retired into the country, where, shattered in health, he seems resigned to end his days in the honorable and humble position of a tiller of the earth.

His successor as my agent and assistant manager is Mr. JOHN GREENWOOD, Jr., who has already been seven or eight years in my employ. I am happy to say that I have ever found him a devoted and faithful assistant, a reliable and sagacious counsellor, and a man who, by courtesy and integrity, commands the esteem of all who know him.

He is already favorably known to the American public as a judicious caterer for their gratification, and I trust that at no distant day he may be at least a partial proprietor of the American Museum, or some other popular place of amusement and instruction in New York or elsewhere.

Should I mention the names and qualities of all who are and have been engaged in my various operations, a volume would be required, since at all times, during the last twelve years, I have had in my constant employ from one hundred to three hundred persons, besides thousands who have been indirectly engaged as accessories in my different enterprises.

In 1852, EDWIN T. FREEDLEY, Esq., of Philadelphia, informed me by letter that he was about to publish a book, entitled a "Practical Treatise on Business," and he desired me to furnish him a communication embodying *the results* of my experience and observation. I wrote him the following article, which he published in his valuable work under the title,

BARNUM'S RULES FOR SUCCESS IN BUSINESS.

1. *Select the* KIND *of business that suits your natural inclinations and temperament.* Some men are naturally mechanics; others have a strong aversion to any thing like machinery, and so on; one man

has a natural taste for one occupation, and another for another. "I am glad that we do not all feel and think alike," said Dick Homespun, "for if we did, everybody would think my gal, Sukey Snipes, the sweetest creature in all creation, and they would all be trying to court her at once."

I never could succeed as a merchant. I have tried it unsuccessfully several times. I never could be content with a fixed salary, for mine is a purely speculative disposition, while others are just the reverse; and therefore all should be careful to select those occupations that suit them best.

2. *Let your pledged word ever be sacred.* Never promise to do a thing without performing it with the most rigid promptness. Nothing is more valuable to a man in business than the name of always doing as he agrees, and that to the moment. A strict adherence to this rule, gives a man the command of half the spare funds within the range of his acquaintance, and always encircles him with a host of friends who may be depended upon in almost any conceivable emergency.

3. *Whatever you do, do with all your might.* Work at it if necessary early and late, in season and out of season, not leaving a stone unturned, and never deferring for a single hour that which can be done just as well *now*. The old proverb is full of truth and meaning, "Whatever is worth doing at all, is worth doing well." Many a man acquires a fortune by doing his business *thoroughly*, while his neighbor remains poor for life because he only *half* does his business. Ambition, energy, industry, perseverance, are indispensable requisites for success in business.

4. *Sobriety. Use no description of intoxicating drinks.* As no man can succeed in business unless he has a *brain* to enable him to lay his plans, and *reason* to guide him in their execution, so, no matter how bountifully a man may be blessed with intelligence, if his brain is muddled, and his judgment warped by intoxicating drinks, it is impossible for him to carry on business successfully. How many good opportunities have passed never to return, while a man was sipping a "social glass" with his friend! How many foolish bargains have been made under the influence of the *nervine*, which temporarily makes its victim so *rich!* How many important chances have been put off until to-morrow, and thence for ever, because the wine-cup has thrown the system into a state of lassitude, neutralizing the energies so essential to success in business. The use of intoxicating drinks as a beverage is as much an infatuation as is the

smoking of opium by the Chinese, and the former is quite as destructive to the success of the business man as the latter.

5. *Let hope predominate, but be not too visionary.* Many persons are always kept poor, because they are too *visionary.* Every project looks to them like certain success, and therefore they keep changing from one business to another, always in hot water, always "under the harrow." The plan of "counting the chickens before they are hatched" is an error of ancient date, but it does not seem to improve by age.

6. *Do not scatter your powers.* Engage in one kind of business only, and stick to it faithfully until you succeed, or until you conclude to abandon it. A constant hammering on one nail, will generally drive it home at last, so that it can be clinched. When a man's undivided attention is centred on one object, his mind will constantly be suggesting improvements of value, which would escape him if his brain were occupied by a dozen different subjects at once. Many a fortune has slipped through men's fingers by engaging in too many occupations at once.

7. *Engage proper employees.* Never employ a man of bad habits, when one whose habits are good can be found to fill his situation. I have generally been extremely fortunate in having faithful and competent persons to fill the responsible situations in my business, and a man can scarcely be too grateful for such a blessing. When you find a man unfit to fill his station, either from incapacity or peculiarity of character or disposition, dispense with his services, and do not drag out a miserable existence in the vain attempt to change his nature. It is utterly impossible to do so. "You cannot make a silk purse," etc. He was created for some other sphere. Let him find and fill it.

8. *Advertise, your business. Do not hide your light under a bushel.* Whatever your occupation or calling may be, if it needs support from the public, *advertise* it thoroughly and efficiently, in some shape or other, that will arrest public attention. I freely confess that what success I have had in my life may fairly be attributed more to the public press than to nearly all other causes combined. There *may* possibly be occupations that do not require advertising, but I cannot well conceive what they are.

Men in business will sometimes tell you that they have tried advertising, and that it did not pay. This is only when advertising is done sparingly and grudgingly. Homœopathic doses of advertising will not pay perhaps – it is like half a potion of physic, making the

patient sick, but effecting nothing. Administer liberally, and the cure will be sure and permanent.

Some say, "they cannot afford to advertise;" they mistake – they cannot afford *not* to advertise. In this country, where everybody reads the newspapers, the man must have a thick skull who does not see that these are the cheapest and best medium through which he can speak to the public, where he is to find his customers. Put on the *appearance* of business, and generally the *reality* will follow. The farmer plants his seed, and while he is sleeping, his corn and potatoes are growing. So with advertising. While you are sleeping, or eating, or conversing with one set of customers, your advertisement is being read by hundreds and thousands of persons who never saw you, nor heard of your business, and never would, had it not been for your advertisement appearing in the newspapers.

The business men of this country do not, as a general thing, appreciate the advantages of advertising thoroughly. Occasionally the public are aroused at witnessing the success of a Swaim, a Brandreth, a Townsend, a Genin, or a Root, and express astonishment at the rapidity with which these gentlemen acquire fortunes, not reflecting that the same path is open to all who *dare* pursue it. But it needs *nerve* and *faith.* The former, to enable you to launch out thousands on the uncertain waters of the future; the latter, to teach you that after many days it shall surely return, bringing an hundred or a thousand fold to him who appreciates the advantages of "printer's ink" properly applied.

9. Avoid extravagance; and always live considerably within your income, if you can do so without absolute starvation! It needs no prophet to tell us that those who live fully up to their means, without any thought of a reverse in life, can never attain to a pecuniary independence.

Men and women accustomed to gratify every whim and caprice, will find it hard at first to cut down their various unnecessary expenses, and will feel it a great self-denial to live in a smaller house than they have been accustomed to, with less expensive furniture, less company, less costly clothing, a less number of balls, parties, theatre-goings, carriage ridings, pleasure excursions, cigar smokings, liquor-drinkings, etc., etc., etc.; but, after all, if they will try the plan of laying by a "nest-egg," or in other words, a small sum of money, after paying all expenses, they will be surprised at the pleasure to be derived from constantly adding to their little

"pile," as well as from all the economical habits which follow in the pursuit of this peculiar pleasure.

The old suit of clothes, and the old bonnet and dress, will answer for another season; the Croton or spring water will taste better than champagne; a brisk walk will prove more exhilarating than a ride in the finest coach; a social family chat, an evening's reading in the family circle, or an hour's play of "hunt the slipper" and "blind man's buff," will be far more pleasant than a fifty or a five hundred dollar party, when the reflection on the *difference in cost* is indulged in by those who begin to know the *pleasures of saving*.

Thousands of men are kept poor, and tens of thousands are made so after they have acquired quite sufficient to support them well through life, in consequence of laying their plans of living on too expensive a platform. Some families in this country expend twenty thousand dollars per annum, and some much more, and would scarcely know how to live on a less sum.

Prosperity is a more severe ordeal than adversity, especially sudden prosperity. "Easy come, easy go," is an old and true proverb. *Pride*, when permitted full sway, is the great undying cankerworm which gnaws the very vitals of a man's worldly possessions, let them be small or great, hundreds or millions. Many persons, as they begin to prosper, immediately commence expending for luxuries, until in a short time their expenses swallow up their income, and they become ruined in their ridiculous attempts to keep up appearances, and make a "sensation."

I know a gentleman of fortune, who says, that when he first began to prosper, his wife *would have* a new and elegant sofa. "That sofa," he says, "cost me thirty thousand dollars!" The riddle is thus explained:

When the sofa reached the house, it was found necessary to get chairs to "match," then sideboards, carpets and tables, "to correspond" with them, and so on through the entire stock of furniture, when at last it was found that the house itself was quite too small and old-fashioned for the furniture, and a new one was built to correspond with the sofa and *et ceteras*; "thus," added my friend, "running up an outlay of thirty thousand dollars caused by that single sofa, and saddling on me, in the shape of servants, equipage, and the necessary expenses attendant upon keeping up a fine 'establishment,' a yearly outlay of eleven thousand dollars, and a tight pinch at that; whereas, ten years ago, we lived with much more

real comfort, because with much less care, on as many hundreds. The truth is," he continued, "that sofa would have brought me to inevitable bankruptcy, had not a most unexampled tide of prosperity kept me above it."

10. *Do not depend upon others.* Your success must depend upon your own individual exertions. Trust not to the assistance of friends; but learn that every man must be the architect of his own fortune.

With proper attention to the foregoing rules, and such observations as a man of sense will pick up in his own experience, the road to competence will not, I think, usually be found a difficult one.

<div align="right">P. T. Barnum.</div>

RETROSPECTIVE VIEW.

In taking a survey of the chequered career which is described in these pages, I shall perhaps disagree with some of my more straight-laced but very worthy readers as to the value and significance of that career, and as to the degree of consideration which it shows that I have justly earned from the public. I shall however give my candid opinion upon the subject, even at the risk of being charged with egotism.

The great defect in our American civilization, it is generally acknowledged by observing and thoughtful men, is a severe and drudging practicalness – a practicalness which is not commendable, because it loses sight of the true aims of life, and concentrates itself upon dry and technical ideas of duty, and upon a sordid love of acquisition – leaving entirely out of view all those needful and proper relaxations and enjoyments which are interwoven through even the most humble conditions in other countries. If in the Catholic states of Europe there are too many holidays, with us the fault is on the other side: we have none at all. The consequence is, that with the most universal diffusion of the means of happiness ever known among any people, we are unhappy. Without ideality, "a primrose by the river's brim" does not arrest the attention of the American; the flower "a simple primrose is to him, and it is nothing more."

With their traditions and habits, our countrymen, of the middling classes, inherit in too great a degree a capacity only for the most valueless and irrational enjoyments, and their inclination to intemperance and kindred vices has repeatedly and most

conclusively been shown to be a natural result of the lamentable deficiency among us of innocent and rational amusements. I am not going to set up as a philosopher, but the venerable and illustrious name of CHANNING – eminent alike for wisdom, benevolence, piety, and purity, for a private and public character unsurpassed in its elevation – may be adduced as earnestly and unqualifiedly supporting these views; and no higher authority, I conceive, has ever existed in this country upon morals and society, and especially upon the difficult subject which he illustrated so admirably in the noblest production of his genius, the essay "On the Elevation of the Laboring Portion of the Community."

As a business man, undoubtedly, my prime object has been to put money in my purse. I succeeded beyond my most sanguine anticipations, and am satisfied. But what I have here said, will prepare the reader for what I conceive to be a just and altogether reasonable claim, that I have been a public benefactor, to an extent seldom paralleled in the histories of professed and professional philanthropists.

My travelling museums of natural history have been the largest and most interesting ever exhibited in the United States, and no author, or university even, has ever accomplished as much in the diffusion of a knowledge of the varied forms and classes of animal life. These, with my museums in New York, Philadelphia, and Baltimore, have been one of the chief means by which I have instructed the masses.

For the elevation and refinement of musical taste in this country, it will not be denied that I have done more than any man living. By bringing Jenny Lind to the United States, I inaugurated a new era in the most beautiful and humanizing of all the fine arts, and gave to the cultivated and wealthy as well as to the middling classes a larger measure of enjoyment than has ever been derived from the enterprise of any other single individual.

I will not enter into a further recapitulation of the benefits I have conferred on my countrymen and countrywomen, as a minister to their instruction and happiness, while pursuing my main purpose of making money. The charges with which my claims in this respect will be met, are, simply, that I have *managed*, while my vocation has been that of a manager. It is granted. I have advertised my curiosities and my artists with all the ingenuity of which I was capable. My interests demanded that course, and it was my business to consult my interests in all legitimate ways. No one, however, for

himself, can say that he ever paid for admission to one of my exhibitions more than his admission was worth to him. If a sight of my "Niagara Falls" was not worth twenty-five cents, the privilege of seeing the most extensive and valuable museum on this continent was worth double that sum to any one who was enticed into it by the advertisements of that ingenious contrivance. And I should like to see the moralist or the Christian who thinks my patron would have done as well with his money at the drinking den or any of the alternative places of buying entertainment.

I might here close this book, hoping that the interest of some portions of it may be an offset to the dullness of others; but I must please myself, and perhaps gratify curiosity, by adding a brief history of my present residence, known as

IRANISTAN.

Finding, in 1846, that fortune continued to smile upon me, I began to look forward to the time when I could withdraw from the whirlpool of excitement, and permanently settle down with my family, to spend the remainder of my life in comparative tranquillity.

I wished to reside within a few hours of New York. I never saw more delightful locations than upon the borders of Long Island Sound, between New Rochelle, N. Y., and New Haven, Conn.; and my attention was therefore turned in that direction. BRIDGEPORT seemed to be about the proper distance from the great metropolis. It is pleasantly situated at the terminus of two railroads, which traverse the fertile valleys of the Naugatuck and Housatonic rivers. The enterprise which characterized the city, seemed to mark it as destined to become the first in the State in size and opulence; and I was not long in deciding, with the concurrence of my wife, to fix our future residence in that vicinity.

For this purpose I purchased seventeen acres of land, less than a mile west of the centre of the city, and fronting with a good view upon the Sound. Although nominally in Bridgeport, my residence is in Fairfield, a few rods west of the Bridgeport line.

In deciding upon the kind of house to be erected, I determined, first and foremost, to consult convenience and comfort. I cared little for style, and my wife cared still less; but as we meant to have a good house, it might as well, at the same time, be unique. In this, I confess, I had "an eye to business," for I thought that a pile of

buildings of a novel order might indirectly serve as an advertisement of my various enterprises.

<div align="center">IRANISTAN.</div>

Visiting Brighton, I was greatly pleased with the Pavilion erected by George IV. It was the only specimen of Oriental architecture in England, and had not been introduced into America. I concluded to adopt it, and engaged a London architect to furnish me a set of drawings in the style of the Pavilion, differing sufficiently to be adapted to the spot of ground selected for my homestead.

On my first return to the United States, I brought these drawings with me – engaged a competent architect and builder, and gave him instructions to proceed with the work, not "by the job" but "by the day," and to spare neither time nor expense in erecting a comfortable, convenient, and tasteful residence.

The whole was finally completed to my satisfaction. My family removed into the premises, and on the fourteenth of November, 1848, nearly one thousand invited guests, including the poor and the rich, helped us in the old-fashioned custom of "house-warming."

When the name IRANISTAN was announced, a waggish New York editor syllabled it, *I-ran-i-stan*, and gave as the interpretation, that *I ran* a long time before *I could stan'!* More correctly, however, the name signifies "Eastern Country Place," or, more poetically, "Oriental Villa."

I have no desire to ascertain the entire cost. All I care to know is, that it suits me, which would be a small consideration with me, did it not also suit my family.

I have seldom mentioned my wife and children in these pages, yet they have always been dearer to me than all things else in the wide world; and, whether in poverty or in abundance, no place on earth has ever been so attractive to me as my home.

My children are all daughters. CAROLINE C., the eldest, was born May 27, 1833, and married Mr. DAVID W. THOMPSON, October 19, 1852.* They reside a few rods west of Iranistan. The officiating clergyman was my esteemed friend the Rev. M. BALLOU, whose fine abilities are equalled only by the geniality of his spirit. He resided at the time in Bridgeport, but has since removed to Hartford. HELEN M., my second daughter, was born April 18, 1840. FRANCES J., the

*The name of their only child is Frances Barnum Thompson, born December 27, 1858.

third, was born May 1, 1842, and died April 11, 1844. PAULINE T., the fourth, was born March 1, 1846.

I should have mentioned, in another place, that the plot of ground on which my villa is erected, was a bare field at the date of my purchase. I transplanted many hundred fruit and forest trees, and acres of evergreens and shrubbery, and thus in a few years adorned the premises with what would have required an age in the ordinary process of growth. In all this, I hope I shall not be considered presumptuous if I quote the language of Sir William Temple:

> "The measure of choosing well is, whether a man likes what he has chosen; which, I thank God, has befallen me; and though, among the follies of my life, building and planting have not been the least, and have cost me more than I have the confidence to own, yet they have been fully recompensed by the sweetness and satisfaction of this retreat, where, since my resolution taken, of never entering again into any public employments, I have passed five years without ever going once to town, though I am almost in sight of it, and have a house there always ready to receive me."

I have not yet wholly retired from business, though I desire hereafter to restrict my attention chiefly to the American Museum and my interests in Bridgeport. I am frequently in New York, and occasionally in other great cities, yet I am never so happy as when I return to my "homestead." I am writing the closing pages of this Autobiography on the sixth anniversary of the "house-warming," and my heart is warm with gratitude. I am at home, in the bosom of my family; and "home" and "family" are the highest and most expressive symbols of the kingdom of heaven.

THE END.

Accoucheur NOUN a male midwife or doctor ❏ *I think my sister must have had some general idea that I was a young offender whom an Accoucheur Policemen had taken up (on my birthday) and delivered over to her* (*Great Expectations* by Charles Dickens)

addled ADJ confused and unable to think properly ❏ *But she counted and counted till she got that addled* (*The Adventures of Huckleberry Finn* by Mark Twain)

admiration NOUN amazement or wonder ❏ *lifting up his hands and eyes by way of admiration* (*Gulliver's Travels* by Jonathan Swift)

afeard ADJ afeard means afraid ❏ *shake it–and don't be afeard* (*The Adventures of Huckleberry Finn* by Mark Twain)

affected VERB affected means to assume the appearance of ❏ *Hadst thou affected sweet divinity* (*Doctor Faustus 5.2* by Christopher Marlowe)

aground ADV when a boat runs aground, it touches the ground in a shallow part of the water and gets stuck ❏ *what kep' you?–boat get aground?* (*The Adventures of Huckleberry Finn* by Mark Twain)

ague NOUN a fever in which the patient has alternate hot and cold shivering fits ❏ *his exposure to the wet and cold had brought on fever and ague* (*Oliver Twist* by Charles Dickens)

alchemy ADJ false or worthless ❏ *all wealth alchemy* (*The Sun Rising* by John Donne)

all alike PHRASE the same all the time ❏ *Love, all alike* (*The Sun Rising* by John Donne)

alow and aloft PHRASE alow means in the lower part or bottom, and aloft means on the top, so alow and aloft means on the top and in the bottom or throughout ❏ *Someone's turned the chest out alow and aloft* (*Treasure Island* by Robert Louis Stevenson)

ambuscade NOUN ambuscade is not a proper word. Tom means an ambush, which is when a group of people attack their enemies, after hiding and waiting for them ❏ *and so we would lie in ambuscade, as he called it* (*The Adventures of Huckleberry Finn* by Mark Twain)

amiable ADJ likeable or pleasant ❏ *Such amiable qualities must speak for themselves* (*Pride and Prejudice* by Jane Austen)

amulet NOUN an amulet is a charm thought to drive away evil spirits. ❏ *uttered phrases at once occult and familiar, like the amulet worn on the heart* (*Silas Marner* by George Eliot)

amusement NOUN here amusement means a strange and disturbing puzzle ❏ *this was an amusement the other way* (*Robinson Crusoe* by Daniel Defoe)

ancient NOUN an ancient was the flag displayed on a ship to show which country it belongs to. It is also called the ensign ❏ *her ancient and pendants out* (*Robinson Crusoe* by Daniel Defoe)

antic ADJ here antic means horrible or grotesque ❏ *armed and dressed after a very antic manner* (*Gulliver's Travels* by Jonathan Swift)

antics NOUN antics is an old word meaning clowns, or people who do silly things to make other people laugh ❏ *And point like antics at his triple crown* (*Doctor Faustus 3.2* by Christopher Marlowe)

appanage NOUN an appanage is a living allowance ❑ *As if loveliness were not the special prerogative of woman–her legitimate appanage and heritage!* (*Jane Eyre* by Charlotte Brontë)

appended VERB appended means attached or added to ❑ *and these words appended* (*Treasure Island* by Robert Louis Stevenson)

approver NOUN an approver is someone who gives evidence against someone he used to work with ❑ *Mr. Noah Claypole: receiving a free pardon from the Crown in consequence of being admitted approver against Fagin* (*Oliver Twist* by Charles Dickens)

areas NOUN the areas is the space, below street level, in front of the basement of a house ❑ *The Dodger had a vicious propensity, too, of pulling the caps from the heads of small boys and tossing them down areas* (*Oliver Twist* by Charles Dickens)

argument NOUN theme or important idea or subject which runs through a piece of writing ❑ *Thrice needful to the argument which now* (*The Prelude* by William Wordsworth)

artificially ADV artfully or cleverly ❑ *and he with a sharp flint sharpened very artificially* (*Gulliver's Travels* by Jonathan Swift)

artist NOUN here artist means a skilled workman ❑ *This man was a most ingenious artist* (*Gulliver's Travels* by Jonathan Swift)

assizes NOUN assizes were regular court sessions which a visiting judge was in charge of ❑ *you shall hang at the next assizes* (*Treasure Island* by Robert Louis Stevenson)

attraction NOUN gravitation, or Newton's theory of gravitation ❑ *he predicted the same fate to attraction* (*Gulliver's Travels* by Jonathan Swift)

aver VERB to aver is to claim something strongly ❑ *for Jem Rodney, the mole catcher, averred that one evening as he was returning homeward* (*Silas Marner* by George Eliot)

baby NOUN here baby means doll, which is a child's toy that looks like a small person ❑ *and skilful dressing her baby* (*Gulliver's Travels* by Jonathan Swift)

bagatelle NOUN bagatelle is a game rather like billiards and pool ❑ *Breakfast had been ordered at a pleasant little tavern, a mile or so away upon the rising ground beyond the green; and there was a bagatelle board in the room, in case we should desire to unbend our minds after the solemnity.* (*Great Expectations* by Charles Dickens)

bah EXCLAM Bah is an exclamation of frustration or anger ❑ *"Bah," said Scrooge.* (*A Christmas Carol* by Charles Dickens)

bairn NOUN a northern word for child ❑ *Who has taught you those fine words, my bairn?* (*Wuthering Heights* by Emily Brontë)

bait VERB to bait means to stop on a journey to take refreshment ❑ *So, when they stopped to bait the horse, and ate and drank and enjoyed themselves, I could touch nothing that they touched, but kept my fast unbroken.* (*David Copperfield* by Charles Dickens)

balustrade NOUN a balustrade is a row of vertical columns that form railings ❑ *but I mean to say you might have got a hearse up that staircase, and taken it broadwise, with the splinter-bar towards the wall, and the door towards the balustrades: and done it easy* (*A Christmas Carol* by Charles Dickens)

bandbox NOUN a large lightweight box for carrying bonnets or hats ❑ *I am glad I bought my bonnet, if it is only for the fun of having another bandbox* (*Pride and Prejudice* by Jane Austen)

barren NOUN a barren here is a stretch or expanse of barren land ❑ *a line of upright stones, continued the*

length of the barren (*Wuthering Heights* by Emily Brontë)

basin NOUN a basin was a cup without a handle ❏ *who is drinking his tea out of a basin* (*Wuthering Heights* by Emily Brontë)

battalia NOUN the order of battle ❏ *till I saw part of his army in battalia* (*Gulliver's Travels* by Jonathan Swift)

battery NOUN a Battery is a fort or a place where guns are positioned ❏ *You bring the lot to me, at that old Battery over yonder* (*Great Expectations* by Charles Dickens)

battledore and shuttlecock NOUN The game battledore and shuttlecock was an early version of the game now known as badminton. The aim of the early game was simply to keep the shuttlecock from hitting the ground. ❏ *Battledore and shuttlecock's a wery good game vhen you an't the shuttlecock and two lawyers the battledores, in which case it gets too excitin' to be pleasant* (*Pickwick Papers* by Charles Dickens)

beadle NOUN a beadle was a local official who had power over the poor ❏ *But these impertinences were speedily checked by the evidence of the surgeon, and the testimony of the beadle* (*Oliver Twist* by Charles Dickens)

bearings NOUN the bearings of a place are the measurements or directions that are used to find or locate it ❏ *the bearings of the island* (*Treasure Island* by Robert Louis Stevenson)

beaufet NOUN a beaufet was a sideboard ❏ *and sweet-cake from the beaufet* (*Emma* by Jane Austen)

beck NOUN a beck is a small stream ❏ *a beck which follows the bend of the glen* (*Wuthering Heights* by Emily Brontë)

bedight VERB decorated ❏ *and bedight with Christmas holly stuck into the top.* (*A Christmas Carol* by Charles Dickens)

Bedlam NOUN Bedlam was a lunatic asylum in London which had statues carved by Caius Gabriel Cibber at its entrance ❏ *Bedlam, and those carved maniacs at the gates* (*The Prelude* by William Wordsworth)

beeves NOUN oxen or castrated bulls which are animals used for pulling vehicles or carrying things ❏ *to deliver in every morning six beeves* (*Gulliver's Travels* by Jonathan Swift)

begot VERB created or caused ❏ *Begot in thee* (*On His Mistress* by John Donne)

behoof NOUN behoof means benefit ❏ *"Yes, young man," said he, releasing the handle of the article in question, retiring a step or two from my table, and speaking for the behoof of the landlord and waiter at the door* (*Great Expectations* by Charles Dickens)

berth NOUN a berth is a bed on a boat ❏ *this is the berth for me* (*Treasure Island* by Robert Louis Stevenson)

bevers NOUN a bever was a snack, or small portion of food, eaten between main meals ❏ *that buys me thirty meals a day and ten bevers* (*Doctor Faustus 2.1* by Christopher Marlowe)

bilge water NOUN the bilge is the widest part of a ship's bottom, and the bilge water is the dirty water that collects there ❏ *no gush of bilge-water had turned it to fetid puddle* (*Jane Eyre* by Charlotte Brontë)

bills NOUN bills is an old term meaning prescription. A prescription is the piece of paper on which your doctor writes an order for medicine and which you give to a chemist to get the medicine ❏ *Are not thy bills hung up as monuments* (*Doctor Faustus 1.1* by Christopher Marlowe)

black cap NOUN a judge wore a black cap when he was about to sentence

a prisoner to death ❑ *The judge assumed the black cap, and the prisoner still stood with the same air and gesture.* (*Oliver Twist* by Charles Dickens)

boot-jack NOUN a wooden device to help take boots off ❑ *The speaker appeared to throw a boot-jack, or some such article, at the person he addressed* (*Oliver Twist* by Charles Dickens)

booty NOUN booty means treasure or prizes ❑ *would be inclined to give up their booty in payment of the dead man's debts* (*Treasure Island* by Robert Louis Stevenson)

Bow Street runner PHRASE Bow Street runners were the first British police force, set up by the author Henry Fielding in the eighteenth century ❑ *as would have convinced a judge or a Bow Street runner* (*Treasure Island* by Robert Louis Stevenson)

brawn NOUN brawn is a dish of meat which is set in jelly ❑ *Heaped up upon the floor, to form a kind of throne, were turkeys, geese, game, poultry, brawn, great joints of meat, suckling-pigs* (*A Christmas Carol* by Charles Dickens)

bray VERB when a donkey brays, it makes a loud, harsh sound ❑ *and she doesn't bray like a jackass* (*The Adventures of Huckleberry Finn* by Mark Twain)

break VERB in order to train a horse you first have to break it ❑ *"If a high-mettled creature like this," said he, "can't be broken by fair means, she will never be good for anything"* (*Black Beauty* by Anna Sewell)

bullyragging VERB bullyragging is an old word which means bullying. To bullyrag someone is to threaten or force someone to do something they don't want to do ❑ *and a lot of loafers bullyragging him for sport* (*The Adventures of Huckleberry Finn* by Mark Twain)

but PREP except for (this) ❑ *but this, all pleasures fancies be* (*The Good-Morrow* by John Donne)

by hand PHRASE by hand was a common expression of the time meaning that baby had been fed either using a spoon or a bottle rather than by breast-feeding ❑ *My sister, Mrs. Joe Gargery, was more than twenty years older than I, and had established a great reputation with herself . . . because she had bought me up "by hand"* (*Great Expectations* by Charles Dickens)

bye-spots NOUN bye-spots are lonely places ❑ *and bye-spots of tales rich with indigenous produce* (*The Prelude* by William Wordsworth)

calico NOUN calico is plain white fabric made from cotton ❑ *There was two old dirty calico dresses* (*The Adventures of Huckleberry Finn* by Mark Twain)

camp-fever NOUN camp-fever was another word for the disease typhus ❑ *during a severe camp-fever* (*Emma* by Jane Austen)

cant NOUN cant is insincere or empty talk ❑ *"Man," said the Ghost, "if man you be in heart, not adamant, forbear that wicked cant until you have discovered What the surplus is, and Where it is."* (*A Christmas Carol* by Charles Dickens)

canty ADJ canty means lively, full of life ❑ *My mother lived til eighty, a canty dame to the last* (*Wuthering Heights* by Emily Brontë)

canvas VERB to canvas is to discuss ❑ *We think so very differently on this point Mr Knightley, that there can be no use in canvassing it* (*Emma* by Jane Austen)

capital ADJ capital means excellent or extremely good ❑ *for it's capital, so shady, light, and big* (*Little Women* by Louisa May Alcott)

capstan NOUN a capstan is a device used on a ship to lift sails and anchors ❑ *capstans going, ships going out to sea, and unintelligible sea creatures roaring curses over the*

bulwarks at respondent lightermen (*Great Expectations* by Charles Dickens)

case-bottle NOUN a square bottle designed to fit with others into a case ❏ *The spirit being set before him in a huge case-bottle, which had originally come out of some ship's locker* (*The Old Curiosity Shop* by Charles Dickens)

casement NOUN casement is a word meaning window. The teacher in *Nicholas Nickleby* misspells window showing what a bad teacher he is ❏ *W-i-n, win, d-e-r, der, winder, a casement.* (*Nicholas Nickleby* by Charles Dickens)

cataleptic ADJ a cataleptic fit is one in which the victim goes into a trancelike state and remains still for a long time ❏ *It was at this point in their history that Silas's cataleptic fit occurred during the prayer-meeting* (*Silas Marner* by George Eliot)

cauldron NOUN a cauldron is a large cooking pot made of metal ❏ *stirring a large cauldron which seemed to be full of soup* (*Alice's Adventures in Wonderland* by Lewis Carroll)

cephalic ADJ cephalic means to do with the head ❏ *with ink composed of a cephalic tincture* (*Gulliver's Travels* by Jonathan Swift)

chaise and four NOUN a closed four-wheel carriage pulled by four horses ❏ *he came down on Monday in a chaise and four to see the place* (*Pride and Prejudice* by Jane Austen)

chamberlain NOUN the main servant in a household ❏ *In those times a bed was always to be got there at any hour of the night, and the chamberlain, letting me in at his ready wicket, lighted the candle next in order on his shelf* (*Great Expectations* by Charles Dickens)

characters NOUN distinguishing marks ❏ *Impressed upon all forms the characters* (*The Prelude* by William Wordsworth)

chary ADJ cautious ❏ *I should have been chary of discussing my guardian too freely even with her* (*Great Expectations* by Charles Dickens)

cherishes VERB here cherishes means cheers or brightens ❏ *some philosophic song of Truth that cherishes our daily life* (*The Prelude* by William Wordsworth)

chickens' meat PHRASE chickens' meat is an old term which means chickens' feed or food ❏ *I had shook a bag of chickens' meat out in that place* (*Robinson Crusoe* by Daniel Defoe)

chimeras NOUN a chimera is an unrealistic idea or a wish which is unlikely to be fulfilled ❏ *with many other wild impossible chimeras* (*Gulliver's Travels* by Jonathan Swift)

chines NOUN chine is a cut of meat that includes part or all of the backbone of the animal ❏ *and they found hams and chines uncut* (*Silas Marner* by George Eliot)

chits NOUN chits is a slang word which means girls ❏ *I hate affected, niminy-piminy chits!* (*Little Women* by Louisa May Alcott)

chopped VERB chopped means come suddenly or accidentally ❏ *if I had chopped upon them* (*Robinson Crusoe* by Daniel Defoe)

chute NOUN a narrow channel ❏ *One morning about day-break, I found a canoe and crossed over a chute to the main shore* (*The Adventures of Huckleberry Finn* by Mark Twain)

circumspection NOUN careful observation of events and circumstances; caution ❏ *I honour your circumspection* (*Pride and Prejudice* by Jane Austen)

clambered VERB clambered means to climb somewhere with difficulty, usually using your hands and your feet ❏ *he clambered up and down stairs* (*Treasure Island* by Robert Louis Stevenson)

clime NOUN climate ❑ *no season knows nor clime* (*The Sun Rising* by John Donne)

clinched VERB clenched ❑ *the tops whereof I could but just reach with my fist clinched* (*Gulliver's Travels* by Jonathan Swift)

close chair NOUN a close chair is a sedan chair, which is a covered chair which has room for one person. The sedan chair is carried on two poles by two men, one in front and one behind ❑ *persuaded even the Empress herself to let me hold her in her close chair* (*Gulliver's Travels* by Jonathan Swift)

clown NOUN clown here means peasant or person who lives off the land ❑ *In ancient days by emperor and clown* (*Ode on a Nightingale* by John Keats)

coalheaver NOUN a coalheaver loaded coal onto ships using a spade ❑ *Good, strong, wholesome medicine, as was given with great success to two Irish labourers and a coalheaver* (*Oliver Twist* by Charles Dickens)

coal-whippers NOUN men who worked at docks using machines to load coal onto ships ❑ *here, were colliers by the score and score, with the coal-whippers plunging off stages on deck* (*Great Expectations* by Charles Dickens)

cobweb NOUN a cobweb is the net which a spider makes for catching insects ❑ *the walls and ceilings were all hung round with cobwebs* (*Gulliver's Travels* by Jonathan Swift)

coddling VERB coddling means to treat someone too kindly or protect them too much ❑ *and I've been coddling the fellow as if I'd been his grand-mother* (*Little Women* by Louisa May Alcott)

coil NOUN coil means noise or fuss or disturbance ❑ *What a coil is there?* (*Doctor Faustus 4.7* by Christopher Marlowe)

collared VERB to collar something is a slang term which means to capture.

In this sentence, it means he stole it [the money] ❑ *he collared it* (*The Adventures of Huckleberry Finn* by Mark Twain)

colling VERB colling is an old word which means to embrace and kiss ❑ *and no clasping and colling at all* (*Tess of the D'Urbervilles* by Thomas Hardy)

colloquies NOUN colloquy is a formal conversation or dialogue ❑ *Such colloquies have occupied many a pair of pale-faced weavers* (*Silas Marner* by George Eliot)

comfit NOUN sugar-covered pieces of fruit or nut eaten as sweets ❑ *and pulled out a box of comfits* (*Alice's Adventures in Wonderland* by Lewis Carroll)

coming out VERB when a girl came out in society it meant she was of marriageable age. In order to "come out" girls were expecting to attend balls and other parties during a season ❑ *The younger girls formed hopes of coming out a year or two sooner than they might otherwise have done* (*Pride and Prejudice* by Jane Austen)

commit VERB commit means arrest or stop ❑ *Commit the rascals* (*Doctor Faustus 4.7* by Christopher Marlowe)

commodious ADJ commodious means convenient ❑ *the most commodious and effectual ways* (*Gulliver's Travels* by Jonathan Swift)

commons NOUN commons is an old term meaning food shared with others ❑ *his pauper assistants ranged themselves behind him; the gruel was served out; and a long grace was said over the short commons.* (*Oliver Twist* by Charles Dickens)

complacency NOUN here complacency means a desire to please others. To-day complacency means feeling pleased with oneself without good reason. ❑ *Twas thy power that raised the first complacency in me* (*The Prelude* by William Wordsworth)

complaisance NOUN complaisance was eagerness to please ❏ *we cannot wonder at his complaisance* (*Pride and Prejudice* by Jane Austen)

complaisant ADJ complaisant means polite ❏ *extremely cheerful and complaisant to their guest* (*Gulliver's Travels* by Jonathan Swift)

conning VERB conning means learning by heart ❏ *Or conning more* (*The Prelude* by William Wordsworth)

consequent NOUN consequence ❏ *as avarice is the necessary consequent of old age* (*Gulliver's Travels* by Jonathan Swift)

consorts NOUN concerts ❏ *The King, who delighted in music, had frequent consorts at Court* (*Gulliver's Travels* by Jonathan Swift)

conversible ADJ conversible meant easy to talk to, companionable ❏ *He can be a conversible companion* (*Pride and Prejudice* by Jane Austen)

copper NOUN a copper is a large pot that can be heated directly over a fire ❏ *He gazed in stupefied aston-ishment on the small rebel for some seconds, and then clung for support to the copper* (*Oliver Twist* by Charles Dickens)

copper-stick NOUN a copper-stick is the long piece of wood used to stir washing in the copper (or boiler) which was usually the biggest cooking pot in the house ❏ *It was Christmas Eve, and I had to stir the pudding for next day, with a copper-stick, from seven to eight by the Dutch clock* (*Great Expectations* by Charles Dickens)

counting-house NOUN a counting-house is a place where accountants work ❏ *Once upon a time—of all the good days in the year, on Christmas Eve—old Scrooge sat busy in his counting-house* (*A Christmas Carol* by Charles Dickens)

courtier NOUN a courtier is someone who attends the king or queen—a member of the court ❏ *next the ten courtiers;* (*Alice's Adventures in Wonderland* by Lewis Carroll)

covies NOUN covies were flocks of partridges ❏ *and will save all of the best covies for you* (*Pride and Prejudice* by Jane Austen)

cowed VERB cowed means frightened or intimidated ❏ *it cowed me more than the pain* (*Treasure Island* by Robert Louis Stevenson)

cozened VERB cozened means tricked or deceived ❏ *Do you remember, sir, how you cozened me* (*Doctor Faustus 4.7* by Christopher Marlowe)

cravats NOUN a cravat is a folded cloth that a man wears wrapped around his neck as a decorative item of clothing ❏ *we'd 'a' slept in our cravats to-night* (*The Adventures of Huckleberry Finn* by Mark Twain)

crock and dirt PHRASE crock and dirt is an old expression meaning soot and dirt ❏ *and the mare catching cold at the door, and the boy grimed with crock and dirt* (*Great Expectations* by Charles Dickens)

crockery NOUN here crockery means pottery ❏ *By one of the parrots was a cat made of crockery* (*The Adventures of Huckleberry Finn* by Mark Twain)

crooked sixpence PHRASE it was considered unlucky to have a bent sixpence ❏ *You've got the beauty, you see, and I've got the luck, so you must keep me by you for your crooked sixpence* (*Silas Marner* by George Eliot)

croquet NOUN croquet is a traditional English summer game in which players try to hit wooden balls through hoops ❏ *and once she remembered trying to box her own ears for having cheated herself in a game of croquet* (*Alice's Adventures in Wonderland* by Lewis Carroll)

cross PREP across ❏ *The two great streets, which run cross and divide it into four quarters* (*Gulliver's Travels* by Jonathan Swift)

culpable ADJ if you are culpable for something it means you are to blame ❏ *deep are the sorrows that spring from false ideas for which no man is culpable.* (*Silas Marner* by George Eliot)

cultured ADJ cultivated ❏ *Nor less when spring had warmed the cultured Vale* (*The Prelude* by William Wordsworth)

cupidity NOUN cupidity is greed ❏ *These people hated me with the hatred of cupidity and disappointment.* (*Great Expectations* by Charles Dickens)

curricle NOUN an open two-wheeled carriage with one seat for the driver and space for a single passenger ❏ *and they saw a lady and a gentleman in a curricle* (*Pride and Prejudice* by Jane Austen)

cynosure NOUN a cynosure is something that strongly attracts attention or admiration ❏ *Then I thought of Eliza and Georgiana; I beheld one the cynosure of a ballroom, the other the inmate of a convent cell* (*Jane Eyre* by Charlotte Brontë)

dalliance NOUN someone's dalliance with something is a brief involvement with it ❏ *nor sporting in the dalliance of love* (*Doctor Faustus Chorus* by Christopher Marlowe)

darkling ADV darkling is an archaic way of saying in the dark ❏ *Darkling I listen* (*Ode on a Nightingale* by John Keats)

delf-case NOUN a sideboard for holding dishes and crockery ❏ *at the pewter dishes and delf-case* (*Wuthering Heights* by Emily Brontë)

determined ■ VERB here determined means ended ❏ *and be out of vogue when that was determined* (*Gulliver's Travels* by Jonathan Swift) ■ VERB determined can mean to have been learned or found especially by investigation or experience ❏ *All the sensitive feelings it wounded so cruelly, all the shame and misery it kept alive within my breast, became more poignant as I*

thought of this; and I determined that the life was unendurable (*David Copperfield* by Charles Dickens)

Deuce NOUN a slang term for the Devil ❏ *Ah, I dare say I did. Deuce take me, he added suddenly, I know I did. I find I am not quite unscrewed yet.* (*Great Expectations* by Charles Dickens)

diabolical ADJ diabolical means devilish or evil ❏ *and with a thousand diabolical expressions* (*Treasure Island* by Robert Louis Stevenson)

direction NOUN here direction means address ❏ *Elizabeth was not surprised at it, as Jane had written the direction remarkably ill* (*Pride and Prejudice* by Jane Austen)

discover VERB to make known or announce ❏ *the Emperor would discover the secret while I was out of his power* (*Gulliver's Travels* by Jonathan Swift)

dissemble VERB hide or conceal ❏ *Dissemble nothing* (*On His Mistress* by John Donne)

dissolve VERB dissolve here means to release from life, to die ❏ *Fade far away, dissolve, and quite forget* (*Ode on a Nightingale* by John Keats)

distrain VERB to distrain is to seize the property of someone who is in debt in compensation for the money owed ❏ *for he's threatening to distrain for it* (*Silas Marner* by George Eliot)

Divan NOUN a Divan was originally a Turkish council of state–the name was transferred to the couches they sat on and is used to mean this in English ❏ *Mr Brass applauded this picture very much, and the bed being soft and comfortable, Mr Quilp determined to use it, both as a sleeping place by night and as a kind of Divan by day.* (*The Old Curiosity Shop* by Charles Dickens)

divorcement NOUN separation ❏ *By all pains which want and divorcement*

hath (*On His Mistress* by John Donne)

dog in the manger, PHRASE this phrase describes someone who prevents you from enjoying something that they themselves have no need for ❏ *You are a dog in the manger, Cathy, and desire no one to be loved but yourself* (*Wuthering Heights* by Emily Brontë)

dolorifuge NOUN dolorifuge is a word which Thomas Hardy invented. It means pain-killer or comfort ❏ *as a species of dolorifuge* (*Tess of the D'Urbervilles* by Thomas Hardy)

dome NOUN building ❏ *that river and that mouldering dome* (*The Prelude* by William Wordsworth)

domestic NOUN here domestic means a person's management of the house ❏ *to give some account of my domestic* (*Gulliver's Travels* by Jonathan Swift)

dunce NOUN a dunce is another word for idiot ❏ *Do you take me for a dunce? Go on?* (*Alice's Adventures in Wonderland* by Lewis Carroll)

Ecod EXCLAM a slang exclamation meaning "oh God!" ❏ *"Ecod," replied Wemmick, shaking his head, "that's not my trade."* (*Great Expectations* by Charles Dickens)

egg-hot NOUN an egg-hot (see also "flip" and "negus") was a hot drink made from beer and eggs, sweetened with nutmeg ❏ *She fainted when she saw me return, and made a little jug of egg-hot afterwards to console us while we talked it over.* (*David Copperfield* by Charles Dickens)

encores NOUN an encore is a short extra performance at the end of a longer one, which the entertainer gives because the audience has enthusiastically asked for it ❏ *we want a little something to answer encores with, anyway* (*The Adventures of Huckleberry Finn* by Mark Twain)

equipage NOUN an elegant and impressive carriage ❏ *and besides, the equipage did not answer to any of*

their neighbours (*Pride and Prejudice* by Jane Austen)

exordium NOUN an exordium is the opening part of a speech ❏ *"Now, Handel,"* *as if it were the grave beginning of a portentous business exordium, he had suddenly given up that tone* (*Great Expectations* by Charles Dickens)

expect VERB here expect means to wait for ❏ *to expect his farther commands* (*Gulliver's Travels* by Jonathan Swift)

familiars NOUN familiars means spirits or devils who come to someone when they are called ❏ *I'll turn all the lice about thee into familiars* (*Doctor Faustus 1.4* by Christopher Marlowe)

fantods NOUN a fantod is a person who fidgets or can't stop moving nervously ❏ *It most give me the fantods* (*The Adventures of Huckleberry Finn* by Mark Twain)

farthing NOUN a farthing is an old unit of British currency which was worth a quarter of a penny ❏ *Not a farthing less. A great many back-payments are included in it, I assure you.* (*A Christmas Carol* by Charles Dickens)

farthingale NOUN a hoop worn under a skirt to extend it ❏ *A bell with an old voice–which I dare say in its time had often said to the house, Here is the green farthingale* (*Great Expectations* by Charles Dickens)

favours NOUN here favours is an old word which means ribbons ❏ *A group of humble mourners entered the gate: wearing white favours* (*Oliver Twist* by Charles Dickens)

feigned VERB pretend or pretending ❏ *not my feigned page* (*On His Mistress* by John Donne)

fence ■ NOUN a fence is someone who receives and sells stolen goods ❏ *What are you up to? Ill-treating the boys, you covetous, avaricious, in-sa-ti-a-ble old fence?* (*Oliver Twist* by

Charles Dickens) ■ NOUN defence or protection ❑ *but honesty hath no fence against superior cunning* (*Gulliver's Travels* by Jonathan Swift)

fess ADJ fess is an old word which means pleased or proud ❑ *You'll be fess enough, my poppet* (*Tess of the D'Urbervilles* by Thomas Hardy)

fettered ADJ fettered means bound in chains or chained ❑ *"You are fettered," said Scrooge, trembling. "Tell me why?"* (*A Christmas Carol* by Charles Dickens)

fidges VERB fidges means fidgets, which is to keep moving your hands slightly because you are nervous or excited ❑ *Look, Jim, how my fingers fidges* (*Treasure Island* by Robert Louis Stevenson)

finger-post NOUN a finger-post is a sign-post showing the direction to different places ❑ *"The gallows," continued Fagin, "the gallows, my dear, is an ugly finger-post, which points out a very short and sharp turning that has stopped many a bold fellow's career on the broad highway."* (*Oliver Twist* by Charles Dickens)

fire-irons NOUN fire-irons are tools kept by the side of the fire to either cook with or look after the fire ❑ *the fire-irons came first* (*Alice's Adventures in Wonderland* by Lewis Carroll)

fire-plug NOUN a fire-plug is another word for a fire hydrant ❑ *The pony looked with great attention into a fire-plug, which was near him, and appeared to be quite absorbed in contemplating it* (*The Old Curiosity Shop* by Charles Dickens)

flank NOUN flank is the side of an animal ❑ *And all her silken flanks with garlands dressed* (*Ode on a Grecian Urn* by John Keats)

flip NOUN a flip is a drink made from warmed ale, sugar, spice and beaten egg ❑ *The events of the day, in combination with the twins, if not with the flip, had made Mrs.*

Micawber hysterical, and she shed tears as she replied (*David Copperfield* by Charles Dickens)

flit VERB flit means to move quickly ❑ *and if he had meant to flit to Thrushcross Grange* (*Wuthering Heights* by Emily Brontë)

floorcloth NOUN a floorcloth was a hard-wearing piece of canvas used instead of carpet ❑ *This avenging phantom was ordered to be on duty at eight on Tuesday morning in the hall (it was two feet square, as charged for floorcloth)* (*Great Expectations* by Charles Dickens)

fly-driver NOUN a fly-driver is a carriage drawn by a single horse ❑ *The fly-drivers, among whom I inquired next, were equally jocose and equally disrespectful* (*David Copperfield* by Charles Dickens)

fob NOUN a small pocket in which a watch is kept ❑ *"Certain," replied the man, drawing a gold watch from his fob* (*Oliver Twist* by Charles Dickens)

folly NOUN folly means foolishness or stupidity ❑ *the folly of beginning a work* (*Robinson Crusoe* by Daniel Defoe)

fond ADJ fond means foolish ❑ *Fond worldling* (*Doctor Faustus* 5.2 by Christopher Marlowe)

fondness NOUN silly or foolish affection ❑ *They have no fondness for their colts or foals* (*Gulliver's Travels* by Jonathan Swift)

for his fancy PHRASE for his fancy means for his liking or as he wanted ❑ *and as I did not obey quick enough for his fancy* (*Treasure Island* by Robert Louis Stevenson)

forlorn ADJ lost or very upset ❑ *you are from that day forlorn* (*Gulliver's Travels* by Jonathan Swift)

foster-sister NOUN a foster-sister was someone brought up by the same nurse or in the same household ❑ *I had been his foster-sister* (*Wuthering Heights* by Emily Brontë)

fox-fire NOUN fox-fire is a weak glow that is given off by decaying, rotten wood ❑ *what we must have was a lot of them rotten chunks that's called fox-fire* (*The Adventures of Huckleberry Finn* by Mark Twain)

frozen sea PHRASE the Arctic Ocean ❑ *into the frozen sea* (*Gulliver's Travels* by Jonathan Swift)

gainsay VERB to gainsay something is to say it isn't true or to deny it ❑ *"So she had," cried Scrooge. "You're right. I'll not gainsay it, Spirit. God forbid!"* (*A Christmas Carol* by Charles Dickens)

gaiters NOUN gaiters were leggings made of a cloth or piece of leather which covered the leg from the knee to the ankle ❑ *Mr Knightley was hard at work upon the lower buttons of his thick leather gaiters* (*Emma* by Jane Austen)

galluses NOUN galluses is an old spelling of gallows, and here means suspenders. Suspenders are straps worn over someone's shoulders and fastened to their trousers to prevent the trousers falling down ❑ *and home-knit galluses* (*The Adventures of Huckleberry Finn* by Mark Twain)

galoot NOUN a sailor but also a clumsy person ❑ *and maybe a galoot on it chopping* (*The Adventures of Huckleberry Finn* by Mark Twain)

gayest ADJ gayest means the most lively and bright or merry ❑ *Beth played her gayest march* (*Little Women* by Louisa May Alcott)

gem NOUN here gem means jewellery ❑ *the mountain shook off turf and flower, had only heath for raiment and crag for gem* (*Jane Eyre* by Charlotte Brontë)

giddy ADJ giddy means dizzy ❑ *and I wish you wouldn't keep appearing and vanishing so suddenly; you make me one quite giddy.* (*Alice's Adventures in Wonderland* by Lewis Carroll)

gig NOUN a light two-wheeled carriage ❑ *when a gig drove up to the garden gate: out of which there jumped a fat gentleman* (*Oliver Twist* by Charles Dickens)

gladsome ADJ gladsome is an old word meaning glad or happy ❑ *Nobody ever stopped him in the street to say, with gladsome looks* (*A Christmas Carol* by Charles Dickens)

glen NOUN a glen is a small valley; the word is used commonly in Scotland ❑ *a beck which follows the bend of the glen* (*Wuthering Heights* by Emily Brontë)

gravelled VERB gravelled is an old term which means to baffle or defeat someone ❑ *Gravelled the pastors of the German Church* (*Doctor Faustus 1.1* by Christopher Marlowe)

grinder NOUN a grinder was a private tutor ❑ *but that when he had had the happiness of marrying Mrs Pocket very early in his life, he had impaired his prospects and taken up the calling of a Grinder* (*Great Expectations* by Charles Dickens)

gruel NOUN gruel is a thin, watery cornmeal or oatmeal soup ❑ *and the little saucepan of gruel (Scrooge had a cold in his head) upon the hob.* (*A Christmas Carol* by Charles Dickens)

guinea, half a NOUN half a guinea was ten shillings and sixpence ❑ *but lay out half a guinea at Ford's* (*Emma* by Jane Austen)

gull VERB gull is an old term which means to fool or deceive someone ❑ *Hush, I'll gull him supernaturally* (*Doctor Faustus 3.4* by Christopher Marlowe)

gunnel NOUN the gunnel, or gunwale, is the upper edge of a boat's side ❑ *But he put his foot on the gunnel and rocked her* (*The Adventures of Huckleberry Finn* by Mark Twain)

gunwale NOUN the side of a ship ❑ *He dipped his hand in the water over the boat's gunwale* (*Great Expectations* by Charles Dickens)

Gytrash NOUN a Gytrash is an omen of misfortune to the superstitious, usually taking the form of a hound ❏ *I remembered certain of Bessie's tales, wherein figured a North-of-England spirit, called a "Gytrash"* (*Jane Eyre* by Charlotte Brontë)

hackney-cabriolet NOUN a two-wheeled carriage with four seats for hire and pulled by a horse ❏ *A hackney-cabriolet was in waiting; with the same vehemence which she had exhibited in addressing Oliver, the girl pulled him in with her, and drew the curtains close.* (*Oliver Twist* by Charles Dickens)

hackney-coach NOUN a four-wheeled horse-drawn vehicle for hire ❏ *The twilight was beginning to close in, when Mr. Brownlow alighted from a hackney-coach at his own door, and knocked softly.* (*Oliver Twist* by Charles Dickens)

haggler NOUN a haggler is someone who travels from place to place selling small goods and items ❏ *when I be plain Jack Durbeyfield, the haggler* (*Tess of the D'Urbervilles* by Thomas Hardy)

halter NOUN a halter is a rope or strap used to lead an animal or to tie it up ❏ *I had of course long been used to a halter and a headstall* (*Black Beauty* by Anna Sewell)

hamlet NOUN a hamlet is a small village or a group of houses in the countryside ❏ *down from the hamlet* (*Treasure Island* by Robert Louis Stevenson)

hand-barrow NOUN a hand-barrow is a device for carrying heavy objects. It is like a wheelbarrow except that it has handles, rather than wheels, for moving the barrow ❏ *his sea chest following behind him in a hand-barrow* (*Treasure Island* by Robert Louis Stevenson)

handspike NOUN a handspike was a stick which was used as a lever ❏ *a bit of stick like a handspike* (*Treasure Island* by Robert Louis Stevenson)

haply ADV haply means by chance or perhaps ❏ *And haply the Queen-Moon is on her throne* (*Ode on a Nightingale* by John Keats)

harem NOUN the harem was the part of the house where the women lived ❏ *mostly they hang round the harem* (*The Adventures of Huckleberry Finn* by Mark Twain)

hautboys NOUN hautboys are oboes ❏ *sausages and puddings resembling flutes and hautboys* (*Gulliver's Travels* by Jonathan Swift)

hawker NOUN a hawker is someone who sells goods to people as he travels rather than from a fixed place like a shop ❏ *to buy some stockings from a hawker* (*Treasure Island* by Robert Louis Stevenson)

hawser NOUN a hawser is a rope used to tie up or tow a ship or boat ❏ *Again among the tiers of shipping, in and out, avoiding rusty chain-cables, frayed hempen hawsers* (*Great Expectations* by Charles Dickens)

headstall NOUN the headstall is the part of the bridle or halter that goes around a horse's head ❏ *I had of course long been used to a halter and a headstall* (*Black Beauty* by Anna Sewell)

hearken VERB hearken means to listen ❏ *though we sometimes stopped to lay hold of each other and hearken* (*Treasure Island* by Robert Louis Stevenson)

heartless ADJ here heartless means without heart or dejected ❏ *I am not heartless* (*The Prelude* by William Wordsworth)

hebdomadal ADJ hebdomadal means weekly ❏ *It was the hebdomadal treat to which we all looked forward from Sabbath to Sabbath* (*Jane Eyre* by Charlotte Brontë)

highwaymen NOUN highwaymen were people who stopped travellers and robbed them ❏ *We are highwaymen* (*The Adventures of Huckleberry Finn* by Mark Twain)

hinds NOUN hinds means farm hands, or people who work on a farm ❏ *He called his hinds about him* (*Gulliver's Travels* by Jonathan Swift)

histrionic ADJ if you refer to someone's behaviour as histrionic, you are being critical of it because it is dramatic and exaggerated ❏ *But the histrionic muse is the darling* (*The Adventures of Huckleberry Finn* by Mark Twain)

hogs NOUN hogs is another word for pigs ❏ *Tom called the hogs "ingots"* (*The Adventures of Huckleberry Finn* by Mark Twain)

horrors NOUN the horrors are a fit, called delirium tremens, which is caused by drinking too much alcohol ❏ *I'll have the horrors* (*Treasure Island* by Robert Louis Stevenson)

huffy ADJ huffy means to be obviously annoyed or offended about something ❏ *They will feel that more than angry speeches or huffy actions* (*Little Women* by Louisa May Alcott)

hulks NOUN hulks were prison-ships ❏ *The miserable companion of thieves and ruffians, the fallen outcast of low haunts, the associate of the scourings of the jails and hulks* (*Oliver Twist* by Charles Dickens)

humbug NOUN humbug means nonsense or rubbish ❏ *"Bah," said Scrooge. "Humbug!"* (*A Christmas Carol* by Charles Dickens)

humours NOUN it was believed that there were four fluids in the body called humours which decided the temperament of a person depending on how much of each fluid was present ❏ *other peccant humours* (*Gulliver's Travels* by Jonathan Swift)

husbandry NOUN husbandry is farming animals ❏ *bad husbandry were plentifully anointing their wheels* (*Silas Marner* by George Eliot)

huswife NOUN a huswife was a small sewing kit ❏ *but I had put my huswife on it* (*Emma* by Jane Austen)

ideal ADJ ideal in this context means imaginary ❏ *I discovered the yell was not ideal* (*Wuthering Heights* by Emily Brontë)

If our two PHRASE if both our ❏ *If our two loves be one* (*The Good-Morrow* by John Donne)

ignis-fatuus NOUN ignis-fatuus is the light given out by burning marsh gases, which lead careless travellers into danger ❏ *it is madness in all women to let a secret love kindle within them, which, if unreturned and unknown, must devour the life that feeds it; and, if discovered and responded to, must lead ignis-fatuus-like, into miry wilds whence there is no extrication.* (*Jane Eyre* by Charlotte Brontë)

imaginations NOUN here imaginations means schemes or plans ❏ *soon drove out those imaginations* (*Gulliver's Travels* by Jonathan Swift)

impressible ADJ impressible means open or impressionable ❏ *for Marner had one of those impressible, self-doubting natures* (*Silas Marner* by George Eliot)

in good intelligence PHRASE friendly with each other ❏ *that these two persons were in good intelligence with each other* (*Gulliver's Travels* by Jonathan Swift)

inanity NOUN inanity is silliness or dull stupidity ❏ *Do we not wile away moments of inanity* (*Silas Marner* by George Eliot)

incivility NOUN incivility means rudeness or impoliteness ❏ *if it's only for a piece of incivility like to-night's* (*Treasure Island* by Robert Louis Stevenson)

indigenae NOUN indigenae means natives or people from that area ❏ *an exotic that the surly indigenae will not recognise for kin* (*Wuthering Heights* by Emily Brontë)

indocible ADJ unteachable ❏ *so they were the most restive and indocible* (*Gulliver's Travels* by Jonathan Swift)

ingenuity NOUN inventiveness ❑ *entreated me to give him something as an encouragement to ingenuity* (*Gulliver's Travels* by Jonathan Swift)

ingots NOUN an ingot is a lump of a valuable metal like gold, usually shaped like a brick ❑ *Tom called the hogs "ingots"* (*The Adventures of Huckleberry Finn* by Mark Twain)

inkstand NOUN an inkstand is a pot which was put on a desk to contain either ink or pencils and pens ❑ *throwing an inkstand at the Lizard as she spoke* (*Alice's Adventures in Wonderland* by Lewis Carroll)

inordinate ADJ without order. To-day inordinate means "excessive". ❑ *Though yet untutored and inordinate* (*The Prelude* by William Wordsworth)

intellectuals NOUN here intellectuals means the minds (of the workmen) ❑ *those instructions they give being too refined for the intellectuals of their workmen* (*Gulliver's Travels* by Jonathan Swift)

interview NOUN meeting ❑ *By our first strange and fatal interview* (*On His Mistress* by John Donne)

jacks NOUN jacks are rods for turning a spit over a fire ❑ *It was a small bit of pork suspended from the kettle hanger by a string passed through a large door key, in a way known to primitive housekeepers unpossessed of jacks* (*Silas Marner* by George Eliot)

jews-harp NOUN a jews-harp is a small, metal, musical instrument that is played by the mouth ❑ *A jews-harp's plenty good enough for a rat* (*The Adventures of Huckleberry Finn* by Mark Twain)

jorum NOUN a large bowl ❑ *while Miss Skiffins brewed such a jorum of tea, that the pig in the back premises became strongly excited* (*Great Expectations* by Charles Dickens)

jostled VERB jostled means bumped or pushed by someone or some people

❑ *being jostled himself into the kennel* (*Gulliver's Travels* by Jonathan Swift)

keepsake NOUN a keepsake is a gift which reminds someone of an event or of the person who gave it to them. ❑ *books and ornaments they had in their boudoirs at home: keepsakes that different relations had presented to them* (*Jane Eyre* by Charlotte Brontë)

kenned VERB kenned means knew ❑ *though little kenned the lamplighter that he had any company but Christmas!* (*A Christmas Carol* by Charles Dickens)

kennel NOUN kennel means gutter, which is the edge of a road next to the pavement, where rain water collects and flows away ❑ *being jostled himself into the kennel* (*Gulliver's Travels* by Jonathan Swift)

knock-knee ADJ knock-knee means slanted, at an angle. ❑ *LOT 1 was marked in whitewashed knock-knee letters on the brewhouse* (*Great Expectations* by Charles Dickens)

ladylike ADJ to be ladylike is to behave in a polite, dignified and graceful way ❑ *No, winking isn't ladylike* (*Little Women* by Louisa May Alcott)

lapse NOUN flow ❑ *Stealing with silent lapse to join the brook* (*The Prelude* by William Wordsworth)

larry NOUN larry is an old word which means commotion or noisy celebration ❑ *That was all a part of the larry!* (*Tess of the D'Urbervilles* by Thomas Hardy)

laths NOUN laths are strips of wood ❑ *The panels shrunk, the windows cracked; fragments of plaster fell out of the ceiling, and the naked laths were shown instead* (*A Christmas Carol* by Charles Dickens)

leer NOUN a leer is an unpleasant smile ❑ *with a kind of leer* (*Treasure Island* by Robert Louis Stevenson)

lenitives NOUN these are different kinds of drugs or medicines: lenitives and

palliatives were pain relievers; aperitives were laxatives; abstersives caused vomiting; corrosives destroyed human tissue; restringents caused constipation; cephalalgics stopped headaches; icterics were used as medicine for jaundice; apophlegmatics were cough medicine, and acoustics were cures for the loss of hearing ❏ *lenitives, aperitives, abstersives, corrosives, restringents, palliatives, laxatives, cephalalgics, icterics, apophlegmatics, acoustics* (*Gulliver's Travels* by Jonathan Swift)

lest CONJ in case. If you do something lest something (usually) unpleasant happens you do it to try to prevent it happening ❏ *She went in without knocking, and hurried upstairs, in great fear lest she should meet the real Mary Ann* (*Alice's Adventures in Wonderland* by Lewis Carroll)

levee NOUN a levee is an old term for a meeting held in the morning, shortly after the person holding the meeting has got out of bed ❏ *I used to attend the King's levee once or twice a week* (*Gulliver's Travels* by Jonathan Swift)

life-preserver NOUN a club which had lead inside it to make it heavier and therefore more dangerous ❏ *and with no more suspicious articles displayed to view than two or three heavy bludgeons which stood in a corner, and a "life-preserver" that hung over the chimney-piece.* (*Oliver Twist* by Charles Dickens)

lighterman NOUN a lighterman is another word for sailor ❏ *in and out, hammers going in ship-builders' yards, saws going at timber, clashing engines going at things unknown, pumps going in leaky ships, capstans going, ships going out to sea, and unintelligible sea creatures roaring curses over the bulwarks at respondent lightermen* (*Great Expectations* by Charles Dickens)

livery NOUN servants often wore a uniform known as a livery ❏

suddenly a footman in livery came running out of the wood (*Alice's Adventures in Wonderland* by Lewis Carroll)

livid ADJ livid means pale or ash coloured. Livid also means very angry ❏ *a dirty, livid white* (*Treasure Island* by Robert Louis Stevenson)

lottery-tickets NOUN a popular card game ❏ *and Mrs. Philips protested that they would have a nice comfortable noisy game of lottery tickets* (*Pride and Prejudice* by Jane Austen)

lower and upper world PHRASE the earth and the heavens are the lower and upper worlds ❏ *the changes in the lower and the upper world* (*Gulliver's Travels* by Jonathan Swift)

lustres NOUN lustres are chandeliers. A chandelier is a large, decorative frame which holds light bulbs or candles and hangs from the ceiling ❏ *the lustres, lights, the carving and the guilding* (*The Prelude* by William Wordsworth)

lynched VERB killed without a criminal trial by a crowd of people ❏ *He'll never know how nigh he come to getting lynched* (*The Adventures of Huckleberry Finn* by Mark Twain)

malingering VERB if someone is malingering they are pretending to be ill to avoid working ❏ *And you stand there malingering* (*Treasure Island* by Robert Louis Stevenson)

managing PHRASE treating with consideration ❏ *to think the honour of my own kind not worth managing* (*Gulliver's Travels* by Jonathan Swift)

manhood PHRASE manhood means human nature ❏ *concerning the nature of manhood* (*Gulliver's Travels* by Jonathan Swift)

man-trap NOUN a man-trap is a set of steel jaws that snap shut when trodden on and trap a person's leg

❑ *"Don't go to him,"* I called out of the window, *"he's an assassin! A man-trap!"* (*Oliver Twist* by Charles Dickens)

maps NOUN charts of the night sky ❑ *Let maps to others, worlds on worlds have shown* (*The Good-Morrow* by John Donne)

mark VERB look at or notice ❑ *Mark but this flea, and mark in this* (*The Flea* by John Donne)

maroons NOUN A maroon is someone who has been left in a place which it is difficult for them to escape from, like a small island ❑ *if schooners, islands, and maroons* (*Treasure Island* by Robert Louis Stevenson)

mast NOUN here mast means the fruit of forest trees ❑ *a quantity of acorns, dates, chestnuts, and other mast* (*Gulliver's Travels* by Jonathan Swift)

mate VERB defeat ❑ *Where Mars did mate the warlike Carthigens* (*Doctor Faustus Chorus* by Christopher Marlowe)

mealy ADJ Mealy when used to describe a face meant pallid, pale or colourless ❑ *I only know two sorts of boys. Mealy boys, and beef-faced boys* (*Oliver Twist* by Charles Dickens)

middling ADV fairly or moderately ❑ *she worked me middling hard for about an hour* (*The Adventures of Huckleberry Finn* by Mark Twain)

mill NOUN a mill, or treadmill, was a device for hard labour or punishment in prison ❑ *Was you never on the mill?* (*Oliver Twist* by Charles Dickens)

milliner's shop NOUN a milliner's sold fabrics, clothing, lace and accessories; as time went on they specialized more and more in hats ❑ *to pay their duty to their aunt and to a milliner's shop just over the way* (*Pride and Prejudice* by Jane Austen)

minching un' munching PHRASE how people in the north of England used to describe the way people

from the south speak ❑ *Minching un' munching!* (*Wuthering Heights* by Emily Brontë)

mine NOUN gold ❑ *Whether both th'Indias of spice and mine* (*The Sun Rising* by John Donne)

mire NOUN mud ❑ *Tis my fate to be always ground into the mire under the iron heel of oppression* (*The Adventures of Huckleberry Finn* by Mark Twain)

miscellany NOUN a miscellany is a collection of many different kinds of things ❑ *under that, the miscellany began* (*Treasure Island* by Robert Louis Stevenson)

mistarshers NOUN mistarshers means moustache, which is the hair that grows on a man's upper lip ❑ *when he put his hand up to his mistarshers* (*Tess of the D'Urbervilles* by Thomas Hardy)

morrow NOUN here good-morrow means tomorrow and a new and better life ❑ *And now good-morrow to our waking souls* (*The Good-Morrow* by John Donne)

mortification NOUN mortification is an old word for gangrene which is when part of the body decays or "dies" because of disease ❑ *Yes, it was a mortification–that was it* (*The Adventures of Huckleberry Finn* by Mark Twain)

mought VERB mought is an old spelling of might ❑ *what you mought call me? You mought call me captain* (*Treasure Island* by Robert Louis Stevenson)

move VERB move me not means do not make me angry ❑ *Move me not, Faustus* (*Doctor Faustus 2.1* by Christopher Marlowe)

muffin-cap NOUN a muffin-cap is a flat cap made from wool ❑ *the old one, remained stationary in the muffin-cap and leathers* (*Oliver Twist* by Charles Dickens)

mulatter NOUN a mulatter was another word for mulatto, which is a person with parents who are from different

races ❏ *a mulatter, most as white as a white man* (*The Adventures of Huckleberry Finn* by Mark Twain)

mummery NOUN mummery is an old word that meant meaningless (or pretentious) ceremony ❏ *When they were all gone, and when Trabb and his men but not his boy: I looked for him—had crammed their mummery into bags, and were gone too, the house felt wholesomer.* (*Great Expectations* by Charles Dickens)

nap NOUN the nap is the woolly surface on a new item of clothing. Here the surface has been worn away so it looks bare ❏ *like an old hat with the nap rubbed off* (*The Adventures of Huckleberry Finn* by Mark Twain)

natural ■ NOUN a natural is a person born with learning difficulties ❏ *though he had been left to his particular care by their deceased father, who thought him almost a natural.* (*David Copperfield* by Charles Dickens) ■ ADJ natural meant illegitimate ❏ *Harriet Smith was the natural daughter of somebody* (*Emma* by Jane Austen)

navigator NOUN a navigator was originally someone employed to dig canals. It is the origin of the word "navvy" meaning a labourer ❏ *She ascertained from me in a few words what it was all about, comforted Dora, and gradually convinced her that I was not a labourer–from my manner of stating the case I believe Dora concluded that I was a navigator, and went balancing myself up and down a plank all day with a wheelbarrow–and so brought us together in peace.* (*David Copperfield* by Charles Dickens)

necromancy NOUN necromancy means a kind of magic where the magician speaks to spirits or ghosts to find out what will happen in the future ❏ *He surfeits upon cursed necromancy* (*Doctor Faustus chorus* by Christopher Marlowe)

negus NOUN a negus is a hot drink made from sweetened wine and water ❏ *He sat placidly perusing the newspaper, with his little head on one side, and a glass of warm sherry negus at his elbow.* (*David Copperfield* by Charles Dickens)

nice ADJ discriminating. Able to make good judgements or choices ❏ *consequently a claim to be nice* (*Emma* by Jane Austen)

nigh ADV nigh means near ❏ *He'll never know how nigh he come to getting lynched* (*The Adventures of Huckleberry Finn* by Mark Twain)

nimbleness NOUN nimbleness means being able to move very quickly or skilfully ❏ *and with incredible accuracy and nimbleness* (*Treasure Island* by Robert Louis Stevenson)

noggin NOUN a noggin is a small mug or a wooden cup ❏ *you'll bring me one noggin of rum* (*Treasure Island* by Robert Louis Stevenson)

none ADJ neither ❏ *none can die* (*The Good-Morrow* by John Donne)

notices NOUN observations ❏ *Arch are his notices* (*The Prelude* by William Wordsworth)

occiput NOUN occiput means the back of the head ❏ *saw off the occiput of each couple* (*Gulliver's Travels* by Jonathan Swift)

officiously ADV kindly ❏ *the governess who attended Glumdalclitch very officiously lifted me up* (*Gulliver's Travels* by Jonathan Swift)

old salt PHRASE old salt is a slang term for an experienced sailor ❏ *a "true sea-dog", and a "real old salt"* (*Treasure Island* by Robert Louis Stevenson)

or ere PHRASE before ❏ *or ere the Hall was built* (*The Prelude* by William Wordsworth)

ostler NOUN one who looks after horses at an inn ❏ *The bill paid, and the waiter remembered, and the ostler not forgotten, and the chambermaid taken into consideration* (*Great Expectations* by Charles Dickens)

ostry NOUN an ostry is an old word for a pub or hotel ❑ *lest I send you into the ostry with a vengeance* (*Doctor Faustus* 2.2 by Christopher Marlowe)

outrunning the constable PHRASE outrunning the constable meant spending more than you earn ❑ *but I shall by this means be able to check your bills and to pull you up if I find you outrunning the constable.* (*Great Expectations* by Charles Dickens)

over ADV across ❑ *It is in length six yards, and in the thickest part at least three yards over* (*Gulliver's Travels* by Jonathan Swift)

over the broomstick PHRASE this is a phrase meaning "getting married without a formal ceremony" ❑ *They both led tramping lives, and this woman in Gerrard-street here, had been married very young, over the broomstick (as we say), to a tramping man, and was a perfect fury in point of jealousy.* (*Great Expectations* by Charles Dickens)

own VERB own means to admit or to acknowledge ❑ *It's my old girl that advises. She has the head. But I never own to it before her. Discipline must be maintained* (*Bleak House* by Charles Dickens)

page NOUN here page means a boy employed to run errands ❑ *not my feigned page* (*On His Mistress* by John Donne)

paid pretty dear PHRASE paid pretty dear means paid a high price or suffered quite a lot ❑ *I paid pretty dear for my monthly fourpenny piece* (*Treasure Island* by Robert Louis Stevenson)

pannikins NOUN pannikins were small tin cups ❑ *of lifting light glasses and cups to his lips, as if they were clumsy pannikins* (*Great Expectations* by Charles Dickens)

pards NOUN pards are leopards ❑ *Not charioted by Bacchus and his pards* (*Ode on a Nightingale* by John Keats)

parlour boarder NOUN a pupil who lived with the family ❑ *and somebody had lately raised her from the condition of scholar to parlour boarder* (*Emma* by Jane Austen)

particular, a London PHRASE London in Victorian times and up to the 1950s was famous for having very dense fog–which was a combination of real fog and the smog of pollution from factories ❑ *This is a London particular . . . A fog, miss* (*Bleak House* by Charles Dickens)

patten NOUN pattens were wooden soles which were fixed to shoes by straps to protect the shoes in wet weather ❑ *carrying a basket like the Great Seal of England in plaited straw, a pair of pattens, a spare shawl, and an umbrella, though it was a fine bright day* (*Great Expectations* by Charles Dickens)

paviour NOUN a paviour was a labourer who worked on the street pavement ❑ *the paviour his pickaxe* (*Oliver Twist* by Charles Dickens)

peccant ADJ peccant means unhealthy ❑ *other peccant humours* (*Gulliver's Travels* by Jonathan Swift)

penetralium NOUN penetralium is a word used to describe the inner rooms of the house ❑ *and I had no desire to aggravate his impatience previous to inspecting the penetralium* (*Wuthering Heights* by Emily Brontë)

pensive ADV pensive means deep in thought or thinking seriously about something ❑ *and she was leaning pensive on a tomb-stone on her right elbow* (*The Adventures of Huckleberry Finn* by Mark Twain)

penury NOUN penury is the state of being extremely poor ❑ *Distress, if not penury, loomed in the distance* (*Tess of the D'Urbervilles* by Thomas Hardy)

perspective NOUN telescope ❑ *a pocket perspective* (*Gulliver's Travels* by Jonathan Swift)

phaeton NOUN a phaeton was an open carriage for four people ❑ *often*

condescends to drive by my humble abode in her little phaeton and ponies (*Pride and Prejudice* by Jane Austen)

phantasm NOUN a phantasm is an illusion, something that is not real. It is sometimes used to mean ghost ❑ *Experience had bred no fancies in him that could raise the phantasm of appetite* (*Silas Marner* by George Eliot)

physic NOUN here physic means medicine ❑ *there I studied physic two years and seven months* (*Gulliver's Travels* by Jonathan Swift)

pinioned VERB to pinion is to hold both arms so that a person cannot move them ❑ *But the relentless Ghost pinioned him in both his arms, and forced him to observe what happened next.* (*A Christmas Carol* by Charles Dickens)

piquet NOUN piquet was a popular card game in the C18th ❑ *Mr Hurst and Mr Bingley were at piquet* (*Pride and Prejudice* by Jane Austen)

plaister NOUN a plaister is a piece of cloth on which an apothecary (or pharmacist) would spread ointment. The cloth is then applied to wounds or bruises to treat them ❑ *Then, she gave the knife a final smart wipe on the edge of the plaister, and then sawed a very thick round off the loaf: which she finally, before separating from the loaf, hewed into two halves, of which Joe got one, and I the other.* (*Great Expectations* by Charles Dickens)

plantations NOUN here plantations means colonies, which are countries controlled by a more powerful country ❑ *besides our plantations in America* (*Gulliver's Travels* by Jonathan Swift)

plastic ADJ here plastic is an old term meaning shaping or a power that was forming ❑ *A plastic power abode with me* (*The Prelude* by William Wordsworth)

players NOUN actors ❑ *of players which upon the world's stage be* (*On His Mistress* by John Donne)

plump ADV all at once, suddenly ❑ *But it took a bit of time to get it well round, the change come so uncommon plump, didn't it?* (*Great Expectations* by Charles Dickens)

plundered VERB to plunder is to rob or steal from ❑ *These crosses stand for the names of ships or towns that they sank or plundered* (*Treasure Island* by Robert Louis Stevenson)

pommel ■ VERB to pommel someone is to hit them repeatedly with your fists ❑ *hug him round the neck, pommel his back, and kick his legs in irrepressible affection!* (*A Christmas Carol* by Charles Dickens) ■ NOUN a pommel is the part of a saddle that rises up at the front ❑ *He had his gun across his pommel* (*The Adventures of Huckleberry Finn* by Mark Twain)

poor's rates NOUN poor's rates were property taxes which were used to support the poor ❑ *"Oh!" replied the undertaker; "why, you know, Mr. Bumble, I pay a good deal towards the poor's rates."* (*Oliver Twist* by Charles Dickens)

popular ADJ popular means ruled by the people, or Republican, rather than ruled by a monarch ❑ *With those of Greece compared and popular Rome* (*The Prelude* by William Wordsworth)

porringer NOUN a porringer is a small bowl ❑ *Of this festive composition each boy had one porringer, and no more* (*Oliver Twist* by Charles Dickens)

postboy NOUN a postboy was the driver of a horse-drawn carriage ❑ *He spoke to a postboy who was dozing under the gateway* (*Oliver Twist* by Charles Dickens)

post-chaise NOUN a fast carriage for two or four passengers ❑ *Looking round, he saw that it was a post-chaise, driven at great speed* (*Oliver Twist* by Charles Dickens)

postern NOUN a small gate usually at the back of a building ❑ *The little servant happening to be entering the*

fortress with two hot rolls, I passed through the postern and crossed the drawbridge, in her company (*Great Expectations* by Charles Dickens)

pottle NOUN a pottle was a small basket ❑ *He had a paper-bag under each arm and a pottle of strawberries in one hand . . .* (*Great Expectations* by Charles Dickens)

pounce NOUN pounce is a fine powder used to prevent ink spreading on untreated paper ❑ *in that grim atmosphere of pounce and parchment, red-tape, dusty wafers, ink-jars, brief and draft paper, law reports, writs, declarations, and bills of costs* (*David Copperfield* by Charles Dickens)

pox NOUN pox means sexually transmitted diseases like syphilis ❑ *how the pox in all its consequences and denominations* (*Gulliver's Travels* by Jonathan Swift)

prelibation NOUN prelibation means a foretaste of or an example of something to come ❑ *A prelibation to the mower's scythe* (*The Prelude* by William Wordsworth)

prentice NOUN an apprentice ❑ *and Joe, sitting on an old gun, had told me that when I was 'prentice to him regularly bound, we would have such Larks there!* (*Great Expectations* by Charles Dickens)

presently ADV immediately ❑ *I presently knew what they meant* (*Gulliver's Travels* by Jonathan Swift)

pumpion NOUN pumpkin ❑ *for it was almost as large as a small pumpion* (*Gulliver's Travels* by Jonathan Swift)

punctual ADJ kept in one place ❑ *was not a punctual presence, but a spirit* (*The Prelude* by William Wordsworth)

quadrille ■ NOUN a quadrille is a dance invented in France which is usually performed by four couples ❑ *However, Mr Swiveller had Miss Sophy's hand for the first quadrille* (country-dances being low, were utterly proscribed) (*The Old Curiosity Shop* by Charles Dickens) ■ NOUN quadrille was a card game for four people ❑ *to make up her pool of quadrille in the evening* (*Pride and Prejudice* by Jane Austen)

quality NOUN gentry or upper-class people ❑ *if you are with the quality* (*The Adventures of Huckleberry Finn* by Mark Twain)

quick parts PHRASE quick-witted ❑ *Mr Bennet was so odd a mixture of quick parts* (*Pride and Prejudice* by Jane Austen)

quid NOUN a quid is something chewed or kept in the mouth, like a piece of tobacco ❑ *rolling his quid* (*Treasure Island* by Robert Louis Stevenson)

quit VERB quit means to avenge or to make even ❑ *But Faustus's death shall quit my infamy* (*Doctor Faustus 4.3* by Christopher Marlowe)

rags NOUN divisions ❑ *Nor hours, days, months, which are the rags of time* (*The Sun Rising* by John Donne)

raiment NOUN raiment means clothing ❑ *the mountain shook off turf and flower, had only heath for raiment and crag for gem* (*Jane Eyre* by Charlotte Brontë)

rain cats and dogs PHRASE an expression meaning rain heavily. The origin of the expression is unclear ❑ *But it'll perhaps rain cats and dogs to-morrow* (*Silas Marner* by George Eliot)

raised Cain PHRASE raised Cain means caused a lot of trouble. Cain is a character in the Bible who killed his brother Abel ❑ *and every time he got drunk he raised Cain around town* (*The Adventures of Huckleberry Finn* by Mark Twain)

rambling ADJ rambling means confused and not very clear ❑ *my head began to be filled very early with rambling thoughts* (*Robinson Crusoe* by Daniel Defoe)

raree-show NOUN a raree-show is an old term for a peep-show or a fairground entertainment ❏ *A raree-show is here, with children gathered round* (*The Prelude* by William Wordsworth)

recusants NOUN people who resisted authority ❏ *hardy recusants* (*The Prelude* by William Wordsworth)

redounding VERB eddying. An eddy is a movement in water or air which goes round and round instead of flowing in one direction ❏ *mists and steam-like fogs redounding everywhere* (*The Prelude* by William Wordsworth)

redundant ADJ here redundant means overflowing but Wordsworth also uses it to mean excessively large or too big ❏ *A tempest, a redundant energy* (*The Prelude* by William Wordsworth)

reflex NOUN reflex is a shortened version of reflexion, which is an alternative spelling of reflection ❏ *To cut across the reflex of a star* (*The Prelude* by William Wordsworth)

Reformatory NOUN a prison for young offenders/criminals ❏ *Even when I was taken to have a new suit of clothes, the tailor had orders to make them like a kind of Reformatory, and on no account to let me have the free use of my limbs.* (*Great Expectations* by Charles Dickens)

remorse NOUN pity or compassion ❏ *by that remorse* (*On His Mistress* by John Donne)

render VERB in this context render means give. ❏ *and Sarah could render no reason that would be sanctioned by the feeling of the community.* (*Silas Marner* by George Eliot)

repeater NOUN a repeater was a watch that chimed the last hour when a button was pressed–as a result it was useful in the dark ❏ *And his watch is a gold repeater, and worth a hundred pound if it's worth a penny.* (*Great Expectations* by Charles Dickens)

repugnance NOUN repugnance means a strong dislike of something or someone ❏ *overcoming a strong repugnance* (*Treasure Island* by Robert Louis Stevenson)

reverence NOUN reverence means bow. When you bow to someone, you briefly bend your body towards them as a formal way of showing them respect ❏ *made my reverence* (*Gulliver's Travels* by Jonathan Swift)

reverie NOUN a reverie is a daydream ❏ *I can guess the subject of your reverie* (*Pride and Prejudice* by Jane Austen)

revival NOUN a religious meeting held in public ❏ *well I'd ben a-running' a little temperance revival thar' bout a week* (*The Adventures of Huckleberry Finn* by Mark Twain)

revolt VERB revolt means turn back or stop your present course of action and go back to what you were doing before ❏ *Revolt, or I'll in piecemeal tear thy flesh* (*Doctor Faustus 5.1* by Christopher Marlowe)

rheumatics/rheumatism NOUN rheumatics [rheumatism] is an illness that makes your joints or muscles stiff and painful ❏ *a new cure for the rheumatics* (*Treasure Island* by Robert Louis Stevenson)

riddance NOUN riddance is usually used in the form good riddance which you say when you are pleased that something has gone or been left behind ❏ *I'd better go into the house, and die and be a riddance* (*David Copperfield* by Charles Dickens)

rimy ADJ rimy is an adjective which means covered in ice or frost ❏ *It was a rimy morning, and very damp* (*Great Expectations* by Charles Dickens)

riper ADJ riper means more mature or older ❏ *At riper years to Wittenberg he went* (*Doctor Faustus chorus* by Christopher Marlowe)

rubber NOUN a set of games in whist or backgammon ❏ *her father was sure of his rubber* (*Emma* by Jane Austen)

ruffian NOUN a ruffian is a person who behaves violently ❏ *and when the ruffian had told him* (*Treasure Island* by Robert Louis Stevenson)

sadness NOUN sadness is an old term meaning seriousness ❏ *But I prithee tell me, in good sadness* (*Doctor Faustus 2.2* by Christopher Marlowe)

sailed before the mast PHRASE this phrase meant someone who did not look like a sailor ❏ *he had none of the appearance of a man that sailed before the mast* (*Treasure Island* by Robert Louis Stevenson)

scabbard NOUN a scabbard is the covering for a sword or dagger ❏ *Girded round its middle was an antique scabbard; but no sword was in it, and the ancient sheath was eaten up with rust* (*A Christmas Carol* by Charles Dickens)

schooners NOUN A schooner is a fast, medium-sized sailing ship ❏ *if schooners, islands, and maroons* (*Treasure Island* by Robert Louis Stevenson)

science NOUN learning or knowledge ❏ *Even Science, too, at hand* (*The Prelude* by William Wordsworth)

scrouge VERB to scrouge means to squeeze or to crowd ❏ *to scrouge in and get a sight* (*The Adventures of Huckleberry Finn* by Mark Twain)

scrutore NOUN a scrutore, or escritoire, was a writing table ❏ *set me gently on my feet upon the scrutore* (*Gulliver's Travels* by Jonathan Swift)

scutcheon/escutcheon NOUN an escutcheon is a shield with a coat of arms, or the symbols of a family name, engraved on it ❏ *On the scutcheon we'll have a bend* (*The Adventures of Huckleberry Finn* by Mark Twain)

sea-dog PHRASE sea-dog is a slang term for an experienced sailor or pirate ❏ *a "true sea-dog", and a "real old salt,"* (*Treasure Island* by Robert Louis Stevenson)

see the lions PHRASE to see the lions was to go and see the sights of London. Originally the phrase referred to the menagerie in the Tower of London and later in Regent's Park ❏ *We will go and see the lions for an hour or two–it's something to have a fresh fellow like you to show them to, Copperfield* (*David Copperfield* by Charles Dickens)

self-conceit NOUN self-conceit is an old term which means having too high an opinion of oneself, or deceiving yourself ❏ *Till swollen with cunning, of a self-conceit* (*Doctor Faustus chorus* by Christopher Marlowe)

seneschal NOUN a steward ❏ *where a grey-headed seneschal sings a funny chorus with a funnier body of vassals* (*Oliver Twist* by Charles Dickens)

sensible ADJ if you were sensible of something you are aware or conscious of something ❏ *If my children are silly I must hope to be always sensible of it* (*Pride and Prejudice* by Jane Austen)

sessions NOUN court cases were heard at specific times of the year called sessions ❏ *He lay in prison very ill, during the whole interval between his committal for trial, and the coming round of the Sessions.* (*Great Expectations* by Charles Dickens)

shabby ADJ shabby places look old and in bad condition ❏ *a little bit of a shabby village named Pikesville* (*The Adventures of Huckleberry Finn* by Mark Twain)

shay-cart NOUN a shay-cart was a small cart drawn by one horse ❏ *"I were at the Bargemen t'other night, Pip;" whenever he subsided into affection, he called me Pip, and whenever he relapsed into politeness he called me Sir; "when there come up in his*

shay-cart Pumblechook." (Great Expectations by Charles Dickens)

shilling NOUN a shilling is an old unit of currency. There were twenty shillings in every British pound ❑ *"Ten shillings too much," said the gentleman in the white waistcoat.* (*Oliver Twist* by Charles Dickens)

shines NOUN tricks or games ❑ *well, it would make a cow laugh to see the shines that old idiot cut* (*The Adventures of Huckleberry Finn* by Mark Twain)

shirking VERB shirking means not doing what you are meant to be doing, or evading your duties ❑ *some of you shirking lubbers* (*Treasure Island* by Robert Louis Stevenson)

shiver my timbers PHRASE shiver my timbers is an expression which was used by sailors and pirates to express surprise ❑ *why, shiver my timbers, if I hadn't forgotten my score!* (*Treasure Island* by Robert Louis Stevenson)

shoe-roses NOUN shoe-roses were roses made from ribbons which were stuck on to shoes as decoration ❑ *the very shoe-roses for Netherfield were got by proxy* (*Pride and Prejudice* by Jane Austen)

singular ADJ singular means very great and remarkable or strange ❑ *"Singular dream," he says* (*The Adventures of Huckleberry Finn* by Mark Twain)

sire NOUN sire is an old word which means lord or master or elder ❑ *She also defied her sire* (*Little Women* by Louisa May Alcott)

sixpence NOUN a sixpence was half of a shilling ❑ *if she had only a shilling in the world, she would be very lilkely to give away sixpence of it* (*Emma* by Jane Austen)

slavey NOUN the word slavey was used when there was only one servant in a house or boarding-house—so she had to perform all the duties of a larger staff ❑ *Two distinct knocks, sir, will produce the slavey at any*

time (*The Old Curiosity Shop* by Charles Dickens)

slender ADJ weak ❑ *In slender accents of sweet verse* (*The Prelude* by William Wordsworth)

slop-shops NOUN slop-shops were shops where cheap ready-made clothes were sold. They mainly sold clothes to sailors ❑ *Accordingly, I took the jacket off, that I might learn to do without it; and carrying it under my arm, began a tour of inspection of the various slop-shops.* (*David Copperfield* by Charles Dickens)

sluggard NOUN a lazy person ❑ *"Stand up and repeat ''Tis the voice of the sluggard,'"' said the Gryphon.* (*Alice's Adventures in Wonderland* by Lewis Carroll)

smallpox NOUN smallpox is a serious infectious disease ❑ *by telling the men we had smallpox aboard* (*The Adventures of Huckleberry Finn* by Mark Twain)

smalls NOUN smalls are short trousers ❑ *It is difficult for a large-headed, small-eyed youth, of lumbering make and heavy countenance, to look dignified under any circumstances; but it is more especially so, when superadded to these personal attractions are a red nose and yellow smalls* (*Oliver Twist* by Charles Dickens)

sneeze-box NOUN a box for snuff was called a sneeze-box because sniffing snuff makes the user sneeze ❑ *To think of Jack Dawkins—lummy Jack —the Dodger—the Artful Dodger— going abroad for a common twopen- ny-halfpenny sneeze-box!* (*Oliver Twist* by Charles Dickens)

snorted VERB slept ❑ *Or snorted we in the Seven Sleepers' den?* (*The Good-Morrow* by John Donne)

snuff NOUN snuff is tobacco in powder form which is taken by sniffing ❑ *as he thrust his thumb and fore-finger into the proffered snuff-box of the undertaker: which was an ingenious little model of a patent*

coffin. (*Oliver Twist* by Charles Dickens)

soliloquized VERB to soliloquize is when an actor in a play speaks to himself or herself rather than to another actor ❑ *"A new servitude! There is something in that," I soliloquized (mentally, be it understood; I did not talk aloud) (Jane Eyre* by Charlotte Brontë)

sough NOUN a sough is a drain or a ditch ❑ *as you may have noticed the sough that runs from the marshes* (*Wuthering Heights* by Emily Brontë)

spirits NOUN a spirit is the nonphysical part of a person which is believed to remain alive after their death ❑ *that I might raise up spirits when I please* (*Doctor Faustus* 1.5 by Christopher Marlowe)

spleen ■ NOUN here spleen means a type of sadness or depression which was thought to only affect the wealthy ❑ *yet here I could plainly discover the true seeds of spleen* (*Gulliver's Travels* by Jonathan Swift) ■ NOUN irritability and low spirits ❑ *Adieu to disappointment and spleen* (*Pride and Prejudice* by Jane Austen)

spondulicks NOUN spondulicks is a slang word which means money ❑ *not for all his spondulicks and as much more on top of it* (*The Adventures of Huckleberry Finn* by Mark Twain)

stalled of VERB to be stalled of something is to be bored with it ❑ *I'm stalled of doing naught* (*Wuthering Heights* by Emily Brontë)

stanchion NOUN a stanchion is a pole or bar that stands upright and is used as a building support ❑ *and slid down a stanchion* (*The Adventures of Huckleberry Finn* by Mark Twain)

stang NOUN stang is another word for pole which was an old measurement ❑ *These fields were intermingled with woods of half a stang* (*Gulliver's Travels* by Jonathan Swift)

starlings NOUN a starling is a wall built around the pillars that support a bridge to protect the pillars ❑ *There were states of the tide when, having been down the river, I could not get back through the eddy-chafed arches and starlings of old London Bridge* (*Great Expectations* by Charles Dickens)

startings NOUN twitching or night-time movements of the body ❑ *with midnight's startings* (*On His Mistress* by John Donne)

stomacher NOUN a panel at the front of a dress ❑ *but send her aunt the pattern of a stomacher* (*Emma* by Jane Austen)

stoop VERB swoop ❑ *Once a kite hovering over the garden made a stoop at me* (*Gulliver's Travels* by Jonathan Swift)

succedaneum NOUN a succedaneum is a substitute ❑ *But as a succedaneum* (*The Prelude* by William Wordsworth)

suet NOUN a hard animal fat used in cooking ❑ *and your jaws are too weak For anything tougher than suet* (*Alice's Adventures in Wonderland* by Lewis Carroll)

sultry ADJ sultry weather is hot and damp. Here sultry means unpleasant or risky ❑ *for it was getting pretty sultry for us* (*The Adventures of Huckleberry Finn* by Mark Twain)

summerset NOUN summerset is an old spelling of somersault. If someone does a somersault, they turn over completely in the air ❑ *I have seen him do the summerset* (*Gulliver's Travels* by Jonathan Swift)

supper NOUN supper was a light meal taken late in the evening. The main meal was dinner which was eaten at four or five in the afternoon ❑ *and the supper table was all set out* (*Emma* by Jane Austen)

surfeits VERB to surfeit in something is to have far too much of it, or to overindulge in it to an unhealthy degree ❑ *He surfeits upon cursed*

necromancy (*Doctor Faustus chorus* by Christopher Marlowe)

surtout NOUN a surtout is a long close-fitting overcoat ❏ *He wore a long black surtout reaching nearly to his ankles* (*The Old Curiosity Shop* by Charles Dickens)

swath NOUN swath is the width of corn cut by a scythe ❏ *while thy hook Spares the next swath* (*Ode to Autumn* by John Keats)

sylvan ADJ sylvan means belonging to the woods ❏ *Sylvan historian* (*Ode on a Grecian Urn* by John Keats)

taction NOUN taction means touch. This means that the people had to be touched on the mouth or the ears to get their attention ❏ *without being roused by some external taction upon the organs of speech and hearing* (*Gulliver's Travels* by Jonathan Swift)

Tag and Rag and Bobtail PHRASE the riff-raff, or lower classes. Used in an insulting way ❏ *"No," said he; "not till it got about that there was no protection on the premises, and it come to be considered dangerous, with convicts and Tag and Rag and Bobtail going up and down."* (*Great Expectations* by Charles Dickens)

tallow NOUN tallow is hard animal fat that is used to make candles and soap ❏ *and a lot of tallow candles* (*The Adventures of Huckleberry Finn* by Mark Twain)

tan VERB to tan means to beat or whip ❏ *and if I catch you about that school I'll tan you good* (*The Adventures of Huckleberry Finn* by Mark Twain)

tanyard NOUN the tanyard is part of a tannery, which is a place where leather is made from animal skins ❏ *hid in the old tanyard* (*The Adventures of Huckleberry Finn* by Mark Twain)

tarry ADJ tarry means the colour of tar or black ❏ *his tarry pig-tail* (*Treasure Island* by Robert Louis Stevenson)

thereof PHRASE from there ❏ *By all desires which thereof did ensue* (*On His Mistress* by John Donne)

thick with, be PHRASE if you are "thick with someone" you are very close, sharing secrets- it is often used to describe people who are planning something secret ❏ *Hasn't he been thick with Mr Heathcliff lately?* (*Wuthering Heights* by Emily Brontë)

thimble NOUN a thimble is a small cover used to protect the finger while sewing ❏ *The paper had been sealed in several places by a thimble* (*Treasure Island* by Robert Louis Stevenson)

thirtover ADJ thirtover is an old word which means obstinate or that someone is very determined to do want they want and can not be persuaded to do something in another way ❏ *I have been living on in a thirtover, lackadaisical way* (*Tess of the D'Urbervilles* by Thomas Hardy)

timbrel NOUN timbrel is a tambourine ❏ *What pipes and timbrels?* (*Ode on a Grecian Urn* by John Keats)

tin NOUN tin is slang for money/cash ❏ *Then the plain question is, an't it a pity that this state of things should continue, and how much better would it be for the old gentleman to hand over a reasonable amount of tin, and make it all right and comfortable* (*The Old Curiosity Shop* by Charles Dickens)

tincture NOUN a tincture is a medicine made with alcohol and a small amount of a drug ❏ *with ink composed of a cephalic tincture* (*Gulliver's Travels* by Jonathan Swift)

tithe NOUN a tithe is a tax paid to the church ❏ *and held farms which, speaking from a spiritual point of view, paid highly-desirable tithes* (*Silas Marner* by George Eliot)

387

towardly ADJ a towardly child is dutiful or obedient ❑ *and a towardly child* (*Gulliver's Travels* by Jonathan Swift)

toys NOUN trifles are things which are considered to have little importance, value, or significance ❑ *purchase my life from them bysome bracelets, glass rings, and other toys* (*Gulliver's Travels* by Jonathan Swift)

tract NOUN a tract is a religious pamphlet or leaflet ❑ *and Joe Harper got a hymn-book and a tract* (*The Adventures of Huckleberry Finn* by Mark Twain)

train-oil NOUN train-oil is oil from whale blubber ❑ *The train-oil and gunpowder were shoved out of sight in a minute* (*Wuthering Heights* by Emily Brontë)

tribulation NOUN tribulation means the suffering or difficulty you experience in a particular situation ❑ *Amy was learning this distinction through much tribulation* (*Little Women* by Louisa May Alcott)

trivet NOUN a trivet is a three-legged stand for resting a pot or kettle ❑ *a pocket-knife in his right; and a pewter pot on the trivet* (*Oliver Twist* by Charles Dickens)

trot line NOUN a trot line is a fishing line to which a row of smaller fishing lines are attached ❑ *when he got along I was hard at it taking up a trot line* (*The Adventures of Huckleberry Finn* by Mark Twain)

troth NOUN oath or pledge ❑ *I wonder, by my troth* (*The Good-Morrow* by John Donne)

truckle NOUN a truckle bedstead is a bed that is on wheels and can be slid under another bed to save space ❑ *It rose under my hand, and the door yielded. Looking in, I saw a lighted candle on a table, a bench, and a mattress on a truckle bedstead.* (*Great Expectations* by Charles Dickens)

trump NOUN a trump is a good, reliable person who can be trusted ❑ *This lad Hawkins is a trump, I perceive* (*Treasure Island* by Robert Louis Stevenson)

tucker NOUN a tucker is a frilly lace collar which is worn around the neck ❑ *Whereat Scrooge's niece's sister—the plump one with the lace tucker: not the one with the roses—blushed.* (*A Christmas Carol* by Charles Dickens)

tureen NOUN a large bowl with a lid from which soup or vegetables are served ❑ *Waiting in a hot tureen!* (*Alice's Adventures in Wonderland* by Lewis Carroll)

turnkey NOUN a prison officer; jailer ❑ *As we came out of the prison through the lodge, I found that the great importance of my guardian was appreciated by the turnkeys, no less than by those whom they held in charge.* (*Great Expectations* by Charles Dickens)

turnpike NOUN the upkeep of many roads of the time was paid for by tolls (fees) collected at posts along the road. There was a gate to prevent people travelling further along the road until the toll had been paid. ❑ *Traddles, whom I have taken up by appointment at the turnpike, presents a dazzling combination of cream colour and light blue; and both he and Mr. Dick have a general effect about them of being all gloves.* (*David Copperfield* by Charles Dickens)

twas PHRASE it was ❑ *twas but a dream of thee* (*The Good-Morrow* by John Donne)

tyrannized VERB tyrannized means bullied or forced to do things against their will ❑ *for people would soon cease coming there to be tyrannized over and put down* (*Treasure Island* by Robert Louis Stevenson)

'un NOUN 'un is a slang term for one—usually used to refer to a person ❑ *She's been thinking the old 'un* (*David Copperfield* by Charles Dickens)

undistinguished ADJ undiscriminating or incapable of making a distinction between good and bad things ❑

their undistinguished appetite to devour everything (*Gulliver's Travels* by Jonathan Swift)

use NOUN habit ❏ *Though use make you apt to kill me* (*The Flea* by John Donne)

vacant ADJ vacant usually means empty, but here Wordsworth uses it to mean carefree ❏ *To vacant musing, unreproved neglect* (*The Prelude* by William Wordsworth)

valetudinarian NOUN one too concerned with his or her own health. ❏ *for having been a valetudinarian all his life* (*Emma* by Jane Austen)

vamp VERB vamp means to walk or tramp to somewhere ❏ *Well, vamp on to Marlott, will 'ee* (*Tess of the D'Urbervilles* by Thomas Hardy)

vapours NOUN the vapours is an old term which means unpleasant and strange thoughts, which make the person feel nervous and unhappy ❏ *and my head was full of vapours* (*Robinson Crusoe* by Daniel Defoe)

vegetables NOUN here vegetables means plants ❏ *the other vegetables are in the same proportion* (*Gulliver's Travels* by Jonathan Swift)

venturesome ADJ if you are venturesome you are willing to take risks ❏ *he must be either hopelessly stupid or a venturesome fool* (*Wuthering Heights* by Emily Brontë)

verily ADV verily means really or truly ❏ *though I believe verily* (*Robinson Crusoe* by Daniel Defoe)

vicinage NOUN vicinage is an area or the residents of an area ❏ *and to his thought the whole vicinage was haunted by her.* (*Silas Marner* by George Eliot)

victuals NOUN victuals means food ❏ *grumble a little over the victuals* (*The Adventures of Huckleberry Finn* by Mark Twain)

vintage NOUN vintage in this context means wine ❏ *Oh, for a draught of*

vintage! (*Ode on a Nightingale* by John Keats)

virtual ADJ here virtual means powerful or strong ❏ *had virtual faith* (*The Prelude* by William Wordsworth)

vittles NOUN vittles is a slang word which means food ❏ *There never was such a woman for givin' away vittles and drink* (*Little Women* by Louisa May Alcott)

voided straight PHRASE voided straight is an old expression which means emptied immediately ❏ *see the rooms be voided straight* (*Doctor Faustus 4.1* by Christopher Marlowe)

wainscot NOUN wainscot is wood panel lining in a room so wainscoted means a room lined with wooden panels ❏ *in the dark wainscoted parlor* (*Silas Marner* by George Eliot)

walking the plank PHRASE walking the plank was a punishment in which a prisoner would be made to walk along a plank on the side of the ship and fall into the sea, where they would be abandoned ❏ *about hanging, and walking the plank* (*Treasure Island* by Robert Louis Stevenson)

want VERB want means to be lacking or short of ❏ *The next thing wanted was to get the picture framed* (*Emma* by Jane Austen)

wanting ADJ wanting means lacking or missing ❏ *wanting two fingers of the left hand* (*Treasure Island* by Robert Louis Stevenson)

wanting, I was not PHRASE I was not wanting means I did not fail ❏ *I was not wanting to lay a foundation of religious knowledge in his mind* (*Robinson Crusoe* by Daniel Defoe)

ward NOUN a ward is, usually, a child who has been put under the protection of the court or a guardian for his or her protection ❏ *I call the Wards in Jarndcye. They*

are caged up with all the others.
(*Bleak House* by Charles Dickens)

waylay VERB to waylay someone is to lie in wait for them or to intercept them ❏ *I must go up the road and waylay him* (*The Adventures of Huckleberry Finn* by Mark Twain)

weazen NOUN weazen is a slang word for throat. It actually means shrivelled ❏ *You with a uncle too! Why, I knowed you at Gargery's when you was so small a wolf that I could have took your weazen betwixt this finger and thumb and chucked you away dead* (*Great Expectations* by Charles Dickens)

wery ■ ADV very ❏ *Be wery careful o' vidders all your life* (*Pickwick Papers* by Charles Dickens) ■ *See* wibrated

wherry NOUN wherry is a small swift rowing boat for one person ❏ *It was flood tide when Daniel Quilp sat himself down in the wherry to cross to the opposite shore.* (*The Old Curiosity Shop* by Charles Dickens)

whether PREP whether means which of the two in this example ❏ *we came in full view of a great island or continent (for we knew not whether)* (*Gulliver's Travels* by Jonathan Swift)

whetstone NOUN a whetstone is a stone used to sharpen knives and other tools ❏ *I dropped pap's whetstone there too* (*The Adventures of Huckleberry Finn* by Mark Twain)

wibrated VERB in Dickens's use of the English language "w" often replaces "v" when he is reporting speech. So here "wibrated" means "vibrated". In *Pickwick Papers* a judge asks Sam Weller (who constantly confuses the two letters) "Do you spell it with a 'v' or a 'w'?" to which Weller replies "That depends upon the taste and fancy of the speller, my Lord" ❏ *There are strings . . . in the human heart that had better not be wibrated* (*Barnaby Rudge* by Charles Dickens)

wicket NOUN a wicket is a little door in a larger entrance ❏ *Having rested here, for a minute or so, to collect a good burst of sobs and an imposing show of tears and terror, he knocked loudly at the wicket* (*Oliver Twist* by Charles Dickens)

without CONJ without means unless ❏ *You don't know about me, without you have read a book by the name of The Adventures of Tom Sawyer* (*The Adventures of Huckleberry Finn* by Mark Twain)

wittles ■ NOUN wittles is a slang word which means food ❏ *I live on broken wittles–and I sleep on the coals* (*David Copperfield* by Charles Dickens) ■ *See* wibrated

woo VERB courts or forms a proper relationship with ❏ *before it woo* (*The Flea* by John Donne)

words, to have PHRASE if you have words with someone you have a disagreement or an argument ❏ *I do not want to have words with a young thing like you.* (*Black Beauty* by Anna Sewell)

workhouse NOUN workhouses were places where the homeless were given food and a place to live in return for doing very hard work ❏ *And the Union workhouses? demanded Scrooge. Are they still in operation?* (*A Christmas Carol* by Charles Dickens)

yawl NOUN a yawl is a small boat kept on a bigger boat for short trips. Yawl is also the name for a small fishing boat ❏ *She sent out her yawl, and we went aboard* (*The Adventures of Huckleberry Finn* by Mark Twain)

yeomanry NOUN the yeomanry was a collective term for the middle classes involved in agriculture ❏ *The yeomanry are precisely the order of people with whom I feel I can have nothing to do* (*Emma* by Jane Austen)

yonder ADV yonder means over there ❏ *all in the same second we seem to hear low voices in yonder!* (*The Adventures of Huckleberry Finn* by Mark Twain)